ABOUT THE AUTHORS

Once described as "the lost daughter of Iggy Pop and Brigitte Bardot," **Cherie Currie** is still performing, writing, and acting. She is one of the most prominent chain-saw carvers in the world, and she placed in two major competitions in 2005. She is recording a new album and enjoys writing and performing live with her son, Jake.

Tony O'Neill is the author of *Digging the Vein* and *Down and Out on Murder Mile*, and coauthor of the *New York Times* bestseller *Hero of the Underground*. He lives in New York City with his wife and daughter.

NEON ★ ★ ANGEL

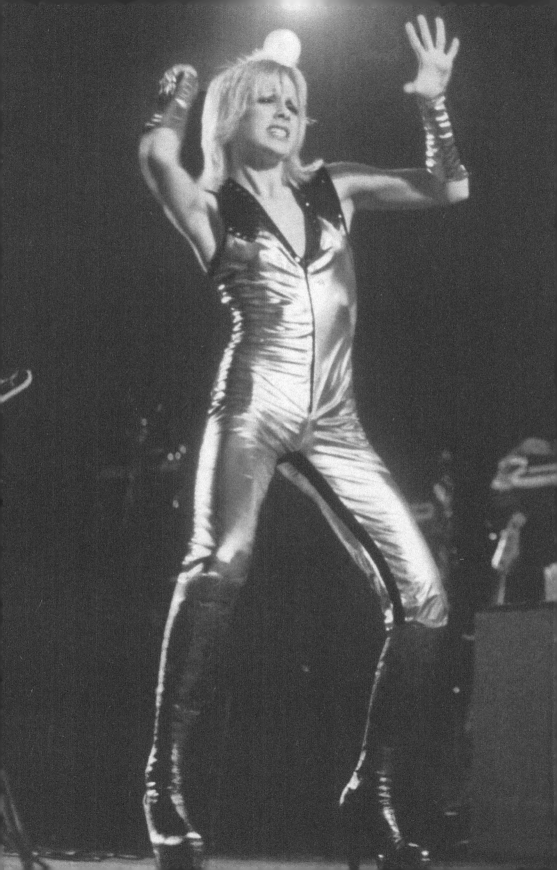

★

Can't stay at home, can't stay at school
Old folks say, "You poor little fool"
Down the street I'm the girl next door
I'm the fox you've been waiting for

Hello Daddy, hello Mom
I'm your ch-ch-ch-ch-ch-cherry bomb
Hello world, I'm your wild girl
I'm your ch-ch-ch-ch-ch-cherry bomb

Stone age love and strange sounds too
Come on, baby, let me get to you
Bad nights causin' teenage blues
Get down, ladies, you've got nothing to lose

Hello Daddy, hello Mom
I'm your ch-ch-ch-ch-ch-cherry bomb
Hello world, I'm your wild girl
I'm your ch-ch-ch-ch-ch-cherry bomb

Hey street boy, want your style
Your dead-end dreams don't make you smile
I'll give ya something to live for
Have ya, grab ya till you're sore

Hello Daddy, hello Mom
I'm your ch-ch-ch-ch-ch-cherry bomb
Hello world, I'm your wild girl
I'm your ch-ch-ch-ch-ch-cherry bomb

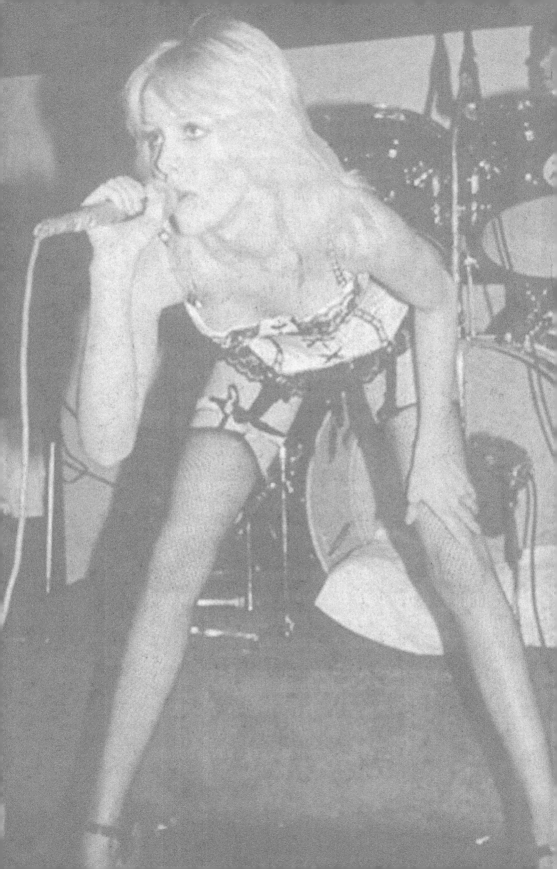

NEON

A MEMOIR OF A RUNAWAY

ANGEL

CHERIE CURRIE

WITH TONY O'NEILL

!t
itbooks
AN IMPRINT OF HARPERCOLLINSPUBLISHERS

*it*books

Unless otherwise noted, all photographs courtesy of the author.

Frontispiece photograph by Brad Elterman; title page photograph by Bob Gruen; table of contents photograph by Janet Macoska.

"Cherry Bomb" written by Joan Jett and Kim Fowley. Jett Pack Music Inc./Peer Music Ltd.

A hardcover edition of this book was published in 2010 by It Books, an imprint of HarperCollins Publishers.

HarperCollins books may be purchased for educational, business, or sales promotional use. For information please write: Special Markets Department, HarperCollins Publishers, 10 East 53rd Street, New York, NY 10022.

FIRST IT BOOKS PAPERBACK PUBLISHED 2011.

Designed by Renato Stanisic

The Library of Congress has catalogued the hardcover edition as follows:
Currie, Cherie, 1959–
 Neon angel : a memoir of a Runaway / Cherie Currie with Tony O'Neill.
 p. cm. — (It books)
 ISBN 978-0-06-196135-9
 1. Currie, Cherie, 1959– 2. Rock musicians—United States—Biography. I. O'Neill, Tony, 1978– II. Runaways (Musical group) III. Title.
 ML420.C9867A3 2010
 782.42166092—dc22
 [B] 2010000095

ISBN 978-0-06-196136-6 (pbk.)

11 12 13 14 15 OV/RRD 10 9 8 7 6 5 4 3 2 1

This book is for my mother, Marie; you are a miracle, my best friend, and I love you. My son, Jake Robert Hays; you amaze me every day and I couldn't be more proud. And Kenny Laguna. You never gave up on me or this book. Without you, none of this would be possible. You are extraordinary and I love you.

In loving memory of Sandy West Pesavento.

A special thanks to my twin sister, Marie; my brother, Don; Vena and my niece Grace; sister Sandy and brother Alan Levi; Cristina Lukather; Trevor Lukather; Wolfgang (Dad) Kaupish; Joan Jett; Gretchen Bonaduce; and Robert Hays, the best ex-husband in the world.

CONTENTS

AUTHOR'S NOTE

This edition is based in part on Neon Angel *by Cherie Currie with Neal Shusterman, published in 1989.*

All incidents and dialogue are to the best of the author's recollection and knowledge. Some identities were changed to protect the innocent, and in some cases, regrettably, the not-so-innocent.

ACKNOWLEDGMENTS

Mauro DiPreta; Jennifer Schulkind; HarperCollins/It Books; Tony O'Neill; Neal Schusterman; William Pohlad; Bob and Jeanne Berney; Joy, Steve, Elle, and Dakota Fanning; Chris Schwartz; Carianne Brinkman; Julie Rader and all at Blackheart Records Group; Ted Stachtiaris; Paul Bresnick; Apparition; Art Linson; John Linson; Floria Sigismondi; River Road; Sabrina Ballard; Pam Apostolou; Katt Lowe; and Tim Farris.

FOREWORD
by Joan Jett

met Cherie one night in the San Fernando Valley, at a club called the Sugar Shack, which had become the place to go, since Rodney's had recently closed. Kim Fowley and I went there specifically to find a lead singer for the Runaways. I remember seeing Cherie and her twin sister, Marie. They were standing together—they were quite striking, and they definitely stood out.

Cherie had her hair in kind of a grown-out Bowie cut, and I picked right up on that. When Kim and I spoke to her about trying out for the band as a lead singer, she said yes, but the rest I won't chronicle here, since it's all in the book. The thing is, she got the job! For me, Cherie was a great lead singer, perfect for our band. "The Blond Bombshell"—she had total command of the stage. A little tough, a lot nasty.

We were always well-rehearsed, so the shows were tight. As I watched from my position to her right, Cherie was always very compelling. We were very close friends, too. Besides our own music in the band, we both loved Bowie and a lot of the same music. (There was plenty of disconnect about favorite music, too.)

When the Runaways went to Japan with a hit record, it was so thrilling, so big, so hysterical—and so different from America—it seemed like all we had dreamed of. We lost one of our members in Japan, and Cherie soon followed after we got home.

She had a big following, and was on a lot of magazine covers, so she figured she could do better on her own, or at least that's what I thought she felt. When Cherie quit the Runaways, I was so pissed! She had bailed on the dream! I was very angry and hurt for several years after that. Of course, I never stopped loving the Runaways, and Cherie, too.

She left in 1977, and after that Cherie and I didn't really know each other for nearly two decades. I've grown up a lot since then, and now I realize things happen the way they are supposed to happen. I'm not mad at Cherie anymore, either.

And during the past fifteen years or so, since we have been working on the business and legacy of the Runaways, we have rekindled our friendship. I must say, I really only knew a small part of Cherie. *Neon Angel* is a chronicle of a remarkable journey—the story of a remarkable woman who has an uncanny knack of reinventing herself—from singer to actor to drug counselor to physical trainer to mom to author to painter to chain-saw carver. Anyway, when Cherie and I recently got together to record our songs for the Runaways movie, it was like we never left. Thirty-two years had passed, but time stood still, and we never missed a beat.

While excelling at every turn, she has also exhibited an ironic flair for finding herself in dramatic situations.

So, to conclude, Cherie Currie—mother, uniquely devoted ex-wife, musician, versatile visual artist—is really so talented. (I still can't believe Cherie carves wood with a chain saw, and is so good at it!) But what truly amazes me is what a fine, honest, introspective author she is—with an incredible tale about an incredible life, and a fascinating personal odyssey, as she lived it.

Joan Jett
January 2010

NEON ANGEL

Diamond Dogs *and Revelations*

September 8, 1974

My twin sister, Marie, and I looked uncharacteristically plain that night. In fact, we looked like any pair of normal fifteen-year-old girls from the Valley. A pair of blue jeans, our plainest, most boring blouses. No makeup, no nothing, but the "plain Jane" look was deliberate. Tonight was a special night, and the outfits were carefully chosen.

When we snuck out of the bedroom, the duffel bag slung casually over my shoulder, our mom sensed movement immediately and called out from the kitchen, "Girls? Is that you?"

"Yeah, Mom," Marie called back as we headed toward the front door without pausing, "it's us. We're just heading out . . ."

"Where are you going?" she called again, her voice betraying a hint of suspicion.

"Babysitting!" we chimed in union, before I added, "We told you already!"

Babysitting was what we told our mom whenever we were doing something that we knew she wouldn't approve of. *Babysitting* was code for going to the nightclubs where we dressed outrageously and danced all night. *Babysitting* was code for smoking pot and drinking Mickey's Big Mouth beer with the neighborhood kids. On this particular night, *babysitting* was code for a rock concert. The lie fell

easily off my tongue as we pulled open the door and the murky San Fernando Valley air hit our faces, sweet with the scent of juniper and the promise of freedom. I was fifteen years old, and it felt like lying had become almost second nature recently. That sickly feeling I used to get with every half-truth or outright lie was now so mild, it was almost unnoticeable. Anyway, tonight I had bigger things on my mind than the white lies I told my mother to keep her blissfully unaware. Tonight was a special night: it had been marked in my calendar for months. Tonight was my first-ever David Bowie concert, and nothing on this earth was going to stop me from getting there.

The door closed behind us, and we crept into the night.

We started off walking casually down the block, in case Mom was peeping out from a kitchen window. After all, we wouldn't have wanted to make her suspicious. I walked with the easy gait of someone who had nothing to hide. Marie was looking over her shoulder, creeping along the sidewalk like a fugitive on the run.

"Calm down, will you?" I hissed. "You look so nervous! Mom's cool. She's so busy with *Wolfgang* she won't even suspect anything. We're just babysitting, remember?"

Wolfgang was my mother's new boyfriend. Wolfgang was German, and extremely wealthy. He was handsome I suppose—for an old guy—and always dressed in expensive tailored suits. He worked for the World Bank and traveled a lot. All I really knew about his work was that he made a lot of money doing it, and lived in Indonesia. When he was here in California, my mom seemed happy. When he was gone, she would be quiet and a little sad. I had the feeling Wolfgang disliked me, but that was okay with me. I disliked Wolfgang because Wolfgang was not my father, and he never would be.

"It's not Mom I'm worried about," Marie confessed, still looking over her shoulder at the empty suburban street behind us. "Its Derek."

I rolled my eyes. "Oh PLEASE! Stop going on about Derek!" I sighed.

Derek was Marie's ex-boyfriend, and a prime, grade-A creep. Marie had been seeing him in the months since Dad left for good, and she had finally gotten around to dumping his ass a few weeks ago. Mom knew nothing about Derek while Marie was dating him,

and it's a good thing, too, because I'm sure she would have had him arrested, or banned Marie from ever leaving the house again if she'd gotten wind that her fifteen-year-old daughter was dating some sleazy old dude in his twenties. I have no idea what the hell Marie saw in Derek: he wasn't handsome, he wasn't charming; in fact, all he had going for him was that he owned a car. Marie was way too good for him. She's was a really beautiful girl, and I used to feel hopelessly inferior to her, despite the fact that we were twins and most people claimed that they couldn't tell us apart . . .

That's why the whole Derek thing puzzled me. The whole idea was gross, and I reminded Marie of this whenever I got the chance. When Marie finally got rid of him, I was really happy about it. The downside was that ever since she dumped him, Derek was all that Marie seemed to talk about.

"Don't ruin my night!" I begged as we saw the car idling a little farther down the block. "I don't wanna hear about Derek, okay? We're having fun tonight."

"Okay," Marie said, sounding unsure. "He just makes me nervous. He's CRAZY, Cherie! I'm not kidding, sometimes he really freaks me out . . . I think he's been following me."

"I'm not surprised, Marie. He's a freak! Why the hell did you even date him? You'd better not ruin tonight by talking about *Derek*." I spat the word as if it was so distasteful that I could barely stand to have it in my mouth. "He's lame. He sucks! Don't waste your breath talking about that loser . . ."

At this, Marie finally smiled. As we stood next to the car, she finally conceded, "Yeah. You're right. He does suck." Then she smiled, all of the worry finally falling away from her pretty face.

I pulled the door open. My best friend, Paul, was behind the wheel. His eight-track was blasting the soundtrack of the evening: *Diamond Dogs* by David Bowie. "Hey, girls!" He laughed. "Jump in . . ."

Paul was our designated driver for the evening. He was seventeen and an only child. His parents gave him anything he wanted, including a yellow Camaro Sport with a black stripe down the side. It was Paul who'd introduced us to Bowie, glam rock, everything that had become the center of my universe. Paul was a strange introverted guy

who was totally obsessed with David Bowie. He talked through his teeth, and had this weird phobia about never eating anything that he had touched. When we were at McDonald's, he would eat every part of a french fry except for the part that his fingers came into contact with. And he had this strange, wheezy laugh that reminded me of Muttley from *Wacky Races*. Despite all of these quirks, I liked Paul: I thought he was cute; weird but cute. I guess he was handsome in a bizarre kind of way; he dressed and even looked a little like Bowie. Plus he had cool taste in music. I would have gone out with him if he had asked me to. He just never seemed interested. I sensed something uncomfortable between us whenever I got too close to Paul.

Uncomfortable really summed Paul up. I didn't know too much about boys and how their minds worked back then, and it wasn't until years later that I found out he was gay. He was one of the coolest guys I knew, my best friend back then. There was a time when Marie was my best friend, but over those past few months I'd been closer to Paul than to Marie, who had been sucked up into the vortex of Derek. Over the summer we had begun to slowly drift apart: Marie was hanging out with her own circle of friends, most of whom I thought didn't like me. Tonight was typical behavior from her. We'd been talking about going to this Bowie concert for months, and now that the day had finally arrived, Marie was too busy worrying about her goony ex-boyfriend to enjoy herself.

"Jesus," said Paul as we pulled away, "what's with the frown, Marie?"

"I'm NOT frowning!" Marie screeched. "I'm just worried about Derek . . ."

I rolled my eyes at Paul, and he grimaced, well familiar with the ongoing saga of Marie and Derek. It was Paul who'd originally introduced us to all of the hot clubs in L.A. It was Paul who'd first brought us to Rodney Bingenheimer's English Disco, a club on the Sunset Strip that was ground zero for glam rock in L.A. It was Paul who'd taken us to the Sugar Shack in North Hollywood—an under-twenty-one club where they played all the best new music, all of that amazing English glam that I loved: Bowie, Elton John, the Sweet, Mott the Hoople . . . The Sugar Shack had become a home away from home for me in those past few months, a place where I could forget about

all of the problems I was having at home since Dad left, a place to have fun, dress up, and dance. And Rodney's! Everybody was a star at Rodney's, and the club was a frantic mix of young kids dressed in their most outrageous, sluttiest, sexiest outfits, groupies, faces from the glam scene, and the weird, older guys who'd congregate to ogle all of the barely teen jailbait staggering around the dance floor in revealing outfits and six-inch platform boots. Of course, that's where Marie met Derek.

"Don't worry about Derek." Paul sneered. "He'll be at Rodney's tonight. Like always . . ."

"But—"

"Shut UP!" I yelled. "Derek, Derek, Derek! I don't want to hear his name again tonight!"

We pulled into a run-down gas station on Ventura Boulevard. The attendant was a fat slob in grease-stained denim overalls chomping on an unlit cigar. We smiled our sweetest smiles, and asked for the key to the bathroom. He looked us up and down, and with a grunt tossed it over to us. The key itself was tiny, but it was attached by a chain to a piece of two-by-four as big as my arm. We hurried around the corner and let ourselves into the bathroom.

Inside, the place was even worse than I'd imagined. The toilet was backed up with wads of paper, and the bowl was full to the brim with yellow water and God knows what else. The tiled floor was cracked and dotted with puddles of pee and dark smears of who knows what. Around the bare flickering lightbulb, flies swarmed and swirled. The mirror was cracked and filthy, but it made no difference to us: tonight, this was our dressing room. Using the tiny sink as a dressing table, we began our transformation.

"This place is really gross!" Marie shuddered, pulling out her red-glitter-covered jeans and her makeup case.

I said, "Uh-huh," trying not to breathe through my nose.

We stripped down to our underwear, careful not to touch any of the disgusting surfaces in the place, well used to this routine by now. Piece by piece the old Cherie started to disappear. In her place, this new Cherie-thing was appearing, Cherie the glitter queen: fire-engine-red satin pants, a T-shirt with a purple glittery thunderbolt

emblazoned across it, and silver five-inch platform space boots. I admired my look in the mirror: I was so bright, so shiny, that for a moment I forgot I was standing in this shitty, gross public restroom. As Marie applied her shocking-pink lipstick, I began the delicate process of gluing a string of rhinestones onto my eyelids with eyelash glue. Everything was *borrowed* from Mom's makeup case. When I was done, I looked perfectly bizarre, an alien princess crash-landed in Southern California. It was not just a physical transformation; it was a mental one, too. When I was dressed like this, I finally felt at home in my own skin. I was not just plain old Cherie Currie, sweet little surfer girl from the Valley anymore; I was the Cherie-thing: something wild, untamed, and glamorous. I was my own creation, something monstrous, mysterious, and powerful.

When we emerged from the bathroom, the attendant's eyes nearly popped right out of his head. We dumped the key back on the counter with a smirk. We left him staring, his mouth flapping open, as we ran on unsteady heels back to Paul's car.

"Hot!" he exclaimed as we jumped into the car. "Love the eyes!" Then with a squeal of rubber on asphalt, we were off into the night again.

But not for long! At Lankershim Boulevard we came to a dead stop—there was a sea of chrome, stretching off into the distance. The night air was alive with the sound of horns honking and the screams and laughter as an impromptu party started spontaneously taking place in this insane traffic jam. Lights flashed hypnotically, shining up into the night sky with a steady rhythm; people stood up in their convertibles dancing to music that we couldn't hear. As we crept forward, you could feel the electricity growing in the air like the prelude to a thunderstorm.

"There must be a million people coming to this concert!" I breathed in wonder. I had never seen such a mass of humanity before. I could barely believe that I was about to see David Bowie in the flesh. It seemed almost too good to be true.

"It's the last concert in town," Paul said. "Half these people probably don't even have tickets. They think they're going to be able to get some from scalpers. This is chaos . . ."

I breathed in, and let the excitement fill all of the empty places inside of me as we pulled into the parking lot. I could not remember ever having felt this excited before—my first rock concert! Tonight was all about David Bowie, my beautiful, wonderful David.

"You know what Derek said to me?" Marie said, suddenly breaking the spell. I shot her my dirtiest dirty look and snapped, "I don't want to know." Instead, I turned the stereo up, and David Bowie's voice began to shake the interior of the car, filling me up again with good feelings . . . I can't quite put it into words what exactly David Bowie meant to me back then. Over the past few years, Bowie had filled all of those empty spaces inside of me, spaces that began to appear, like wormy wood holes in old furniture, since the day my dad upped and left.

That day was still a fresh wound. I'd often run it through in my head, wondering if I could have done something, said something, that would have made it end differently.

I was twelve years old. I woke up first that morning, chilled to the bone by the air-conditioning, my stomach churning with fear and excitement. Today was a special day . . . today was the day that Dad was coming home!

I peered out from under the covers and surveyed the bedroom. Clothes lay in piles on the floor, records covered every available surface. The room was so bad that Mom wouldn't even come into it anymore. Maybe she was afraid that the mess would eat her alive. Across the room, Marie was still asleep, dead to world. She always sleeps silently, no snorting or sleep-talking, just like a little princess. Everything Marie does is just so. She sleeps daintily, she eats daintily. She's so perfect. I'm sure that when I sleep I snore, or talk or do something else that is awful and embarrassing. Despite the fact that everyone says that we're identical, we're not really . . . Marie's face is fuller than mine; prettier, too. I wish that my face looked like hers. People get us mixed up all of the time, but I can't understand how. I feel like the ugly stepsister, the twisted mirror image of the perfect little girl that is my twin.

Marie blinked awake and noticed me staring at her. This didn't faze her anymore; she was well used to waking up to find me looking at her with a weird mix of envy and adoration. She just stared back without saying anything. Then,

noticing the air-conditioning, she said, "I feel like a polar bear," and we both laughed.

Mom was in the kitchen, drinking coffee. Outside, the heat was stifling already. We lived in Encino back then, which is to say the Valley. The Valley is always at least ten degrees hotter than the rest of Los Angeles. I looked at Mom and wondered if she was thinking about Dad, too. I wondered what she'd say when he walked through the door. I wondered what she'd say to him when they made up.

I got myself a glass of orange juice and sat watching my mother reading the paper. She pulled a face every time she read about something horrendous. It was nine-thirty in the morning, and her platinum hair was already perfectly coiffed, her makeup impeccable. Back then, my mom was the most glamorous person I had ever known. She reminded me of Marilyn Monroe with a little Lucille Ball mixed in.

My mom came out to Hollywood from Illinois when she was just eighteen years old to be an actress. With her parents' permission, she and a girlfriend got a ride to California and rented a tiny one-room apartment in Hollywood with a Murphy bed for thirty-seven bucks a month. She found work as a Burger Shack carhop, bringing trays loaded with burgers, french fries, and chocolate malts to the customers parked in Ford Model A's and Chryslers parked outside. All the time she was waiting for her big break. My mom was blond, beautiful, and determined: she eventually paid her way through acting school by working nights as a cigarette girl at a Hollywood after-hours club. I remember her telling me that Orson Welles once tipped her ten dollars for a pack of Camels. My mom's looks and grit eventually landed her movie roles. She was under contract with Republic Pictures and starred alongside the likes of Roy Rogers and the Andrews Sisters. She found that she was particularly adept at playing the ditsy blonde. That was a long time ago. Mom doesn't act anymore, but every morning she still dresses as if she were auditioning for a role.

"When is Dad gonna be here?" I asked.

She took a sip of her coffee and sighed. "He didn't say, really. It could be anytime. You know your father . . ."

That is all I could get out of her. Mom hadn't said much about our dad since they announced that they were separating. The months leading up to the separation were unbearable. Their fights—which we had never been used to—were intense and heartbreaking. I remember watching my father holding

my mother's wrists as they fought on the front porch, in a desperate attempt to stop her from hitting him. And my mother's sobbing phone calls would echo down the halls. "I found him there! In the hotel . . . with . . . with that floozy!"

Mom's first husband was an abusive drunk named Bill. They had a daughter together, my older sister, Sandie. Mom told us that Bill had once chased her around the bedroom during a drunken rampage and put a lit cigarette out on her forehead. All this with my mom still clutching Sandie in fear. After that, Mom left him for good and returned to Illinois for a while, before returning to her career in Hollywood. She met my father at the Cock and Bull Restaurant on Sunset Boulevard, which was quite a celebrity hot spot in those days. My future dad, Don Currie, was working as a bartender there and Mom would often tell us the story of the first time they met. Mom was all dressed up, having come back from an interview, and she was sitting at the bar with friends. One of the other bartenders nudged my father and nodded toward Joan Crawford, who had just walked into the place, commenting, "Now, there is a beautiful woman!" My father fixed my mother in his deep blue gaze and said, "I think the prettiest lady is right here in front of me . . ." It was love at first sight, my mom said. There's no doubt about it, my mom really loved my dad and he loved her, too. This is what made their separation so hard on everybody.

"What does *separate* mean?" asked my little brother, Donnie, after Mom and Dad made the announcement. Marie scowled at him and said, "It means they're getting a divorce, Dumbo!" Dumbo is the name we called Donnie whenever we'd get mad at him, on account of his ears, which stuck right out from his head. He blushed when Marie said this. After all, what kid wouldn't be self-conscious about his ears when his big sisters call him "Dumbo" and his mom makes him sleep with a weird turban-thing wrapped around his head in an effort to get them to lie flat?

Marie and I never had much patience for Donnie back then, although he was really okay for a kid brother. He looked up at her with big uncomprehending eyes. With a curse, Marie stormed out of the room. He looked at me for an answer, but I didn't have one.

And then, Dad was gone. Off to live with Grandma and Aunt Evie, ten miles away in Reseda. At first, I pretended that he was on a trip, but as the weeks dragged on, his absence started to hurt me, as painfully as if I had physically lost a piece of myself. Mom refused to even mention Dad's name after he left, but all Marie and I could talk about was how much we missed him. Mom just

carried on like he had never been there in the first place. We all cried about it, late at night in bed, where mom couldn't hear, but it didn't help. The tears just made me feel emptier and lonelier than before.

In our family, my mother was the disciplinarian. Or as my father used to say, "She likes to wear the pants in the family." Of course, my dad never liked that, and I was secretly convinced that this was a huge contributing factor to their split.

We never had what you would call a traditional mother-daughter relationship. I never went to the movies with my mom, or did any of those mother-daughter things that other kids in my school seemed to do with their moms. My mom worked all of the time, so us three kids tended to all hang out by ourselves. I never told my mom about my first period, or discussed any of the embarrassing, strange things that puberty does to a young girl. Sandie was the one who helped us with all of that. My mom was too busy working to put food on the table. Anyway, my mom was uncomfortable talking about "things like that," and I always felt too embarrassed to bring them up. As a result, despite the fact that I grew up in her house, I don't think my mother and I really got to know each other. At least not until much later, when we could relate to each other as grown women. As an adolescent, I was a mystery to my mother. My mom was totally absorbed in her work: running a successful dress shop called the Donna-Rie Shop. After Dad moved out, my mom had to support three kids and she became even more short-tempered and distant than before. Now I can understand why she acted this way, but at the time it filled me with confusion and resentment. All I ever wanted was to make my mom proud, I just never felt like I added up or was good enough. I guess most kids feel that way, at one time or another. When my dad moved out of the house, my world literally crumbled. My father was the protector, the one who slept with a gun under the mattress, the one who would always ensure that we never came to any harm. With Dad gone, we felt scared, as if there was no one to protect us. The family just came apart at the seams.

But then, one day, in answer to my prayers came the news that Dad was coming back, to talk. I decided that this could only mean one thing: they had come to their senses, and they were getting back together.

I sipped my orange juice, and looked at my mother for clues. But she was inscrutable, absorbed by the latest urban horrors served up by the newspaper. I looked out of the window instead, and noticed that the sky was

blue—perfect, cloudless, endless blue. So I knew everything was going to be all right.

After all, I figured, bad things can't happen on a hot, cloudless, sunny day like today.

"Dav-id! Dav-id! Dav-id! Dav-id!"

Inside the Universal Amphitheater, the crowd was getting restless, and the fans were chanting louder, louder, cries and whistles and screams building in one section of the hall before fading out, the noise rising up somewhere else. The air was wet, hot, intoxicating. The pungent, sweet smell of marijuana hung in the sticky air. . .

"Dav-id! Dav-id! Dav-id!"

The excitement was almost too much. I could feel my heart pounding against my rib cage, and I got the idea that it might burst open altogether. I could not wipe the big, stupid grin off of my face. Then the lights went down, and the roar of the audience was deafening . . . In the dark, I could see a sea of faces, lights bouncing off the sea of glitter like some kind of woozy kaleidoscope. Next to me was some crazy guy in a silver space suit, the full-on Ziggy Stardust outfit, with crazy boots that had live goldfish swimming around in the glass platform soles. Onstage it looked as though there was some kind of strange, futuristic city with blood dripping down from the top of the buildings. My eyes were just about to pop out of my head: I had never seen anything like this before! The set was amazing, heavy with smoke, and there were dark figures doing spidery dance movements in the shadows. The band was somewhere onstage; I could hear them pick up their instruments, indistinct, shadowy figures. I scanned the stage for David Bowie, but he was nowhere to be seen. I was screaming, almost without realizing it. Then, as the lights dimmed, the chiming of bells began . . . I knew this music intimately already, having played the LP almost until the grooves had worn away . . . It was "1984"! All around, sweaty, twisting figures were pushing up against me, dancing, screaming, cheering . . .

Then a silhouette appeared behind the sheer curtain and everybody

went insane because we knew that it was Bowie. He struck a pose, and the audience lost their minds. He spread his legs, crouching down . . . and then, as my mouth hung open, the curtains burst apart and David Bowie hopped onto the stage.

I was shocked—so shocked I stopped screaming for a moment. This wasn't the David Bowie from the cover of *Diamond Dogs*! This wasn't Ziggy Stardust, or Aladdin Sane . . . this was an altogether different David Bowie. . . . He was dressed in a beige zoot suit, with suspenders, and his fire-engine-red hair was slicked back. It was a far cry from the silver bodysuit and platforms that I had imagined. Even the band was different—the Spiders from Mars replaced by some kind of mutant space-age soul outfit. It looked like *Soul Train*, as re-imagined by cross-dressing Martians. Of course he isn't what I expected, I realized. He would NEVER be what anybody expected!

I watched this impossibly thin, pale, alien prince singing to me. Not on vinyl, but right there . . . right in front of my face, this beautiful, hypnotic, strange man was singing to me, and although I could not quite put it into words, I instinctively knew that what I was experiencing was something religious, something profound. The crowd seemed to move as one being, pushing toward the front, a tidal wave of teenage energy, and although I had heard the words coming out of David's mouth a million times, it felt as if I were hearing the words for the first time, each line reaching across the massive amphitheater and falling around me like a meteor shower.

The heat and the frustration, the alienation and the loneliness, the lust and the anxiety and the joy that seemed like it had been building inside of me for years, were suddenly unbearable, like the pressure was too much and I felt like a bomb primed to explode, and only David Bowie knew how I felt. His words explained what was deep down inside of me better than I ever could. The unbearable adolescent energy simmering inside of me was suddenly ignited. I imagined that I might erupt, go off like old footage they'd show on TV of the A-bomb, just explode! Take this whole concert out with me in an eruption of glitter and fury . . .

All around me were Bowie's kids . . . Ziggy Stardust's bastard children, the kids who knew that David Bowie was the most beautiful,

plastic-profound creature on the planet. Not the dumb kids at school who'd sneer that Bowie was a "fag" or too "weird" . . . The place was filled instead with the kids who felt just like me, who felt like we'd fallen to earth, too. We were screaming for him . . . screaming, and singing and dancing out all of our rage, frustrations, and joys.

When the song ended, the lights went out. And for a fraction of a second, before the place erupted into hysteria, it seemed like there was a moment of shocked silence.

For that moment, I was somewhere else. Somewhere profound. What I was witnessing tonight was nothing short of a revelation.

I was back in my home and my sister and I were watching Donnie cannonball into the swimming pool, when the doorbell rang and everybody looked up. Could that be Dad? I was standing on the very edge of the diving board, about to jump in, but suddenly I couldn't move. The doorbell rang again. He had a key, didn't he? If it was Dad, why was he ringing the bell? Then the thought hit me: he's ringing the bell because he's holding his suitcases and needs our help. Dad is really coming home!

My dad was the most beautiful, handsome man I had ever known. Before he met my mother, he was a Marine paratrooper, a gunnery sergeant. He was heavily decorated for his service in some of the most treacherous Japanese campaigns of World War II. Don Currie was a slim, handsome man with a smooth, Dean Martin–esque singing voice. His voice was so good that Larry Crosby had wanted him to cut a record, although my father never pursued it. Dad was a sweet, fun-loving guy, and was great with us kids. He was also a hit with the ladies. My mom used to tell us that when they were dating, she would dock him five hundred dollars every time she caught him dating another woman. When they married, they had enough saved from Dad's indiscretions to fully furnish their first apartment.

There was a dark side to my father, too. His experiences during the war had left a huge impression on my dad, and I remember sometimes, when he'd tell us his war stories, his eyes would seem to get bluer, with a faraway look that would almost take you there. I remember him telling us about an old buddy of his who had contracted syphilis during the war, and had become severely depressed. Depressed enough that the others in the unit had taken

away his gun, and hid their own weapons, fearing what he might do. One morning my father woke up to find his gun missing. He immediately feared the worst, and ran through the barracks looking for his friend. He found him in the latrine, standing very still, with my father's gun at his side. When Dad would recount this story, he'd pause, reaching out for his glass of watery bourbon and ice, and take a smooth long gulp. He was strangely at ease when he talked about the war, wrapped up in those memories like they were a comfortable old coat. He told us that the last thing he said to his friend as the man raised the gun to his head was "Don't do it, baby!" And then, in a flash of cordite, my father's friend blew his own head clean off.

"He just stood there," my father said in a voice that was suddenly weak. "Just stood there with the gun still in his hand, and his head clean gone. Then the body calmly sat down on a bench. Then it fell over on the floor. My gun was still in his hand."

My father was a drinker. A social drinker—my parents threw these amazing parties, where they'd listen to Dean Martin or the Mills Brothers singing "Shine, little glow-worm, glimmer, glimmer, shine little glow-worm, glimmer!" and Dad would be behind the bar they had built in the family room, mixing cocktails, telling stories, and playing the genial host. But other times he would drink alone, and his face would look older somehow. His eyes were distant, lost in some far-off memory. When I'd see him like that, I'd ask, "Are you okay, Daddy?" He'd snap back to reality, give me a smile, and say, "I'm doing great, Kitten, I feel like a tiger." My father was a hero in the war, and now sometimes I felt that he was unable to adjust to the role of everyday man. I could see that there was some unfathomable sadness in my father's heart, something deeper, and darker than a child like me could ever comprehend.

"Daddy!"

We raced, dripping wet, through the den and toward the front door. Mom was already opening the door, and there, with the sun spilling in from behind him, was Dad. Donnie barged past all of us, and leaped into his arms, still dripping, and Dad was smiling and he dropped the suitcases to the ground so he could catch him. Suddenly we were all on him, all talking to him at once, telling him about everything that had gone on in the four weeks since he left: "Marie and I are starting seventh grade!" "Some new neighbors moved in next door!" "I learned to do flips into the pool!" Dad was laughing, and shaking his

head, and trying to listen, but it was too much to follow . . . Donnie was asking, "Do you want a drink, Dad? Are you thirsty?"

"Are you hungry?" Marie interrupted. "We have barbecue!"

I was pulling on my father's sleeve. "Do you want to go for a swim? It'll cool you off!"

Dad couldn't answer, he just smiled and kissed us, happily overwhelmed by all of the commotion. He looked at us like he never wanted to take his eyes off of us ever again. He took a step inside, and I said, "I'll get your suitcases, Dad!"

"Can you handle them, Kitten?"

"Sure!"

I reached down, grasped the thick leather handles, and prepared myself for the weight of the heavy cases.

Except something was wrong.

When I picked them up, they lifted easily. Far too easily. I started carrying them toward Mom and Dad's bedroom, and with every step I took, they seemed lighter and lighter. An empty feeling started to grow in the pit of my stomach as I realized something terrible. Something that made me wish I hadn't even woken up that morning. Something more terrible than anything that had happened since Dad left a month ago.

I realized that the suitcases were empty. They weren't meant for bringing things home. They were meant for taking things away.

In the bedroom, I silently put the cases down. I walked over to Dad's closet and opened it up. It looked sparse in there: Dad had taken a lot of his stuff with him when he left last month. I ran my hands across the remaining clothes—my father's shirts, slacks, and sport coats. Taking the sleeve of one in my hands, I pressed it to my face. I breathed in, deeply. It smelled like my father's Old Spice. A sweet-painful feeling came over me. I hoped silently that he'd leave this jacket here. I heard someone behind me and spun around, scared that I had been caught snooping, but it was only Marie.

She was standing in the doorway, watching me silently. Her face was a mixture of confusion and hurt. She already knew what I knew, in that strange way that twins can pick up on each other's thoughts. Finally she said, "What do you think he'll take this time?"

I shook my head slightly.

"Do you think he'll take his clothes?" Marie asked, walking toward me. "Or the furniture? Maybe even the car?"

Suddenly full of self-righteous fury, I screamed, "Is that all you care about? The stupid CAR?"

Marie looked hurt, and I immediately felt bad because I knew it was not Marie I was mad at. I was just mad, and scared, and I needed to vent. Marie just happened to be the one standing there.

"No!" she said suddenly, her cheeks reddening. Then she added in a little voice, "All I mean is that if he only takes his clothes . . . then that probably means that he'll still come back sometime. That's all."

I looked away from her and said, "He's got two suitcases. How do you think he's going to take the furniture, genius?"

"I know!" Marie said, coming over and standing inches from me. I felt her presence behind me, our bodies almost touching. I didn't turn to look at her. "So that's good, right? I mean, it's not like he showed up with a U-Haul. If he'd had a U-Haul, then you know it's bad news. But, I mean, he wouldn't just up and leave like that! This is his house! His pool! The furniture is his . . . the business, too! People don't just up and leave all of that stuff, do they?"

I shrugged, but Marie carried on regardless.

"No, if he just takes his clothes, then that means that he has to come back."

Marie was trying to sound strong and decisive, but every statement came out of her mouth sounding like a question. I sighed. I thought to myself, People DO just up and leave. He already upped and left. What's going to be different this time? Instead, I said, "You're right. Let's see what he takes."

When Dad came into the bedroom to pack, he placed his glass down on the wooden dressing table without a coaster. I was about to say something, because Mom hated it when he did that, but I stopped myself, realizing that I didn't really care. I watched the glass as it sat there, half full of a watery mixture of Scotch and melting ice, the condensation creeping down the outside, the water stain forming against the wood. Mom always complained that Dad should use coasters, and Dad always said that he forgot. There were little water stains from my father's glasses all over the house. Little mementos of him. Little traces of what once was.

Slowly, my father started taking his clothes off of the hangers. Then he stopped, and turned to me.

"You don't have to watch, Kitten," he said. "Why don't you go play in the pool?"

I shook my head. "I've been in the pool all day. I want to stay here. With you." I didn't know where my mom was. I could hear Donnie screaming and splashing in the pool, oblivious to everything that was going on. Marie was in our bedroom, upset, pretending to watch TV. Daddy packed his jacket, the one that smelled like him. He packed quickly, and I watched how easily the two suitcases swallowed everything that was hanging in the closets. I started to feel an irrational hatred toward those stupid suitcases. He was only taking his clothes. Even though Marie said that was a good thing, I had a bad feeling about all of this. I felt sick deep in the pit of my stomach. Trying to ignore it, I said, "Are you coming back to visit soon? I mean . . . will we see you on weekends and stuff? What about next weekend?"

When my father looked at me, I got scared because he looked different. He looked old, tired, and sad. His eyes were bloodshot, and his face was creased with pain and worry. My father usually looked so handsome, so much younger than all of the other fathers at my school, but today he looked drained, worn out. Like he had aged twenty years. That same look that came over his face when he was sitting in his chair, silently brooding over God knows what awful memory of the war. He turned away again, and picked up the Scotch. He took a long sip, and replaced it on the water ring. Barely looking at me, he said, "Kitten . . . I guess your mom didn't tell you . . ."

The moment he said this I wanted to cry, because I knew what was coming. Whenever Dad said that, it meant bad news. Not just bad news, but the kind of life-changing bad news that hits you with the force of an atomic blast. "I guess your mom didn't tell you . . . Grandpa died," or "I guess your mom didn't tell you . . . we're getting a divorce."

This time it was a doozy, though, and for a moment I thought that I must have misheard him, or that this was all some kind of terrible dream, and I was still hidden away in my bedroom, twisting and turning in a fitful sleep.

"I guess your mom didn't tell you," my father said this time. "I'm moving to Texas."

I stood there, my mouth gaping open but no words coming out. I felt my face flush, and a wave of sickness pass through me. It was a feeling that no twelve-year-old should ever feel. I managed to croak the word "Texas?" back at him. I mean . . . Aunt Evie's house seemed like it was far away. But

Texas? As in the Alamo, and cowboys and stuff? As in a thousand miles away? TEXAS?

"I'm going to start a business," my father said, as if somehow this was the most rational thing in the world. "I going into the eight-track-tape business. There's good money in eight-track tapes. I think the eight-track has a big future . . ."

What was it Marie had said? People don't just leave their homes, their businesses!

"What about the dress shop?" I stammered, cursing myself for not saying what I really meant, which was "What about US?"

"Your mom can handle the shop just fine without me. You know your mom— she always wants to be the one who wears the pants in the family. And you know I don't go for that kind of news, Kitten." His voice got harder and dripped with resentment when he said the next part: "I don't want to talk bad against your mother, Kitten . . . But I guess now she's got what she wanted all along."

I opened my mouth, and then closed it again. I realized that there was nothing to say to my father anymore. We were finally beyond words. He'd come to collect his belongings, and now he was going to leave and move to Texas, and there was nothing in the world I could do about it. He knew that when he showed up today with those empty suitcases. The divorce was going through, there was no turning back. Sure, it would be months before all of the paper- work was figured out, but for all intents and purposes, when my father walked out of the house today with his suitcases full of clothes, leaving nothing but an empty closet and some water stains to remind us that he was ever there, the divorce would be final. Inside I was screaming. I could feel the tears welling up inside of me, but somehow they would not come out of my eyes.

"It's not the end of the world, Kitten," he said weakly. I wanted to scream at him. I wanted to scream that it was WORSE than the end of the world. Much worse. If the world ended right now, I would be fine with it. One huge BOOM and it's all over. But this? This is going to hurt for the rest of our lives!

My father continued packing, unsure and unsteady. Opening drawers then closing them absently without taking anything out. "Kitten," he said meekly, "please go play . . ." I silently turned, and walked out of the room in shock. In the bedroom, Marie was watching the TV with the sound turned down. I

knew that she heard every word my father and I had said. Her face was glacial, blank.

"Stupid Texas!" she said finally, her voice wobbling. "This whole thing stinks! Divorce shouldn't be allowed!" Then she got up and stormed out of the room, slamming the door behind her.

I walked slowly over to the window. The sky was still perfect; it was another beautiful sunny day in Southern California. You stop noticing the weather after a while. Even perfection can become routine. Today it should have been snowing. Or raining. There should have been lightning, and the rumble of thunder, or hailstones the size of golf balls battering against the glass. But there was none of that. There was just the sunlight, and that terrible, endless sky.

In half an hour, my father was gone. Even Donnie knew now, although he probably didn't grasp the enormity of what was going on. My father hugged us all at once, and we cried together. When my father held me close, I could smell his aftershave, and could feel wetness on his cheeks. The only other time I'd seen tears in Daddy's eyes was when I was four years old, the day Grandpa died. He tried to say good-bye now, but it came out as a choking sob. We held on to him, trying to keep him from leaving. We held on for dear life. He dragged us to the door, having to pry our hands from him, tears in his eyes. Eventually he had to call our mom and say, "Marie, can you help me, please?" We clung to him, screaming, and crying, and pleading with Daddy not to go. Mom came over and started pulling our hands off him. He gave us one last long, tearful look and then disappeared. The screen door closed behind him, with a terrible, final bang.

As I turned away from the door, I noticed a space on the wall where a picture used to be. A picture of all four of us kids. Besides the clothes, that was the only other thing he took with him. I realized just how wrong Marie really was. He only took his clothes, not because he was coming back, but because he wanted to leave everything exactly as it was for us. He didn't want anything to be missing from our lives. Nothing, that is, but him.

That night I lay in bed, the tears frozen on my cheeks, with my headphones on, listening to my music. The guitars swirled and cascaded in my head. I tried to listen so hard that I could disappear inside of the music. I knew that something fundamental had changed today, that nothing would ever be the same again. I felt so empty inside. Everything I knew had been taken away

from me, everything that seemed so solid, and real, and warm . . . I realized
that there were no guarantees in this world. Who or what could I trust in
anymore? I turned the volume up, more and more, until the music was so
loud and powerful that it battered against my ears and there was nothing to
do but give myself up to it, surrender to it. I wanted the music to make this
terrible, empty feeling go away. When I concentrated on the music hard
enough, the fear and the loneliness disappeared. I was in a place where there
was nothing but the music. Just the pounding, glorious, primal beat of the
drums, the dizzying roar of the electric guitar. . .

As the last note rang out across the Universal Amphitheater, the
lights began to go up, signaling that this really was the end of the
show and there would be no more encores. My whole body was vi-
brating with an energy that felt like the aftermath of being struck by
lightning. All of a sudden we were bathed in the fluorescent glow of
the houselights, and we saw each other again—a sea of kids, bathed
in sweat, makeup cracked and running down our faces, the smell of
stale marijuana smoke and spilled beer everywhere . . .

I didn't want it to be over.

I realized that the rest of these kids would be content now to go
home, resume their lives, having let out a little of the pressure that
had been building inside of them. Now they were not afraid that their
skulls were just going to blow apart like a forgotten World War II
land mine. But not me! I knew that this would never be enough: I
needed more than that. I looked toward the stage, where people were
reaching out to the roadies as they pulled away the wires on the stage,
begging for a memento, a torn fragment of a set list, any smidgen of
tonight at all to take away and keep.

But mementos were not enough for me. Even Daddy's water stains
would fade away over time. I didn't want to go back to my lonely,
ordinary reality. I wanted something more . . .

That night I was changed, altered in some profound way, and I
knew that I would never be the same again. Marie and Paul could
not see it as we headed back to the car . . . I felt totally different from
what I had been before. Even when I was back at home, wiping away

the remains of my makeup in the bathroom mirror, I could not see any physical manifestations of this change. But I could sense it, a glow inside of me that was growing with each passing moment.

Was this what all of those religious types were talking about when they said they had been born again? I guess that must be it. All I knew was that something was going to happen, and it was going to happen soon.

I could sense it!

2

Rebel, Rebel

"Bh jeez, Cherie. Seriously . . . Mom is gonna kill you!"

My sister was half laughing as she said this. I rolled my eyes and mimed "whatever" at her. I was chewing gum as I stared at myself in the mirror. I pursed my lips and exhaled, and a large pink bubble formed, growing, growing, growing, until it popped.

I was fifteen years old, and back then my life consisted of rock concerts and hanging out in coolest nightclubs in Hollywood. Specifically the Sugar Shack and Rodney Bingenheimer's English Disco.

And today, with my horrified sister's help, I was dying my hair red, white, and blue.

"Very patriotic." My sister laughed when I told her what I wanted her to do. "But it ain't the Fourth of July. It's only May!"

"I'm serious. Are you gonna help me, or what? I can't do it by myself . . ."

Marie started mocking me in a whiny voice: "I can't do it myself, Marie!" I scowled at her, but she did get up off the chair and led the way into the bathroom. There, she took a look at my head, deciding on the best plan of attack. She separated a small portion of my hair and started braiding. "If we do it in sections, at least it might look half decent . . ." She sighed. I had to admire Marie. It had to be hard on her to see the changes I was going through. Once the braids were in place, she took one last look at me to gauge whether I was kidding. She could see in my eyes that I was not. She shook her head.

"Mom is gonna KILL you, Cherie. She'll freak."

"She's so busy with Wolfgang she probably won't even notice . . ."

"Yeah, right! She'll notice THIS!"

"Come ON, Marie. Help me out! You know I'm going to do it anyway . . ."

Equipped with red and blue food coloring, she squirted the runny ooze into the sections that she had skillfully braided through my long blond hair. Marie started rubbing this slimy, red gunk into one third of my hair, wearing a pair of Mom's rubber gloves. Of course, my sister didn't want to mess up her perfect nails. Sometimes I couldn't believe that we were twins.

When she started rubbing the blue dye into the next section, Marie said, "I don't know if this stuff will ever come out, Cherie." She was looking at my multicolored hair, frowning with concern.

"So what?" I smiled. "It's only food coloring. If it doesn't come out, I'll bleach it out."

That silenced her for a few moments. She carried on, shaking her head at me.

"Is this all about those jerks in school yesterday?" Marie said to me, her voice softening. She still seemed to think that she could talk me out of going to school with multicolored hair. "I think you're over-reacting to this whole thing, Cherie."

I stared at her for a moment. "For your information, I am NOT overreacting. I'm REACTING. That's different. It's important to react when you're pissed off."

The incident happened the day before. I was watching these creeps harassing this seventh grader for stepping on the ninth-grade lawn. Those ninth-grade punks would pounce if you were caught cutting a corner of their precious lawn. The poor kid looked about ready to pee in his pants. They were shoving him around and laughing at him. "Hey, freak!" one of them yelled. "Nice glasses! You steal 'em off of Mr. Magoo?"

The kid just took it. He was scared stiff. Then the ringleader grabbed the glasses right off of his face, and threw them on the ground. He got right up in this kid's face and yelled. "YOU'RE A FREAK!" he taunted. "A FOUR-EYED FUCKING FREAK!" He gave him one

last shove before upending him into a garbage can. He and the others stood around laughing like a pack of jackals. I went to help the poor kid out of the trash, dusting him off a little. He was crying. "Come on," I said softly. "Lemme help you get your glasses . . ."

Suddenly I was shoved from behind. The ringleader was bearing down on me already. "Whatcha helping this FREAK for? Huh?" Then he turned to the rest of his cronies and said, "I guess she must be a freak-lover BITCH!"

As soon as he shoved me, I felt the anger rising in my chest. That feeling, like a red cloud was descending over my eyes as the rage began to pump through my veins, setting my heart off on a skittering, pounding rhythm. I clenched my fists till my hands shook.

"You're calling *this* kid a freak?" I screamed. "I'll show you a REAL freak!"

The kid started backing off, startled by my outburst, and the smile slid from his face. Thankful that the attention was off him for the moment, the kid I'd helped out of the garbage started hunting around for his glasses. The bully sneered at me, shrugged, and took off with the pack of wolves he was with. I watched them go, fuming. I had to show them! I mean, they can't call this poor kid a freak just because he wears glasses! No, I had to be true to my word. Tomorrow these idiots were going to see a real freak, all right!

Marie put down the blue coloring. She noticed that some of it had got on her pants. "Shit, Cherie, look at this! God*damn* it!"

"Oh, chill out." I laughed. "And tell me how I look!"

Marie shook her head. "You look awful. Really, really awful."

"Good!"

She held up the mirror so I could get a good look at the back of my head. "You did a great job," I said, admiring her work. "You could do this for a living . . ."

With my hair done, I went back into the bedroom and started picking out my outfit for tomorrow. The bedroom was divided neatly into Marie's side and my side. You could tell which was which within seconds of walking in. Her wall was nice and neat, with a few black-light posters on the wall that were so "in" back then. On my wall . . . well, there *was* no wall; there was nothing but an endless collage of

magazine cuttings and newspaper clippings on David Bowie. The collection ran floor to ceiling and it was beautiful, my pride and joy. I'd memorized every single line of every article. I'd memorized every angle of his devastatingly beautiful face.

I settled on the most mismatched outfit I could find. A pair of old shredded jeans and my Diamond Dogs Tour T-shirt, topped off with a jacket that totally clashed with it. On the floor was my newest obsession: a pair of red platform tennis shoes. These babies had more rubber than the Goodyear Blimp, and made me a good four inches taller. They cost forty dollars. Or at least they would have cost forty dollars if I hadn't stolen them. It was a piece of cake: I told the girl I wanted to try them on, and then sent her into the back room to get me something in a different size. By the time she had returned, I was halfway around the block, with the shoes stuffed under my jacket.

Marie was standing in the doorway, watching me get dressed. "The teachers are gonna have a field day with you," she said, shaking her head.

I shrugged. "They live with it," I told her. I stopped and looked at myself in the mirror. The image was good . . . but there was still something missing. I went to my dresser and grabbed some fluorescent makeup pencils. I walked over to Marie and dumped them in her hand.

"Okay, last favor. Tomorrow morning, just before we leave for school, I want you to draw a big red-and-blue lightning bolt across my face. Just like the cover of *Aladdin Sane*. You'll do that for me, right?"

"Come on, Cherie. You're taking this too far . . . !"

"Will you do it or not?"

Marie sighed, but she didn't say no.

Yeah, I wanted to make a point, but it ran far deeper than that. Seeing the abuse that poor seventh grader endured had sparked a recent memory that had haunted me every day since. A few months before, I had come face to face with the most notorious bully in the school. Her name was Big Red and she was the meanest kind of bully, plain and simple. She had bright, wavy red hair: that's why they called her Big Red. I got the feeling that she liked it . . . that having

a nickname like that made her feel big and important. Still, nobody dared call her "Big Red" to her face unless you were one of her goons or followers. Our first encounter was during my freshman year. One day after Phys. Ed. she and two of her goonies came up to me in the locker room. I was in the middle of changing, and all I was wearing was my shorts. I didn't see her at first. Though I could sense something was off, like you would an impending storm, a gut feeling of a disaster looming in the distance. My eyes slowly and instinctively rose from my locker and there was Big Red, the hulking great she-bitch who had been terrifying the smaller kids all semester.

She closed my locker. "I heard you ain't afraid of me," Big Red said, in a voice dripping with threat. Her two crooked cronies' laughed in time, chomping at their gum, sneering wickedly at me. For a moment I thought how I never saw Big Red alone. She was always with her goons. It occurred to me that maybe she was afraid. Afraid what the kids would do to her if they ever caught her alone.

I just looked at her confused. Up until this point, I hadn't said anything to anybody about Big Red. Up until this point, I had only heard the stories and saw the tears and the terrified sobbing faces of the kids she had scared the crap out of. Up until this point she had only been throwing her weight around with the other kids. I had just been ignoring her, hoping she would leave me alone.

"You deaf or something?" Big Red snarled, when I just stood there looking at her. I put my hands to my chest trying to cover myself. I shook my head no.

"Well I heard that you ain't scared of me. That you're real brave, huh Cherie?"

"Why would I be afraid?" I said meekly, "I don't even know you . . ."

Without another word Big Red backhanded me hard across the face. Everybody in the locker room stopped, and the sound of knuckles against flesh echoed around the room like a gunshot. I flew backwards, over a bench, and ended up flat on my back. "Haw! Haw! Haw!" laughed Big Red, as all of her cronies joined in. "Haw! Haw! Haw!"

I stood up, obviously shaken. She didn't miss a beat. She pointed a

finger into my face like a harpoon and her mouth was so close to me I could feel her breath. I turned my head. "You BETTER be afraid, you little BITCH!" She sneered. "Next time you'll be afraid!" She poked me hard in the chest, then she smiled and I could see her red lipstick smeared across her teeth. She looked around the room. Everyone looked away and then, like a monster in a horror movie, she was gone. I was left standing there, half naked, paralyzed with fear. I could feel my body tremble violently until I crumbled in tears. The silence was deafening and only the sound in that packed locker room were the wailing echoes of my sobs.

As I walked toward Mulholland Junior High, the catcalls started before I had even made it inside the gate. As I walked down the corridors, past the lockers, I felt a hush fall over the whole building. People stopped talking and turned to openly gawk at me. I walked past them all, looking down my nose at them.

"Nice hair, Cherie!" someone yelled as I walked past. "D'you get mugged by a circus?"

I kept on walking, flipping the kid off. Everybody had something to say to me today. "Your hairdresser have a psychotic episode, or somethin'?" "What happened—can't afford hair spray anymore, so now you're using spray paint?"

I didn't even make it a minute in Mr. Thomas's first-period history class. He took one look at me and sent me straight to the dean's office. I liked Mr. Thomas. He was a gray-haired, middle-aged ex-Marine-looking type of a guy. He kind of reminded me of my dad. He seemed to understand that I was going through a pretty rough adolescence, and although he would never come right out and say it, I felt like he really did care. Out of all my teachers, he was easily my favorite.

The dean took one look at me and sighed. "Okay, Cherie," she said. "Would you like to tell me what's going on?" I gave her some ridiculous story about how I volunteered over at Encino Hospital, and how the outfit was for some special event we were doing there after school. Amazingly, she believed me. In fact the dean, principal, and

the rest of the school staff bought it hook, line, and sinker. The story worked so well that they told me that if things "got out of hand" with the other kids, they would release me early from school, "just this one time." Very nice of them! Now I could keep my promise to those dumb-ass bullies, *and* cut out of school early . . . all compliments of the Mulholland Junior High staff.

It went on like that all morning. Teachers pulled me aside to ask me if everything was all right at home. I just chewed my gum and gave them my best thousand-yard stare. When I sat down to eat lunch, it got worse. The catcalls, and the laughter, and the snide comments . . . "Nice shoes! Can you dunk a basketball now?" "What's with the face? Is it a rash, or did a graffiti artist mistake you for a wall?"

The thing is, I wasn't angry. Not really. The more they laughed, the more they stared, the better I felt. The more powerful I felt. Everybody in this cafeteria knew who Cherie Currie was! The more they took notice, the greater was my victory. I turned around and looked for the kid with the glasses who they'd called a freak yesterday. He was sitting by himself at a distant table. I walked over there and sat down right next to him. As I sat down he just stared at me, his mouth hanging open. I don't know if he even recognized me. Maybe he thought I was about to beat him up or something. Instead I smiled and said, "Aren't those guys creeps?"

He nodded quickly and said, "Yeah!"

I leaned in and said, "They're always ragging on *normal* people like us!"

He laughed a little at this and started to relax, cautiously. He still couldn't stop staring at me, though.

"Did it cost a lot of money?" he asked eventually. "I mean—uh—your hair?"

I shook my head. "Not a penny. I like your glasses."

He got a little red in the cheeks and looked away. "I hate them," he said quietly. "I keep asking my parents to get me new ones but they won't."

"I like 'em just fine," I told him. Then I leaned in again. "Listen—if any of those creeps bother you again, just tell me, okay?"

He nodded, looking a little unsure.

"I mean it. I'll beat the crap out of them for you, okay?"

"Okay."

I could still hear the creeps laughing, right behind us. It didn't matter: I'd made my point. Let them laugh. Its not like it was me they were making fun of. It was the creature that I'd created. The Cherie-thing. It hurts to be laughed at when people are laughing at *you*. I know what that feels like . . . like when Marie's preppy friends would tell me to buzz off whenever I tried to hang out with their little clique. Oh yeah, that hurt a lot. But I could take it if those creeps laughed at the Cherie-thing I had created, because it wasn't really *me*. The real Cherie, the Cherie who gets afraid and embarrassed and hurt, was safely locked away. She was somewhere deep inside of me, in a place where nobody could hurt her. Now I was bigger than *them*. And I had already made a conscious decision not to be afraid of anybody anymore.

When the lunch bell rang, everybody started to leave. The kid with the glasses sitting next to me hurried off in an effort to avoid the bullies who always picked on him. I took off, too—straight out the back gate. Outside of the school, I pulled a cigarette out of my pocket and lit it. I smiled to myself—today was a pretty good day. I'd made my point, all right.

I had my cigarettes, and I had my music, and that was quite enough for me, thank you very much. I'd had enough of school for one day. Anyway, tonight I was heading to Rodney's with Paul, and I didn't want to blow my mood by hanging out with a bunch of creeps. I scrunched up my eyes against the blazing, midafternoon sun. School was hell, but when I was fifteen years old, Rodney Bingenheimer's English Disco was my idea of heaven. Back then, the glam-rock scene was the only place where I really felt at home in my own skin.

Crushing the cigarette under my platform soles, I exhaled a great plume of gray smoke and stormed away from the constraints of Mulholland Junior High, back to the only life that meant anything to me.

3

The Queen of Hate

I was in my bedroom with my headphones on, listening to *Diamond Dogs* again, the music cranked as high as it could go. After seeing Bowie perform these songs live, every note, every line, had taken on a bigger, more profound character. I found myself paying special attention to the instrumentation, to the inflection of Bowie's vocals. The music was providing a clue, a map to where I wanted to go. I sat on my beanbag chair, floating high above my body, transported out of myself by the glorious noise in my head.

My mind was wandering, far from the math homework I was supposed to be working on. I am thinking about a kid named Byron Friday, who was also in the first year of junior high. I had fallen hard for Byron, although he didn't even acknowledge my existence, apart from the occasional casual hello coming in or out of class. Byron was a handsome kid, blond and tanned, with shiny golden hair cut in layers to just above his shoulders. Byron was quiet, introverted, a mystery man on a skateboard. Sometimes I'd see him when we were on lunch break, whipping figure eights in the back parking lot or popping wheelies on his bike where he wasn't supposed to be. I wondered if this was what they meant when they called someone a rebel. I wasn't sure, but I knew that when I looked at him whizzing up and down the asphalt, I'd get a shiver that ran throughout my entire body.

I hadn't told anybody about my crush on Byron, not even Marie. But sometimes, when I was all alone like I was that night, I had this

recurring fantasy about Byron and me. In this fantasy, it was a week-end, and Byron and I were having a picnic on the school lawn while nobody else was around. Byron would give me this look, and smile his cute, crooked smile, and I'd realize he was going to kiss me. He'd reach his hand out and touch my face lightly, slowly moving his lips toward mine . . . I'd get this wonderful, butterfly feeling inside when I'd imagine our lips touching. I wondered if this was what falling in love felt like.

A sharp banging noise that cut through the music in my headphones finally disrupted this fantasy. I didn't even hear him at first, knocking lightly on the sliding door leading from the backyard to my bedroom. Didn't see his silhouette, stark against the fading light outside.

Mom was out to dinner with Wolfgang. Marie was at the movies with her friends. Donnie was sleeping over at a friend's house. I didn't even know when they were supposed to be back. Marie said maybe ten o'clock, but that didn't mean anything. I was enjoying having the place to myself. I had my homework laid out before me and it wasn't until Derek banged louder on the glass that I finally looked up from my books and saw him standing there. He was yelling something, his mouth twisted up.

Oh, yuck, I thought, what does this jerk want?

I took off my headphones and clicked off the record player. I could hear him through the glass: "Hey, Cherie! Let me in!"

"Marie's not here!" I yelled back at him.

He shrugged his shoulders and raised his palms up to the sky as if to say, "So what?" I shook my head at him and picked up the head-phones again.

"Cherie, come on, I just wanna speak to you for a second!"

With a sigh, I put the headphones down and crept barefoot over to the door. I looked at him and wrinkled my nose. He was dressed in his usual uniform of skintight torn blue jeans and a filthy-looking Led Zeppelin T-shirt. Derek's dark shoulder-length hair looked dirty, and when he smiled his ugly smile, you could see yellow crooked teeth poking through his thin lips. He wasn't Byron Friday, that's for sure. I unlocked the door and opened it a crack.

"I said Marie's not here. She's out."

"Lemme in, Cherie," he said, putting his mouth up against the opening. "I'm freezing out here!"

"No!" I spat. "Go away!"

Derek weirded me out, and the idea of being alone with him was not something I would ever consider. He was a real sleaze: when he and my sister were together, he was always pawing at her, trying to snake his hands up her skirt or down her top . . . like a fucking dog in heat! I could never understand why Marie put up with him, car or no car. Even worse, whenever he was here, and Marie went out to bring him a beer or something, I'd catch him staring at me with those dead insect eyes of his. He'd look at me a certain way, and it was as if those liver lips of his would get wetter and mushier. *Ugh!* If I'd get up to leave the room, I would feel his gaze on me, running up and down my body, appraising me. I could almost hear his breathing get labored.

I was about to shut the door and lock it again, but he slipped his fingers through the crack and said, "Just for a second? C'mon! I just want to wait and talk until Marie gets back."

"I'm doing my homework!"

Ignoring me, he wrenched the door open and squeezed more of himself inside. I backed off instinctively. I took a few steps away from him, and now Derek was standing in my bedroom, staring at me. He pulled the door closed behind him.

My heart started to beat faster. It was like his very presence had sucked the life out of the room. He was just standing there, looking at me with that vile grin of his. His eyes going from mine, traveling farther down my body, making me feel small and uncomfortable. With a blush I realized that I was standing in front of him wearing nothing but a nightshirt and my underwear. I felt burning heat prickling on my cheeks. Oh God!

Derek was always ugly, but there was something even uglier about him tonight. He looked disheveled. Sweaty. Like he had been up for three or four nights drinking. I could smell the booze on him, wafting over to me like the sickly sweet smell of a freshly painted room. His clothes were dirty and wrinkled. His hair seemed greasy. His face sweaty and that big, bulbous Italian nose of his looked red.

Oh God, oh God, oh God.

Suddenly everything that Marie had been saying about Derek over the past few weeks flooded back to me.

I think he's been following me.

I'm serious, Cherie, he really freaks me out.

Sometimes he scares me.

Something in his eyes.

He's CRAZY, Cherie.

My mouth suddenly went dry, and with a lightning bolt of realization, I knew that I was in danger. I looked to Derek for clues, but he looked away from me and started walking around the bedroom, making himself at home. He walked over to my beanbag chair and picked up the headphones. He put them on and asked, "So whatcha listening to?"

"Listen, Derek," I said in a voice that sounded a lot more confident than I actually felt. "No one's home. I can't have you in here! I promise, I'll tell Marie you came by, okay? But I want you to leave now!"

But Derek wasn't listening. He looked over to the turntable and muttered, "Oh yeah. You like Bowie. He's a faggot, you know . . ." Then he took the headphones off and let them drop to the beanbag chair again. "Marie told me you liked Bowie. I can't stand that shit. He ain't a real man. What kind of a man wears fuckin' makeup?"

I watched him as he walked around the room, surveying everything. He'd randomly pick up a book, or a record, and look it over. Say something dumb, like "Algebra, huh? I useta hate algebra. I dunno why they make you learn that shit." Touching everything. Putting his hands on my stuff. I wanted to tell him to fuck off, but I didn't have a voice. I knew that if I tried to yell at him right then, it would come out as a dry squeak.

Then he stopped, and looked at me with a curious expression on his face. "You look exactly like your sister," he said in a strange, melancholy voice. "I just can't get over it."

I didn't answer him, afraid that anything I might say would cause him to lose it with me.

He leaned forward a little, and added in a hoarse whisper, "Are you . . . *completely* identical?" When he said this, he glanced down at my crotch, lifting his eyebrows then bringing his eyes to mine.

His physical presence scared me. At the Bowie concert, I'd felt su-perhuman. Back then I felt like I was eleven feet tall. But now, with Derek standing only feet away from me, I felt like what I was: I felt like a fifteen-year-old girl who was about to pee her pants out of sheer terror.

Please, leave me alone! my mind screamed. But my mouth did nothing; I just stared at him with wide, uncomprehending eyes.

What time is it?

Is it ten yet?

Fear and rage were building inside of me. Not so long ago I was on top of the world, the glitter queen, invincible and tough. Now this ugly, sweaty creep in bad need of a shower was standing in my bedroom, touching my things. Why wouldn't he just *leave*? But more than the anger was the fear. If Derek had pulled out a gun on me right then, I wouldn't have been surprised. I knew he was unstable. Forc-ing your way into someone's bedroom and refusing to leave wasn't normal behavior, was it? Derek was crazy, no doubt about it.

"Whatcha afraid of, Cherie?" he said, smiling at me, revealing a terrible glimpse of teeth. "You don't have to be afraid of me! I won't hurtcha!"

A mad part of me was desperate to believe him. But I didn't, not really. I was more afraid than I had ever been my entire life. He looked at me like a hungry dog.

"Stop looking at me!" I snapped. He didn't listen to me, though. He continued to stare, looking right through me. I felt like he could see right through my nightshirt. I felt totally embarrassed, humili-ated, and terrified all at once. What the hell did Marie ever see in this creep?

When I was ten, my dad spanked me. I remember this clearly be-cause it was one of the only times he ever did that. He caught me kissing a kid called Winnie, who used to live right down the street. Winnie was kind of a feral child; the others even called him Winnie the Wolf. He was always prowling the streets alone, and we never really saw his parents much. The house he lived in was run-down and shabby. He used to dress real scruffy, and was notorious for being a bad kid, and everyone in the neighborhood knew it. He would walk

right into other kids' front yards and beat the shit out of them for no reason. Right there, with the kids' parents screaming bloody murder and running out of the house threatening to kick his ass. But Winnie didn't care, and Winnie's parents didn't care, and for some strange reason I kind of liked Winnie. Winnie didn't fit in either. The difference between Winnie and me was that Winnie was incapable of caring to fit in, and I guess for some strange reason I found that intriguing.

Winnie the Wolf was the first boy who ever kissed me. He tasted of bubble gum and cigarettes, and I didn't really like it, but it was a strange enough sensation that I thought about it for a long time afterward.

I had been friends with Winnie for a while; I had smoked my first cigarette with him. It was a Sunday and I was standing on the corner with Winnie when we pressed our lips together and kissed. I'm not sure why we even did it. It wasn't a real kiss—we were just kids imitating what we saw on TV. Our lips were tightly closed, and we just wiggled our heads from left to right in an imitation of passion, not really understanding what we were doing. Suddenly I heard my dad yelling "Cherie!"

When my dad turned the corner and yelled, he gave Winnie a look scary enough to make him split immediately. "I've been looking for you," Daddy said in that low voice he used when he was mad. "You're late for church!"

I started crying immediately. I knew from the look on my dad's face that I was in a whole heap of trouble. He grabbed my hand and we started back toward the house. In a small voice I asked, "Am I going to church now, Daddy?"

"No, Cherie. You're going to wait at the house. I'm going bring Mom, Marie, and Donnie over to the church . . . I'll deal with you when I get back."

Terrified, I started begging Dad to let me go to church. I was a good little Catholic girl. I had swallowed all of the stories of guilt and passion and sacrifice and damnation without question. I wanted to go pray for my immortal soul, because I had kissed a boy. I wanted to beg Jesus for forgiveness. But Dad wasn't listening. He brought me to the house and told me to sit in the corner and wait for him. Grandma

offered to stay behind with me, but Daddy said no, which made me even more terrified. Grandma was so sweet and softhearted that she would tremble and cry whenever we had to get a spanking. I guessed that he didn't want Grandma to have to see it. I sat there, shaking and crying, a horrible desolate feeling inside of me. Daddy left, and the whole time that the family was gone I didn't move a muscle. I sat there; the only movement I made was the jerky heaving of my shoulders as I cried. I heard the car pulling into the driveway after a while, and felt my stomach go to knots. When Dad walked into the living room, he was carrying the paddle.

I'll never forget that paddle. Mom had brought it back from a trip to Mexico: it was a little wooden paddle with a hand-painted image on it, of a guy in a sombrero spanking three red butts that were sticking up in the air. I thought it was funny when she first brought it back, right up until the first time she used it. As soon as I saw the paddle, I began to cry and beg Daddy not to do it.

Daddy looked straight ahead. I had never seen my dad like this. Then, without a word, he put me over his knee and spanked me. Looking back, I suppose it didn't hurt so much, but the fact that I had disappointed my dad so much really *did*. I never forgot that. The memory is as fresh today as it ever was.

When he was done, he stared at me, his face a mixture of sadness and regret, and he said, "You stay away from that damned kid, Cherie, he's bad news. *I mean it, Kitten!* Stay away!"

I was bawling, snot running down my face, hysterical, and I asked, "Why, Daddy? WHY?"

"Because I said so!"

After that, the subject of Winnie the Wolf was never raised again. I don't know what happened to Winnie the Wolf. The family moved away and that was that. But now, with Derek staring at me in that creepy way, the memory came back to me, because for the first time in my life I realized exactly why my dad had spanked me. Because there is a certain type of person in this world, a type that has something black inside of their soul. Like Winnie. Like Derek. But Derek was somehow WORSE than Winnie the Wolf. Derek was what Winnie would grow into. Something not quite normal. Something more

monster than man. My cheeks reddened as I remembered the way that Winnie's lips felt against mine. I felt nauseous. I wished I had never kissed him. I wished that Winnie the Wolf were dead. Winnie and Derek both. I looked up at Derek, looked right into that red, ugly face. I wish I could kill them both myself, I thought. I wish I had the guts!

"Marie told me," Derek said in a deep, phlegmy voice. He started to walk toward me, purposefully now. Like his mind was made up. "She told me . . . you were a virgin."

I didn't know where to look! I couldn't believe what he was saying to me. I felt so embarrassed, so small, so damn scared. He reached out a hand and grabbed me by the arm.

"So pretty," he said. "And fresh. I like girls who are fresh."

I jerked my arm away. "Get away from me, Derek!"

"What's the matter?" He smiled. "You don't want a real man?"

Marie and Mom will be home soon, I thought to myself.

Very soon.

They'll walk in the door together, and Derek will run.

Very soon.

Please.

Please come home.

Please . . .

I kept saying this as he came closer. Closer. I kept saying it as he grabbed me again, this time using both of his hands to clamp my shoulders tight. He put his face real close to mine, and I could smell his stinking breath as he said, "You'll like it, I promise." I tried to struggle, but he was bigger than me and stronger than me and he started pushing me toward the bed.

Please . . .

Please . . .

I kept saying this as he shoved me back onto the bed, sweeping my stuffed animals aside, and placed a sweaty palm over my mouth so I couldn't yell. Stupid bastard! Couldn't he see that I was so scared that I couldn't yell if I tried?

He put his face close to mine. Too close for anyone to get. I could smell his breath. Cigarettes and stale booze, rot and decay. He was still smiling that idiotic smile.

"You're gonna like it. You're gonna thank me for this, I swear . . ." I closed my eyes. I could feel his hot breath against my face. I struggled furiously, but he pressed his hand against my mouth so hard I couldn't breathe. "I have a thing for virgins," he was saying from some faraway place. "Come on, Cherie . . . It won't hurt. You'll like it . . . I promise . . ."

I could feel my nightshirt being pulled up, and his free hand pulling my panties down roughly. He had his whole body weight pressed against me now, and as I struggled it became harder and harder to move. "Get . . . off . . . me . . . Derek!" I screamed. "Get . . . the HELL . . . OFF ME! GET OFF ME! GET OFF!"

I could feel it pressing against me. His *thing*. I could feel him rummaging around down there, unzipping himself, and he was breathing into my ear. "Stop fucking struggling, you're gonna like it . . . you're gonna *thank me,* now stop . . . fucking . . . struggling!"

Then he brought a hand up to his mouth and spit against his palm. He forced the hand down between my legs, smearing the slime on me. I could feel his thing pressing hard against me. Oh God. Oh God, this just can't be happening.

When he pushed into me, I screamed. I had never felt pain like that. It was the most horrible piercing pain, and it emanated from deep inside of me. Like I was being torn open. He was thrusting into me, grunting into my ear each time he did. I literally went crazy . . . Finding strength I never knew I had, I started beating against him with my fists, and letting loose a scream from the very depths of my soul.

I was operating on pure instinct. All I could think to do was to hurt him so bad that he would get off of me. I started ripping at his hair, tearing it out of his head in clumps, scratching at his eyes, punching him. He tried to grab my wrists to make me stop, but there was no chance! I screamed, and beat against him, and tried to tear his flesh right open. In a frenzy, I managed to hurt him enough that he jerked back for a moment, and that fucking grin finally left his lips. As he pivoted back, his *thing* slipped out of me, and this gave me the leverage I needed. I brought my knees up to the fetal position and managed to shove them against his chest, pushing him back. Suddenly Derek, the aggressor, the bully, and the monster, was yelping like a kicked

dog. I could see the bright red scratches across his face, the blood spotting where I opened up his skin. And the look on his face! Total and utter incomprehension. He staggered away, wrenching the sliding doors open and running for his life into the darkness, his pants still hanging half off him.

"GET THE FUCK OUT! I'LL KILL YOU, MOTHERFUCKER! GET OUT OF HERE! GET THE FUCK OUT!"

I was ready to kill. I had never, ever felt anger like that. I was shaking with fury and I could feel the anger and the pain and the adrenaline coursing through me. But Derek was gone. I had beaten him off.

I staggered over to the door, sobbing hysterically, and pulled it closed, snapping the lock back into place.

Snip.

Snip-snip.

I watched my hair fall to the bathroom floor, little blond tufts, little amputated parts of myself. Did I feel sad? Happy? I didn't know. I didn't know what I felt, apart from angry. I felt very angry, but I suppose I had always felt angry.

Snip.

Snip.

I felt hate. *Hate* is a powerful word; I liked the way it felt on my tongue. *Hate.* It's a hard word, like a punch to the mouth. It leaves a taste of copper in there after you say it the right way. HATE.

I thought about the blood that drip-dripped down my legs, and the deep, searing pain Derek left behind. Oh God, he hurt me. He hurt me real bad.

Snip.

Off came another lock.

Derek liked them young, young and fresh. That's what he told me. That's why he told me he was doing it. Young and fresh. Just like I was. Just like I was before that night.

When Marie found me and I told her what happened, we made a decision not to tell Mom. Mom didn't even know about Derek, and how could I talk about something like this with my mother? And

even if we called the cops, I knew what Derek would say—that I had let him into the bedroom. If a girl lets a guy into a bedroom, then everybody knows that she was asking for it. Right? The only thing I could think of that was even worse than what just happened to me was the idea of everybody knowing about it. I could just imagine what they'd say, what they'd whisper about me behind my back. No, this had to be our secret. My secret. I decided that I would go to the grave without ever telling another living soul about what happened with Derek.

In the weeks that followed the rape, I would discover that Derek had not only taken my virginity, he'd also left me a memento—a fucking infection. My mom had to take me to the doctor, which was a totally embarrassing experience. She never asked how I got it; I guess she was trying to be all cool and modern or something. Of course, I never told her what had happened.

But that was all still to come. That day I'd made a decision. That day I'd decided that I wasn't going to be told what to do anymore, and that nobody was going to just take what they wanted from me. That day I'd realized that there are only two types of people in this world— the people who do the DOING, and the people who have stuff done to them. I knew which I wanted to be.

Sitting on the edge of the bathtub, with Mom's sharp, shiny scissors in my hand, I took another strand of hair and placed it between the blades.

Snip.

I knew that when I walked into school the next day, they were all going to know how I felt. They were all going to feel the hatred radiating out from me. Good. Fuck 'em! I wanted to take this hate that was inside of me and shove it down their fucking throats. Make them choke on it.

As the pile of hair on the floor grew bigger and bigger, I found myself feeling stronger and stronger. When I walked into a room from this moment on, everyone was going to know that Cherie Currie was here. All of the Winnie the Wolfs of this world, all the Dereks of this world, all of the kids in school who thought they were tough . . . All

of the jocks and the snobs and the dweebs! I wanted them to fear me, to know that you do not fuck with Cherie.

No more wimpy surfer Valley girl.

No more pretending.

If I was going to be the glitter queen at night, then that's what I'd be during the day as well. No more trying to fit in: if they didn't like it . . . tough shit.

Snip.

If they hated it, good! If they laughed, I didn't care. I'd give them more. If they thought David Bowie was a faggot and a weirdo, good. I'd be so fucking weird they won't know what hit them. They were gonna get all of the hatred I felt inside shoved right in their stupid faces.

Snip.

Snip.

I looked into the mirror. I had done a fine job. Ugly, beautiful, just like David Bowie. I felt exhausted, like a great weight was lifted right off of me. Now all I had to do was figure out how to turn what I had on my head into something resembling the style that Bowie wore on the cover of *Pin Ups*. That freaky round helmet of spiked hair on the top, but long at the back. I had always admired that look, but of course I was too wimpy to do something about it. But not anymore!

The teachers were going to hate me. Good! They'd say, "You might as well shave it all off, Cherie, it would look just as bad!"

"Maybe I will!" I'd spit back, and then I'd turn and walk away. They'd have to learn it, too: you don't fuck with Cherie Currie. Not anymore.

Soon my hair was going to look just like David Bowie's. I would BE David Bowie. I would be ugly-beautiful, horrible and handsome. That moment, that electric flash at the Bowie concert when I felt that I was truly invincible—that's how I wanted to feel all of the time. Not afraid. Not some little square kid from the suburbs. Cherie fucking Currie, the Queen of Hate.

And nobody—NOBODY—would be able to hurt me *ever* me again.

4

Learning Experiences

It was Saturday morning, sometime in the spring, and the damn birds were singing outside of my window. I groaned, turned over, and tried vainly to block it all out. It was no use, though; they kept on chirping and hooting, so I reluctantly opened my eyes. The sunlight was streaking in through the window, turning the bedroom into a furnace. I sat up and looked over to Marie's empty, unmade bed. The clock told me that it was 10 A.M. I was still hurting pretty bad from the previous night of partying, but I could hear voices coming from the den, so I figured that I'd better get up.

The main voice I could hear belonged to T.Y. He had a booming, theatrical voice that carried throughout the house. T.Y. was short for Tony Young, and he was my sister Sandie's husband. He was tall and handsome and had the kind of chiseled good looks that belonged on a movie poster. He had thick, dark hair, warm hazel eyes, and—clichéd though it is to say—a million-dollar smile. He was in his midthirties and he was an actor, of course. In those days, he regularly had bit roles in stuff like *Mission: Impossible* and *Star Trek*. Back in the early sixties, he'd even had his own TV show called *The Gunslinger*. As the title suggested, it was a western, in the vein of *Gunsmoke* or *The Lone Ranger*.

My sister Sandie was an actress. She had been acting professionally since she was sixteen years old, and I thought she was beautiful: she had long red hair and glacial blue eyes.

Sandie and T.Y. had met on the set of *Policewomen*, a 1974 feature film that they both starred in. They had been inseparable ever since. Mom had left the States, off to visit Wolfgang in Indonesia for a few weeks, so Sandie and T.Y. were in charge of us kids. That was fine with us, because Marie, Donnie, and I were all crazy about T.Y. He was pretty cool for a grown-up: he seemed to know what was going on, and he was one of the rare adults we could all relate to. Of course, Mom didn't like T.Y.—at least, she didn't like him as much as she'd liked Sandie's previous boyfriend, Ron Honeywell. That was because Ron was handsome, rich, and Mom knew damn well that an actor's life is unstable at best.

I rubbed my eyes and stretched.

It suddenly hit me what today was: today was the release of David Bowie's new album: *David Live*. Rumor had it that it would include songs recorded at the show I saw with Marie and Paul. Paul said that he was going to buy a copy and bring it over this morning . . . I looked at the clock again and groaned. He was due here any minute.

I leaped out of bed and looked at myself in the mirror. Oh Jesus! Last night's makeup was still smudged all over my face, and my hair was a horror show: it was flattened against my head on one side and sticking straight up in the air on the other. My mascara had smeared down my cheeks, and it occurred to me that I looked like some kind of space-age version of Baby Jane.

"You look like shit, Cherie!"

Marie's voice made me jump. I didn't even realize she was standing behind me. Even though it was first thing in the morning, Marie looked totally together.

I wrinkled up my nose and summoned my most sarcastic voice. "Oh REALLY, Marie? Well, thanks for pointing that out."

She laughed a little. Although we both ragged on each other all of the time, there was no genuine animosity between us, really. Sure, there was a part of me back then that resented how well adjusted Marie was, and how easily she fit in with the popular kids in school. There was something effortless about her; I never caught her looking the slightest bit out of whack. It was more of a friendly rivalry than anything else. She was still my twin sister, and that is a bond that runs so deep that it would surely be unfathomable to most people.

Marie started making her bed, and as she did this she casually said, "Oh yeah . . . uh, Paul just called."

"And . . . ?"

"And, uh, he said he had the Bowie album and he'll be here in, like, fifteen minutes."

"Oh SHIT!" I screamed, and I hustled out of the bedroom to lock myself in the bathroom. When I emerged half an hour later, I was a totally new Cherie. I had transformed myself: my hair was fixed, perfect, just like Bowie's on the cover of *Aladdin Sane,* only platinum blond. Last night's makeup had been scrubbed off, and in its place was baby-blue eye shadow, black eyeliner, and reddish-pink rouge. On my lips I had applied shiny pink lip-gloss. Of course, I didn't wear lipstick—primarily because Bowie didn't wear lipstick.

I walked into the den. Marie and Paul were hanging out. I ran over and threw my arms around Paul, squealing, "Let me see it!" Paul pulled the LP out of a paper bag and handed it to me. He muttered, "Here you go . . ." through his clenched teeth. I held the album breathlessly, running my thumbs over the gatefold sleeve. "Oh my God." I sighed. "It's wonderful . . ."

Marie looked at me with that familiar mix of pity and indulgence. She liked Bowie, too, but regarded my obsession with the Thin White Duke as bordering on the unhealthy. The cover image was one of the most beautiful I had ever seen: Bowie, dressed in that slick zoot suit he'd worn at the show, striking a pose. He looked incredible. The picture had a blue cast over it, bathing him in a futuristic neon glow.

David Bowie is the most beautiful man on the planet, I thought as I stared transfixed at the image.

Paul started laughing that strange laugh of his, but I knew he was just as excited as I was. Paul was the only guy I knew whose obsession with all things David Bowie could even come close to mine. "Wait till you hear it," he said. "It's INCREDIBLE."

"Come on!" I grabbed Paul's arm and tried to lead him to my bedroom. "Let's go to my room and listen!" He shook his head, and jingled his car keys.

"No can do. I have some stuff to do before the party tonight. Do you two need a ride?"

Marie shook her head. "No, Vickie is picking us up. We're helping her to set up . . ."

I was already heading to my bedroom, so I called back to them, "Okay, thanks, Paul! See ya later!"

I ran into my room and pulled the record out of its sleeve. Holding the shiny black disk in my hands, I examined it carefully for imperfections. Then, gently, I placed it on the turntable. I put the needle on the groove, put my headphones on, and flopped back onto my bean-bag chair. I could hear the screams of the audience filling my head, making my stomach flutter in anticipation. I closed my eyes, and it was almost as if I were really there again. As the music began, I got the strange sensation I was floating . . . altered . . . transported.

Before the party, I decided that a change of outfit was in order. I did have an outrageous silver glittery outfit picked out, but after seeing how handsome Bowie looked on the cover of *David Live,* I decided to go with a suit and tie. It was a hand-me-down from my brother, small and fitted, and it hugged me in all the right places, but I was still a little bummed that it wasn't an actual zoot suit. Still, I had to admit this was a pretty good compromise. I struck a pose in the mirror and smiled at myself.

It was eight o'clock and Marie was in the bedroom getting ready with me. She was dressed in blue jeans, a long-sleeved shirt, boots, and a belt. It was way too conservative for my taste, but I had to admit she looked good for a surfer chick. T.Y. knocked and then peeked around the bedroom door, smiling at us indulgently. He looked like a doting father. I knew back then that T.Y. really wanted kids, but Sandie was dead set against it. I still believe that this was because Marie and I had flushed her favorite dolls down the toilet when we were toddlers. We didn't do it to be mean—we were trying to give them a bath. But Sandie took it badly, and I honestly think that this put her off of the idea of having children, *ever.*

"Cherie-zee!" he boomed with that movie-star voice of his. "Look at you! You look great, darlin'!"

"Oh, thanks, T.Y.!" I smiled. I felt a flutter of pride. I never usually got this kind of affirmation about the way I looked in those days, so when it did happen, it made me feel pretty special. T.Y. looked over at Marie, who was looking at him expectantly, her eyebrow raised.

"And look at YOU, Marie-zee!" T.Y. grinned. "Lookin' beautiful!"

"Love you, too, Tony . . ." Marie smiled as she went on doing her makeup.

T.Y. stepped into the room, dressed in his uniform of white linen pants and a tan tunic. He looked like he'd just got back from an Indian spiritual retreat. T.Y. was a West Coast free-spirit kind of a guy. Nothing seemed to get to him, and even his attitude toward work was pretty laid-back. Not even Mom's blatant objection to his and Sandie's relationship could rattle him. T.Y. took it all in stride. Sure, he attended acting classes, and he worked once in a while, but he didn't go out and beat the pavement looking for acting jobs the way my sister Sandie did. Tony was more content to just sit back and let the universe take care of itself. He had a daughter from a previous marriage who was around our age, but it was always amusing when he'd attempt to get all paternal with us. To that end, he cleared his throat. "Now, uh, girls . . ." he said, trying his best to sound responsible. "I don't know what you get into at these parties or whatever . . . whether you have a beer, or you take a hit off a joint . . ."

Hearing Tony talk to us about grass made me smile. It was always funny when an older person tried to talk to me about drugs, even Tony, who was pretty much a party guy. He'd once allowed Marie and me to throw a party where we invited all our friends from school. He'd even provided the beer. Fast-forward a few hours, and the house was full of staggering, vomiting, crying, and otherwise incapacitated fifteen-year-olds, and there was T.Y., walking around unfazed by it all. I knew that at least T.Y. knew what he was talking about. My mom tried to have that talk with me, and I couldn't take her seriously. At fifteen, I felt that I knew more about drugs than she did.

"Well"—T.Y. smiled—"I'm not trying to get into your business. I just want you to be cool . . ."

He reached into his shirt pocket and produced a couple of enormous pills. "Just take these," he said. "They're vitamins. They'll make you feel a whole lot better in the morning . . ."

He threw a pill to me and I caught it. He repeated the routine with Marie. We looked at him, and I thought that T.Y. had to be the coolest grown-up I'd ever known. If my mom knew I was drinking or taking drugs, she'd ground me forever. All T.Y. was worried about was making sure I didn't get a hangover. The whole health kick is something that he and Sandie had been into for a while. On his way out, he put a handful of oval, peach-colored pills on the nightstand.

"Those are papaya enzymes," he told us. "They're good for your digestion." Then he flashed that movie-star smile and backed out of the room, closing the door behind him.

With a little time to kill, Marie and I decided to go to the rec room and play pool for a while. Mom had agreed to let us convert the garage into a rec room, sometime around our fourteenth birthday. We painted a mural on one wall, with this crazy prehistoric fantasy type of scene. In swirling fluorescent colors, we painted a dragon about to devour a naked woman with a baby in her arms. In the background there was a volcano erupting and spewing neon-red lava, with various stars, planets, and flying creatures hung in the skies above the scene. We also had a couch, and the pool table, and best of all a ladder that led up to a second floor where there was a twin bed, Lava lamp, and table . . . This was in case anyone needed to crash for the night.

Marie had a new boyfriend, Steve, who lived just down the street. I caught them up there once, making out. As grossed out as I was to see my sister with a guy, it was better at least than her being with Derek. We hadn't seen Derek since the rape. Not seeing him around made it a hell of a lot easier to pretend that it never happened.

With a *clunk*, I accidentally sank the cue ball into a corner pocket. "Goddammit!" Marie laughed and said, "Nice one, doofus!"

With Marie beating me at pool as usual, it was relief when I heard Vickie honking her horn outside.

"Oh, tough break." I smiled. "I'll finish beating you next time . . ."

Marie flipped me the bird, and we said good-bye to Sam and T.Y. before jumping into Vickie's old red Chevy.

Vickie was a good friend. She was eighteen and had already graduated from high school. Whenever I wanted to ditch school, she'd pick me up in her car and we'd take off to waste time, listen to music, and hang out . . . People said that we could have been sisters, and it was true: the resemblance was really uncanny. She'd even cut her hair into a shag around the same time that I did . . . although she drew the line at dyeing it every color of the rainbow.

Vickie was beaming when I got in the car with my suit and tie on. "Whoa!" she said. "Cherie—you look radical! Man, you look just like a female David Bowie!"

If there was any compliment in the world that was guaranteed to make me feel amazing when I was fifteen years old, that was it. I looked out of the window, grinning. Yeah, I thought to myself, I AM the female David Bowie. After all, I could move like him, and I could sing along to all of his records perfectly.

"Dammit, I AM David Bowie!" I announced.

Marie tutted and rolled her eyes. "You're a weirdo, Cherie, I swear to God."

"Fuck off," I told her, wrinkling my nose. She folded her arms and looked out of the window. I could feel the anger bubbling in my chest. It hurt because I knew that she really did think I was a weirdo; this wasn't just some sisterly teasing. This was the Marie I had to put up with when she was hanging out with her stupid "popular" friends. Well, FUCK THEM, I thought, tonight I was going to have fun. Nobody was going to ruin that for me—not even Marie.

Vickie lived with her mom in a modest home in Sherman Oaks. But this weekend her mom was away, so Vickie decided it was good opportunity to throw a blowout party.

"So, who's coming tonight?" Marie asked as we arrived at Vickie's place.

"Ah . . . a lot of people. Danny, Paul, Gail . . . A few others . . ."

I knew Gail through Marie. She was a strange one, and no doubt about it. She was on this 1930s kick, and wore her hair real short with

these loose curls pressed against her head. She had narrow shoulders and wide hips, and was kind of gangly and awkward. Like me, she caused people to do double takes when she walked into a room.

We got out of the car, and Marie said, "You know, Gail and I went shopping the other day, down on Hollywood Boulevard. Man, she knows all of the cool shops. She's a pretty hip chick, you know? But she's tough, too! We were walking down the street and some asshole pulled up beside us hooting and hollering out of the window, screaming 'LEZBOS!' You know what Gail did? Man, she chased that moron down the street screaming 'FUCK YOU, you fucking FAGGOT!' You shoulda seen the guy! He looked like he was gonna crap his pants or something. He couldn't get out of there fast enough. It was so cool!"

Vickie shrugged. "What's the problem? Gail *is* a lesbian!"

"I know!" Marie laughed. "But she said she didn't think it was fair to me . . ."

Inside, I was putting out bowls of potato chips when Vickie pulled me aside and whispered, "I have something for you." She put something into my hand. I looked at it. It was a round white pill, a pill that was somewhat the craze at parties in those days—a quaalude. Without hesitation, I popped it into my mouth and washed it down with a mouthful of rum and Coke. "Luding out" was becoming one of my favorite highs in those days—when the mix of booze and pills was just right, it felt as though you were wading through warm, viscous liquid when you walked, and each gooey step sent little shivers of ecstasy erupting down your spine like firecrackers.

"Thanks, sweetie," I said. "This party is gonna be a blast!"

By ten o'clock, the party was in full swing, and I was feeling real good. Relaxed, happy, and my head was swimming pleasantly. Every time someone talked to me, it was as if their words were floating over to my ears, coming to me in telepathic waves. The lude was strong, and for a moment I almost panicked . . . was it too strong? I had seen kids pass out—I mean, literally just keel right over—when they couldn't handle their ludes. Their eyes would go unfocused and then they'd just fall flat on their faces, busting noses or cracking teeth in the process. Or, they'd crawl off into a corner and pass

out, and kids would draw mustaches on their faces as they lay there drooling.

But no, not me. I was David Bowie, right? I could handle it. I could handle anything. The lights were low, and the air was hot, and the living room was crammed with young people. I saw Paul and Gail sitting together on the couch. I watched them, with sleepy, heavy eyes. Gail was staring at me. I stopped and took her in dreamily. People walked between us, but she never took her eyes off me. The way she stared at me made me shiver. She smiled at me, and I felt my lips turning upward, too, as if we were connected in some weird way. I felt a little removed from my own body, like I was floating above myself, observing my own movements with the detached interest of an observer. A familiar piano refrain began to play, and I realized that it was Elton John's "Candle in the Wind." As I noticed this, I began to dreamily sway with the music. I saw Gail coming toward me, ignoring everyone around her, walking straight over to me, putting her hand on mine, and saying, "Would you like to dance?"

Her eyes . . . her eyes were like saucers, big pools of inky blackness . . . and I felt the sudden lurch of vertigo, as if I could have toppled into those cavernous holes. "Sure . . ." I heard myself slur. *Pull it together, Cherie . . .* some distant part of my brain was demanding. *You can handle one quaalude!*

She guided my hand, placing it on her waist. She put her arm around my shoulders and pulled me in close. I could smell her perfume, feel the heat radiating off her body. We started swaying to the music. I felt her hot breath against the nape of my neck, and it sent a delicious shiver down my spine. The room was dark, so dark I could hardly see. I felt her mouth against my ear, the soft wetness of her tongue touching my skin. Then, almost without knowing how it happened, we were kissing. Our lips crushed together and I could taste her, I could feel her tongue in my mouth. I felt as if I were on another planet, the combination of the booze, the quaalude, the music, and Gail was giving me something of an out-of-body experience. A shudder of recognition traveled through my body: I was the alien—a chameleon, androgynous, not like the others with their rigidly defined

roles . . . I could change my sex as easily as I could change my hair color. I imagined that this was how Bowie must have felt when *he* was with a woman.

"Come with me," Gail whispered. She took my hand and led me off the dance floor. We walked past the other shadowy figures in the room as the song ended, and Lou Reed's "Vicious" started up. We walked down the hallway, past necking couples, and long-haired stoner kids passing around a joint, laughing hysterically to themselves . . . toward the fluorescent glow of the bathroom. We walked in, and Gail closed the door behind us.

"Now I have you all to myself," she muttered.

In the harsh light of the bathroom, suddenly everything was thrown into sharp focus. I looked at Gail and smiled softly.

Hell, what's the big deal? Bisexuality is cool. Everybody's bi these days. I swore I would never be afraid, didn't I?

I grabbed hold of Gail and pulled her toward me, and then we were kissing with frenzied abandon. I pushed her up against the wall and ran my hands under her clothes, feeling the smooth contours of her body, our breath hot and fast, and in time with one another . . . I didn't even hear the bathroom door open; I didn't notice Vickie standing there as Gail and I made out furiously. Vickie stood there with her mouth hanging open, and I finally noticed her when she blurted, "Jesus Christ, Gail! What the FUCK are you DOING?"

I froze, and we pulled apart. Gail turned and sneered at Vickie. "What the fuck does it LOOK like we're doing?"

I was standing there, with my back against the cool tiles, dazed by everything that was happening. I looked at Vickie through heavy-lidded eyes, but she was bumming me out. She looked like she was about to cry or something. "Cherie?" she said softly.

I didn't say a word. It was if the words got lost on the way from my brain to my mouth. I was shocked by how upset she seemed. Vickie scowled at me, and then focused her ire on Gail.

"I don't want you doing this!" she spat. "Not with Cherie! She's wasted, goddammit!"

Gail ran a finger across my bottom lip and said, "Well . . . she looks *fiiiine* to me, Vickie. She looks *perfect*."

Gail put her arms around me again, and pressed those soft lips against mine. As we kissed, I could hear Vickie crying.

"Gail, you need to get out of here. RIGHT NOW. I'm serious—I want you to LEAVE!"

We broke apart. Gail stared at me and said, "You wanna come with me?"

Vickie marched over, and begged me, "Cherie, no! Please don't!"

I looked at Vickie, and then at Gail. "I'll see you around, Vick," I said, before heading to the door, with Gail's hand in mine.

We pushed past the kids in the hallway. I was totally intrigued by Gail. Unfortunately, Vickie, poor Vickie, well, she just didn't understand. Not the way I did. I thought of Bowie, and Elton, and Lou Reed. If they could all come out about being bi, then I wanted to know what it's all about. Jesus, I was fifteen years old—I wasn't a baby anymore. I *wanted* to experience this. I wanted to experience *her.*

Gail drove me home. We crept into the rec room and climbed the stairs to the second floor. I put some music on, Bowie crooning, "*It was a god-awful small affair . . .*" and I fell into bed with Gail. When we kissed this time, there was an urgency to it, a passion that propelled us along with its own momentum. I could smell her skin, her perfume, and I wanted her. I wanted this. The sensation was both alien and familiar in some strange way . . . She raised her hips and slowly slid her pants down . . . I felt her running her fingers through my hair as I kissed her body, moving my mouth down, down her smooth, flat stomach . . . down, down until I reached the soft curls of her hair. . . .

And then—like some shocking, horror-movie jump cut—I was awake in the bed.

It was morning. And I was going to puke.

A ray of sun was burning against my face, and my mouth felt rotten, dry. My head hurt, and my body hurt. I looked to my side dreamily and suddenly I jerked fully awake. There was another head on the pillow. Gail was right here next to me, sleeping. Suddenly I felt my guts churn as the floor dropped out from underneath me.

OH GOD!

It really happened. It wasn't some kind of drug-induced erotic

dream. Gail was sleeping in the bed next to me, and the memories from last night started flooding back to me. What had I done? I got to my unsteady feet and started pulling on my clothes. The movement started to bring Gail around, and I heard her murmur, "Where are you going?" in a sleepy, faraway voice.

I didn't answer. I couldn't. All I could do was climb down the stairs and run into the house. I staggered toward the bedroom, convinced that any moment I was going to begin projectile vomiting. My head was pounding from the booze and the pill. As I staggered over to my bed, I saw Marie sitting on hers, looking at me with open disgust.

"Where WERE you, Cherie? Where were you last night?" she demanded. I just stood there, rocking back and forth on my heels like a deer caught in headlights. I felt that if I moved one more muscle, I would vomit for sure. I wanted Marie to take pity on me, to see how pathetic I felt, but she didn't. She just kept on, pushing home her advantage.

"Vickie told me you left with Gail!" she spat, before adding in a shocked murmur, "She told me *everything*!"

I staggered over to my own bed and sat down. I rested my throbbing head in my hands.

"What did you DO with her? Cherie, what did you DO?"

All I could do was breathe. Breathe. I felt like I was going to faint, or maybe just drop dead right there and then from a mixture of shame and horror. I managed to murmur, "Gail's in the garage. She's sleeping upstairs . . ."

Marie fixed me with her most withering stare. "Did you *sleep* with her?"

I just looked at my sister, my mouth open slightly. I felt like I'd just been slapped. I'd spent most of my childhood trying to win my twin sister's approval. I couldn't bear to hear her talk to me this way. I felt like dirt. I looked away, and put my head back into my hands. I began moaning to myself.

"You . . . you . . ." I could hear Marie's voice cracking as she said this. "You just answered my question!"

With that, my sister ran out of the room. I staggered to my feet,

because I could feel the tears welling up inside of me, and I followed her out to the living room, trying to grab hold of her, trying to explain. "Wait—Marie! Just listen!"

She reeled around, and her face was red. She was incandescent with fury. She held a shaking finger up to my face and hissed, "I don't even know you anymore, Cherie. I swear to God, I don't! You're sick, you know that? SICK!"

I stood there, shaking. I could feel the tears about to come. I didn't want to cry. I didn't want to give her the satisfaction. But I couldn't help it. Then, unbelievably, the situation got even worse. Hearing the commotion, Sandie and T.Y. came barging in demanding to know what was going on. Sandie got in between us.

"Hey, cool it!" she yelled. "What the hell is going on?"

Marie stared at her, her eyes wet with tears. "Why don't you ask HER?"

I looked at Sandie, and then at T.Y. T.Y. looked really worried. I looked back at Sandie and she was staring at me expectantly. I could feel all of their eyes burning into me, staring at me, looking for an explanation. I couldn't take it anymore. Finally I shouted out, "I slept with a girl last night!"

There was a moment of stunned silence in the room. And then SLAP! Sandie got me good, right across the face. I didn't even see it coming, and I saw stars for a moment. Then, before I even knew what I was doing, I had my older sister by the throat, and was pushing her against the wall like a wild woman.

"Don't you ever—EVER hit me again!" I screamed.

I pulled my fist back, about to give it to her right in the mouth, but then I froze when I saw the terror on my sister's face. Before anything else could happen, I felt myself being lifted from the ground as T.Y. grabbed me from behind and pulled me away. "Enough!" he was screaming. "Girls, that's ENOUGH!"

Sandie was crying now, and I couldn't hold back anymore. I started sobbing and ran out of the room, completely mortified. I ran out of the house, and when I was on the street, I sat on the curb sobbing harder than I had ever sobbed in my entire life. I could feel my heart

pounding in my chest, and I felt like I was going to vomit. The feeling of dread was all-encompassing, and I honestly would have welcomed death with open arms at that moment. My entire world felt like it had crumbled around me. At the end of the street was the Lincoln Bank building, and I imagined how it would feel to plunge from the top of it, to feel the black wind whistling past my ears, knowing that in a fraction of a second all of my pain would suddenly end.

I felt a hand on my shoulder. It was T.Y. I stiffened and didn't look up at him, but he sat down next to me anyway. I stared at the sidewalk. I heard that voice of his saying, "So how's it going, Cherie-zee?"

There was something weirdly comforting about his voice, but I was still crying, I was still torn apart inside. "Not so good, T.Y.," I managed to blubber.

"Come on, darlin'," he said, and I felt his big hands running through my hair. "Your sisters will cool down. I mean, look, I know this must feel like the end of the world right now. But it isn't. Not by a long shot."

"That's what you think," I said in a small shaky voice.

T.Y. shrugged. "I hate to break it to you, kid," he said, "but life is full of tough situations. It's how you react to them, that's what matters. You know what you just had? You just had a learning experience, darlin'. That's all. In fact, when you really get down to it, that's pretty cool, because now you just grew up a bit more. What happened last night isn't the most important thing . . . it's what you take from it, and what you do next that matters. You see?"

I sniffed, and wiped the tears away from my face with a shaking hand. T.Y. put his arm around me and looked up to the sky. "Beautiful day, isn't it?" he said in a dreamy voice.

We sat there in silence for a few moments. Then I turned to him. "You're not disappointed in me, T.Y.?"

T.Y. laughed that deep, sweet laugh of his. "Oh, hell no, Cherie-zee. I'm not disappointed in you at all. In fact, I'm proud of you. You just chalked up some real life experience . . ."

Somewhere off in the distance I heard a car door slam and an engine rev. It was Gail leaving, and as she sailed past the two of us,

she waved out the window. I waved weakly back at her, watching her car disappear down the road.

T.Y. turned to me. "You ready to go back in?"

I shrugged, and looked up at the sky. I felt as if a great weight had lifted off of me. I turned to him and said, "Sure, T.Y. I'm ready."

He took my hand, and we walked back into the house.

5

The Orange Tornado

There was a point when I realized that you could get away with just about anything so long as you do it with enough conviction. Take my image for instance. When I first changed my look, the kids at school didn't know what to make of it. I guess most of them thought that I had lost my mind, but I didn't let it bother me. In fact, I secretly *enjoyed* that they were so freaked out by me. Marie often had to come to my defense when the kids would try to come after me: I remember one kid threw an apple at me, smacking me right on the head. Before I could even react, Marie had jumped on him, and she gave him an almighty ass kicking. But slowly, in almost unperceivable steps, they started to come around. When they realized that their opinion of how I looked didn't matter to me in the slightest, a begrudging kind of respect made its way around my school. Soon people were talking to me again . . . even sitting with me at lunchtime.

Big Red was more agreeable, too.

Once, just before class started, someone tapped me on the shoulder. I turned, and standing there, bigger and uglier than ever, was Big Red. I folded my arms and just stared at her.

"Uh, Cherie . . ." she said, her face registering utter confusion as she got a load of the lightning bolt, the hair, the outfit.

I didn't say a word.

"I, uh . . ." Big Red looked around, and then dropped her voice to

a hoarse whisper. "I just wanted to tell you . . . that I'm sorry. That we're cool, okay?"

She looked like she was waiting for me to respond. I didn't say anything. I just stared at her like she had two heads.

"Uh . . ." Big Red carried on, "we *are* cool, aren't we?"

I looked at her for a moment. Then I turned and walked away, leaving her standing there with her mouth flapping open.

Not long after that, I noticed others who were cutting their hair in a shag and borrowing other things from my look. I had gone from teen terror to trendsetter in less than a year. At first, it pissed me off: all of those square kids who were jeering at me and calling me names were now suddenly dyeing their hair and dressing like gender-bending little glam rockers. But then I started to see the funny side. This was a valuable lesson in the mentality of the crowd.

There was a part of me, deep down, that almost missed being an outcast in school. A contrary, punkish part of myself really *enjoyed* hating everyone. Still, I figured that there were plenty more people out there to hate. There was always something to kick against. Just because I was having an easier time in school didn't mean that the Dereks of this world had gone anywhere.

I didn't go to Rodney's club anymore. It was finally closed down. The place had become a magnet for all kinds of negative attention, and it eventually went under in a cloud of legal and financial problems. Some people said that Rodney's died the moment that Rodney allowed Chuck E Starr to play disco records, breaking the glam-rock hegemony at the club. Of course, the fact that the place was always full to the brim with drunk and stoned underage kids probably didn't help matters. All it took was for Iggy Pop to fall over in the club a few times, and then the press started writing about the scene at Rodney's in their typically overblown and hysterical way. Once that happened, the club's fate was pretty much sealed. Once the club closed, Chuck E Starr packed up his records and moved over to the Sugar Shack.

Since the passing of Rodney's, the glitter sluts, the space-age Lolitas, the young, the damned, and the glamorous dispersed all around Hollywood. Some went on to full-time groupie-dom, camping outside of hotel rooms trying desperately to score a member of a band—any

band at all—while others spun out on drugs and booze. Me, I followed the music, and found myself hanging out at the Sugar Shack.

The Sugar Shack was in many ways a continuation of what had been going on at Rodney's English Disco with one big difference: it was an under-twenty-one club, meaning that when the security people checked IDs, they were making sure that you *were* underage before they'd let you in, which is an interesting reversal of normal circumstances. Paul was a regular at the Sugar Shack with me; Marie, too. Everybody knew us at the Sugar Shack back then. We had cultivated the most outrageous image, and there were already armies of kids who'd based their entire looks on how Marie and I dressed. We fell in love, had our hearts broken, and broke hearts at the Sugar Shack. The Shack provided the greatest soundtrack to a childhood that you could ever imagine.

As Mom and Wolfgang had gotten more and more serious, and Mom spent more and more time away from home, the Sugar Shack became the closest thing I had to a stable family life. I knew everybody who went there regularly. Most of the time I just went there by myself, wanting to dance, make new friends, watch, and be a part of the carnival-like atmosphere.

It was at the Sugar Shack that I met a man who—for better or worse—would change my life, forever.

They didn't serve alcohol at the Sugar Shack, and that night I was sat at the juice bar sipping a Coca-Cola. The club was tiny, and always packed with kids. At that moment Chuck E Starr was DJing disco, so I'd stepped off the dance floor to take a break. But I knew that soon he would drop a crowd favorite like "The Time Warp" or "Suffragette City," and kids would line up to do their best moves, checking themselves out in the mirrored columns as they danced. Of course, just because they didn't serve alcohol didn't mean that kids didn't drink it: they just went out to the parking lot and guzzled everything from flasks filled with booze stolen from their parents' liquor cabinets, to Colt 45, or Mad Dog 20/20, before they staggered back inside blasted out of their skulls. Quaaludes were also a favorite, and in the upstairs room you could see survivors of the glam-rock scene—guys in huge platforms with fire-engine-red hair

and their best Ziggy Stardust outfits staggering around totally luded out, making out with each other and getting into all kinds of trouble. I liked quaaludes a lot, but alcohol didn't really do it for me. I found the spectacle of those drunk, crying, puking, and fighting kids a little pathetic. No, I was there to get off on the music . . . and the music was amazing. At that moment hundreds of kids were on the dance floor, doing their best moves to Donna Summer's "Love to Love You." I was watching, smoking a cigarette and admiring the sea of beautiful people. I could already see a few booze casualties in the crowd, and I smiled a little to myself. Not everyone could handle their drink as well as my father could.

"Hello," said a voice to my right. It had a theatrical, booming quality that startled me. I figured that it was maybe some random creep trying to make a move on me, so I turned to tell him to fuck off, but when I clamped my eyes on the figure next to me, I stopped myself. I immediately realized that this was no ordinary creep. For a start, he was not under twenty-one. Not by a long shot! The stranger was tall—real tall—and wearing the ugliest, tackiest bright orange suit that I had ever laid eyes on. The suit looked dirty and crumpled, as if he had woken up wearing it. He looked like some weird cross between a tangerine and Lurch from *The Addams Family*. Under the flickering club lights, it looked like he was wearing makeup and he looked impossibly old to me. Like somebody's insane, cross-dressing grandfather! He was so strange and tacky-looking, that I started to laugh. He seemed unperturbed, though; he just kept staring at me, radiating this air of overblown importance. No, this guy was no ordinary creep. This guy was an *extraordinary* creep.

"I've seen you around," the tangerine-Lurch said. "You come here a lot, don't you?"

"Yeah," I told him, turning back to my Coke to signal that the conversation was at an end. Instead of taking the hint, he just stood there smiling at me. I started to get an uncomfortable feeling. I didn't like the way that this guy was looking at me. I thought of Derek, and then pushed the thought away. No. This guy seemed weird, but harmless. Probably just some kind of burnout, the kind of freak that you see everywhere in Hollywood clubs, just some creepy old dude who

used to be a child actor or something. Or he could have been in the entertainment industry—a journalist, club promoter, or something. Otherwise he wouldn't have even made it past the bouncers. But I was in a club packed with people. This creep couldn't try anything.

"I like your look," the freak was saying. "I like it a lot. You got balls, you know what I mean? The platinum-blond hair . . . the tight pants . . . the makeup. Very cool. And you have this look in your eyes that says, 'I can beat the crap out of truck driver.'"

This made me laugh. I looked up to him again, and said, "What exactly do you want?"

He straightened up, took a deep breath, and announced, "My name is Kim Fowley."

I stared back at him. He was standing there, rocking back on his heels, as if everything had just been explained because he'd uttered his name. I still had no idea who this creep was. After an awkward moment's silence, I said, "Well, good for you. Am I supposed to know you, or something?"

Actually, the name did sound vaguely familiar. Not that I was about to give him the satisfaction of knowing that. I think I'd heard Rodney mention it once or twice, but beyond some vague connection with the music industry, I really didn't have a clue who this guy was. I was getting intrigued, though. What exactly did he want? He smiled at me again, and called for someone to join us over the thunderous sound of the club's PA. "Joan! Joan, come over here!"

A girl walked over to us. She was around my age, really pretty, with brown- and blond-streaked hair, dark eyes that seemed to radiate right out of her face. She walked over from the edge of the dance floor and stood next to Kim Fowley. She seemed real shy, and was hiding her face behind that long dark hair.

"I'd like you to meet Cherie," he said. I was about to ask him just how the hell he knew my name, but he cut me off. "Cherie—I'd like you to meet Joan Jett."

Now I *was* impressed. Starstruck, almost. I had heard Joan Jett's name around the scene for what seemed like forever. Rodney Bingenheimer used to talk about her in the hushed, reverential tones he reserved for the most important faces on the scene. "That girl is

going places," he would say. I had seen her at the English Disco: she was a young, stunning Suzi Quatro look-alike. This was before Suzi had really blown up in a big way in America, and even though she was from the United States, she was still mostly successful in Europe. But, to the kids from the glam-rock scene, Suzi was a goddess. We all wanted to look like her, sound like her, be like her.

Joan smiled and put her hand out toward me, saying hi. She seemed friendly enough, and her presence relaxed me a little. If Joan was involved with this Fowley guy, then he couldn't be all bad, could he?

"Tell me, Cherie . . . can you sing? Or play an instrument?" Kim asked.

I pursed my lips. This question had thrown me for a loop. I looked around for Paul or Marie, wondering if this was some kind of setup. Nobody was paying attention to us, though. I shrugged and said, "I can't play an instrument. Why?"

"Have you ever heard of the Runaways?" Joan asked me.

"Sure. They're a new group, right?"

Joan nodded. Word of mouth about the Runaways had been spreading around the scene for the past few months. Nobody seemed to know too much about them, except that they were supposed to be the new hot thing. Everybody already had an opinion on them, yet nobody seemed to have seen them play yet.

Now that I had admitted to knowing who the Runaways were, Kim went into his full salesman spiel.

"They're only the hottest band of the decade!" he informed me with a satisfied grin. "The Runaways are a teenage all-girl rock-and-roll band. The Runaways are going to be the next female Beatles—the girl equivalent of Elvis, or Bowie, or Bo fucking Diddly. I am the magician, the visionary that is going to make it happen. They are going to change the world! Joan here is the rhythm guitarist . . ."

The way he said it made me feel that he had given this speech many times before. Still, I couldn't help but be sucked in by his enthusiasm. What I couldn't figure out was why on earth he was giving this speech to *me*.

"So, uh . . . what do you want with me?"

"Read my lips," Kim told me. "*We—like—your—look*. Yes? You *can* sing, can't you?"

When he said this, a few things flashed across my mind. The first was my music teacher Ms. Davenport refusing to let me into the choir the first time I tried out, on the grounds that she thought my voice sucked. She didn't use those exact words, but she didn't have to—her face had said it all. I did get in on the second attempt, though, so maybe old Davenport was having her period that day, or something. The next thing I thought of was the school talent show, where I'd recently won first prize by lip-synching to David Bowie. Marie and I had spent hours getting the costumes and the choreography perfect. When the song was over, the auditorium had gone wild. It was the craziest feeling, the most thrilling, goose-bump-inducing sensation, when the final note rang out and the whole place erupted in cheers.

"Yeah, I can sing," I told him, trying to play it cool.

I almost blurted out that my sister and I used to sing Dean Martin songs with my father at the Kiwanis Club but I stopped myself, feeling like a hopeless square for even thinking about mentioning it. Instead I said, "I came in first at the school talent show, singing David Bowie."

I decided to leave out the lip-synching part.

"David Bowie, huh?" Kim said to me. Then he points a finger at my chest. "If my instincts are correct . . . and one thing you will learn about me, Cherie, is that my instincts are ALWAYS correct . . . by the time I'm done with you, you are going to be bigger than David Bowie. In fact," he said with a leer, "you are going to have the likes of David Bowie licking those silver platform boots of yours . . ."

Joan started laughing at this, rolling her eyes. I guess she was well used to the strange way that Fowley spoke, but I was still staring at him like he had two heads. He pulled a notebook and pen out of his pocket, and asked me, "So—when are you free to audition?"

Audition? Suddenly it hit me, with a twist of fear in the bottom of my gut: they were obviously trawling the under-twenty-one clubs, looking for a blond girl in tight pants who looked like she could beat

up a truck driver so she could sing in this crazy band they were putting together. And here I was. I placed a trembling hand on my glass of soda and tried my best to look nonchalant.

"Um, audition?" I repeated dumbly.

"Yes—audition. What is a good time for you?"

A new song started up, and a cheer went up from the crowd when the first downbeat rocked the floor, because everyone knew what was coming already. "Benny and the Jets" by Elton John. That song was a favorite of mine in those days; it always put me in a trancelike, relaxed state. But not tonight. Not now . . .

"Gee, Mr. Fowley . . ." I stammered. "I don't know. Anytime, I guess . . ."

I watched as he thumbed through his appointment book. I still couldn't quite believe what was happening.

"Saturday at two?" he asked, fixing me with an expectant stare.

I realized with a start that that was only three days away. "Sure, perfect," I blurted out before I could change my mind.

"Excellent." He made some notes in that little book of his. "Tell me—are you familiar with Suzi Quatro's music?"

"Sure . . . I have all her albums," I said. *Of course* I had all of her albums: I was a music nut. My mom used to tell me that I wouldn't have room left for my bed if the vinyl collection in my bedroom kept growing.

"Great. Well, I want you to learn one of her songs. Any one you like. You can sing that for your audition for the band."

Kim Fowley was all business now. He was scribbling an address in his book. He ripped the page out and pressed it into my hand. With a sly smile he started to turn away, but then stopped, as if remembering something very important. Then he asked me, "Exactly how old are you, Cherie?"

I sat up and assumed my most mature look.

"Fifteen," I told him in my most confident voice. "I'm going to be sixteen in a few months . . ."

With that, his huge, weird face creased into a smile. Not an altogether nice smile either.

"Good," he cooed. "Very good!" Something about the way he said it made me imagine that he was about to say, "Young and fresh . . . Just the way I like them!" but thankfully, he didn't.

With that, he spun on his heels and walked away. I sat there, watching him go, slightly shell-shocked.

"It was nice to meet you," Joan said, before she herself went to leave. Then she half turned and yelled back, "See you Saturday!" And then she was gone, following Kim Fowley's hulking orange frame into the crowd.

I just sat there flabbergasted by everything that had just gone on. I was so caught up in my own thoughts that I barely registered that "Benny and the Jets" had ended, segueing into "Personality Crisis" by the New York Dolls, and that Paul was standing right in front of me, looking at me with a strange expression on his face.

"Are you okay?" he asked. "You look like you've seen a ghost . . ."

"Do you know a guy called Kim Fowley?" I asked, ignoring him.

"Sure. The record producer? He did that song 'They're Coming to Take Me Away' that Doctor Demento always plays on his show, didn't he? Wow—he was here?" Paul started craning his neck to catch a glimpse of Fowley, who was already long gone.

"Yeah . . ." I said, still slightly dazed. "I was talking to him. He asked me to audition for an all-girl rock band called the Runaways. Joan Jett was with him."

"For real?"

"Yeah."

Paul laughed that strange laugh of his. "Holy shit, Cherie! I leave you alone for five minutes, and what happens? You go and become a rock star!"

"Shut up!" I giggled as Paul dragged me onto the floor to dance. On the way by, I saw Marie. I called her over, and started babbling to her about what just happened.

"Who?"

"Kim Fowley!"

"Who's he?"

"That big weird-looking guy in the orange suit!"

"Oh," Marie said, wrinkling her nose. "He tried to talk to me, too. He asked me if I could play bass guitar. I told him to fuck off! What a *loser* . . ."

When I got home that night, I wanted to tell my mom what had happened, but I couldn't because she was in Indonesia with Wolfgang. She'd been away a lot lately, and Sandie had been the de facto parent in the house for a while. In a way, this was even better than telling my mom, because Sandie would get it; she was already in the industry. When I was younger, I thought that my older sister was the coolest chick in the world: she had her own apartment in Hollywood when she turned eighteen, and was living a life that seemed so glamorous to me: shooting commercials by day, waiting for her big break, and working as a cocktail waitress by night to support herself. Then she got her shot at the big time: a role in a western called *Rio Lobo,* starring John Wayne. At this point, she had gone on to star in four more movies. She met T.Y. on the set of a movie called *Policewomen* where she played a cop who infiltrates an all-female criminal gang. I mean, imagine my big sister being a movie star and even *marrying* her gorgeous male lead? When I was fifteen, I thought that if I could follow in my big sister's footsteps, I would die happy.

It was late when I got home, but I still started banging on Sandie's door. "Sandie—wake up!" I hissed through the bedroom door. "I have to tell you something!"

If anyone was going to understand just what a big deal this was, it was my big sister. Despite the fact that there had been some real tension between us ever since the Gail incident, I knew that she would understand what a big deal an audition for a major record producer was. Marie was trying to talk me into just going to bed. "Cherie, can't it wait till the morning? It's, like, midnight!"

"No!" I snapped. "This is important!"

Sandie and T.Y. staggered out in their bathrobes, rubbing their bleary eyes. "Uh, Cherie . . ." Sandie was saying, "what is it? What's wrong?"

I laughed, bubbling over with the excitement of it all. "Oh God, Sandie! I just got the most amazing news!"

By now, the commotion had even roused Donnie, who staggered

out of his bedroom, bleary-eyed and yawning. "What's all the noise?" he demanded. "Did someone die or something?"

"Okay, Sandie. Listen to this. Kim Fowley . . . who is like the most important guy in the music industry—I mean big time important, okay? *Kim Fowley* wants me to audition for the Runaways! On Saturday!"

Marie rolled her eyes. She'd been hearing this all night. "That guy's a creep," she insisted. "I wouldn't trust him!"

I shot her a dirty look. "Oh yeah? You tell *Joan Jett* that!"

I turned back to Sandie and T.Y. Of course, they had no idea who either Kim Fowley, the Runaways, or Joan Jett were, but they both smiled at me indulgently and nodded their heads.

"I'm so happy for you, honey," Sandie said.

"You're going to knock 'em dead at that audition, Cherie-zee," T.Y. added sleepily.

Coming from Sandie and T.Y., this meant the world. I felt my heart skipping in my chest.

Donnie said, "So, uh, if you join this band, you'll be on like records and stuff?"

"Oh yeah!"

He sighed, and threw his arms up into the air. "Great! Now I'll even have to listen to you on the radio!"

It was late, and Sandie fixed us all a midnight snack. There wasn't much talk after that. Everyone was tired, everyone except me. After a while we all drifted back to our beds. While Marie slept I crept out of bed, silently opened the door, and stepped out to the backyard. It was November, and the air was cool. It never really got too cold out here in the Valley. I could hear the steady rhythm of the crickets. The sky was clear, and I could see a million stars, stretching off into infinity. I had read and reread magazine articles on all of my favorite rock stars obsessively, and I knew that sometimes all it takes is a simple twist of fate to be discovered. Wasn't Suzi Quatro discovered by Mickie Most playing some dive in Detroit, just because he happened to be in town on another gig? A part of me was afraid of being disappointed, but another part of me, some fearless part of me, was determined that this chance meeting with a famous record producer was going to change my life forever. I

thought of David Bowie onstage, the way he commanded literally thousands of people with every careful, stylized gesture. I thought of the power he had over his audience. The power he had over me! I wanted to be powerful; I wanted to be extraordinary, too . . .

I stared at the stars. I knew that I would not be able to sleep tonight. I remembered the joint I had in the bottom of my purse. It had literally been sitting there for a month; it had been shoved into my hand at some party, and I'd never bothered to smoke it. I found that I never really reacted well to grass in the past; it made me feel strange, a little paranoid. But I'd sometimes buy a half lid of marijuana, mostly so I could share it with the older kids in the neighborhood who smoked. They always wanted to hang out with me because I had grass: when you're a teenager, drugs can be an important bonding tool.

I pulled the joint out. It was battered and bent out of shape from lying in the bottom of my purse for so long.

I lit it up and took a deep toke, holding in the harsh gray smoke just like the older kids did. I could feel it burning my lungs—it felt much harsher than tobacco. The almost unbearable urge to cough came over me, but I swallowed it down. When I finally exhaled the plume of pungent smoke into the night air, I felt pretty light-headed.

The sky was beautiful. Suddenly the world seemed vast and infused with possibilities. After gazing at the heavens for a few moments, I took another toke, and managed to hold the smoke in easier. When I exhaled, I started to think about just how *big* everything was. I sat back, taking in that vast, inky blackness, those million tiny points of silver shimmering up there in space like twinkling, undulating Christmas lights . . .

Finally I felt myself relaxing, as I slowly began to get wonderfully, wonderfully stoned.

6

Cherry Bomb

When Saturday rolled around, I was just about ready to faint, puke, or pee my pants. I had never *felt* anxiety like that before. I suddenly felt like the old Cherie again: little, innocent, scared Cherie. *Why the hell did I agree to this?* I was sitting in the car with Sandie, cruising over to the audition, and my nails were bitten down to the quick already. I checked the car's a/c again, but it was still off. I was *freezing,* though, and my fingertips felt like icicles. I checked my reflection again in the passenger-seat visor, and immediately wished that I hadn't bothered. I looked like shit, pure and simple. I looked terrified, just some little scared kid. Not for the first time that day, it crossed my mind that the Runaways might take one look at me and say, "Get the fuck out of here!"

Sandie gave me a sideways glance and noticed the expression of dread on my face. "You'll be fine!" she said again. "Don't sweat it. You're gonna knock 'em dead!"

I tried to tell myself that Sandie was right. I'd been practicing like hell ever since that first meeting with Joan and Kim.

I tried to get away from my toxic thoughts by mentally running through the song that I had picked for my audition. I went for a slow, sultry number called "Fever" from Suzi's latest album, *Your Mama Won't Like Me.* I had been in my bedroom for the past three days singing this song obsessively. Marie helped me to choose it, and she'd agreed that this one was the best choice. It was a cover version, of

some old Peggy Lee song, but Suzi's version was real cool . . . It has this brooding quality that I liked, and I could really emote when I sang the words. Just reciting the lyrics to myself calmed me a little. *They are gonna be blown away when they hear this,* I told myself. I did just what Mr. Fowley said: "Get yourself a good Suzi Quatro song." And here I was, prepared, ready. Confident. I started to feel a little mellow again. A little more like myself. That was, until we pulled over and Sandie said: "We're here!"

I was immediately freaking out again, and a part of me wanted to tell Sandie to forget about it, to just take me home. I thought about Marie, holding her hands over her ears and saying, "If I hear you sing that fucking song one more time, Cherie, I swear my head's gonna explode. Knock it off!"

Miming along to David Bowie at the school talent show, or singing along to records in my bedroom, was one thing . . . but standing up in front of a group of strangers, singing in my own voice, all of them looking at me, judging me, and evaluating me . . . that was a whole other ball game. I started to feel nauseous.

I looked out of the window, expecting to see some high-tech recording studio or gleaming office building. I was naive enough to think it would be something eye-catching and grand like the Capitol Records building on Vine. Instead we were sitting outside of a small, unimpressive suburban house, somewhere in Canoga Park—a residential neighborhood out in the San Fernando Valley.

"I think we're at the wrong place," I said.

Sandie shook her head. "Nope, this is definitely the address."

I grabbed the paper from her hand and looked at it. I glanced back at the little house we were parked outside of and made a face. I guess this *was* it. I opened the door and stepped out onto the sidewalk. The afternoon sun did nothing to help warm me up.

Sandie called after me, "Call me when you're done. And relax! Have fun . . . and good luck!"

"Thanks . . ."

And with that, my big sister was gone. A part of me wanted her to stay, but she'd given me some spiel earlier about not wanting to "crowd my creative space" that made perfect sense at the time, but

the logic of it was lost on me now as I approached the house alone. I walked up the driveway, knocked on the front door. No reply. I gave the door a little push and it swung open.

"Hello?"

I stepped inside, and found myself in a regular-looking suburban house. I could hear the chatter of voices coming from a door to the right. I followed this sound and pushed open the door that led into a big garage. There were instruments all over the place and a raggedy-looking couch over on one end. On the couch was a young girl, around my age, I'd guess. She was sitting there, slapping drumsticks on her knees and then twirling them artfully in her hands. Her hair was dirty blond, and she had muscles literally bursting from her tight, sleeveless T-shirt. Man, talk about being able to beat up a truck driver! She looked up, and the drumsticks suddenly froze in her fingers.

"Hey!" she said. I walked over to her, and she put out her hand for me to shake. I took it, and she had a grip like iron.

"Sandy," she said. "Sandy West. I'm the drummer . . . in case you couldn't tell. You must be Cherie, right?" She grinned when she said this, and her smile was infectious.

"Yeah. I'm Cherie." I smiled. "Nice to meet you."

I looked around the garage, and saw two other girls. Neither of them was Joan Jett. The taller girl approached me first. She had long brown hair and wore black, high-heeled leather boots. There was a guitar casually slung around her shoulders. She had a real sour look on her face. "Hey, I'm Lita. Lita Ford."

"Hi, Lita," I said, reaching out a hand. "Cherie."

She took my hand and scowled. "Damn, your hands are fuckin' cold!"

I laughed nervously at that, and was rewarded with a humorless stare. Then Lita turned her back to me and walked off, leaving me standing there like a doofus.

Sandy got up and stood next to me. She put a hand on my shoulder and said, "Don't sweat it! It'll be fun."

Off in the corner, the third girl was fiddling with an amplifier. She was blond, thin, and pretty frail-looking. I figured she couldn't be more than fourteen years old. Suddenly her amp erupted in a squeal of

earsplitting feedback, and she shouted, "Fuckin' SHIT!" She clicked it off and came over to check me out instead.

"Kari Krome," she said. "I don't play an instrument. I just write the words. Nice to meet you." She smiled, revealing a row of buckteeth. "You're Cheryl, right?"

"Cherie."

All three of them went to the couch so they could stare at me some more. I stood there awkwardly. I felt like I was facing some kind of schoolgirl jury.

"Cherie's a pretty name," said Kari finally.

"So is Kari . . ."

"Is it real?" Sandy asked. "We all have stage names. Well, besides Lita, that is."

"Yeah, that's my real name—Cherie Currie." I shrugged. I immediately clammed up again. I could feel my heart pounding in my chest and my mind racing to find something witty, cool, or intelligent to say.

Lita threw her long hair back with a shake of her head. "It doesn't sound real," she sniffed.

I just stared at her, not sure how to respond. Then Sandy punched her on the arm. "Shut up!" She laughed, and then she turned to me. "Ignore her. It's a great name . . ."

"Thanks . . . I think."

They laughed, breaking the tension a little. Thankfully, that's when Joan Jett and Kim Fowley entered the room. I didn't really know them either, but a familiar face—any familiar face—made me feel a little better. I smiled at them expectantly, and noticed that Kim Fowley was still dressed in that raggedy-looking orange suit from the other night. Right away he was all business.

"Good afternoon, Cherie. Glad you could make it. Just to get everything out in the open: if you pass the audition, you will be replacing a girl named Micki Steele."

"Only she doesn't know it yet!" interjected Joan.

"Yes. Well, poor Micki doesn't quite fit in with the group . . ."

"Yeah." Lita sneered. "Kim doesn't feel that she's good-looking enough, isn't that right?"

"She lacks rock-and-roll authority. This is a rock-and-roll band,"

Kim said. "Nothing against her, but she's just not *pretty* enough. That's important. Anything less than *total world domination* is not an option . . ."

"*And* she's too old!" Joan laughed.

"Yeah," Sandy said. "Anyway, there's *tons* of good bass players around."

I kind of froze up when she said this. "Bass? I don't play bass! How can I replace her?"

Kim frowned at me. "Calm down, dear. All you have to do is sing. Sing and look pretty. We're going to be looking for a fifth girl to play bass, all right?"

I nodded my head, feigning understanding. All of this had happened so fast, and they all were talking over each other so much, I was feeling like a deer caught in headlights. Kim clapped his hands and turned to the girls, yelling, "Okay, dogs! Jump to it! Time is money!"

The girls hopped up from the couch and picked up their instruments like professionals. Joan slung her guitar casually around her neck and strummed a few chords. The way she held that thing, you'd have sworn she'd been born with it around her neck. It was weird because back at the club, there had been something so shy and withdrawn about her. But, man, when she put that guitar around her neck, you couldn't take your eyes off her. She oozed attitude and charisma. I was very, very intimidated by her and totally drawn to her at the same time.

Sandy took her place behind the drum kit and started bashing away. The noise was shocking, reverberating around the small concrete garage. They all seemed so comfortable, so natural, and yet again I started wondering just what the hell I was doing there. Then I noticed the lone microphone standing front and center. Fear flashed through my body. I mean, they looked like a *band*. And then there was me . . .

Slowly the noise died down to a hush, and all eyes turned to me. I could feel myself sweating. I felt the moistness spreading out from my underarms, and I started to panic that there was going to be a great big damp patch in the armpits of my T-shirt. How fucking gross! I thought. They're gonna laugh me out of here if that happens . . .

"So, uh, what song did you learn?" Joan asked. " 'Your Mama Won't Like Me'?"

When she said this, she began playing the grimy, funky guitar riff that opened the track. I stood there, watching her. Her hands moved around the frets like it was second nature. She stopped after a few bars, and seeing me shaking my head, she suggested, " 'Can the Can'?"

With that, Sandy let loose with the stomping, glam-rock beat that kicked off that track. I felt the sweat beginning to drip down my back. *Drip—drip—drip* . . . When I didn't jump on the mike and start singing, they stopped playing one by one, the music clattering to a messy finish. The three of them looked at me questioningly. I cleared my throat and said, "Uh . . . no. What about 'Fever'?"

" 'Fever'?" screamed Lita, in this disgusted voice. Everybody just stood there staring, as if I had said the dumbest thing in the world.

"Do any of you guys know 'Fever'?" mumbled Joan. Slowly everybody began shaking their heads and shrugging.

Holy shit! I'd spent three days perfecting my performance of "Fever," and nobody could play the fucking song. I felt my heart sink through my boots and my face became prickly with heat as I blushed neon red. I looked over to Kim, with this pleading look in my eyes. "You told me to learn any Suzi Quatro song, didn't you?"

But Kim was no help whatsoever. He just rolled his eyes to the ceiling and sighed. "Jesus Christ, why am I surrounded by amateur, teenage dog dirt?" Kari sat next to him on the couch, sniggering to herself.

Lita looked totally turned off by me now. " 'Fever' is too SLOW, man!" she said. "We don't play slow stuff like that!"

My face went from red to deep purple. I could feel them all judging me, laughing at me. Sandy twirled her drumstick and laughed. "Kim! You should have told her we don't play that MOR shit!"

"What—what's MOR?" I stammered.

"Fucking middle-of-the-road, pansy-ass shit, that's what!" Lita spat.

Well, that was it. I figured it was about time for me to drag my sorry ass home and go hide in my bedroom closet for a while. I started to think about how humiliated I was going to be when I got

home and told everyone that I blew it before I even managed to sing a note. Jesus Christ!

"Why don't we just *write* a song for her?" Joan said suddenly.

I looked around the room for clues. "What? Right now?"

"No," Lita snapped, rolling her eyes. "Three weeks from fucking Tuesday. Of course right now! Kim, what do you think? Kari?"

Kari looked as puzzled as I did, but Kim was intrigued. He got this gleam in his eye and said, "Why not? It's only rock and fucking roll, isn't it?" Then he looked up at me and waved his hand dismissively. "Go on, dogs! We have work to do!"

With that, Kim and Joan shuffled out of the garage and into what I had just discovered was Kari Krome's parents' house. The place was deserted, so I figured that they must be at work. Joan took her guitar with her. "We won't be long!" Kim called out to us as they left.

We won't be long? I didn't know enough about music to wonder if this was unusual or not. For all I knew, this was how it worked in the music game. Maybe Bowie and Mick Ronson were in the habit of turning to the rest of the Spiders from Mars and saying, "We won't be long! We're off to write a song." So trying to keep whatever cool I had left, I just stammered, "Sure." Then I sat there with Kari, Sandy, and Lita glaring at me, trying to make small talk.

After a few moments, an obviously agitated Lita turned to Sandy and barked, "Come on! Let's fuckin' play something instead of sitting on our asses!" With that, Sandy jumped behind her drum kit and she and Lita started jamming out "Highway Star" by Deep Purple. As they played together I was amazed at how good they were. I felt like there was no way I would be good enough for this band. Not a chance in hell!

"'Cherry Bomb'?" I said, looking at the sheet of paper that Joan had shoved into my hands. Everybody was in the garage again. This new song had been written in approximately half an hour.

"Yeah," Joan said, "'Cherry Bomb.' Kim and I wrote it just for you. It's, like, a play on your name. Cherie—Cherry. You get it?"

I looked at the paper. The lyrics were scrawled out on a tattered page from one of those spiral notebooks for school. Joan had her guitar slung over her shoulders. Kim was pacing around next to us. "Hmm," I said, examining the words. I started to smile as I read them. They were pretty good, and kind of in-your-face, too. I started to wonder how strange it would feel to sing those words out loud. They had a fuck-you attitude that I liked. It was as if Joan and Kim knew me, because those words pretty much summed up my life at that moment. When I was done, I nodded my head enthusiastically. I looked up at Joan, and she was smiling expectantly.

"Whaddaya think?"

"I like it—"

"Good," Kim interrupted. "So let's do it!" Then he turned to Lita and said, "Play your guitar like this!" He started miming playing a guitar, and tunelessly chanted, *"Duh-duh-duh-duh-duh-duh-duh-duh!"*

Joan started to play the guitar, and it sounded a lot better than the noise Kim was making. Lita joined in, watching Joan's hands for the chords. Sandy tapped along on the hi-hats. Everybody started trying to figure out the song at once. As Joan strummed the opening chords, Kim started singing.

Can't stay at home, can't stay in school . . .

Well, maybe *singing* was too generous a term. He just . . . spoke the words, with that weird, deep voice of his. Whenever he'd chant a line, I would do my best to sing it back to him, imitating his rhythm as best I could.

Old folks say, "You poor little fool."

"Good!" Joan smiled. "You're a fast learner."

As everybody got more and more confident, they started playing the track more forcefully. The noise was reverberating through the whole neighborhood. Over the music I could hear Kim screaming at them to play it faster, louder, dirtier. As the song started to take shape,

I realized it had this stomping beat, and this raw aggression to it, that sounded really different to me. There was a feel to it, like nothing else I'd ever heard. I felt a shiver of electricity run down my spine.

Down in the street I'm the girl next door . . .
I'm the fox you've been waiting for!

I swallowed down my fears. Nobody had ever written a song for me, and I had to admit it felt pretty fucking cool. Of course, this scared me even more, because as excited as I felt right then, I knew that the disappointment would be crushing if this audition didn't work out.

When Lita broke a string, we had to take a short break while she retuned.

"Uh, Joan," I said, pulling her aside, "how many other girls are auditioning to be the lead singer?"

Joan shook her head. "Don't worry about it. This is *your* time. Seriously—they might not show it, but the girls like you. I can tell. And Kim likes you, and that's the most important thing. You've got as good a shot as anyone else . . ."

"But how *many*?" I asked again.

She shrugged. "Not a lot."

"How many is not a lot?"

Joan finally sighed. "Jeez, Cherie, I dunno. Like nine or ten?"

I suddenly wished I had kept my big mouth shut. It was probably better when I *didn't* know. I swallowed my doubts, and we continued to run through the song. "Cherry Bomb" was pretty simple—three verses and a big, rocking chorus. I liked it. I liked it a hell of a lot. I hoped that today wouldn't be the only chance I had to sing it.

When I finally performed the whole song with the band, it passed in a heartbeat. I could barely hear myself above the sound of the blood rushing in my ears. Kim sat with his fingers in his ears and his eyes closed. He listened intently with a look on his face like he was deep in meditation.

I grabbed hold of the microphone and did my best to channel David Bowie.

Hello Daddy, hello Mom!
I'm your ch-ch-ch-ch-ch-ch-ch-cherry bomb!
Hello world! I'm your wild girl!
I'm your ch-ch-ch-ch-ch-ch-ch-cherry bomb!

When the song was done, nobody said anything to me . . . the music stopped, and Kim nodded, looking thoughtful. Then they put their instruments down and shuffled out of the garage into the living room so they could go deliberate. I could hear them all in there, arguing with each other. Complaining. I clamped my hands over my ears, determined not to hear what was going on. Painful minutes passed. With each second that dragged on, my anxiety grew.

This was going on for far too long for it to be good news. They were probably trying to figure out the nicest way to say, "Thanks, but no thanks. Now buzz off back to wherever it is that you came from!"

I still believed somewhere in the back of my mind that picking "Fever" had killed any chance I might have had. They probably thought that I was a total fucking geek. Lita's words echoed in my head: "Middle-of-the-road, pansy-ass shit!" I looked back down to my watch. Twenty minutes had passed! They were probably sitting in there making fun of me. Doing impressions of my singing for each other's amusement. For the nine-hundredth time that afternoon, I cursed myself for not picking "Can the Can."

Suddenly the door opened, and Joan walked into the garage. Behind her were Kim and the rest of the band. Joan's eyes were totally unreadable. The rest of them just stood around with their arms folded, staring at me. I looked to Sandy's face, and I swear her look said, "You sucked." I turned to Kim, and imagined him saying, "You have the look, kid, but you don't got the talent. Now get outta here." I couldn't even bring myself to look at Kari, or Lita, who I was already convinced hated my guts.

"Okay, dogs," Kim said, clapping his hands together. "Looks like it's make-or-break time for our little Cherie Bomb. Let's go down the line. Joan?"

"I liked it."

"Sandy?"

"Great. You were great!"

"Lita?"

Lita looked at me and snorted. She shrugged her shoulders. "Yeah," she said finally, "I guess."

"Kari?"

"Yeah."

"Well," Kim said with a theatrical sigh, "welcome to the doghouse, Cherie. You have been given a chance to be part of history. Now don't fuck it up!"

They all just stood there. I was stunned, unable to speak. Joan was the first one to come over to me. She smiled.

"Congratulations," Joan Jett said. "Welcome to the Runaways."

7

"Welcome to the Runaways"

Before I even knew what was happening, Sandy West had picked me up and literally thrown me over a parked car. Sandy was my friend and I loved her, but she could have a temper and she definitely had the muscles to back it up. Off in the distance, I could hear Kim Fowley screaming, "You fucking *dog*! If that dog puke talks back to me ONE MORE TIME, it's over! In fact, it's all over for *all* you fucking dog cunts! You seem to forget who the main dog is here!"

"Shut up, Cherie!" Sandy screamed in my face. "Goddammit, can't you just keep your fucking mouth shut? You're going to ruin this for everyone! You know what Kim's like!"

Yeah, I knew what Kim was like, all right. This incident took place only weeks into my stint as the Runaways' lead singer. Ever since I'd joined the band, my day-to-day existence had suddenly become *all* about Kim Fowley: his demands, his threats, his expectations, his insults, and his promises. My life was suddenly all about rehearsals, and full of talk about potential record deals; and Kim Fowley was ruthless at the helm like some kind of demented ship's captain. Despite the fact that Kim was loud, and as rude as hell to all of us, something he was doing seemed to be working: there was a definite feeling within the band that something big was about to happen.

But, goddammit, he was a nasty bastard. That's what led to the blowup between Sandy and me. Sandy's strong arms suddenly hurling me through the air did shock me enough to calm me down a little.

A moment ago I'd been ready to snap. It was a typical rehearsal, and Kim had been his usual abusive self, screaming and hurling insults at us, and I had just had enough.

"Listen, man," I'd said. "Don't fucking talk to me like that! I'm not your fucking dog, okay? Don't call me names anymore!"

When you were screaming at Kim, he would always look like he was holding back a laugh. His eyes would look right at you and his face would twitch from a smile to a pucker. It was infuriating. When I was done, Kim smiled and waved his hand dismissively.

"Go and sing," he said in a voice dark with sarcasm. "That's what you're here to do. Why don't you leave the thinking to me, *sweetheart?*"

We stared at each other for a moment as the rest of the band looked on with detached interest. Lita had a smile flickering on her lips. After all, she didn't like me much and she thought that Kim was an asshole, too, so this was prime entertainment for her whatever way it turned out. It was the first time I had tried to assert myself with Kim since joining the band.

My heart was pounding, anger coursing through me. But Kim just nodded again, signaling for me to go back over to the microphone and continue singing. "Go on," he said. I gave him one last look, thought, "Fuck it," and turned to walk back to my spot.

Then I heard him mutter, "Good dog."

Motherfucker!

In the ensuing fight, I called him a lousy bastard cocksucker and he lost it with me, and started threatening to drop the entire band and find some other girls. "Younger, prettier, more talented girls who would appreciate all he was doing for them!" as he put it. That's when we all spilled out of the rehearsal room yelling at each other, and Sandy threw me over the hood of a parked car to silence me.

I looked up at her looming over me. I could see in her eyes that she really didn't want to hurt me. Since I'd joined the Runaways, Sandy and Joan had been the two people closest to me, and I knew that the band meant everything to them. As soon as I hit the ground, Sandy was the first one there to help me up. She pulled me aside and

whispered, "I'm sorry, Cherie. Look—this band means everything to me. When I heard Kim say he'd pull the plug, I just freaked . . . Man, are you okay?" She turned me around and brushed the dirt off my butt.

"I'm okay," I said, starting to laugh a little at the ridiculousness of it all. "I understand."

"Okay, cool . . ." She smiled at me with those beautiful, piercing blue eyes of hers. In a few moments everything would be forgotten, and the rehearsal went on as if nothing had happened.

As I was fast learning, this was just another day in the life of the Runaways.

Joining the Runaways was a little like the scene at the beginning of *The Wizard of Oz* where Dorothy is picked up by the tornado, spun around, and dropped in the topsy-turvy world of Oz. From the moment I joined the band, my life changed. My life didn't change for the *better* necessarily. But it did change.

The first step was completing the lineup. Joan, Sandy, Lita, and I started auditioning bass players. I didn't know a lot about music back then, and I didn't understand why we even *needed* a bass player. I thought that things sounded just fine the way they were. But no, Kim was back to scoping the under-twenty-one clubs looking for talent, and one of the prospects, a recommendation from Rodney Bingenheimer, was a quiet, bookish girl with the unfortunate name of Jackie Fuchs. Jackie was very different from the rest of us. For one, she was real girly, and reminded me a little of Marie because her nails and hair were always perfect. The rest of us were a little tougher, a little less concerned with stuff like that.

I thought that the contrast was interesting, but the rest of the girls didn't think so. Also, she really couldn't play well. Lita, Sandy, and Joan were very serious about their instruments. Lita could play complex Deep Purple riffs with ease, and sometimes I thought that she and Sandy would have been happier playing in a metal band rather than with the Runaways. So when Jackie auditioned and played her bass badly, looking girlish and pretty, they were just about ready to physically throw her out of the room. It was me who made a case for her. I kind of felt bad for Jackie. She seemed sweet, and a little lost.

I felt that she would be a good contrast to the rest of the band, and I figured that her bass playing would improve as things progressed. It was a decision I would definitely come to regret.

"Come on!" I said. "Why not give her a chance?"

I got my way for two reasons. One was that even though Jackie couldn't play so well, she was still better than any of the other girls who auditioned. And then there was Kim, who was eager to get the band moving. Every time things took too long, he was quick to remind us that "This is costing me fucking money! I gotta pay for this trailer, and unless you dogs start earning your way soon, I'm gonna have to put you back on the streets, where you belong!"

Everything with Kim was about money. That was his entire focus—the deal. The record deal was the payoff that Kim was totally obsessed with. He never talked about the money *we* would make on the record. Instead he kept the focus on us all being stars, legends. If Jackie asked about what kind of money we stood to make, he shut her down with a withering look, before informing her drily that she should worry about her bass playing and leave the finances to him. Also, when we were writing songs, Kim was always involved. I was innocent enough back then to think that this was just because he cared about the songs, but it didn't take me long to realize that Kim was sharp enough to know that the real money was in the publishing and he wanted his name attached to as many of the songs as possible.

Also, the fact that Jackie was cute and young didn't count against her with Kim. So when I spoke up for her, Kim initially weighed in on my side. Still, with Joan, Sandy, and Lita putting their collective foot down, Kim told Jackie that she was out of luck. A few weeks later, he came to us with the news that after her unsuccessful first audition, Jackie had supposedly formed her own all-girl band. The way he said it made it perfectly clear that he admired her tenacity and he was going to ask her to come back. Just like that, Jackie was in the band. All that needed to go was her "unattractive" last name— so Jackie Fox was officially the fifth member of the Runaways.

With the lineup completed, rehearsals got under way. The trailer we rehearsed in was tiny and dirty. It was a little mobile trailer on wheels out by Cahuenga and Barham, stuck away in the back of a

minimall with a freeway roaring past it. It was the least glamorous, most disgusting rehearsal space you could imagine. I guess that when we weren't rehearsing in there, somebody kept a dog inside it, because whenever we'd show up for practice, the place was always full of fresh dog shit. We'd have to step our way around it to set up our instruments. They'd clean it up sometimes, but the place was carpeted, so shit was stuck to the carpet fibers, making sure that the place always stank to high heaven. There were some foldout chairs, and sound-proofing on the walls, and that was it.

We had a roadie, an older hippy-looking guy with long brown hair and a beard. He used to pick up Jackie, Joan, and me up in his VW bus to bring us over to rehearsal after school and on weekends. He was a nice guy, but oh boy, did he stink. He soon earned the nickname "Stinky" with the band. He obviously had never used deodorant a day in his life. In the back of the bus there were no seats; instead there was a bed that we would sit on. I guess the bus was his home away from home. I don't know where Kim got him from, but he was the kind of guy who was born to roadie for a rock-and-roll band. Joan and I would be sitting in the back while he blasted Jefferson Airplane on his tape deck, a loose joint dangling from somewhere in his beard. We'd be holding Joan's leather jacket up to our noses to try to block out his toxic body odor. Joan would make faces at me, and I would literally be crying with laughter at the ridiculousness of the situation. I wasn't sure what I had expected from being in a band, but this certainly wasn't it.

"Gosh, man," Joan said one day when she couldn't take it any longer. "You know . . . maybe you should use deodorant or something."

I looked at Joan and almost cracked a rib from laughing so hard. I figured that maybe he'd be offended. But instead, he said very breezily, "No, man . . . I don't believe in deodorant. Did you know that deodorant causes cancer, man? Anyway, the smell of the human body is beautiful. It's a turn-on."

Well, that was it. I was gagging and giggling at the same time. He did carry all of the instruments, though, and help set them up, so we couldn't complain too much.

The rehearsals were long, and we worked hard. It was a trip,

because we were doing something that no other kid in my school was doing. I was sure that even David Bowie had to put up with crappy rehearsal spaces, and dog shit, and screaming managers in the early days. School started to feel like a distraction, and I found myself daydreaming about record deals and concerts packed with screaming fans during the stifling hours I spent in my classrooms.

After the incident where Sandy threw me over the car, I learned to keep my mouth shut, and I even got used to Kim's shouting and screaming. In a strange way, I started to like him. Maybe it was because I didn't have a strong parental figure at home, but when he'd curse me out for not singing a line right, I would genuinely feel awful, and always make sure that I did better the next time. What hurt more than the verbal abuse was the feeling that I had let Kim down. I was suddenly a little girl again, trying to make the only adult in the room proud of me.

Kim had this thing about calling us dogs. We were "dog shit," "dog puke," "dog puck," and "dog piss." If we didn't play a song right, we were as "useless as the fleas on a dog's ass." We were "the flies swarming around a pile of dog shit." Shit, I was fifteen years old and I didn't know any better—none of us did. We just figured this kind of stuff was normal when you were in a band.

Joan was the engine that drove the songwriting, and when we started playing tracks like "You Drive Me Wild" and "Thunder," we really started to feel like the band had a special kind of chemistry. I even got to cowrite a little, throwing lyric ideas in on the songs "Secrets" and "Dead End Justice." After I joined the band, Kari Krome started to get fazed out. I never knew the full story, but I heard that Kim cut her loose one day and I never saw or heard from her again. Incidents like that seemed designed to make us realize that we were all replaceable, so we did our best not to antagonize Kim too much.

With Kari gone, Joan became the main songwriter along with Kim. He was adamant about being involved at every level of the process, and the routine was that Joan usually came up with a song and then Kim added some lyrics to make sure that he got those future royalties. Looking back, it was obvious that Joan didn't need Kim to help her write, but she was as young and insecure as the rest of us,

and Kim really made us all feel that we needed him. After all, we were just the fortunate dogs that Kim had plucked out of the gutter to be superstars. This was Kim Fowley's trip, and we were the lucky few that he'd chosen to come along for the ride.

Everything was written very quickly, and it worked with the spirit of the band. We were young and pissed off, and wanted everything right now, now, now! And the music reflected that. Our songs were about drinking, boys, staying out late, screaming "fuck authority." It may have been rough around the edges, but it had a certain kind of teenage energy that you can't fake. Even though the band started off as a concept, we quickly became a real band. I guess that's why Kim had to assert himself so strongly in the rehearsal room, and in every aspect of our lives. He was probably scared that eventually we'd wise up and realize that WE were the Runaways, not Kim, and like Frankenstein's monster, we'd eventually turn on the man who stitched us together.

"Okay, you dogs, listen up!" Kim said one afternoon. "We're going to have a visitor. He is from Mercury Records. He's an executive, and he has the power to make you famous. His name is Denny Rosencrantz, and you are going to play for him, and you are going to play well . . . " He struck a pose, flicking his tongue and pulling his T-shirt sleeve up over his bony shoulder. For some reason, he thought that was seductive. But, we all thought it was just plain gross.

Denny Rosencrantz was a very Latin-looking, handsome, older guy with a goatee and a tan. Legend has it that he was looking for an all-girl rock-and-roll band because his friend Jimi Hendrix had once told him, "One day, girls are going to play guitars, and there will be girls and women in rock and roll and they're going to be damned good." So when the Runaways came along, he thought that Jimi's prediction was coming true. When Kim led him into the rehearsal room, wearing his nice tailored suit, he looked a little taken aback by the pitiful surroundings. I expected Kim to introduce us, but he didn't. Instead he stood there, the master of ceremonies, and said, "This is the Runaways. They are the future of rock and roll . . ."

Earlier that day, Joan had told me that this was Denny's second visit to the trailer. The first time he came to see an earlier lineup of the

band and had passed, resulting in Kim firing Micki Steele and starting again with Joan, Sandy, and Lita. Hearing stuff like that made me real nervous. This was definitely a make-or-break performance.

"Well," barked Kim, "don't just stand there looking *sexy*. Play, goddammit!"

Sandy counted us off, and we dove into "Cherry Bomb." All through the performance, I looked anywhere but into the eyes of Denny Rosencrantz. When the final note rang out, we looked over to him expectantly. Denny turned to Kim and gave him a nod. He was smiling. Then he turned to us and said, "Girls—how would you like to make a record for me?"

Nobody knew what to say. A record? It felt like I had barely been in the band for two minutes, and now we had a deal with Mercury Records? I felt light-headed, euphoric. It was left to Lita to sum up the mood in the room when she said, "Fuck yeah, Mr. Rosencrantz, we wanna make a record!"

Mom's News

When Mom finally returned from Indonesia, I was bubbling over with news for her. In the weeks since I joined the Runaways, things had been happening pretty quickly. Kim had been organizing warm-up gigs for us. We started playing shows at house parties, full of other teenage kids, setting up in the living room or even on the roof in one instance. Kim had us dress in matching T-shirts with the Runaways logo on them—a cherry, inspired by "Cherry Bomb." These shows were chaotic, exciting, and messy. The kids in the audience reacted to us in such a crazy, hysterical manner that it seemed like they might tear the place apart. One of these gigs ended up being stopped by the police because the kids were getting so rowdy.

I soon learned that Kim Fowley, as well as being a weirdo with the dress sense of an escaped mental patient on acid, was also a master of hype and media manipulation: word of mouth on the Runaways had been spreading far and wide, and we hadn't even signed the deal with Mercury yet. The idea of a group of teenage girls playing real rock and roll was causing serious waves in the L.A. music scene.

So when Mom finally walked in the door, I was on her immediately, bombarding her with news about the record deal, the shows, and the press interviews. My mom nervously shot Wolfgang a look and then crushed my enthusiasm as quickly as the time my dad hit me with the news that he was moving to Texas.

"Well . . . that's great, honey," she said. "That's really great. But Wolfgang and I have some wonderful news for you, too . . ."

One day later, and Mom's "wonderful news" was really starting to sink in. As a steady rain splashed against the window, I began seething more steadily with resentment. My mom was marrying Wolfgang, and moving to fucking Indonesia.

It is difficult to describe how this made me feel. To say that the wind had been taken out of my sails would be a huge understatement. When Mom arrived home, I was on top of the world—brimming over with the feeling that I was a part of something *important*. At fifteen years old, I was the lead singer in a band that was about to sign with a major record label. I had found my calling; I knew what I wanted to do with the rest of my life. I was becoming fast friends with the girls in the band, and already there was a real sense of family among us. The Runaways were going to take over the world; we had no doubt about it.

Instead of my having even one day to enjoy our success, all of it was suddenly swept away by Mom and Wolfgang's news. The rage inside of me was almost unbearable. I wondered if she even cared about my happiness. Did I even matter to her? At fifteen, I already had a degree of independence that most kids my age never know. To have that suddenly snatched away from me, to be reminded that I was nothing more than an accessory to my mother's plans, really hurt. But more than the rage was the fear. The uncertainty. I mean—what the hell was going to happen to *us*?

Indonesia? Until Mom met Wolfgang, I had no idea that Indonesia even existed. As far as I was concerned, she might as well have come home and announced that she was taking off to start a new life on planet Mars.

"So, what should we do?" Marie asked me for the millionth time that morning. Marie, Donnie, and I had all been sitting around the den whispering about my mother's latest crazy plan. Mom had gone again; she was over at the shop, trying to catch up on all the work she'd missed. I couldn't even dwell on how *that* made me feel. Wolfgang, the shop—it was getting hard to see what *our* place in Mom's life even was.

"How the hell should I know?" I snapped. "Indo-fucking-nesia? Like Texas wasn't far enough for her, she had to go one better and jump fucking continents?" I scowled, and continued staring at the floor as if I would discover some sort of solution down there.

"Well, I'm *going*," said Donnie. "I don't wanna stay here! I want to explore the world! See new things! Live in the jungle! Wolfgang says there's jungles all over *Indosia*."

"It's *In-do-nesia*, dip-shit," I said.

I couldn't decide what hurt more. The fact that my mom had announced that she was leaving for Indonesia, and then dropped the biggest decision of my life on my lap at fifteen years old . . . or that she actually said yes to marrying Wolfgang. Words could not describe the loathing I felt for Wolfgang right then. The idea of my mom marrying anyone else but my dad filled me with self-righteous fury. How dare he try to take my dad's place!

"Do you *really* think that she'll sell the house?" Marie asked.

"Duh! Of course she will! You know Mom—she's gonna do what's best for her, and as for what we want . . . Once she's made up her mind . . . that's it."

Mom never changed her mind. It was another thing about her that made me mad. I felt like I could break something. Or someone. If we stayed, we would have to move in with Grandma and Aunt Evie. Sandie would continue on in her unwanted "mom" role for a while longer, at least until the house and everything we owned in the world was sold. The idea of all of us being crammed into Aunt Evie's tiny house was not something I was looking forward to.

"Well, I'm going!" Donnie announced again.

"Yeah, we heard you!" I sneered. "So why don't you just shut up and let us talk?"

"I'm just saying! I'm not moving in with Grandma and Aunt Evie, so there'll be more room for you guys! Besides, it's so *boring* there . . ."

"Oh *yeah*?" Marie said. "But what if Dad comes back?"

Donnie got thoughtful when Marie said this. We spoke to Dad every week, and we were always asking him if he was going to come back, but he never gave us an answer. He would never tell us about what he was planning to do. Aunt Evie had confided in us that his

eight-track business wasn't doing well, and that he was selling Dish-masters instead. Of course, Dad would never tell us that himself, he was way too proud. Grandma had even gone as far as saying that Dad was going to move back from Texas anytime now. A part of me still found it hard to believe, though. Donnie turned away from us and stared at the TV. *The Andy Griffith Show* was on, with the sound turned down. Donnie kind of reminded me of Opie, because he was such a good-hearted kid. I actually thought it was a brave thing to want to see the world.

Donnie had proved to me just a few years ago how brave he really was. When I was in fifth grade, a sixth-grade bully named Danny slapped me in the face for sticking up for a girlfriend of mine that he was picking on. When Donnie saw me crying and I told him what happened, he told me, "Don't worry, sis, I'll take care of it." Then he gave me a hug. Don was only in the third grade then. Later that day, as we were sitting outside in the lunch area, we heard screaming, and here came Danny running like a bat out of hell with my little brother, Don, hot on his heels, hitting him everywhere but the bottoms of his feet. They vanished around the corner while everybody looked on. A few minutes later, a beaten, bruised, and red-faced Danny walked up to me and apologized. "I'm sorry! I'll never bother you again . . . but please, don't sic your brother on me anymore . . . *please*!"

Even though we fought like hell, I loved Donnie, and the thought of him moving to another part of the world made me feel sick inside. I never dreamed that I wouldn't have Donnie around to pick on. I didn't even want to call him "Dumbo Ears" anymore.

"I don't care," Donnie said to no one in particular. "Even if Dad *does* come back, I'm going. I want to live with Mom and Wolfgang—I like Wolfgang. He's cool, and he's smart, and he told me that he'll take me all over the world. Plus . . . he said that he'll buy me a bike."

I said to Donnie, "It must be easy being a moron," but there was no malice in it. When you're his age, the promise of a big house and a brand-new bike is irresistible. He gave me the finger, so I jumped on him and start tickling him, until he got red in the face and screamed, "UNCLE!"

It seemed that as soon as things started going my way, something

had to come along to ruin it all. Just weeks after joining the Runaways, I was being forced to choose between the band and my own brother and mother. I mean—how was I supposed to do that?

Despite the rehearsals every day after school, and on weekends, from two in the afternoon until late in the evening in that stinking little trailer, being the lead singer of a rock band had been an incredible experience so far. The music was powerful, and there was a real electricity when the five of us played together: the small shows that we had played so far had given us a taste of just what a stir the Runaways could create. To give up this once-in-a-lifetime opportunity to go live in Indonesia with Mom and Wolfgang was just not going to happen.

Kim ran the band like a finely tuned sports team, with him as the maniacal coach barking from the sidelines. *"You stupid dogs! You fucking fleas on the ass of a dog! Go to the E minor there, you fucking piece of idiot dog shit! You girls suck! You sound like dog vomit!"* But it worked: we all feared Kim Fowley. And the fear worked: if you didn't want Kim in your face spitting "dog's asshole!" then you hit all your notes, and you gave each run-through one hundred percent.

Finally, after putting up with his well-rehearsed tantrums and rampages, we were able to ink the deal with Mercury and record a debut album "that will alter the face of rock and roll—FOREVER!" as Kim liked to put it.

Kim Fowley was a master of hype. He organized photo shoots and magazine interviews. He drilled us about how to act and what to say. He invented wild stories. Even hired kids to picket outside rock concerts, holding signs that read WE WANT THE RUNAWAYS! The people who did the interviews didn't have a clue what to make of us. Most of the time they were these long-haired, jaded guys who didn't think for a minute that we played our own instruments. In fact, they'd ask us to outright confess to the "lies," and demand that we tell them that this whole thing was some kind of scam concocted by Kim Fowley. They'd ask Joan dumb questions like "So, uh, what makes you *think* you can play the guitar?" Joan got pissed when people said dumb shit like that to her, but in the end we had to laugh. We just thought of them as assholes. I didn't realize it at the time, but this attitude was

one that would hound the Runaways for our entire career. Our songs were about sex, heartbreak, partying, and the teenaged rock-and-roll lifestyle . . . all of the things that mattered to us. It's funny to think how a bunch of teenage girls could drive those journalists so *crazy*. Kim encouraged us to be even more outrageous. He kept telling us that we were going to be the biggest band in the world, and part of me was beginning to believe him.

"Sex sells," he told us constantly. "But teenage, jailbait sex? It makes a man want to spew in his pants! It's provocative! Makes the chicks want to grab their crotch. It's jailbait, dry-humping paradise for these old fucks! And that's the best kind of sex there is . . ."

The Runaways train had left the station and I was on it, plain and simple. As if reading my mind, Donnie said, "There'll probably be rock bands in In-do-nemia. They'll probably use coconuts instead of drums, and washboards for guitars."

"Shut up, Donnie!" Marie laughed.

I knew that right at that moment Kim Fowley was off making the deal with Mercury Records. "There's no band like the Runaways in Indonesia," I said, staring out into space.

Don got huffy and told me, "Well, I'm going whether you go or not!"

I threw a pillow at him, catching him good on the head.

While the walls were crashing down on me with my family, I started to see the girls more as a substitute family. Music, which had always been my drug, was now the only thing I could rely on. And the last thing I needed was to feel sorry for myself. Though my home life sucked, I wasn't the only one in the band with problems. Those girls had plenty of their own to deal with! In the three weeks I'd known them, I'd learned that Joan's mom was all alone, working like a dog to keep the family together and put food on the table. Jackie also came from a single-parent household. Sandy and Lita were the lucky ones. Their parents were still together and I was happy for them. "Wolf-gang's house is huge," Marie said finally. "I mean—you saw the pictures. We'd each get our own room."

I stared at Marie, sick of the whole conversation at that point. "Is that what you want?" I demanded. "Is that all you care about?"

Marie shouted at me, "I just want us to stay together! That's ALL I want! What's wrong with that?"

I looked over at Donnie, who was already in Indonesia in his mind.

"I mean as many of us as possible," Marie said quietly.

It was getting close to two o'clock. I was due at rehearsal soon. I imagined how it would feel to walk into rehearsal today and announce that I was leaving the band to move to Indonesia. The girls would all tell me that I'd lost my fucking mind. As for Kim, I don't know, but I had the impression that as far as he was concerned, one pretty blond fifteen-year-old was as good as another. He'd probably replace me before I was even on the plane.

"Marie," I said, "if I stay and move in with Grandma and Aunt Evie . . . what would you do?"

Without even pausing, Marie said, "I'll do whatever you do, Cherie. We have to stay together."

There was nothing more to say. Pretty soon I heard a couple of long blasts as Stinky signaled with the horn that he was waiting outside. As I walked out the door toward that banged up VW bus, I looked back to the house. Marie was standing at the door, and she waved with a slight smile on her face like she could read my mind. "Indonesia?" she called after me, with a sparkle in her eye.

I turned, struck a pose, then yelled. "When pigs fly!"

Saying Good-bye

The weeks leading up to Mom's departure for Indonesia were terrible. Really, really terrible. The house was in an uproar, and us kids could only look on as the last strands of our old happy, stable family life were slowly ripped apart. When Marie and I told Mom that we would not be going to Indonesia with her, she said nothing for a while. Her face showed no emotion. She simply said, "If that's what you want . . ." and walked away, continuing the process of dismantling our family unit.

It turned out that Grandma and Aunt Evie were right about Dad coming back. That should have been cause for celebration, but it wasn't, not really. The reason was Mom. Once Mom realized that Marie and I were not going to go with her, she began calling Dad up and screaming at him. Even though my father was already planning on returning, Mom started *demanding* that he return immediately. I remembered Dad's words from three years ago: "You know your mom—she always wants to be the one who wears the pants in the family. And you know I don't go for that kind of stuff, Kitten."

I started to fear that Dad would decide to stay in Texas, just to spite her. Marie and I would sit silently on the front porch, listening to them argue over the phone. My mother was hysterical. "They're your CHILDREN! They need you, dammit! Don't you love them; don't you care about them?"

We'd wince when she said stuff like that. It was like the old days

all over again, before they'd separated. My mom was always good at sticking Dad where it really hurt, and then twisting the blade. We could hear him on the other end of the phone raising his voice—which was totally out of character for him. It was an angry, distorted electronic noise, like a wasp was stuck in the receiver. Mom had decided that since Marie and I were going to stay in California, it was our father's duty to return home right away to look after us.

True to my fears, Mom's interference made things worse. Dad argued. He got angry. The very fact that my mother had suddenly started *ordering* him to return home had set him firmly against the whole idea. The simple fact was that he didn't want to deal with Mom. Our mother would relate all of the latest twists and turns to us over the breakfast table, her eyes wet with tears, and the insinuation was not lost on us. *He doesn't want the responsibility of looking after you girls,* she was saying. *He doesn't want to come home.*

In the end, though, my mother won. Just like in the old days, Mom got her way and Dad agreed to return, brimming with anger and resentment, to resume his life with Aunt Evie, Grandma, and us. With Dad home, Mom decided that she would rent out the house. But later, Wolfgang insisted that she sell it. When we discovered this latest twist, I was furious. Wolfgang had already taken away our mother and our brother, and now he was taking our home away, too. Didn't he have a heart?

So Marie and I found ourselves sharing a small bedroom in Aunt Evie's tiny, crowded house. When we moved in, Aunt Evie told us, "This is your home now. This will always be your home base." Although it was amazing to have our father back in our lives, and the house was filled with familial love, there were still big adjustments.

Already, Mom's distrust of me was mounting. First, I had decided to stay in California rather than live with her. The idea that the Runaways were more important to me than my own mother was a pill she couldn't swallow. In a way, I felt that she would be relieved when she finally left. Our arguments over the past few months had started to turn physical. I was a hurt, angry teenager and my mom was probably glad to be getting away from it all.

Then Kim Fowley showed up at the door after rehearsal one day. I had made the mistake of telling him what was going on. He started shouting and screaming at my startled mother that I had a legally binding contract with Mercury Records and that I couldn't move to Indonesia even if I wanted to.

We had signed the contracts a few days earlier. Because we were all so young, our parents or guardians had to come in and sign for us. With everything that was going on at home, I decided that my sister Sandie would be the best person to come with me. Sandie, who had a little more experience than the other girls' parents when it came to contracts, looked over the paperwork and was about to object. I made a face at her, mouthing "Shut up!" She pulled me aside and told me that the contract put Kim in charge of all of the money, and that was not a good idea, as she thought that Kim was a real snake. I told her to to leave it alone. "If you ruin this for me, I'll never forgive you! Just sign the paper, and don't make waves! I'll never get an opportunity like this again!"

So when Kim got wind of Mom's upcoming move to Indonesia and decided to interfere, he immediately made things much worse. He ranted and raved, waving the paperwork around, and basically told my mom that I belonged to him now, and if she didn't like it she'd better have a good lawyer. My mom stood there, with her jaw on the floor, while this strange man in an orange suit told her he would sue her if she tried to take her own daughter to another country. She slammed the door in his face. But the damage was already done.

When Marie and I moved to Aunt Evie's, Donnie was sent ahead to Indonesia. Mom was due to leave a few weeks later. With the contracts signed, we were immediately put into Fidelity Studios to record the Runaways' debut album.

"You're costing me money!" That was Kim's mantra throughout the recording of the debut album. Recording an album with Kim Fowley at the control was a real step back in time. This was the seventies—albums were big business. Bowie had been releasing beautifully produced albums for years. Led Zeppelin, Pink Floyd, Elton John . . . this was the era of the double LP with beautiful gatefold art,

a product specifically designed to be listened to from beginning to end. This was the era of the album as art—something to be carefully crafted and perfected.

Recording *The Runaways* was a throwback to the Sun Records era: the philosophy was set the tape running, play the song, and get the fuck out of the studio.

Screwing up was not an option. To that end, Jackie Fox was replaced by a skinny bass player with an English accent named Nigel Harrison, who was in some supposedly up-and-coming band we had never heard of called Blondie. Jackie had to look on while Nigel played the songs with the band. This was hard on Jackie—I think the first she knew of it was when Nigel showed up and introduced himself as the bass player.

Kim produced the record the same way he would deal with us in rehearsal: he wanted to make it fast, make it cheap, and get it to market as quickly as possible. There were never instances of Kim sitting in the producer's chair looking thoughtful, wondering if we could get a better take. Each song was run through three times at most, and the best take was picked. It was the same way with the vocals. I had never sung in a recording studio before, and the first time I stood in there facing down that drop mike, with the headphones on, I totally froze. The music was blasting in my headphones, but my voice came out weak and unsure. The tape immediately stopped. I heard Kim storming toward the booth, and I closed my eyes, preparing myself for another verbal backlash. Instead, a totally different Kim popped his head through the booth.

"What's the problem, Cherie?"

"Uh, I'm just nervous, Kim! I'm sorry! I'll . . . I'll try again!"

"Hmm . . ." Kim looked thoughtful for a moment. Then he left the booth, reentering with a harassed-looking engineer in tow. "Take the drop mike out of here," he told the engineer. "I want a regular mike. One she can hold and move around with."

The engineer started objecting, saying that the sound quality wouldn't be right, but Kim dismissed his objections with a wave of his hand.

"It's rock and roll! Who gives a shit about the sound quality? You

think the fucking *kids* are gonna care about what kind of mike she used?"

After a few moments of the engineer rewiring the room, and cursing Kim under his breath, I was standing there with a microphone in my hand.

"The problem," Kim said, "is that you aren't performing. You're trying to SING. I want the Cherry Bomb, not Cherie. Don't think that because we're in the studio that you have to start trying to sing in tune or anything. Move around if you have to. Grab the microphone—wave it around. This isn't high art. You aren't a fucking opera singer or some dog shit like that. This is rock and roll. You have to project—rock-and-roll authority, remember?"

I looked around the sterile room, stuffed full of wires and recording equipment. "It feels kind of weird," I said. "I mean, doing it on-stage is one thing . . . but here?" Kim reached over, and flicked off the light. The room was immediately plunged into darkness. I stood there, confused and afraid to say anything. "Now you're in the dark," he said. "Now you're not in a recording studio anymore. You're on-stage. The room is packed. Do you need anything, water?"

"No," I said meekly.

"Then let's go!" Kim clicked his fingers impatiently. "You ready to do it?"

"Yeah . . ."

This was the closest to tenderness that Kim ever got. At moments like this, I felt that I loved Kim in some weird way. Not loved him like I found him attractive—ugh, God no—but I wanted to make him happy. I wanted to prove him right. Despite the screams, the threats, and the abuse, I was still a kid and Kim Fowley was the only regular adult figure in my day-to-day life. So I instinctively wanted to make him proud of me. I guess when you're a twin, you have some issues with that stuff. Never feeling like a whole person. Always having to compete for the attention of adults. I suppose this was the same mix of love and fear that makes a battered wife stay with her husband.

The next time the song kicked in, I was ready. I moved around in the dark, imagining that I was onstage at one of the tiny, packed clubs

we had been playing. I sang the words as if I were competing with the roar of thousands of kids packed into a full-blown arena. When the track ended, I waited a couple of moments and then said into the mike, "How was that?"

"Great," Kim said through my headphones. "Do it again."

"Can't I listen to it?"

"No!" Kim barked. "There'll be plenty of time for listening and dog shit like that when the album is out. Now come on—time is fucking money!"

The album was recorded and mixed within a matter of weeks. On the day that we finished recording, I came home from the studio to say my good-byes to Mom. I couldn't even feel excited that I had just recorded an album with my band. My mind was fixed on my mother's imminent departure. She was due to leave for the airport later that day. I let myself in, and Marie was standing there looking guilty.

"What's up?" I said. "Where's Mom? Is she still packing?"

Marie shook her head.

"Then where is she? Out back?"

"Mom's gone, Cherie. She left for the airport already."

"*What?*"

I checked the time again. I had left the studio early so I could say good-bye to her. I looked at Marie; was she joking? One glance at her face told me that she wasn't.

"I gotta get to the airport! Come on!"

Marie and I sped toward the airport, trying to catch up with Mom. I had to beg Marie to drive me because I still didn't have my driver's license. I sat there in the passenger seat silently, my mind racing. Why on earth did she leave without saying good-bye? Did she hate me that much for wanting to stay? Was it because of what Kim Fowley said to her? It must be! She had changed after that. There was this unspoken feeling that she and I weren't even on the same side anymore. The distrust was brewing. Or could it be because of Dad? She always said I was a daddy's girl, and when she was mad at him, it would spill over inexplicably into her being mad at me. I was on Dad's side. I was on Kim's side. I started to realize that as far as my mother was concerned, I was on everybody's side except hers.

I caught Marie glancing at me as she drove. I looked back at her, and she looked away quickly.

"What's going on? There's something else, isn't there?" I demanded.

Marie got real quiet for a moment, and then spoke quietly and deliberately. "Mom thinks . . . well, she thinks that you're going to serve her with court papers."

"What? What the hell do you mean? What court papers?"

"Like, a court order. She has this idea that you . . . that you and Dad are planning to keep her here. To make her take custody of us."

I started to cry inside. In the period after Dad left and Mom was taking care of us, I had gotten used to the calm. But now things were worse than ever: it was the same old drama that the two of them seemed incapable of getting beyond. They were fighting about who should keep the house, who should get the money, who should take care of the kids . . . and they were using anything they could to hurt, batter, and humiliate each other. It was exactly like the old days, the days before Dad left. And now my mother had decided that I was against her, too. There was no more shocking feeling in the world than realizing that my own mother considered me her enemy.

Before Marie had even put the car in park, I was sprinting across the lot, trying to find Mom. I shoved my way through dazed travelers, nearly knocking over an old lady dragging a suitcase, running through LAX like a mad person screaming for her. I had to find her before she boarded the plane! I had to tell her that I loved her, that I wanted her to be happy, that I would never have dreamed of serving her with court papers . . . "You're my mother!" I wanted to tell her. "I want you to be happy!"

Her flight hadn't left yet, and I began frantically searching for her. I had made it all the way to the gate when I caught a glimpse of her. I almost didn't recognize her. She was wearing sunglasses and a big hat that obscured most of her face. She was going at a fast pace, not looking up. Quick and determined, she walked right past me without looking.

It was then that it hit me, that my own mother was wearing a fucking disguise. She was so scared that I was going to hit her with some kind of court order from Dad that she was sneaking out of the

country to avoid me. As she hurried through the gate, I ran toward her, but suddenly found myself blocked by two security guards. I tried to shove my way past them, and they had to restrain me.

"You can't stop me from seeing my MOTHER!" I screamed at them. "I might never see her again! Let me through! LET ME THROUGH!"

They didn't care. It wasn't their job to care. A crowd started to gather as my screams got louder and more hysterical. "Get your hands off me, you asshole!" I screamed at the guard closest to me. "MOM!" I bellowed, "MOMMY! MOOOOOMMMM!" I saw her disappearing down the walkway to the plane and I struggled violently, but the guards held me back. "MOM! I WANT TO SAY GOOD-BYE TO YOU! MOMMY!"

By now, I was hysterical, tears streaming down my face. I saw her shudder at the sound of my voice, but she did not stop or even slow down. "YOU NEVER SAID GOOD-BYE!" I screamed, but it was no good. My mom was so convinced I was here with some devious, ulterior motive that she would not turn back.

By this time a third security guard had arrived, a big bastard, and he grabbed me hard. But it was pointless. All the fight had gone out of me. Marie came running over, and was fighting her way through the crowd that had gathered around me. I flopped into the arms of the guard, sobbing, and saying over and over "Mommy, I love you . . . please . . ." but she was already gone.

I couldn't breathe. I heard Marie telling the guards, "She's my sister. I'm sorry . . . I'll take care of her," and I fell into her arms and cried harder than I have ever cried in my life. Marie had to practically carry me back to the car. She sat me down inside, and we just stayed there for a while, not talking. When my breathing was under control, Marie said, "It'll be all right, Cherie. I promise. You can call Mom when she gets to Indonesia, and explain everything. You can explain the truth to her, and she'll realize that it was all a big mistake."

I didn't answer. Marie stuck the key in the ignition and started back for the house.

Call my mother? Explain to HER? The thought brought a horrendous, rancid taste into my throat. I didn't know if I would ever

be able to speak to my mother again after this. I cried again, I cried all the way home. Not just because of what had happened, but because I knew that after today I would never be the same. Something turned off inside of me that day. Something inside of me snapped, and I stopped caring. I never wanted to feel like that again, and so I began to learn how to shove those feeling deep, deep down inside of myself to a place where they could not hurt me anymore.

The pain of realizing that my own mother was afraid of me was too much for me to deal with. So I had to force myself to stop caring. To stop feeling. It would be two years before I saw my mom again.

Lita's take on it was simple."Don't worry about it," she said. "Parents can be weird. It's their job to be weird."

We were in a tiny, decrepit dressing room following our first official performance as Mercury Records recording artists. It was at a tiny club called Wildman Sam's. When I say tiny, I mean it: this place might as well have been someone's living room. The show was wild that night. After the crazy rehearsal schedule, and the constant running through of the songs, we were on fire. We played so loud, and the tiny place was packed with two hundred kids who danced so hard that I expected the plaster to start falling from the ceiling in great powdery chunks. I guess that's what they call bringing down the house.

"Yeah, I guess. It just sucks, though . . ." I said back to Lita.

Outside of the dressing room, people were trying to get in to meet us. You could hear them yelling, and begging to be let in. Kim was acting as security.

"Look at what we have going on right now, Cherie," Lita said. "People are going crazy for us. This will all work out. Don't let it bum you out . . ."

I looked over at Joan. She caught my eye and smiled at me. It was one of those special smiles that she would give me from time to time, like there was some secret between us. Some unspoken understanding. I smiled back at her, and she looked away, leaving me feeling a little light-headed. The pounding on the door, the pleading to come

backstage to meet us, and Kim's yells reverberated from somewhere out in the hallway. Somehow I felt that so long as I had the girls—Joan and Sandy in particular—then maybe I really would be able to deal with all of this.

After all—what other choice did I have?

18

Highs and Lows

With the album recorded, pressed, and in shops in record time, things started moving quickly. There was one last hometown show to do, and then we would set off on our first U.S. tour. We were in Stinky's van, heading toward the venue. I shifted around uncomfortably, trying to ignore the incessant cramping in the pit of my stomach. What a day to get my period! And I didn't even have any aspirin . . . However, not even the cramps or the toxic odor of Stinky's van could ruin my mood. I looked over to Joan and Jackie, and I could see a similar excitement building on their faces. Everybody's nerves were on edge about tonight's show, and why not? This one was going to be special.

Tonight we were playing the Starwood, one of the hottest clubs in West Hollywood. The Starwood was a really cool (although kind of skuzzy) club run by the infamous Eddie Nash. All of the hottest bands had passed through the place, and the audience was an exciting mix of musicians, movie stars, rock legends, and shadowy underworld figures. According to Kim, "everyone" would be there tonight. We had been pressing him excitedly about just who "everyone" was, but he was keeping unusually tight-lipped about the details.

We had played the Starwood once before; it was one of our first "big" shows. That time Kim grabbed hold of me backstage and said, "There's someone I'd like you to meet!" I turned, and there, standing in front of me, were none other than Robert Plant—who was

wearing a Runaways "Robert Loves Kim" T-shirt—and Jimmy Page. I did everything I could to keep my composure, so just shook their hands politely and told them it was nice to meet them. Then Kim led us all into the dressing room, and Lita just about fainted when she saw them. A rock guitarist having the opportunity to hang out with Jimmy Page was like a devout Catholic getting an audience with the pope.

Meeting celebrities was not the only reason I was excited about tonight. The band had outgrown the matching T-shirts, and Kim had brought on a designer called Ciri, who had helped design some cool stage outfits for us: a silver lamé jumpsuit for me, red and black for Joan . . . all of this in preparation for the upcoming U.S. tour. Also, for the first time, I would perform "Cherry Bomb" dressed in a white satin and black lace corset bought from a lingerie store right across the street from the venue. I had seen it there the day before, and something made me stop and look again. As I pressed my nose to the glass, that corset set my brain on fire. Man, how cool would it be if I wore that onstage?

Kim was always screaming that I lacked "rock-and-roll authority." I imagined standing in front of the audience, dressed in *that* getup. That would really blow people's minds. I ran to get Scott Anderson, our new personal manager, and we gawked at the corset together before going inside so I could try it on. When I walked out of the dressing room wearing it, Scott immediately smiled and said "Sold!" and put down the sixty bucks. I don't know what the saleslady thought of some older guy buying sexy lingerie for a sixteen-year-old, but it probably didn't look good. I noticed the way Scott looked at me when I stepped out of the dressing room, and wondered—not for the first time—if he liked me. I had been noticing him giving me long, sideways glances. He was kind of a geeky guy, but then again, I seem to have a thing for oddballs.

Back at the venue, Kim was sold on the whole idea, and he even had me try on the outfit so he could see for himself.

"I want to wear it when I sing 'Cherry Bomb,'" I told him as I emerged from the dressing room. Kim just nodded.

"Turn around. Slowly."

I did, and Kim stared at me, looking thoughtful.

"Before you perform 'Cherry Bomb,' Joan sings 'You Drive Me Wild.' That should be enough time to change."

Kim really saw the potential and ordered, "We'll build you a changing room, right onstage. You will disappear behind the black curtain, and then with a little sleight of hand, Cherie Currie will reemerge transformed. You won't just sing 'Cherry Bomb'—you will BE the Cherry Bomb!"

When Kim announced this to the rest of the band, Lita looked pissed. As the shows had gotten bigger and bigger, I'd noticed a dark shift in Lita's attitude toward me. As I grew more confident in front of audiences, I sensed a growing resentment about how much attention I was getting. Lita seemed threatened by it. Every so often she would make bitchy comments about how skinny I was, and it was obvious this was because she was starting to have some weight issues of her own. Weight issues as in she was getting a fat ass. When you live on a diet of cheeseburgers and beer, keeping in shape ain't easy. That's why I'd only eat fish and vegetables—that drove Lita fucking nuts. So when Kim told everybody about my costume change, Lita just went off, as if the whole corset idea was a personal ploy to take attention away from her guitar playing.

I didn't take it too badly, though. I was beginning to learn that the best way to deal with Lita Ford's tantrums was to ignore them completely.

As the van pulled up to the venue, we noticed that kids had already started to line up outside. "Man," I said as the van came to a stop, "people are already waiting to get in?"

As soon as we got out, the fans rushed over to us to ask for autographs. The first time this happened, it was a surreal experience. I felt a little weird and unworthy. But as it happened more and more, I was learning to adjust to it. With each successive show, things got bigger and better. Having a record out changed everything. The audiences screamed for us, they knew our names; they'd line up for hours to see our shows. There was a big buzz about the Runaways in the L.A. scene. We all could feel that something was definitely about to happen, and all of the hard work was going to pay off.

As I exited the van, a girl with long, dark hair and a battered-looking leather jacket approached me shyly. "Hey, Cherie," she said. "Man . . . we think you guys are so cool. Would you, uh . . . would you sign this for me?"

Without making eye contact, she shoved a copy of *Bomp* magazine in my hands. I remembered some journalist hanging out with us a few weeks ago to do an interview, but I hadn't seen the magazine until now. My picture was on the cover. I wanted to be happy but wondered if the others had seen this yet. Ugh, Lita was going to throw a shit fit when she saw that they didn't use a group shot. It gave me a sinking feeling inside.

I smiled at the kid and said, "Sure I will."

She handed me a pen, and I scrawled my name on the cover. Then the kid grabbed me, and she planted a kiss right on my cheek before running off. I started to laugh. Man, I could really get used to this.

"C'mon!" Stinky grabbed me by the arm and led me into the club. Walking into the Starwood, I got a rush of adrenaline when I saw the stage. Sandy and Lita had traveled separately and were there already—Lita thrashing out big heavy power chords, and Sandy grinning and twirling her drumsticks. People were running around like crazy, barking instructions, setting up for tonight, and the colored lights were bouncing off the drum kit, dazzling me. Sandy saw us watching, and jumped out from behind her kit, running over to give each of us a hug. Lita kept on thrashing away on her guitar like she was trying to draw blood.

Joan and Jackie got onstage and plugged in, and then we started to run through a few songs. As the last note of "California Paradise" rang out through the empty, cavernous room, I walked over to check out the "dressing room." It was a shoddy, makeshift wooden box with a black curtain stapled to it. My friend Vickie would help me change into the corset, and with both of us in there, it was going to be a tight squeeze, like trying to change in a rickety, upright coffin. It was going to be a hell of a night, that's for sure.

Even Kim was in a good mood. After sound check, he took us to Hamburger Hamlet on Sunset, which made us think that maybe the world was coming to an end. By the time we made it back to the club

an hour and a half later, the line to get into the Starwood stretched around the block and halfway up Crescent Heights. Lita pressed her face against the VW's filthy window and then said, "Fuck, man! Look at all those people! They're all here to fucking see US!"

Joan just stared and said, "Wow . . ."

"Kim," Jackie said, "you *are* going to make sure security takes us into the dressing room, aren't you?"

Kim sighed, rolled his eyes, and ordered Stinky to keep us in the van while he went to look for security. . .

Slipping in the back door of the club, you could feel the energy already. The air inside was hot, and wet. The place was full to capacity and the crowd was already screaming "RUN-A-WAYS! RUN-A-WAYS!" They yelled it over the opening band as they finished a song and rushed into their next number. There was a bunch of people as we were rushed through the back corridors and toward the dressing room. Kim was walking next to me, and my cramps were starting to bother me again.

"Uh, Kim . . . Do you have any aspirin?" I asked, through gritted teeth.

"Why?" Kim said. "Are you sick?" He grinned, as if the idea that I might be sick was amusing to him, the bastard.

"No. I've got my period, okay? I have cramps."

"Ugh!" Kim said, looking thoroughly disgusted. "One of my dogs is *on the rag*, is she? Well, no. I don't have aspirin! I'm your manager, not your mother . . ."

"I do," Lita said, handing me a couple from her gig bag.

"Thanks."

Backstage, family and friends were hanging out, drinking beers, and laughing. Vickie was there with Marie, and Marie gave me a big hug when she saw me. "You're gonna knock 'em dead," she whispered in my ear. I squeezed her tight for a moment.

"TEN MINUTES!"

As Marie started to pull away from me, she said, "Oh my God—is that Shaun Cassidy?"

I turned around, and Marie was right: there he was looking like he just stepped off of the cover of *Tiger Beat* magazine. He was wearing

sunglasses and one of those funny tam o'shanter hats, trying to look incognito. The thing is, he actually looked comically conspicuous in that getup. Maybe *that* was the point. Kim grabbed him by the arm and introduced me. "Nice to meet you, Cherie," Shaun mumbled. He seemed kind of shy, and up close his skin wasn't good. Maybe it was all of that makeup he wore on those teenybopper photo shoots. He was only a year older than me, and we stood there not saying much to each other, like two awkward kids at a high school dance, before Kim whisked him off to meet the rest of the band. I watched him go. Zits or no zits, he *was* cute.

Jesus, my cramps were getting worse. I considered asking our manager, Scott, for some stronger painkillers. I knew that he carried a mason jar of Placidyls, as well as cocaine, pot, speed, or quaaludes around with him. Everybody partied except for Jackie, who was so straitlaced that it made us all sick. Early on, I made a rule that I never got loaded before a show. Afterward—now, that was a different story.

I started to worry about whether I should have doubled up on my Tampax. I remembered being at the beach when I was twelve and seeing some girl lying out in the sun; and her bikini bottom was soaked with blood. The image was permanently imprinted on my mind. Suddenly a nightmare scenario popped into my head. I imagined myself emerging from that makeshift coffin dressing room, dressed in my new corset . . . and I'd notice people pointing and laughing . . . I'd look down to see a blood trail from my crotch to my knees. Jesus, I shuddered at the thought. Ugh, talk about shitty timing!

Just then Rodney Bingenheimer walked in, with a stunning girl on each arm. They were covered in glitter and towered over him by at least four or five inches. No wonder they called him the mayor of the Sunset Strip! Shaun immediately headed over to him and gave him a big hug. I guess Rodney really *does* know everybody!

A voice from the doorway yelled, "GIRLS, IT'S TIME!" I looked around to see if there were any other stars milling around. There weren't, so the celebrity spotting would have to resume after the show. We were led, single file, down a long corridor to a dark stairway. We held on to each other so that we wouldn't trip over our

six-inch platform boots. One by one the girls walked out onto the stage, and from behind the curtain, I could hear the crowd. The noise was so loud, so intense it made my stomach tingle. I waited until the girls were plugged in and ready to go so I didn't look like an idiot standing around waiting for them to start. I heard Sandy's drumsticks snapping together as she counted off the first song. . .

One. . .

Two. . .

Three. . .

Four!

And suddenly I was out onstage, bathed in the blinding lights, striking a pose just like my hero, David Bowie, did when I saw him at Universal City back in what seemed like another lifetime. The roar of the crowd was deafening. The music was thunderous, and I moved with it, spitting out the words over the sound of the club full of screaming kids. I reached my hand out to the audience, just close enough to brush their outstretched fingertips, before pulling away again. They grabbed at me with a curious mix of desperation and ecstasy in their eyes. They held on to my ankles as I stood on the edge of the stage. As the first song ended, I realized that I was already bathed in sweat. Drenched. My eyes were burning with a combination of sweat, makeup, and glitter. I glanced over to Joan and saw that her makeup was also streaking down her face. She never used waterproof mascara because she told me that she liked the way it looked when it started to run down her face. The first seven songs passed in a haze. As Joan kicked off "You Drive Me Wild," I disappeared into that rickety plywood coffin room for my costume change.

Vickie was standing there, and there was no time for small talk: I unpeeled my wet jeans and T-shirt and stood naked in front of her. Vickie toweled me off quickly. I started pulling on my fishnet stockings and attaching them to the garters. I straightened up so Vickie could cinch the corset tightly around my body. "Is that okay?" she asked. "Tighter . . ." I insisted.

I ran my fingers through my wet hair, slicking it back. My heart was pounding. Vickie stood back a little to get a better look. She yelled into my ear, "You look AMAZING!" I nodded and smiled at

her, facing the curtain. As I heard Joan finish "You Drive Me Wild," my body was trembling with fear and adrenaline. The roar from the audience seemed to be shaking the dressing room's foundations. I peeked through the curtain and saw that the crowd was almost uncontrollable as Sandy started "Cherry Bomb." I closed my eyes for a second, and muttered a prayer to myself, before I tore open the curtain and attacked the stage.

Can't stay at home, can't stay in school . . .

The little room shook as the roar of the crowd became ever more deafening. I stalked around the stage like a tigress, twirling the microphone around me, wrapping the cord around my thighs, bringing it up between my legs. I was singing this song like I had never sung it before. In some strange way I felt that I was one with the audience, and that my body was moving of its own volition as I sang the words, feeling all of the fear drain out of me. The roar was deafening. I moved with a vengeance, releasing all my fears. I felt like a conduit of pure power from a place I didn't know. I was no longer of this world. I had risen above it, beyond it, close enough to touch the face of God.

Fans crawled over each other to get to the stage, only to be thrown back by security. One guy grabbed at my leg, ripping my stocking. Seeing this, Joan walked over and without missing a beat casually kicked him in the head. I saw Jackie reaching over to touch the hand of someone in the audience, and she is nearly dragged offstage. The whole place was in a state of total fucking pandemonium. On the last beat of the song, I looked up to the heavens, punching my hand to the sky. I froze. There was a heart-stopping moment of silence before the crowd went berserk, and I knew that from this moment on, my performances with the Runaways would never be the same.

I ran back to the dressing room to change into my last costume: a T-shirt loaded with blood packs. We had rehearsed this thing where, at the end of "Dead End Justice," Lita would point her guitar at me and riddle me with imaginary bullets. I would throw myself to the stage, slapping the blood packets, exploding them through my T-shirt. I'd bite blood capsules, squirting it from my mouth. This Starwood show would be one of the last times that we would do it—it had become too messy, and too difficult to pull off. As I changed,

some fans rushed onto the stage, and I could feel the tiny room rocking back and forth as they tried to get in. Vickie was panicking, trying to keep the curtain closed as the security guys were dragging the fans away, tossing them back into the audience with a grunt. "Holy shit!" Vickie screamed to me. "This is fucking NUTS!"

After the show, we were hustled back to the dressing room, which was already filled to capacity with press, family, friends, and fans. My heart was still pounding in my chest, and everyone was hugging us, telling us what an amazing show it was. I was on a natural high, and I liked it. It was a mob scene, and for a while all I could do was shake hands and say hello to people I didn't know, pose for pictures, and sign autographs. It seemed that everybody wanted a piece of the Runaways that night. At some point Kim pulled me aside and said, "There's someone here who would like to meet you . . ."

I turned to look, and Kim beckoned to a tall, handsome, dark-haired guy who walked through the crowd toward me. The face was definitely familiar: he had the chiseled good looks of an actor, with long, dark feathered hair that came down to his shoulders.

"Cherie . . . I'd like you to meet someone."

Suddenly I recognized this guy: he'd had a big radio hit recently, and his smiling face was all over the TV these days. He was a big hit with the kids, because this guy was a regular in all of those same teen magazines that Shaun Cassidy frequented. Maybe I had one of his teenybopper albums tucked away in my vinyl collection. I smiled and said, "Hi . . . It's nice to meet you."

He took my hand and kissed it. "You were really great tonight," he said with his soft sing-song voice, fixing me with those dark brown eyes. "I really enjoyed your performance a lot . . ." Then he flashed me that smile—a teenybopper smile that could make a teenage girl cream in her jeans from across the room. The pop singer continued to stare and I looked away, embarrassed. I realized that everyone else had noticed the way he was looking at me, too—suddenly I felt the eyes of the room turning toward him and me. Some people were even snapping photographs of us standing together.

A few moments later, when I regained my composure, Kim tapped me on the shoulder. "A word, Cherie."

I shrugged at the singer and said, "Nice to meet you." He smiled and drifted into the crowd. Kim took me into a quiet corner and looked around, as if he were about to tell me a secret of great importance.

"He likes you," Kim whispered, putting a hand on my shoulder. "He really likes you a lot. He wants you to go to his house . . . for a *drink*. To, uh, get to know you better. Only"—he leaned in real close, those horrible wet lips of his edging closer to my ear—"*don't say a word to the other girls. I don't want any jealousy or other dog shit, you understand?*"

I shrugged Kim's paw off of my shoulder. "I don't know about that, Kim," I said. "I don't even know the guy. How would I get home?"

"I'll pick you up, later. It's all arranged. *I want you to go with him.*"

I gave Kim a look, like he'd lost his goddamn mind. "I don't *care* what you want, Kim," I said coldly. "It's not *about* you." I shook my head and laughed mockingly before walking off to rejoin my friends and family.

Marie said, "Man—did you clock the vibes that guy was giving you? Heavy!"

I wrinkled my nose. "He's a cheese ball," I said.

I looked back, and Kim was staring at me. I looked over at the pop singer, and he was staring at me, too. I noticed that he was wearing white pleated linen pants and a black silk collared shirt, open enough to expose some chest hair. It made him look kind of disco, which was a big turnoff. The only thing that made up for it was his long hair. And that teen-idol smile helped, for sure. I turned away. "Anyway," I said, smiling, "I want to hang out with my friends . . ."

Later that night, after security had ushered everyone out of the club, I was standing alone on the empty stage, waiting for Stinky to finish up so we could get out. Out of the shadows came Kim, with the pop singer still in tow. He waited while Kim hustled over to me and started up with his best salesman routine again.

"He really wants to get to know you," he said. "This could be good for your career! Think about it!"

I started to feel angry at the pressure Kim was putting on me. My

voice went up a couple of octaves as I said, "But I don't WANT to, Kim!"

"*Shhh*! Listen to me." Kim put his face real close to mine. "The two of you together would be great press. You do realize that, don't you? What's good for you is good for the band. You have to be a team player here. Do you know how many other girls would KILL to be in your position? He's fucking *big time,* you DOG!"

Shocked by the sudden venom in Kim's voice, I looked over to the singer again. He was standing there, real casual, shooting me his superstar smile. A shudder ran through my body. I looked back at Kim and said in a pleading tone, "But how will I get *home*?"

Suddenly Kim switched again. His voice took on an almost paternal tone. He put his hands on my shoulders and said, "I'll pick you up in a couple of hours, okay?"

As this was going on, the singer had walked over to us. I still felt uneasy. I looked up at him, and he shot me that teenybopper smile again. "Won't you come, Cherie? I won't bite . . ."

I looked back at Kim, and gave him a dirty look. There was a look on Kim's face that scared me. I had seen that look before—I called it the look of death. I knew that if I didn't choose my words very carefully, Kim Fowley was going to lose his shit in a major way.

I mumbled "okay" and started to gather my things. . .

On the drive over to the pop singer's house, we didn't say much. I lied and told him that I thought his last single was cool. I didn't know if he realized that I was just saying it to be nice. He nodded and said "thank you."

Mostly he did the talking . . . about the music business, about unscrupulous managers and money-grabbing record labels. How hard the industry is. I was distracted, looking out of the window, watching the city fly by and hoping that he didn't live too far away.

Before long we turned north onto Doheny and pulled up at his apartment in West Hollywood. Inside, it was nice, although it seemed pretty small for a big star like him. It looked like a showroom apartment; it was pretty bare and there was not much in the way

of furniture: just a pristine-looking couch, a coffee table, and a few posters on the wall. There were several guitars sitting around on stands, others were just lying on the floor. "This is it . . ." he said, waving a hand around the place. "Home sweet home. You want a drink?"

"Sure. You got rum and Coke?"

"Of course . . ."

He went into the kitchen to get the drinks, and I sat on the couch. I felt nervous. I was in a complete stranger's house, and I had no way of leaving. Ugh, how in the hell did I get myself into this situation?

He brought the drinks over and sat next to me. He was close—too close. It felt totally surreal to be sitting in this apartment next to this guy whose face had been staring out at me from the cover of teen magazines for the past year. Maybe if I were twelve years old, I would have thought that this was the coolest thing ever, but tonight it just felt weird.

"I, uh, I just got out of a long relationship," he told me. "It was pretty rough. I haven't been with anyone for a while."

"Oh yeah?"

"Yeah. I . . . I *like* you, Cherie. I like you a whole lot."

He waited for a response. I took a big gulp of my drink and said, "Oh, well . . . thanks. That's nice of you to say . . ."

"Come on." He suddenly jumped to his feet. "Let me show you the rest of the apartment!"

He took my hand and led me straight into the bedroom. I had to suppress a laugh. The bedroom walls were covered in posters of . . . himself. They were a mix of live concert shots and those sexy, soft-focus shots that made twelve-year-olds all across America go weak at the knees. There were also several gold disks on the wall. One of the album covers was familiar—a full-face shot, which I recognized as the album that I had in my own collection. My eyes traveled down from the walls and came to rest on the bed. It was perfectly made, and he had these pristine white satin sheets on them. Oh God, I thought with a smile, how gay! What kind of man has white satin sheets on his bed? I was suddenly filled with the urge to laugh

hysterically, but I forced it down. He was still holding my hand. Without a word, he led me to the bed.

He took my drink and placed the glass on the nightstand. "I really like you, Cherie," he whispered as he laid me down and pressed his lips against mine. His hands were all over me . . . they glided up under my T-shirt, as he started kissing my body.

I said, "You know, uh . . . Kim is going to be here soon . . ."

I could feel his hot mouth against my skin, and I lost my train of thought. I heard him unzipping my pants, and then I stopped him.

"Wait . . ."

The pop singer shot me a big grin. "I know . . . You're waving your red flag, aren't you?"

I looked at him, my face a mixture of confusion and shock. "Uh—what?" I stammered.

"The red flag. It's your time of the month, right?" He winked at me, and shot that teenybopper smile one more time. "Don't worry. Kim told me. It doesn't bother me . . . *really*."

With that, he got back to it, sliding my pants down. What a betrayal!! I imagined Kim and this guy back at the Starwood laughing at the fact that I was on my period, right before Kim sold me off like some kind of low-rent Hollywood pimp. It was embarrassing, and more than anything in the world I wanted to just go home. I decided to get this over with as soon as possible.

Minutes later, he was finished. He was like a jackrabbit, his face right in mine, twisted up with exertion, and before I knew it, he gave a little groan and his body went limp. Then he rolled off of me onto his back, panting like a thirsty dog.

We lay there for a while, not saying a thing. All I could think was "Please God, don't let him ask if it was good for me."

Right on cue, he said, "So . . . uh, was that okay for you, sweetheart?"

Goddammit.

"Sure," I said, "it was . . . *fine*. Really."

"Cool. You're a nice chick, Cherie, I mean that." He reached out and touched my face lightly. "Well, good night, luv."

With that, he turned over and switched the light off. I was grateful for the darkness, at least.

I lay there awake, all night. I listened to his steady breathing as he slept. I could feel the wetness of my blood spreading out on the white satin sheets, but I was afraid to move or do anything about it. I didn't want to wake him up and have to make small talk. When I couldn't stand it any longer, I lifted the sheets and peeked down. What I saw sent a shudder of horror through my entire body. There was blood *everywhere.* On him. On me. And all over those fucking white satin sheets! It looked like someone had butchered a rabbit down there. More than anything in the world, I wished I were back at home. I wished I were anywhere but there. I spent the longest night of my life lying in those bloody sheets, waiting for the dawn. Of course, Kim had lied about picking me up in a "couple of hours." I realized that the whole thing was a setup by Kim, and I cursed myself for being too meek to stop it.

I slowly crawled out of bed and tiptoed over to the bathroom. I had to get cleaned up. I closed the door silently and flicked on the light. The bathroom was pristine and bright. I didn't even look at myself in the mirror. I was too mortified. I needed towels. I needed to get the blood off of me.

I started looking around, and noticed: all of his towels were fucking white. Didn't this motherfucker own ANYTHING that wasn't white?

I looked under the sink and found a dark washcloth that had obviously been used, but I didn't care anymore. That washcloth was the most welcome sight I had seen all night. I cleaned up, and wrung the blood out of the washcloth and put my clothes on. I tiptoed out to the living room. I sat there in the dark, not making a sound. I didn't sleep all night. Some part of me still believed that Kim might show up to take me home, but he never did. As the sun started to rise, I decided I would call a cab and get the fuck out before this guy woke up. The last thing I wanted to do was face him after last night. Then there were several loud knocks at the door. BLAM! BLAM! BLAM! Shit! I ran over to the front door, and through the peephole I could see

that bastard Kim standing there. In the background I could see a cab waiting. I unbolted the door and opened it a fraction.

"Wait there!" I whispered, closing the door again. It was too late, though; I could hear the pop singer now, moving around in the bedroom. Where the fuck was my purse?

He came out of the bedroom, wearing a pair of tight white underpants. He still had my blood all over him. I couldn't even look at him.

"Don't worry about it, luv," he said in that stupid accent of his. "It's okay. It'll all come out in the wash. The cleaning lady comes later today."

He walked over to the door and opened it. Kim just stood there, grinning nastily. I grabbed my purse and stormed out past the pair of them without even saying good-bye. As I headed over to the cab, I could hear them talking . . . laughing.

I was sitting in the cab, fighting tears, when Kim returned a few minutes later. He jumped in next to me and sneered. "So did you have FUN?"

I didn't answer. In fact, I didn't say another word for the entire cab ride back to my house. All I could think of was how lousy I felt.

Last night I'd discovered what it felt like to be a rock star.

This morning I knew what it felt like to be a whore.

11

Touring

After the Starwood show, a national tour was thrown together, and before we even knew what was happening, we were in a motor home at midnight, heading toward Cleveland for our first big gig. "It's time to spread your wings!" Kim told us, but with everything that was going on at home, it was very difficult for me to think that my wings were anything but clipped. With my mom and me not speaking since she left to live halfway around the world, this felt like the worst possible time to be away from what remained of my family. Leaving Dad, Aunt Evie, Grandma, and Marie was unbearably sad. And on top of it all, Kim was really piling on the pressure. The tour was originally meant to have lasted for only three weeks, but it seemed that every day Kim would inform us that he had added another date. Suddenly three weeks became four, four would become five, and I'd eventually start resigning myself to the fact that nobody really knew when they would get the chance to go home again.

As I looked out of the windows of the RV as we crossed the Mojave Desert, all I could see was the strange outline of alien-looking cacti, a shadowy, strange landscape that made me feel homesick. This was the first time I had ever been so far away from my home, from my family, and I felt as anxious and scared as I ever had.

"We're almost there!" the driver announced for the third or fourth time that evening. He tended to say a lot, even if nobody responded. He was pretty talkative because of all of the blow and speed he did to keep awake on the road: we would blaze through state after state, town after town, his eyeballs almost vibrating in his skull from the effects of all the uppers. It was a scary feeling to realize that your

life was in the hands of this cranked out lunatic, so it was best not to dwell on that thought.

I thought about what Dad and Marie might be doing right now. After Mom left, it felt like a vast black crater had opened up inside of me. I wanted to spend more time with them, to try to fill the hole, but there was no time for that: the album was hitting the stores and Kim insisted that we go out on the road immediately to capitalize on it. At first, Lita tried to make me feel better. She was very kind and understanding about the whole situation. It was a moment between us that I would always be grateful for: for a while, she almost seemed human.

"Yeah," she said. "Well, I'm homesick, too. But goddammit, when I come home I want to BE somebody." She said it in a way that affected me deeply, and in a flash, I felt better. I still thank her to this day for that.

I looked around the large motor home as we tore through the grim night. Could the Runaways fill the emptiness I felt inside? At the beginning I'd hardly known these girls; my initial impression of Joan was that she was tough on the outside, but had a real vulnerability about her when you got to know her. Almost from the moment that I joined the Runaways, there had been a special bond between us. People had started calling us "Salt and Pepper," not just because of our contrasting hair colors, but because we always seemed to be together. With Joan, I found a friendship much more intense, and much more profound, than any I had known up until that point in my life. We were kids: Joan was only one year older than me, and more than with anyone else in the band, I clung to her, and she to me.

When I think back on Joan and our relationship, I can still feel a distant quaking inside. Our friendship was a godsend to me. It ran deep, and at times she was the only one that kept me sane. Joan was perceptive. Almost like she could read my mind. God, how I needed that kind of connection. Especially when I felt so disconnected. I believed in her, and the dream that had driven her this far. I felt safe when I stayed close to her, like I'd be swept up in the safety net of her steadfast vision of what we were all here to do. Sometimes we'd look at each other and I'd get that tingling in my stomach. Her smile was

warm and her fun-loving attitude made me forget just how strange and bizarre this new and crazy world really was. She was my anchor. How do I explain about a person that was my best friend, someone I would confide in like a sister, someone who to me became a strong, sexual attraction? Well, it's easy. Just like how easy it was to be that way with her. I can leave it by saying that I had moments with a friend that quake me to this day. And they were some of the most satisfying moments of my young life.

Sandy was the muscle of the group; she was the rock, strong and passionate, always smiling and joking. Sandy got along with everyone and was never afraid to show her emotions. She could be tough, like the time she threw me over a car to stop my arguing with Kim, but then she'd always feel terrible after getting in your face. She was no-nonsense, with a heart of gold, and if you couldn't deal with that, then you couldn't deal with Sandy.

Jackie was the quiet one, at least at the beginning. She was the bookworm, and the brains. In fact, Jackie was fine until she opened her mouth. Unfortunately she always had something to say, and the way in which she said it was usually annoying. She had a real know-it-all attitude but this was coupled with a massive insecure streak. This combination drove all of us nuts, and Lita was constantly threatening to beat her up.

It would turn out that threats of violence weren't that unusual for Lita—pissed-off, tough, temperamental Lita. One of the first conversations I had with her after joining the band revolved around a fight she had gotten into with two Mexican gang chicks outside of a mall. She had taken them both on, and beaten the crap out of them. When she was walking away, one of the girls unhooked her belt and whipped Lita around the back of the head with it. The belt had wrapped around Lita's skull, and the buckle broke her nose. Instead of letting the girls see that they had hurt her, Lita kept walking as if nothing had happened. She calmly got into her car and drove herself to the hospital. One thing I knew about Lita Ford was that she most definitely wasn't all talk. I could only hope that I remained on her good side for as long as possible. Could these girls *really* be a family to me?

The only thing I knew for sure was that Kim was no father figure. He had put Scott Anderson in charge of us, which was a little like putting a fox in charge of the chicken coop. Scott was one part road manager and one part Dr. Feelgood. When he wasn't looking over the tour schedule and trying to figure out a way to shave off a few hours or bucks traveling from city to city, he was in charge of the entertainment: cutting out lines of blow, handing out downers like they were candy, sending the road crew out to buy us liquor since we were all underage. Plus, Scott was flirting with me like crazy when the other girls weren't looking. Sometimes I'd suspect that he was flirting with the other girls, too. He was a big nerd, and he always carried around this stupid briefcase, which we all knew was just his attempt to try to look like a real manager. At the same time, Scott was only seven years older than us, so we could relate to him more than the other adults who surrounded us. None of us thought he had much of a clue about what he was doing, but next to an insane freak like Kim Fowley, he couldn't help but seem likable.

Kim was doing exactly the opposite of what he promised when I'd shown up at Mercury Records with Sandie to sign the deal. For a start, I was supposed to have a tutor on the road so I could keep up with my schoolwork. Maybe this had been promised to the others, though I knew that Joan had already passed her equivalency exam with flying colors. But when Kim was speaking to my big sister, Sandie, you'd have thought that life on the road with the Runaways would be like some kind of well-supervised school trip. In reality, it was more Hollywood Babylon than Hollywood High.

The tutor was never mentioned again. Unless Scott or one of the roadies was going to surprise me by pulling out some high school textbooks, there was no evidence of an attempt to keep any of us up-to-date with our education. At least, not the kind of education that you get in school!

"The Runaways" was not just a name to Kim Fowley. It was a concept. He wanted us all to act out. He wanted bad girls. Our families had signed us away to him, dazzled by promises of world tours, of fame and fortune, and now Kim was furiously making sure that we lived up to our bad-girl image. As the tour wound on,

I'd begin wonder if it wasn't for the best that my mom was away in Indonesia.

As we got closer to Cleveland and the empty feeling continued to preoccupy me, Joan noticed the look on my face and turned away from the portable TV to come over and speak to me. Just before the tour she'd dyed her hair jet black with a hue of blue in it. It looked amazing, but I was still getting used to seeing her like that. "Hey, Cherie," she said, sitting next to me and nodding out of the window. "Almost there. Aren't you excited? Your first time in *Cleveland*!"

I started to laugh.

"I mean—you must have been excited about this, too, right? I know it's a dream come true for me . . ."

And just like that, Joan had taken me out of my negative thoughts and I was smiling again. I looked at her and thought, "If it wasn't for you, I don't know if I could take this." Though I didn't say it, I think she sensed how I felt.

"Look," Joan said. "I hate being away from home, too. And being stuck in this bus is as boring as hell. But the concerts are gonna be worth it! And it's only for a month . . ."

"Yeah." I laughed. "Not if Kim has his way!"

Kim was always hustling to get us more shows. His attitude was that we should be playing every city, town, and rest stop in the nation. His latest news was that we were going to be opening up for a San Francisco band called the Tubes, who just had a radio hit with a song called "White Punks on Dope." I knew that if it were left up to Kim, this tour wouldn't end until it was time to record our second album. The novelty factor was really helping him find us places to play. Venues were booking us without ever hearing our music: the idea of five tough teenage girls playing balls-out rock music was something totally unheard of. All of the press out of California talked about the crazed reaction we got from our audiences. As much as I wanted the Runaways to succeed, I couldn't help but feel more and more anxious as this thing started to snowball.

After I had gotten over my homesickness, there was the pressure. At first nobody had any expectations—the tour was an exciting novelty. But as it went on, we were expected to be stars—act like stars,

perform like stars, all of the time. It was easy in the beginning when I could just pretend to be David Bowie, and fronting the band was basically an extension of dressing up and miming along to my favorite records in my bedroom mirror: if I screwed up, it didn't matter because it was all make-believe. Now it was for real, and when I stepped out onstage, everybody was watching: especially Kim. And just like in the studio, Kim did not tolerate screwups. If I flubbed a note, he'd scream, and yell, and tell me that I was a useless piece of dog shit. All of that coupled with the fact that I barely knew the girls in the band and I still felt kind of awkward around them . . . it was difficult. The idea of fronting a rock band seemed so easy, so much fun, but in reality it was very difficult. The pressure was scary, and the workload was already intense.

"I'm telling you, Cherie," Joan was saying to me. "Once we start playing these big gigs . . . man, we're NEVER going to want to stop! The big halls will be so *different* from those little clubs we play back home. Just imagine it! There's going to be *thousands* of people. Thousands! And they'll be screaming for us! The stage is gonna be the size of a fucking *tennis court*! Now THAT'S rock and roll!"

When I closed my eyes and tried to picture it, I asked, "You really think it's gonna be that way? You really think we can be that hot?"

"Hey, babe," Joan said, ruffling my hair, "I know we can! We're gonna be like Benny and the Jets!"

The next night, the Celebrity Theatre in Cleveland, Ohio, was sold out. A capacity crowd was squeezed into the hall, and another five hundred were turned away at the door. We were the headline act, which meant that all of those people showed up to see us. Backstage, everybody was pumped, but I was sure I wasn't the only one who was feeling anxiety about the upcoming performance.

"Five minutes, girls!" someone yelled through the dressing-room door. We were blasting Suzi Quatro's album, and whenever a track faded out, we could hear the stomping, clapping, and cheering of the impatient crowd. I bit my lip, and checked one last time that my black fishnet stockings were pulled up all the way, and secured tightly to

my white satin corset. I checked myself in the mirror, which was covered in Magic Marker graffiti left by all of the other bands that had passed through. I didn't feel like a sixteen-year-old girl anymore. The lyrics to "Cherry Bomb" had pretty much become autobiographical at this point: I was not in school; I wasn't at home. I had become the girl that your mom warned you about. I smiled a little as I thought this. Suddenly Scott Anderson was behind me. He put a hand on my bare shoulder and put his mouth close to my ear. "You look so fucking hot," he whispered, before straightening up and continuing with whatever it was that he was supposed to be doing. I looked around, but none of the other girls had noticed. They were all busy: Sandy bouncing her drumstick against her legs and nodding along to the music, Joan fixing her makeup with the guitar slung casually over her shoulder, Lita tuning her guitar. True to form, Jackie was off in the corner reading a fucking book.

I put on my black jumpsuit, covering the corset. Right before "Cherry Bomb," I was supposed to strip it off; it was easier that way. Bad girls: that's what they expected and that's what they were gonna get.

I thought about the order of the songs one last time. We had rehearsed the set so many times, I felt like I'd been born knowing it. There was no uncertainty. Every move, every gesture, had been practiced and practiced until it became second nature. A little bit of Bowie, a little bit of Cherie. I was my own creation now: the Cherie-thing that first came alive back in junior high school was fully grown now. I was complete.

My hands were cold. I thought about that first audition. I felt the same way—like a scared little kid. I could hear thirteen hundred fans chanting our names, I was surrounded by the band, by the road crew, but that dark pit was still inside of me. That emptiness.

A fat roadie called Ralph came over to me. He was wearing a filthy Playboy T-shirt and chewing a wad of tobacco. "Mellow out!" He grinned, exposing brown teeth and giving me a friendly nudge. "It's only fuckin' *Cleveland*!" Then he cackled a dirty laugh and walked out toward the stage. The truth was that the idea of being anywhere but Los Angeles was enough to set my heart racing. Up until earlier

this week, I had never been more than one hundred miles outside of L.A. in my life.

Suddenly the crowd's cheers became a roar, like a tidal wave about to crash. The lights must have gone down. The door burst open, and we all gave each other one last look before Joan led the way through the darkness to the stage. We stood there for a moment, shrouded by darkness. When the lights came up, I was in another world.

I could see dozens of guys wrestling with the security guards, all trying to push, punch, or otherwise force their way to the front so they could be close to us. Some people were holding up our posters, or copies of our LP. They screamed our names, and reached their hands out toward us as Sandy counted off the first song. . .

All at once the stuff Joan had been saying to me made perfect sense. With the spotlights on me, and the makeup already beginning to melt down my face . . . with the earsplitting roar of the crowd and the scream of Joan and Lita's electric guitars . . . With the pounding of Sandy's thunderous, heavy beat, the throbbing of Jackie's bass . . . with all of this going on around me—the frenzied mob in front and the band all around me—I could understand everything that she said. "Benny and the Jets"—idols of teenagers all around the world—that was US!

I realized that the crater inside of me was instantly gone. I realized that the screams of the crowd had filled that hole inside of me in a heartbeat. I didn't need my mother! I didn't need any of that shit! I had rock-and-roll authority, just like Kim demanded, just like my audience demanded. I realized that yes, YES! This IS what I wanted! This was the answer to all of my problems. The crowd, and the music, and the smell of burning pot rising up from the audience in great waves—this was my life! This *was* my family!

I used to want to take what everybody hated and shove it right back into their faces. Not anymore! Now I wanted to give the fans what they wanted. If they wanted their sexy little Cherry Bomb, then that's exactly what they'd get. I concentrated on the primal momentum of the music. In an instant all of my fears, all of my anxieties, were gone. All that was real in the universe was the driving beat of Sandy's drums, the glorious wailing of Lita's guitar. Song by song, we

fucking *destroyed* them. I knew that some of these people came here to gawk, to see if we really could play our instruments like on the record. I wanted to give the doubters the most insane, intense rock-and-roll experience of their lives. I wanted to touch them, the way that David Bowie touched me all those years ago on the Diamond Dogs Tour. I wanted to change their lives! I wanted to alter them—transport them! I realized that we were their fantasy. We *wanted* to be their fantasy. . . .

As Joan sang "You Drive Me Wild," I ran offstage and stripped off my jumpsuit. I ran my hands through my hair, my body literally vibrating with the adrenaline pumping through it. I stood by the curtain, watching the performance go on. I waited for the downbeat that announced the start of "Cherry Bomb," and then I appeared—strutting across the stage, and teasing the boys in the front row who were all beating the shit out of each other for the chance to edge close enough to the front to be in touching distance of me. I wrapped the microphone cord around my body like a snake, and I wailed the opening line of the song . . .

12

Kim Fowley's Sex Education Class

It was New Year's Eve 1975, and we were in our roadie's VW bus, rumbling toward an anonymous motel in Orange County. Tonight we were due to open for the Tubes. Just over a month before, I turned sixteen years old. Somewhere out there in the California heat, I knew that people were getting ready to celebrate at midnight, but for me and everyone else in the van, today was just more miles of asphalt zooming past with monotonous regularity as we were shifted from the venue to the motel and then back again. What nobody tells you about being in a band is how fucking monotonous it can get between shows. Already I had seen—and smelled—enough of Stinky's van to last me several lifetimes.

I felt lousy. The van didn't have air-conditioning, and the passenger window was jammed, so only a sliver of fresh air was making it inside. With me and my friend Rick shoved in the back with all of Stinky's junk, it felt like it was a hundred degrees at least. To top it off, there was Stinky's body odor, which permeated the entire place like mustard gas. The radio was on, and our driver was tapping the steering wheel, singing along to Brewer & Shipley's "One Toke Over the Line." The steady rocking of the van started to make me feel nauseous.

"Are we almost there?" I groaned. "Yeah. Like, five miles to go . . ." Stinky said, before returning to his drumming. Ugh! Five miles. I concentrated on breathing through my mouth. Rick, sensing my discomfort, pulled me closer, giving me a hug.

Rick was a friend of mine from the Sugar Shack scene who was going to join the band on stage tonight. We all called him Rick Bowie, because he had based his entire look on David Bowie's Ziggy Stardust period. He had been helping out backstage for a while, sometimes assisting me with the costume changes, but tonight he was going to get up onstage with us and dance, doing his whole Bowie bit. The show was at the Golden West Ballroom, a nice big local club. Opening for the Tubes was always a highlight for us: we liked the guys in the band a lot, and Kenny Ortega, our choreographer, worked with them as well, and was a part of their stage show. Playing shows with our friends was always a good time.

Sandy, Kim, and Scott were waiting for us at the motel, which we were using as a dressing room. Lita was supposedly driving to the sound check herself, and I supposed that maybe Jackie would be coming with her. Up until the stink in the van started blowing my groove, I had been feeling really good about the upcoming show.

"Are you okay?" Rick asked. "You look pale . . ."

"Yeah," I croaked. "I'm just a little carsick . . ." I signaled by pointing to Stinky and holding my nose. We started giggling like schoolchildren, which, I suppose, we actually were.

After what seemed like an hour, Stinky pulled the van into a motel parking lot and announced that we'd arrived. We piled out of the van, and I started taking huge gulps of fresh air. Thankfully, the nausea started passing, and I took a look around me. It was still early afternoon, and the bright sun was unforgiving. True to my expectations, the motel was a total dump.

Kim was a master at cutting costs. He controlled the money, so nobody was really sure how much was actually passing through his hands, but if you believed Kim, there was never any money for anything, and every dollar he laid out was sending him deeper and deeper into debt. He was always crying poverty, and did everything as cheaply as possible. A favorite gimmick of Kim's was to have the band turn up at important shows in a limo. "Rock and roll is about glamour!" he'd insist. "To be a legend, you have to be separate from the rest of the scum and the human flotsam out there! You must be bigger than life . . ." So he had us roll up in a fancy-ass limo with all

the windows blacked out, all for the benefit of the kids and press who were lined up on the sidewalk trying to get into our show. What those kids didn't know was that in an effort to cut costs, Kim had made us stand around on a street corner two blocks away from the venue so the limo could pick us up. It drove us the two blocks, and we'd make a big show of exiting and being rushed into the venue. When we were done, we were ushered back into the limo, driven two blocks, and dropped off on the same dark street corner we started from. From there, we'd hop into an idling, beaten-up van driven by one of our roadies. When we complained about it the first time—"Why can't we just take the limo *home,* Kim?"—our manager scowled at us and sneered. "Who do you think you are? Elton fucking John? I pay for that thing by the mile! My name isn't Nelson A. Rockefeller, you stupid fucking dogs! Are you *trying* to put me in the poorhouse?"

The motel was one of those typical seedy places on the outskirts of nowhere; there was a small, dark office in the lonely forecourt with a flickering VACANCY sign and a 7UP machine that looked like it had been sitting there rusting since the 1950s. We all filed into the motel, and as usual, Kim had only rented one room for the entire band.

Inside, the place was small, cramped, and decrepit. The wallpaper had turned brown, and had musty damp patches on it. The carpet was stained, and the whole place smelled of mildew. There was a tiny black-and-white television bolted to one wall, and the window looked out upon a blinking neon sign that announced GRANDE LUX MOTEL. There was some time to kill before the show, and we were running around the tiny room, laughing and goofing off. There was a woman, let's call her Marcie, sitting on the bed, pouting. I didn't know what she was doing there.

"I'm *huuuuungry*!" she said, while Kim messed around with the TV trying to pick up a signal. "Yeah, me, too!" Sandy yelled. We all noticed an agitated look come over Kim's face, so we joined in laughing. "Can we order room service?"

"NO!" screamed Kim. "You greedy fucking dogs! Wait until after the show!"

"Pleeease, Kim!" Marcie said, whining. "I could faint if I don't eat!"

I rolled my eyes at Sandy. This Marcie woman was acting weird. She was slurring her words a little, giggling to herself, and rolling around on the bed like she was loaded on quaaludes or some other kind of downer. Sandy raised an eyebrow and whispered, "Cherie—what the fuck is up with her?"

We basically ignored her, though she was acting like a total space cadet. Kim was ignoring her, too, perched on the end of the bed like a crow on a telephone line. He had a grimace on that ugly old face of his as he tried to ignore the commotion in the room. Scott was rummaging through some papers from his briefcase, trying to look productive now that Kim was around.

"FOOD!" we yelled, laughing. "FOOD, FOOD, FOOOOD!"

At this, Kim jumped to his feet. "God FUCKING dog pucks!" he screamed. He threw his hands up in the air as if the very idea of spending money on food were causing him some deep, spiritual pain.

"Come on, Kim!" Sandy said. "Just some burgers or something. We're starving!"

Scott scowled at us, as if we were interrupting his important work. Kim looked thoughtful for a moment, and started stroking his chin. He looked like a cartoon supervillain, plotting some diabolical scheme so he would never have to buy us food again. Sometimes Kim would give us what he called our "per diem"—which seemed to be Latin for an occasional ten, maybe twenty dollars to buy alcohol, cigarettes, or food. Other than that, we hadn't seen a penny from all of those sold-out shows we had been playing. Whenever we brought this up, Kim would tell us that we still owed the record company for the album and promotion, and that unless we had a hit single, we would owe money to Mercury for the rest of our lives. Not knowing much about how the industry worked, we'd just nod sagely and take whatever pitiful handouts Kim decided to throw our way.

"*Keeeiiiiimmmmmmmm!*" Marcie pleaded. "I'm gonna *diiieee* if I don't eat something!"

"All right, you fucking DOGS!" Kim finally screamed in disgust. "I'll get you your fucking dog food. Here . . . you!" He shoved a twenty in Stinky's face. "Go pick up some burgers for these ungrateful dog cunts, will you?"

When Kim handed over that twenty-dollar bill, he looked like he was about to collapse from the strain of it all. Scott watched this all go down with a look of amused indifference on his face.

As we waited around for the burgers, it became more and more apparent that Marcie was not herself. She got up and tried to walk over to us at one point, wobbled, and then fell back onto the bed. Nobody asked her what was wrong; we were content to watch her make a fool of herself. She was acting like a total mess. I started to wonder if someone had slipped her a mickey.

After a while there was a knock on the door, and Stinky returned with our burgers. We started pulling our food out of the grease-stained fast-food bag, and finding a place to sit down and eat.

"OUT, DOGS!" Kim suddenly bellowed.

The girls and I looked at him like he'd lost his mind. Then I went right back to my cheeseburger.

"Dog DAMN it, you dog cunts! Eat outside! I have some business to attend to! Scott, get the bitches out of my room!"

Kim stared at us until we realized that he was dead serious. Scott got up and started ushering us toward the door. We all grumbled under our breath and began gathering together the food so we could trudge outside. When I was halfway out the door, I looked back into the room. Marcie was still lying on the bed staring at her food with a dazed expression on her face.

"You coming, or what?"

Kim shot me a dirty look. "She stays!"

Marcie just sat there, looking up at me through heavy-lidded eyes. I looked over to Rick, who seemed as puzzled as I was. He shrugged. I looked at Scott, who smiled at me knowingly.

"Come on," he said. "Kim has a surprise for you all. A real treat. Just do what he says . . ."

"GET OUT!" Kim bellowed.

"All right, all right!" I said as we backed out of the door. "Keep your damn wig on, man!"

As we shuffled out, Sandy asked Scott what the hell was going on. "What do you mean he's got a surprise for us? What kind of a surprise?"

"Oh, you'll like it . . ." Scott said, winking conspiratorially. "It's gonna be wild!"

With that, he went back in the room, closing the door after him. We sat in the decrepit outdoor hallway, eating our food and complaining about what a wack job Kim was.

"Man," Rick said, stuffing a handful of french fries into his mouth, "is he always such a dick?"

"Always." Sandy laughed. "Actually, that was Kim being nice. At least he bought us food this time . . ."

Stinky had either left to help set up for the gig or was in the van smoking pot. We were all pretty glad because it meant we could breathe easy for a while.

We were still shit-talking Kim when suddenly the door to our room was wrenched open and Scott stuck his head out. "Come on!" he whispered, frantically waving for us to come inside. He peered down the hallway like a lookout during a robbery heist. He held the door open, and with a sigh we all trailed back into the room with our half-eaten burgers in our hands.

Inside, there was some kind of weird scene going on. One of the beds had been pushed up against the wall so that it was the focal point for everybody in the room. Marcie was still on the bed, but most of her clothes were in a pile on the floor. She was leaning against the wall in just her T-shirt and panties. She was rolling her head left to right and talking to herself. As we walked in, Scott closed the door behind us and put the chain across. Kim was standing over Marcie. He looked at us, and waited until we had sat down, as Scott, on the other bed, directed us to do. We were all looking at Kim and Marcie, utterly confused. Then Kim removed his orange suit jacket, revealing a ripped, filthy T-shirt. He had a weird body, skinny and lanky, the skeleton plainly visible through the pale skin. He looked like a praying mantis or something. Marcie had her eyes closed, and was laughing at nothing in particular.

"All right, dogs," Kim said in that theatrical way of his, straightening up. "Pay attention. I'm going to teach you the right way to fuck!"

Nobody knew how to respond to this. There was an uncomfortable

silence in the room as I glanced at Sandy. She shrugged and shook her head. Clearly, she thought he was kidding. This comforted me a little. I looked up at Scott, but he was staring at Kim and Marcie, transfixed.

"Shut up, Kim!" Sandy said. "You're not funny! Stop messing around!"

Kim ignored us. He was advancing toward the bed like a lion stalking its prey. I looked over to Rick. He whispered, "Like, what the fuck? He's kidding around, right?"

"Lesson number one!" Kim grinned as he stood by the foot of the bed. He reached down and started pulling Marcie's T-shirt up, revealing her breasts. She just lay back on the bed laughing hysterically as he started to pull her underwear down, past her knees, dropping them at his feet. Now Marcie was lying almost totally naked on the bed, and she wasn't even trying to cover herself. I felt my cheeks reddening, but I stayed there, frozen to the spot. Kim looked over to us, unmoved by our obvious discomfort. "Observe! This is the correct way to give a bitch head!"

Then, as we looked on in shock, Kim pulled Marcie's legs apart and crawled between them. He started gnawing at her like a hungry dog. I felt my stomach lurch, but I couldn't turn away. I looked at the woman. Instead of fighting him off, she was smiling, her eyes rolling back in her head. "Ohhh God!" she moaned, like she was starring in some cheesy porno flick or something. She arched her back so Kim could have at it. He was making these really disgusting noises . . . slobbering, animal noises, as he thrashed his head from side to side. He looked like he was trying to crawl right up inside of her. He came up for breath for a moment and lifted his face long enough to pant, "What do you want? How do you want me to eat you?"

Laughing, Marcie screamed, "Eat me like a WOLF!"

Kim's face contorted horribly, and he licked his lips before actually *howling*. *"AAAWWWWOOOOOOAAAHHH!"* Then he shoved his face back between her legs and started attacking her with his tongue again.

As this was happening, us girls and Rick were standing there with

our mouths hanging open. There'd been nervous laughter at first, but now there was nothing. It felt very cold in there. The food had been forgotten. The only sound in the room was coming from the bed.

Kim jumped up as if seized by a sudden inspiration, and grabbed a hairbrush from the dresser. It was my hairbrush, I was pretty sure of it. He advanced on the bed again, pushing the woman's legs apart. There was a sick, heavy silence in the room as he started working the handle of the brush into her.

I stood, shaking, and said, "I'm out of here. This is fucking sick!" As I went to leave, Scott grabbed my arm. "Stay!" he commanded. I was intimidated by his tone of voice. I sat back down again silently.

"You like that, don't you?" Kim was saying, and he started sliding the brush in and out of her. Marcie was smiling and moaning like crazy. I remembered when I did the school talent show, some of the acts were so awful . . . there was one girl in particular who got up and sang, and she was no nervous, and so out of tune, that watching her perform was a profoundly uncomfortable experience. She forgot the song, and just stood there looking mortified. People started slow-clapping and booing her. I just wanted to rush up onstage and bundle her off to save her from herself. That memory came back to me at that moment. I was so embarrassed for Marcie that it was unbearable to watch. I felt really sorry for her. This was disgusting. This was total humiliation!

Kim stood up and undid his belt, letting his trousers fall to his ankles. I could see his erect penis through what looked like one-hundred-year-old underwear. He waited until he had mounted Marcie before he pulled them down, as if he were somehow seized by a moment of self-consciousness.

When he had worked his torn underwear down, he asked her, "Do you want it?"

"Oh yes!" Marcie screamed.

"How bad do you want it?" He sneered like a snake coming in for the kill.

"Real bad!" she screamed as she reached for his face like a blind girl.

Then, in front of all of us, Kim shoved himself into her, and started pounding away with all the force and subtlety of a jackhammer. Marcie was screaming her approval as Kim pumped and gyrated against her. The others had started groaning at Kim's sideshow act, and I could hear Sandy shouting "oh my GOD!" over the sound of the blood rushing in my ears. Scott was laughing and clapping, whooping and hollering, like we were at a sporting event. I felt nauseous; I couldn't believe what I was seeing. The only thing that was keeping us from rushing Kim and ripping him off of Marcie was that she was actually *encouraging* it! She seemed to *want* it! The whole scene was so bizarre, so strange, that in a weird way I felt like I was watching a movie rather than witnessing something in real life.

After a few moments, Kim dismounted and grabbed Marcie's knees, spreading her legs apart for us all to see. He looked at us, perfectly serious, and said, "Anybody want to join in?" Marcie just lay there, giggling like a lobotomized fool.

"No . . . fucking . . . WAY!" yelled Rick.

"That's IT, Kim," I yelled. "I've had enough!"

With that, I turned and went to storm out of the room.

"Down, DOG!" Kim commanded. I turned, and he was standing, with his finger pointed right at me. I tried not to look, but I caught a glimpse of his erect penis pointing at me, waving around in the musty air like a cobra ready to strike.

"No, Kim," I yelled. "You're SICK. I'm leaving! This is SO fucking *SICK*!" I stormed off, pulling the chain loose, wrenching open the door, and finally making it out into the corridor. Sandy and Rick followed me. Scott closed the door after us, but stayed in the room.

Sandy was still laughing, nervously. "That was fucking CRAZY!" she said, and giggled.

Rick tried to make light of it. "That was gross!" he said. "And anyway . . . as if you guys don't know the right way to *fuck* already!"

I punched him in the arm, but even this little bit of comic relief wasn't helping to dispense the weirdness. "Hey, you gonna eat that?" Sandy asked, referring to the uneaten hamburger I'd been carrying around with me. "I'm still hungry." I handed it over to her, my appetite totally gone. She took a bite of my burger and announced, "I'm

going back in. This shit is *educational*!" And with that, she walked back into the room and closed the door behind her.

Rick and I walked out to get some fresh air and smoke a cigarette. Nobody said anything at first.

Rick pulled out a cigarette, and lit it off mine.

"Relax, Cherie," he said. "That was fucked up, man, but it'll be all right."

I just made a face, and took another drag.

"I don't know what the fuck was going on in there tonight," Rick said quietly, "but that was MESSED UP."

We stood there for a while, smoking and contemplating what had just happened.

"Hey!"

We turned, and it was Sandy. She was walking toward us with a big grin on her face.

"Come on guys! We gotta go to sound check. It's gonna be show-time soon!"

I put my arm around her as we walked back to the room. Nothing fazed Sandy; she took everything in stride. Seeing her like this, seeing her act as if what happened was really no big deal . . . it was comforting. It didn't change what happened, but somehow it made it easier to deal with. Sandy was the rock in the band, and I knew I could always depend on her when the going got strange. I loved Sandy, and I didn't know what I'd have done if she hadn't been there that afternoon. In a weird way, I felt like I'd awakened from some strange, fevered nightmare. When we walked back into the room, I felt better equipped to pretend that nothing was wrong.

Inside, Marcie was still on the bed. She was dressed now, and she was sitting up, looking slightly more sober. She was eating a hamburger with a queasy smile on her face. I watched her as she clumsily wiped her mouth with a dirty napkin. I didn't say anything to her, none of us did. After all, what could we say?

Kim was standing in the corner of the room, still wearing that ripped T-shirt and his grimy, dingy underwear. He didn't look at me, and I was glad about that. I'd probably have puked if he did. Of all the nasty, degenerate scum on earth, he was the last scum I'd want laying

a crooked finger on me. Scott gave us a nasty smile and I did my best not to make eye contact with him.

Pushing what had just happened out of my mind, I started applying makeup and getting ready for the show. The sickly smell of sex still hung in the air. I felt my stomach lurch again. I could hear the others talking, and laughing, the usual preshow banter. I concentrated on this, on how normal it all seemed . . .

There was a knock on the door, and Stinky told us it was time to leave for sound check. As we headed out to the van, I looked behind me, and caught a final glimpse of Kim in his underwear, looking out after us like some kind of evil old troll, before he closed the door without a word. On the drive over to the club, nobody said much. We didn't even tell the others what happened once we got to the venue.

Once we were onstage running through the songs, the lingering sense of disgust started to fade. I made a vow not to think about what had happened—it was just too much. It was one of the sleaziest, most low-rent experiences I had ever witnessed. Nobody brought it up again. I made a vow that day that if Kim ever tried to lay a finger on me, he would have a goddamn stump by the time I was finished with him.

13

The Road

The road is a strange place. We'd drive from city to city in our RV, and see the country town by town, city by city. At first, touring was a blast. Everything was new to us, and the freedom of being away from our school, our families, and any kind of rules or discipline was exhilarating. When Kim was away—which was most of the time, thank goodness—life on the road was fun. Kim referred to traveling with the band as "babysitting" and preferred to leave that side of things to Scott Anderson, Kent Smythe, and the other roadies. But when we'd hear that Kim was flying in to attend one of our shows, we'd know that it wasn't good news. Usually he would rip us apart afterward, criticizing our every move and making all of us feel like shit. Whenever it seemed like things were getting a little too happy, too relaxed, too much fun, Kim would magically appear and brings us all back down to earth by calling us "dog cunts" and screaming at us for screwing up a note or missing a beat on one of the songs.

One particular evening we were sailing through the shadowy night in the motor home, and I was upset because Kim had really whaled into us after the last show. He'd said that my voice wasn't powerful enough. He made me feel small and insignificant. I was talking to the girls about it, on the verge of tears.

"When I first met Kim," Lita said, "he started off calling me dog meat. You know, I just took it as a term of endearment. You know?

Dog meat, dog piss, dog puke . . . He just has a thing about dogs. You can't take his shit personally!"

I had to laugh. It was hard to think that anybody in this world—even Kim Fowley—could get away with calling Lita Ford "dog piss" without getting their face ripped clean off. I'll give Kim one thing—that motherfucker had *balls*.

"The point," Sandy said to me, "is that Kim is KIM, man. That's never gonna change. I don't think that he really means anything by it—it's just his way, and you gotta get used to it."

I shrugged. Of course, this made perfect sense when we were all together on the tour bus, and Kim wasn't around . . . but it was a different matter when he was screaming in my face, calling me names, telling me that I was useless, that I couldn't sing, that I was dog shit. "I dunno"—I sniffed—"I think he expects too much of me."

Jackie had been listening from across the bus. She put down her book and yelled, "He expects too much from all of us! It's what got us this far! He's like an Olympic coach, Cherie—that's his attitude. He's pushing you—he's pushing all of us. What I'd like to know is where all of the goddamn *money* is going . . ."

Lita groaned at this. The money thing was Jackie's obsession. She saw all of the packed houses that we were playing to, and was constantly complaining about how, at the most, Kim would give us ten dollars here, or twenty dollars there.

"Kim says that we are still paying off Mercury for the album, and the promotion . . . ," I said a little uncertainly, parroting Kim's standard defense.

"Oh yeah? So where does Kim get the money to fly into Pittsburgh or Atlanta so he can bitch us out? Where does he get the money to pay the road crew? He sure as hell isn't turning up at the venue in a fucking motor home. Kim will be flying first class all the way, I bet . . ."

The way Kim paid the band was prevalent at the time, where the artists were overworked and rarely saw their share of the money because of tour expenses and label costs. I never knew where the money went, but I felt we were being ripped off.

We had learned one thing from Kim: when a subject becomes

uncomfortable, you change it quickly. Whenever Jackie asked him about money, Kim would immediately switch things around, telling us that we needed to change our hairstyles or work on our stage moves. Anything but ask too many questions. Now that Jackie had a bug up her ass about the money, we were all a little scared that she might ruin everything by rocking the boat too much. Kim seemed unbalanced enough to actually drop the band altogether, as he constantly threatened to do, and sue us all for breach of contract. So Lita quickly switched the conversation back to Kim's temper tantrums.

"Anyway, Cherie . . . when Kim gets out of hand, just keep your mouth shut. Nod, and say okay, and do the best you can. Seriously, you need to stop arguing with him. It doesn't do any good."

"Oh yeah," Jackie snorted. "Don't rock the boat! That's your fucking mantra these days . . ."

"Shut up, Jackie!"

"Make me!"

"I will make you, bitch!"

Lita walked over to Jackie, and they started screaming at each other. Sandy rolled her eyes and put her headphones on.

Sometimes on the road life seemed really *slow*—especially on those long, late-night drives from city to city. It was like being in suspended animation. You aren't anywhere in particular—you are *in between* places. Quaaludes helped with the boredom. So did Tuinals. Tuinals were these great little blue-and-red pills that helped your body and your mind to adjust to the tortoiselike pace of the road, the minutes and hours dragging by painfully . . . slowly . . . interminably. It was like taking a vacation inside your head. When we were not stoned and drooling on ourselves, we'd pull stupid pranks to pass the time.

One night we were driving down the main drag of some city. I don't know which city—they'd all started to look the same. Some city that wasn't home. Kent, one of our roadies, was driving. He didn't say much, but sometimes he'd chuckle to himself when we'd bitch, complain, and argue with each other. The five of us were sprawled out over the seats of the bus with seltzer bottles in our hands, searching for the perfect victim.

We were in a seedy part of town . . . the kind of place populated almost entirely by check-cashing places, pawnshops, liquor stores, and shady-looking bodegas. Looking out of the window, Sandy spotted them standing on the corner in a group . . . young girls, with too much makeup and bright, flashy clothes that revealed an unseasonable amount of bare skin. Whenever a lone male approached, they'd start hollering over to him, "Hey, honey! Looking for a date! Buy me a drink?"

"Victims!" Sandy screamed, and we all piled over to her window. "KEEENNT!"

On Sandy's cue, Kent did a one-eighty across traffic. We headed toward the unsuspecting street girls, pulling up to the curb alongside them. Sandy spotted them, so they were Sandy's catch. The window was down halfway. As we all looked on, giggling with anticipation, she leaned out and said, "Hey, ladies!"

The hookers looked up to the RV suspiciously. Sandy smiled and waved, and then asked, "Do you have a license for this sort of thing?"

Realizing that she was being laughed at, one of the hookers started screaming, "Bitch, I don't need no motherfuckin' license—"

That's all she got the chance to say.

Suddenly, Sandy depressed the lever, and a jet of seltzer water hit the prostitute full in the face. Sandy started waving the bottle like crazy, soaking her minidress until it became even more see-through.

"OH, YOU CUNT!" the girl screamed as Kent hit the gas and we peeled out, leaving the streetwalkers standing there, cursing us out and shaking angry fists in our direction. I saw the wet streetwalker throw her shoe at the bus, but it fell short, landing in the middle of the road. I was laughing so hard that my stomach hurt. When we were done cracking up, Joan went to the back of the bus and marked another notch in the ceiling. Our count of victims for this tour was up to twenty already.

When we'd pull into a new city so we could play our music, everything changed. Then, suddenly, you were thrown into the fast lane. You became a neon blur, and when you're a neon blur, time becomes an elastic concept. Troubles pass you by. Hours pass like seconds, and

all you can see are the dazzling lights shining in your face. All you can hear is the roar of the crowd.

On the road, I saw thousands of teenagers, lining up outside filled-to-capacity concert halls and auditoriums. They carried our posters, magazines with our faces on the cover, copies of our records. The shows were incredible. The time that we spent up there onstage made all of the rest of the bullshit that came along with touring worthwhile. As the tour went on, the audiences got bigger, the venues got bigger—the Runaways got bigger.

Sometimes the kids who called out for autographs and photographs when we were heading into the venue for sound check would tell us that their parents didn't know they were there. "Oh, my mom HATES you guys," one kid told me. "She says you're a bad influence! You know my mom tore your posters down off of my walls . . ." I found that stuff hysterical. I told Lita about it and she sneered. "Fuck 'em! You can do anything you want to do. You're sixteen—no one can tell you what you should and shouldn't do; we're here doin' a job! You know? We're becoming fuckin' rock stars, so they can stick it!"

Sandy would always say, "We're the voice of a generation. We're the voice of teenagers all around the world, and that won't change . . ."

I knew that she was right about that. On the news they'd tell us that the world was changing . . . Vietnam had been over for years, and Nixon was gone, and Ford had stumbled out of the White House. Now Jimmy Carter was in, and they said it was a whole new America. But none of that stuff really meant shit to us. No matter what was going on in the world, teenagers were still the same: Mickey Mouse could have been in the White House, but it wouldn't matter down on the dance floor. There may have been a war raging halfway around the world, but at home teenagers were still fighting the same old wars as ever: as long as there were teenagers, the Runaways would have an audience.

There was this weird sense as the tour progressed that we were generals in this war. When I'd see the audiences reaching out for us, there was something in their eyes—some strange kind of desperation, some hope that we would change things. I wasn't a political person, but I did realize that there was something inherently political about

a sixteen-year-old girl strutting about onstage, totally free of adult interference, screaming to kids about their own lives.

Nobody could tell us what to do.

Nobody could tell me what I could and couldn't put into my own body. Yeah, we'd drink, we'd do coke, we'd take pills, but so what? We wouldn't be talked down to, laughed at, or dictated to. In moments like that, life as a neon blur was so exciting, so *real*, that it made up for all of the monotony and boredom in between. Nobody could tell me what to do. I did what I damn well pleased. I would not be ruled by my mother, ten thousand miles away, or anybody else's mother, for that matter.

It was while on the road that I realized something that seemed very important to me. I realized that I had spent most of my life as a slave to something. I grew up as an emotional slave to the rotten kids in school, to my parents' bitter fights. Then, after Derek came along, I became a slave to something else: I became a slave to my own hatred and rage. It was on the road with the Runaways that I came to the conclusion that all of that was finally behind me. I was free to do whatever I wanted. I would never be a slave to anything again.

14

Daddy's Car

t's strange how quickly things can change. When we set off on tour fourteen weeks ago, we were nobody. By the time the tour finally ground to a halt at the Santa Monica Civic Auditorium, we were practically household names. When we got back to California for that final show, I stayed in a hotel because I wanted my family to see me for the first time onstage. It was hard to be in town and not see them, but I knew it was going to be worth it. The Runaways really touched a nerve: we played that final night to a packed auditorium, and I have some strange memories of that evening: Cheap Trick was our support act. The idea of a band as big as Cheap Trick opening for US would have been totally unthinkable at the beginning of the tour. After they finished their set, Kim grabbed me—literally right as I was about to walk onstage—and said, "Someone wants to say hello!" I thought maybe it was my family—Kim had insisted that we couldn't see our families until after the show, though.

"Oh yeah?" I said, and turned, only to find myself face-to-face with Rod Stewart. What do you say when you are confronted with a bona fide legend in the music industry? I just smiled and said, "Nice to meet you, Rod." It didn't end there. Marie and I ended up snorting coke with him and Ronnie Wood at Rod's mansion following the after-party. Talk about life in the fast lane! Rod was as drunk as a skunk, and actually started crying when I pulled out the coke.

"Oh my God!" he said, with tears in his eyes. "Nobody EVER

gives me blow! I'm always the one expected to have it! You're so kind! Thank you . . ."

Yeah, that was fun; right up until the point his girlfriend Britt Ekland emerged from her bedroom bleary-eyed, and chewed him out for making so much noise. Reluctantly, Rod told us we had to leave. Still, I think that Britt acted pretty cool for a woman who'd just found her boyfriend snorting coke with a couple of sixteen-year-old girls. Marie and I laughed about it all the way home. . .

Dad, Marie, Grandma, and Aunt Evie all came to that show. It really touched me to see how proud they were. "Well, it's not my kind of music" was my grandma's conclusion, "but you sure have *something.*"

But the surreal craziness of life on tour had to end, and now I found myself back at home again . . . lying in my bed at Aunt Evie's house, physically and mentally exhausted. The house was tiny, and full to the brim: Aunt Evie, Grandma, Dad, Marie, and I were all packed into three bedrooms.

In the kitchen, I could hear Grandma banging pots and pans. Off in the bathroom, the shower was running, so I knew that Marie must be in there. I got back under the covers. Ever since returning from tour, I had been sleeping till noon, seemingly unable to shake the lingering fatigue that those three and a half months on the road had left me with. We toured the country the hard way—no planes, all of it by road, until we caught the plane that took us home. That really made us feel that we were returning as stars. The Runaways had now been featured on the cover of every major music magazine, with the exception of *Rolling Stone.* "Cherry Bomb" was climbing the *Billboard* charts, spurred on by our enthusiastically received live shows and the avalanche of press that Kim had been getting for us. Strange memories of life on the road: an early show at a little roadside dump called the Armadillo in Texas, where the audience tore the place up and tried to pelt us with bottles. Playing a tiny dive in New York City called CBGB, where the audience was a mixture of bums and art-school freaks, a show that landed us an article in *People* magazine. I remember we played alongside Television (who played very long guitar solos) and Talking Heads (who had a female bass player, and

a really weird, pale, and sweaty lead singer). "You girls should stay out of the bathroom," Kent had warned us. "I've been in there, and it ain't pretty." Or there was St. Louis, where we were the opening act for Spirit. When I lost my voice, Randy California came to my hotel room with hot tea and lemon, and gave me advice about looking after my voice while on tour.

Or there was the time toward the beginning of the tour when I got sick. Suddenly my temperature shot up to 102, and I thought I was dying. We couldn't cancel any shows, though; Kim wouldn't allow it. After the tour, I was diagnosed with tonsillitis and my doctor pre-scribed Placidyls to help me sleep. I didn't know it at the time, but Placidyls were an extremely powerful narcotic and were a favorite downer of the King himself, Elvis Presley. We were still booked to play local shows, and my diagnosis was not allowed to interfere with our gig schedule. I would have to play a show, and immediately after I came offstage, Scott Anderson would be waiting to dose me with Placidyls. After that, I was zonked and Sandy would have to carry me to the van.

When I finally had the tonsils removed, it was Joan who was sit-ting by my bedside when I came around from the anesthesia. She was holding my hand. "How you feeling, Cherie?" she whispered.

I smiled weakly, and squeezed her hand to show that I was okay. Out of all the girls in the band, Joan was the one I cared for the most. I loved her in my own strange way. No matter how tough life in the Runaways would become later on, Joan was always my reason for sticking things out. She was a real, genuine, sweet person. I closed my eyes again, and drifted off into a strange, drugged half sleep.

Now that I was back home, life seemed deceptively normal . . . on the surface at least. Grandma cooking in the kitchen. The teddy bears that I'd bought for Marie while on tour were sitting on her empty bed, right next to mine. Even though my mother was long gone, I was still surrounded by my family. Surrounded by love.

Except . . . except things *were* different. It seemed that we all wanted to pretend that things could just go back to the way they were, but the longer I was at home, the harder it was to keep up the facade. My little brother was gone. My mother was gone.

Grandma was getting older . . . and there was Dad. Dad had some problems of his own.

I sat up in my bed. I felt groggy, disoriented. Like my skull was stuffed with cotton. I definitely needed something to get me going. I reached under my mattress and found the pill bottle. Popped the cap and shook out a small white pill with a cross etched into it. I swallowed it dry. I considered swallowing a second, but decided to wait. On the road with the band, these little pills were invaluable. Especially when you'd had a crappy night's sleep and had to be up and awake to do a bunch of press the next morning. They were supposed to be diet pills, but the effect they had on you was similar to being jolted awake by a thousand volts of pleasure. Your heart races, a smile forms on your lips, and suddenly your mind is whirring in a dozen different directions at once. I remembered Jackie rolling her eyes at me and asking why I couldn't just have a cup of coffee like a "normal person."

"Coffee is bad for you," I told her. "I saw it on TV."

Moments after I'd stuffed the bottle back under the mattress, Marie walked in wrapped in a towel, drying her hair. "Where were you last night?" she asked. I was still bundled up in the covers, waiting for the speed to kick in.

"The Sugar Shack. It's like the first time I've been back since the tour ended."

"Is Chuck E Starr still DJing there?"

"Oh yeah!" I said. "You wouldn't believe the fuss he made over me!" Chuck E Starr had been in top form last night, wearing his most outrageous pair of platform boots, the tightest T-shirt, and a pair of space-age silver pants. The moment I walked in, he announced it over the microphone. "Miss Cherie Currie—lead singer of the Runaways!" The dance floor cleared, and kids literally lined up to get me to sign autographs or take pictures with them. I had done this a lot on tour, but there was something different about doing it at the Sugar Shack. There is a special thrill about seeing kids you actually *know* clambering to see you like you were one of the Beatles or something. It was kind of hard not to let stuff like that go to your head. As soon as I thought this, I shouted myself down. With all of the stress and the

hard work I'd put in on the road, why *shouldn't* I enjoy a bit of atten-
tion? It sure beat being yelled at by Kim Fowley!

"That's cool," Marie said as she continued to get dressed. "You
know, Mom called the other day. She said that she even heard of the
Runaways over there."

"Oh," I said coldly. I hadn't spoken to Mom since she left. And I
had no intention of starting now. As far as I was concerned, she could
stay away with Wolfgang for as long as she wanted. I didn't need her
anymore.

Of course, I'd hear about some of their misadventures there, es-
pecially the time Mom had called Aunt Evie to tell us Don had been
attacked by a monkey. He and some friends were at a popular tourist
attraction in Bali called the Monkey Forest when poor Don was am-
bushed by a group of screaming monkeys and one sank her one-inch
fangs into his upper arm. Don was so angry he camped out at the
entrance of the park with a bloody wrap around his wound. Tourists
exiting the buses saw my bloody brother then turned around and got
right back onto the bus. Don later found out that the monkeys had
been trained to pick the pockets of the unsuspecting tourists. It just
made me wonder all over again: What were they doing there anyway?
God, I hated Indonesia!

Marie sighed. "You can't stay angry with Mom forever, Cherie.
You know how she is! We *are* family still . . ."

"I don't want to talk about it," I snapped, and that ended it.

By the time I'd made it into the kitchen, the pill had kicked in and
I felt alive again. I could smell the frying bacon permeating the house
before I got close enough to hear it sizzling. Grandma always made
bacon, and normally it was one of my favorite morning smells because
it reminded me of her. But today, with the effect of the pill, my stom-
ach felt unsettled. I couldn't think of anything in the world I wanted
less than food.

"How do you want your eggs?" Grandma asked as I walked in. I
could feel the amphetamine buzzing around inside of me. I didn't want
to cause a scene, so I told her, "I'll make a BLT for later. That way I get
all food groups—my bread, vegetables, and meat for the day."

Grandma gave me a concerned look. So I said, "Scrambled."

"Like your brain," Marie snorted.

"Yeah, like my brain."

I watched Grandma preparing the eggs, and immediately I sensed that something was wrong. She beat the eggs with a special anxious fervor; her face had a dark shadow over it. I wondered if she'd had an argument with Dad, but then immediately I dismissed the idea. I had *never* heard them so much as exchange an angry word. I nudged Marie. "What's up with Grandma?"

"Beats the hell out of me . . ."

There was an uncomfortable silence in the kitchen as Grandma beat the eggs and poured them into the pan. As the eggs began to cook, she started to cry. Marie and I looked at each other. Then we went over to her to see what was wrong. "Your father didn't come home last night."

It was strange, because there was a time when Grandma would never have worried about my father—who was, after all, a grown man, and a veteran at that. We all knew that Dad could take care of himself. But lately, every time Dad was a little late coming home, Grandma had been worrying up a storm.

"He probably . . ." I began, but then trailed off. He probably what? *He probably stayed at someone else's house?* I dismissed this thought immediately. Not Dad. That wasn't like him. *He probably pulled off the side of the road somewhere to sleep?* Yeah, right. Finally I settled on, "He probably has a good reason."

"Yes," Grandma said. "Well, maybe."

I knew what she was thinking. We were all thinking it, although nobody dared articulate it. Since returning to California, Dad had been working as a bartender again. He worked five nights a week, and then would have to drive home at two in the morning. But as Aunt Evie was fond of pointing out to us, Dad had been at the bar *seven* nights a week recently, and it wasn't because he was a *work*aholic. Grandma was worrying that one day those 2 A.M. drives were going to catch up with my father, just like Aunt Evie warned. One night he was going to fly through one red light too many. He was going to miss a stop sign. Maybe he might not see a road divider. And then . . . Dad wouldn't be coming home ever again.

I looked around the house; the effects of the amphetamine and the growing fear in the pit of my stomach were making me feel ill.

"Maybe he got in late and left early," I offered weakly. But looking beyond the kitchen to Aunt Evie's quiet, antique living room, I could see no evidence that Dad had been here at all last night. Nothing on the couch, no shoes on the floor. The coffee table had nothing on it— no cups, no glasses, no keys. I looked over to Marie, but all she could do was shrug at me.

I left the food behind and went to check out Dad's bedroom. It was quiet, dark, and cold. The bed had not been slept in. Walking around the house, I tried to think of other things. Tomorrow there was a publicity shoot, a session that would last all day with some big-time photographer. Then, in the afternoon, a reporter from *People* magazine was going to interview us. In a few weeks we were leaving for our European tour, which was really exciting. I would finally get a chance to visit the land that David Bowie himself had come from. Today I had decided that I was going to go back to school to drop off some magazine articles that featured the Runaways in old Mrs. Whittaker's office. She was the one who'd told me that I would never amount to anything. Let's see what old Whittaker would think now! Maybe I could hang out in a classroom, and listen to all of the boring facts I'd been missing out on while I'd been touring with the band. All of the stupid equations I'd never be tested on. If I did that, I wouldn't have to think about Dad.

When I walked back in the kitchen, my breakfast was waiting for me. I sat down and looked at the food. Eating was the last thing on my mind. Grandma noticed me staring at my plate and said softly, "I guess we shouldn't worry. He's a grown man. He can look after himself."

I knew that Grandma didn't really believe that. After all, she was his mother. Dad would always be her one and only loving son as far as she was concerned. I took a few unenthusiastic bites of my food and swallowed it down. I could feel cold sweat on my palms, in the nape of my neck, as the pill and the anxiety started to make my heart pound. I went to the living room and started to pace on the thick, beige carpet.

I looked at the pictures on the walls; Aunt Evie had dozens of them. Pictures of Aunt Evie, of Grandma and my late grandpa, pictures of Sandie and Don, Marie and me. There were pictures of Dad when he was younger, his hair dark and thick, the eyes shining out from the past. Even back then, when posing for most of those pictures, he had a cigarette in one hand and a glass in the other. I heard Aunt Evie's voice in my head again. "One day those 2 A.M. drives are going to catch up with him!"

Seized by a sudden inspiration, I walked over to the piano and leaned over it to open the curtains. Looking outside, I felt an enormous wave of relief wash over me. Dad's car was parked right there, in the street.

"Dad's car is out here!" I yelled. "Grandma! Dad's car is here!"

I saw Grandma snap to attention and come hustling out of the kitchen like a woman half her age. She peered through the window and recognized Dad's car immediately. "Then where *is* he?" she wondered aloud.

I took a look in the backyard and the laundry room. There was no sign of Dad. Marie helped, and when we came up empty-handed, she suggested, "Maybe he's taking a walk?" Grandma shook her head. I didn't think so either.

"I think I know where he is," I said. I hoped I was wrong. "Come on, Marie."

A part of me didn't want to deal with this at all. I knew I could just slap on some makeup and head off for Joan's house so we could spend the day talking about anything but our families. But I realized that there was nowhere for me to run, not really. I'd have to deal with this eventually, especially as it became more and more of a regular occurrence.

Marie and I approached the car in the blazing midmorning sunlight. As we got closer, we couldn't see much: just the seats, the dashboard, and the steering wheel. The car looked deserted. It was an old white Chevy. The same car Dad would take us out to dinner in. To the movies. "You're going to be movie stars!" Dad would say to us at the drive-in. "Two beautiful girls like you? They'll be knocking down

the doors for you. You'll see!" He would smile then, and I would look up to my dad and believe him. I would believe every word he said to me as we sat in that car.

We were standing by the car now, peering in at Dad through the glass. He was lying across the front seat, head against the door handle, eyes closed. His body was curled into a ball. His hair was sticking up, and it made him look like a little boy. I hated that. Every so often my dad would look like a little boy, and I couldn't stand it. Without a single word, Marie opened the door. We stood there, looking down at Daddy, and he didn't move. All of the pent-up heat inside of the car floated up to us, along with the pungent smell of stale vodka or bourbon. I wondered for a frozen moment if he was still alive.

Shut up, Cherie! Of course he's alive! He's just sleeping, is all!

I found myself watching the buttons on his shirt, making sure that they were moving rhythmically with the rise and fall of his breathing. I relaxed a little when I saw that they were.

"Should we wake him up?" Marie asked. "I mean, we can't just *leave* him here."

We stood there for a few minutes, too embarrassed to do anything. Then Grandma appeared at the front door in her robe and slippers and yelled, "Is he there?"

"Yeah," I answered, looking back to her. Grandma shook her head sadly and went back inside without saying a word. "Come on."

Marie and I tried to wake him up. It took quite a bit of shaking. When he came to, he blinked up at us, uncomprehending. I saw the misunderstanding flash across his face as his brain struggled to make sense of what was going on. He shook his head, sat up, then produced a comb, seemingly from thin air, and with two swipes across his head looked like my dad once more. His eyes were a little bleary, but the hair was perfect. Only the rough stubble on his cheeks and the smell of alcohol gave him away. When he spoke, his voice was hoarse.

"Well, hello," he said. He smiled at us. "I . . . I, uh, guess I was a little tired last night, that's all. Thought I'd stay out here. Guess I must have slept through the night . . ."

As embarrassed as my father felt, I knew that it could be nowhere as intense as the sadness Marie and I felt right then. I was embarrassed for

him, I was embarrassed for me . . . all I knew was that this moment had to end as quickly as possible, or I felt like I would explode.

"Were you worried about me?" he asked.

I shook my head quickly. "Why should I be worried?" I said. "You're all right, aren't you?"

"Of course I am."

"Why don't you come in," Marie suggested. "Grandma has bacon and eggs for you."

Dad sighed, and looked a little pale. He gripped the wheel and looked straight ahead. Without making eye contact with us, he said, "I'll be in in a minute, kittens."

With something approaching relief, Marie and I went back inside without another word.

At the kitchen table I watched Marie eat her cold bacon and eggs. I heard footsteps, and there was Daddy walking in. Marie and I smiled at him. Grandma looked at him briefly but then turned away, busying herself with the dishes. She had been washing the same dish for five minutes now. With perfect timing, Aunt Evie walked into the kitchen unaware that anything untoward had been going on.

"Morning, everyone!" she sang as my dad shuffled out of the kitchen.

Twenty minutes later Dad reappeared. He was ready for break-fast. He was clean-shaven and dressed in fresh clothes. His eyes were bright, and he looked dashing and handsome once more. When he smiled at us, everything that had gone on that morning was suddenly washed away. Grandma didn't bring up what happened, and Marie and I didn't either. Sometimes it's easier to pretend that something is not happening rather than deal with it in the cold light of day. I was learning to be very good at that. Sometimes I felt that there were too many painful things in this world, and if I thought about them all, my heart might break in two.

I excused myself and went to my room. My head was swimming. It's the pill, I told myself. The pill. It was too much. You need some-thing to calm you down . . . I rummaged around in my purse and found a loose quaalude. I figured that taking it would calm me down; it would smooth out the rough edges of the upper, and help me to

forget everything that went on with Daddy. My father is not an alcoholic, I thought as I washed the pill down with a glass of water. He just likes his liquor, is all.

The thought gave me some comfort. People were too quick to pathologize other people. My father was going through a tough time. He had to leave his life in Texas and come back to California so he could look after us. All because Mom decided to leave. He was back to working as a bartender. Of course my dad needed to drink. He needed to unwind. Just like me.

Just like me.

After taking the second pill, I lay down and stared at the ceiling. I took deep, slow breaths until I could feel my heart slowing down. My stomach was nearly empty, so I felt the quaalude start to take effect quickly. *There, that's better.* I smiled. Things were fine. Things had always been fine. They would always be fine. I closed my eyes.

15

Snapshots of Europe

n Europe, I saw the future of rock music and I didn't like it. Punk rock was everywhere in the UK, and suddenly our shows were packed with scrawny kids wearing dog collars and leather, with safety pins shoved through their noses, ears, even their cheeks. They had ugly, violently colored, chopped-up hair. They wore spikes, torn T-shirts, and they liked to spit on each other for fun. When we did our show at CBGB, we played with bands that the press was calling "punks"—Television, Talking Heads; we saw the Ramones, who were all dressed in leather jackets and torn-up Keds sneakers, playing loud, catchy songs at a lightning pace in divey underground bars. I didn't really get the music: it seemed too loud and aggressive for me. I was always a sucker for melody. Joan really dug it, though, and the Ramones themselves seemed like nice guys. Even the crowd at CBGB was better than what I saw in Britain; the New York take on punk was more cerebral, and almost charming compared with its vicious, violent transatlantic incarnation. Over here, the punks had adopted the Runaways as one of their own, which I found puzzling. At first I thought they hated us! When we were onstage, they pelted us with cans and coins. You could feel their sweat drizzle across your face and body as they screamed and shook violently, bashing into one another. This wasn't an *audience,* it was a frenzied mob. Sometimes they would even spit at us. After the first show, I was convinced that they hated us.

"Don't worry," the promoter assured us in his thick Cockney

accent when we dashed from the stage. "It means they like you. It's a sign of *affection*!"

After a few more violent, antagonistic shows like that, I started to wonder if the ultimate show of appreciation for these kids wouldn't be to actually storm the stage and kill the band. The shows became nerve-racking; each night was becoming less about the music and more like some kind of ritualized blood sport.

I was taking Placidyls every day now. Meanwhile, Scott Anderson had brought some cocaine along with him, and was rationing it out "for emergencies."

On top of everything else, Scott Anderson was being an asshole to me. Toward the end of the first tour, we stopped flirting and actually got together. I'm not really sure how it happened. There was a lot of simmering sexual tension between us and one night he finally asked me out to dinner. After dinner, he drove me to the Holiday Inn in Woodland Hills and got us a room. I was nervous, but excited, too. After we'd checked into a room, I remember he disappeared into the bathroom for a while. When I finally knocked and was told to come in, I found him lying naked in the tub. He was very well endowed. I remember I saw it just . . . *floating* there, and it scared me a little. I was young and inexperienced, and after we'd had sex, I started getting attached, thinking that I was in love with him.

I just needed someone to hold me, someone who would show me affection, and Scott was there. He knew how vulnerable I was, and played into it totally. I was spending so many nights at his place prior to the European tour that I had practically moved in. My father didn't like Scott, and would say, "Cherie, you're sixteen years old. He's almost thirty. Can you honestly tell me you don't see what's wrong with this picture?"

"Scott's a good guy, Dad."

"Well, he works for Kim Fowley. He might not be as much of a snake as Fowley is, but he's a gofer for a snake. And I don't know what's worse."

"I'll marry Scott one day. Just you see."

My father would roll his eyes and change the subject. If my dad had been in a better place, I'm sure he would have killed Scott. But Daddy was sick, and distracted. The entire family had been swept up in the chaos of the Runaways, and in a way I thought that my leaving on tour for a while might have been a relief to them.

I meant what I said to my dad. I felt that I was in love with Scott. Now I see I was just desperate for someone to love me. They didn't have to mean it. The mere words were enough.

But everything changed once we left California. Once the European tour started, Scott began ignoring me. And I didn't like the way he was talking to the other girls; he had that same smirky, flirtatious manner that he had with me before we got together. He acted like I was invisible, and was always having hushed, overfriendly, giggly conversations with the others. Sometimes, when we'd all be partying backstage, I'd notice him placing his hand on Jackie's hip, whispering wetly into Lita's ear. I didn't want to seem jealous but it was eating me up inside. At the time, I swore that if that motherfucker screwed around with any of my bandmates, it would be over. I found out years later that he'd slept with all of us, with the exception of Jackie.

I spent a lot of time hiding out in the bathroom, crying. I took more and more pills, washing them down with booze. I remember once being so high and so angry at Scott that I practically pulled the guy who delivered the room service into my room in one of the English hotels we were staying in so we could have sex. Joan was out at the time. I grabbed the guy and said, "Will you screw me?" He looked terrified, but I didn't give him much choice. I dragged him into the bathroom and we had sex right then and there, in total darkness. Then I told him to get out. I was so confused, so high, so homesick, and so hurt by Scott that a kind of temporary insanity had taken hold of me. A few weeks into the tour I was totally miserable.

We were in a black Mercedes-Benz driving past miles and miles of black, featureless highway. Outside, the air was damp and gray, the sickly haze of the streetlights hanging in the fog that was even grimier and

thicker than L.A. smog. Thoughts of L.A. made the pain inside of me seem even more intense. Jesus, I was even homesick for the *smog*.

The limo was beautiful. Plush. Black leather seats, a minibar. Much better than Stinky's beat-up van. Yes, the Runaways were at least touring in a degree of luxury in those days. But something had changed. There was little talk anymore, no seltzer fights, no jokes. We were simply there to do our jobs.

On the television we were watching Pink Floyd's *Dark Side of the Moon* concert. The song was "The Great Gig in the Sky." Nobody was talking. I was staring at the screen with heavy, stoned eyes. The light danced across my impassive face. During the song, a woman's voice broke out of nowhere and suddenly the entire song soared. This heart-stopping, beautiful wail seemed to be coming from deep inside her soul. I felt Lita reaching out to me, tapping me on the shoulder.

"Whah?" I mumbled.

Lita smiled, and said, "Man, why can't you sing like that?"

As the Runaways were gaining international success, we even made it to the magazines and the jungles of Indonesia. Don wrote to tell me that at school one afternoon he was in the smoking hut, an octagon building for students to smoke cigarettes and congregate between periods. He and his friends were just hanging out when a fellow classmate entered holding a poster from a rock magazine. It was of me, onstage in my corset. The guy held the poster up high for the entire group to see. "Hey, Don! Is this your sister?!" he said loudly, with a condescending tone.

Don said, "I dunno. Bring it closer." The guy crossed the room, obnoxiously displaying his prized poster.

"Well, is it?" He sneered. He was really trying to get Don's goat.

Don said again calmly, "Hmm, I'm not quite sure . . . bring it closer." While the room hooted and hollered, the guy brought it right up to Don's face. In a flash Don punched right through the page, hitting the boy square in the nose. His knees buckled as he stood stunned and embarrassed.

Don then took the poster, held it up for all to see. "This is my

sister, everybody," he yelled proudly. "Her name is Cherie Currie and she's an international rock star!"

I laughed when I read that story, but usually the press caused lots of friction.

In England, they were all over us. The kind of press we were getting was causing problems in the band. I was in the lobby of a hotel somewhere in this gray, cold country flipping through the latest magazine article on us. Ugh, those magazines were so stupid. I finished flipping through the one I was holding and said, "I don't like the pictures."

"Oh, *sure* you don't!" said Sandy sarcastically. The picture they used, just like in all of the other magazines, was an image in which I was standing front and center. The other girls were in the background. The piece itself was particularly stupid. Rock magazines were the worst! They constantly compared us with each other—not in terms of who was the best songwriter, or most talented musician—but by who looked the hottest. Who was prettier than who. Sandy wasn't the only one who was resenting all of the attention I got as the lead singer. Everybody was starting to get pissed at me, as if I were somehow responsible for every stupid article written about us.

Lita grabbed the magazine, and sighed. "Surprise, sur-fuckin'-prise," she said. "It's the fuckin' Cherie Currie show again."

I didn't even give her the courtesy of a glance, but she kept on anyway.

"You *really* don't deserve all of this Cherie. It's bullshit!"

"Oh, give me a break, Lita. I don't write the damn things . . ."

"Oh! You don't write them, that's right. But you sure as hell make sure that you're standing at the front pouting whenever a photographer is around. Dammit, this isn't 'The Cherie Currie Band,' in case you didn't notice! It's the Runaways . . . and most of *us* were here before you were."

"Shut up, Lita!" Sandy said. "We've only been here a week and we're already fighting. How do you think we're going to get through two months if you keep this up?"

I didn't know if I was grateful for Sandy's interference or not.

Lita might have been a bitch, but at least she spoke her mind. The others were content to try to act like we were cool, but they weren't so great at hiding their true feelings. They just expressed them in other ways. All in all, I had the feeling that this tour was going to be a nightmare.

"I'm telling you, Cherie," Lita snapped, "you're getting to be a regular fuckin' prima donna!"

"Bullshit! No, I'm not!"

"Oh yeah?" She stood up, and started counting off the charges against me on her fingers. "Who demanded that Kim not come on this tour?"

"Oh! So now you *want* Kim around? You bitched about him as much as I ever did!"

Ignoring me, she went on: "Who pouted and sulked until she got the window seat on the flight over? Who keeps complaining that the songs aren't in her key?"

"So what? The songs *aren't* in my key!"

"Maybe if you had a better vocal range they would be!"

"Lita, man." Sandy got between Lita and me. "You're starting to sound just like Kim. Why don't you just can it for a while?"

Everybody fell silent. Lita stormed off, and sat over in the farthest corner of the lobby, arms folded, back turned to me. The silence quickly turned uncomfortable.

"It's not my fault!" I said again, in a pleading voice. "Doesn't anyone believe me?"

No answer. Everyone was looking anywhere but in my direction.

"Joan," I said, "don't *you* believe me?"

Joan didn't turn to look at me. Without meeting my gaze, she mumbled, "Yeah. Of course I believe you."

Kent Smythe, our roadie, came over and said, "Okay, ladies. I have your room keys . . ."

I was rooming with Sandy this time around. As soon as we got into the room, she flicked on the television and started complaining about the lack of channels. I went straight into the bathroom and locked myself in. In the bedroom Sandy yelled, "Cherie, you ain't gonna

believe this. There's only two fuckin' channels, and one of them is showing a bunch of old geezers playing darts! Goddamn!"

I dropped the hotel key into my purse and then reached into my bag for a Placidyl. I popped it in my mouth and swallowed hard. I yelled to see if Sandy wanted to go get a drink with me. Another day loomed in front of me, and I wondered how I was going to get through it.

In Glasgow, the audience screamed at us, and beat the living crap out of each other in the aisles as we played. Debris rained down upon us, and we did our best to dodge the bigger items while still hitting our notes. As a song ended and the stage was plunged into darkness, I felt a heavy thud at my feet. When the lights came up again, I saw that it was a huge bowie knife that had flown through the air, landing only inches from my feet. I had actually *felt* it as it embedded itself in the stage.

I felt my blood turn to ice, and I ran offstage in terror. Backstage, I screamed at Kent, who was uselessly trying to calm me down. *"That's it, Kent! I'm not going back out there!"*

"But, Cherie . . . listen!"

"They want to *kill us*!"

"Cherie—they're gonna tear this place apart if you guys don't finish the set!" Then I saw Joan storming off the stage with a worried look on her face. She ran over to me, her guitar still around her neck.

"What the fuck just *happened*?" She had obviously seen the knife sticking up out of the stage, and it had scared the holy shit out of her, too.

"I don't want to go back out there, Joan!" I said, on the verge of hysterics. "I don't want to die playing this stupid show!"

"Look!" Kent interceded. "I'll talk to them. I'll calm them down. They're just kids . . ."

First Kent walked out onstage and said that if they continued throwing stuff at us, the show was going to be canceled. You could barely hear him above the screams and jeers. Then Joan went out, threatened the same, and they quieted down a little. After a few tense

minutes, we reluctantly went back out and finished the set. From that point on, I stood back from the edge of the stage, my eyes combing every inch of that audience. I was determined to head off any more attacks, in case they were planning on throwing grenades, Molotov cocktails, or whatever other shit they hurled at bands they "liked" in this hell hole of place.

I looked down and all I could see was a sea of faces, all twisted up in a mask of rage and hate. Hate was definitely "in" all of a sudden. All of the music I had grown up on seemed quaint, sweet even. These kids were fucking insane. I thought I had taken it to the extreme, but the audiences here actually *scared* me. They made me look like Cinderella! From the corner of my eye, I noticed something twinkling, suspended in the air for a split second. Then it careened toward the stage, and I realized that it was a large glass bottle. It hit Joan's guitar with a loud clunk, deflected, and then shattered at our feet. I caught Joan's eye—she looked as pissed off and scared as I felt. That was *too* close.

When the show finally ended, a dozen security guards had to clear a path to get us out of the venue in one piece. We huddled our way toward the waiting limo, and I realized that this is what it must feel like if you're an infamous prisoner running the gauntlet of a screaming mob on your way to court. Desperate hands reached out to us, trying to tear away a piece of our clothes, a chunk of our hair, anything they could rip away from us to keep for a memento.

"GO!" screamed the security guard as we shoved our way into the limo and the door slammed behind us.

"Jesus Christ," said Joan, her voice dripping with fear and awe. Looking through the windshield, I could see the sea of screaming kids parting slightly as the limo started to roll slowly forward. There was a heavy, rhythmic hammering as the throng of rabid kids slammed their palms against the hood, the roof, the windows.

"I feel like I'm on the last plane out of Burma," Jackie said.

"Me, too," I agreed, although I had no idea what she was talking about.

The limo inched forward, coming to a stop every few moments be-

cause the crowd was blocking the way. The driver honked and cursed at our insane fans through the tinted glass.

Sandy smiled, and looked at me. "Man, I'm thinking that we should maybe throw *you* to them, Cherie. Hey, guys—d'you think that they'll let us go if we give them Cherie?"

Everybody laughed at this, and I joined in. But a part of me wondered how much of a joke it was. I suddenly felt like I was fourteen again, hanging out with Marie and her cool friends. On the outside, looking in.

"Where the fuck are the security guards?" Lita sneered as the limo started to rock from side to side. They seemed to have vanished, and the limo wasn't even moving forward anymore. In fact, the crowd was swarming the vehicle from all sides. I felt hot, claustrophobic. The inside of the limo got dark as the crowd pressed up against the windows, blocking out all light. Faces, smushed out of shape like Play-Doh masks, were pressed up against the glass. Screaming, squished mouths and saliva dripping down the glass, steaming up on the outside. Mohawks and skinheads, leather jackets and chains, and fists pounding against the glass. The rhythmic rocking of the limo got more and more intense. Side to side. Like they were trying to flip us over.

I looked over to Joan, and she looked pissed off and terrified at the same time. "This really sucks!" she said with a slightly hysterical note in her voice.

The pounding got louder. I had this terrible image in my head that they would rip the roof off of the limo like the lid off a tin of sardines, and then drag us all out, screaming, to be ripped to pieces. "Fuck!" the limo driver screamed, and he lurched forward in a panic. The crowd didn't move. The left wheel lifted off the ground. Jesus—the mob was going to turn the limo over any second now.

With a *clunk,* we righted ourselves. Sensing an opportunity, the driver stepped on the gas again. We lurched forward once more and the crowd started to part. I could see light at the end of the long, bleak back alley we were in. As we took off, even over the howls and screams of the crowd, I heard a bloodcurdling scream as the limo rolled over something solid. *Oh God.* I realized in a moment of horror that we had run over one of the teenagers who were rushing the limo.

The limo tore away as we all stared out of the back window at the crowd forming around the fallen kid.

In Liverpool, the crowds were just as insane. We played on while bottles and garbage rained down on us like confetti. By now we were used to it. We performed around it. I learned to sing with one eye slightly above the crowd to watch out for the missiles launched by the audience. As I moved around the stage singing, I could hear glass crunching underneath my platform soles.

Ever since the limo ran over the kid in Scotland, security had been beefed up. As well as a metal barricade, there was a line of roadies standing between the audience and the stage, on the lookout for potential trouble.

In the middle of "Born to Be Bad," the crowd lost it. They seemed to surge forward as one entity, and it became apparent that the audience was preparing to make a break for it. The barricades started tipping forward, and the roadies rushed to prop them up and push the kids back. It was no use: there was a crash as the barricade came down and a sea of kids charged toward the stage, trampling the roadies in their wake. Security flooded the area and pushed the kids back, but I saw one of our road crew being dragged out from underneath a barricade. We found out later that his leg was broken in the melee. Scott was laughing when he told us this. "Don't worry about him! The lucky bastard got a shot of morphine in the hospital!"

After our final show in the UK, we were physically and mentally exhausted. The following day we were due to leave from Dover on the ferry to play in Paris. It had been weeks of rain, cold, uncomfortable hotel rooms, and hostile audiences. On top of it all, I was starting to get sick. Waking up in the morning was getting harder, and when I did, sometimes I'd be nauseous beyond words. A part of me wondered if it was because of the pills I was taking, but if it was, then it was a side effect I was willing to tolerate. If I didn't have drugs that could make me stop feeling for a while, I thought that maybe I'd

have thrown myself out of the window of one of these cold, old English hotels. It had been weeks since we'd arrived, and so far we'd had only two sunny days. The rest of the time it had been cold, gray, and damp. I'm a California girl—I needed the sunlight. I had never felt as homesick.

"Have you ever wondered," asked Jackie as the van tore through the night, heading toward the hotel, "where all of the money goes?"

"Didn't Scott give you a per diem today?" I asked. "He gave me ten pounds."

"Yeah," Sandy said, "me, too. You should ask him."

"No! I don't mean like ten dollars here and there. That's pocket money! I'm talking about the actual *money* money."

Lita sighed. "It's paying off our debts, remember? You know that. We owe money to Mercury Records, the tours are expensive, Kim's been putting tons of money into promotion . . ."

"Every band has to do that stuff," Jackie countered, "but I don't think that they have to rely on handouts from their tour manager to survive." She dropped her voice to a whisper. "Kim pays Scott. He pays the roadies. They aren't here for free. They're on a salary."

"So?" Sandy laughed. "Of course they are. They're working. If we didn't pay them, we wouldn't have a tour!"

"I just think," whispered Jackie, "that it's a little weird that the fucking tour manager is making more than the band. Don't you?"

A silence fell over all of us. Jackie shook her head. "I think that a lot of people are getting rich off of us, and that we're getting ripped off."

Nobody had an answer to that. I guess we had all been suspecting it in our own way, but there was no way to prove it, and no time to try. In the end, all we could do was pretend that it wasn't happening. Keep playing, keep recording, and try to make the Runaways the biggest band in the world. Jackie may have been book smart, but she would have been no better than any of us at trying to call Kim out on this. She'd be fired before she'd finished her first sentence.

"Well"—Lita laughed—"that's one way to kill a rock band. Starve it to death."

She was trying to be funny, but what she'd said actually made

sense. The truth was that bands don't break up; they die. The way things were going in the Runaways, that death was looking to be a particularly violent and ugly one.

"Shhh!"

We looked up. Scott Anderson was walking back toward us. Everybody got back to what they were doing: Sandy and Joan were listening to music. Lita was playing the guitar. Jackie had her nose in a book. Scott came over to me.

"Hey, Cherie," he said.

I stared out of the window, ignoring him. When I felt his hand on my leg, I softened a little.

"You okay?"

I looked at him. He was smiling at me, looking concerned. I shrugged.

"Betcha can't wait to get out of this dump, huh?"

I laughed a little. "You got that right."

Scott looked around furtively to make sure nobody else was listening. "You, uh, you want some coke?"

"Sure."

"Here." He pressed a vial into my hand. There was quite a bit. "Have fun, and just stick what's left in your makeup case. Oh, but save some, because I don't know how easy it's gonna be to score in Paris."

I nodded, and then Scott was off doing the rounds, speaking to everyone. We were all off in our own worlds these days, not talking, not even looking at each other. The misery in the van that night was palpable.

At the hotel in Dover, I was back to rooming with Joan. I popped a Placidyl and waited for that feeling of pleasant numbness. It didn't cure the ache that I felt down inside of me, but it took my mind off it. I decided to spend the night watching TV, but at midnight the channels closed down after playing the British national anthem. And then it went to the test screen. I changed the channel, and everything was the same. Dead. Dead, dead, dead.

Jesus, I thought, David Bowie really came from here? Maybe he wasn't lying when he said he was an alien.

I wanted to take another Placidyl but decided not to. I had been feeling sick lately, a weird lingering nausea that never seemed to leave me. My weight had dropped a worrying amount since the start of the tour. I didn't want to take too many drugs in this state and end up in a coma or something. Even when I took the drugs I realized that this just wasn't fun anymore. The drugs had become a part of my routine. Something to wake me up. Something to help me sleep. Something to calm my nerves. There was a time when I was able to wake up, go to sleep, and have fun without a pill or a line to help me function. These days it felt like I might have a nervous breakdown if I didn't have them.

I vowed that as soon as we were back home, I'd stop. I just needed this to help me deal with all of the bullshit and the stress of this damned tour. It took a while, but I fell into a shallow, fitful sleep.

I woke up in the middle of the night. Joan was screaming. I flicked on the lights and she was sitting up in bed, gasping for air. She had a look on her face that I saw her get every so often—like she wanted to cry, but she was too tough to do it. So she'd get angry instead.

"Joan? Joan? What's wrong?"

"Oh shit . . ." Joan said. "I just had the craziest dream. It was terrible."

"Fuck, you scared the shit out of me."

"Sorry, I dreamed that we were performing. I was singing 'Born to Be Bad' . . . and then out of nowhere I hear BLAMBLAMBLAMBLAM! Like a fucking machine gun is going off. And I feel my body—just shaking and on fire. Like I'm riddled with bullets. I look down and there are bullet holes all across my guitar, and there's . . . *blood*. Blood just *pouring* from the guitar. And—and I turned to you, and the others, and I'm yelling, 'I'm shot! I've been shot!' but nobody will help me. You all think it's a part of the act . . ."

We talked about the dream, and the tour, and everything else until Joan fell asleep again at around three in the morning. I just lay there in the cold, dark hotel room. I could feel the Placidyl still swimming

through my brain, but it was no good. Sleep would not come. I crawled into the fetal position and thought of Dad, and Grandma, and most of all I thought about Marie. All of them were back at home, lying in their own beds. More than anything in the world, I wanted to be at home, too, away from all of this. The tour stretched out in front of me, infinite and terrifying. Oh God, I wanted to go home.

16

Greetings from Scotland Yard

We were in the car the next morning, sitting in a line of traffic at the shores of Dover, waiting to catch the ferry to Calais, France. Scott had told us that the concert in Paris was sold out, and despite the typically damp, gray English skies, our spirits were pretty high. It felt good to be heading to a new country.

We had a few vehicles in a convoy, and the British police were going from car to car checking things out. They seemed especially interested in our road crew.

"It's the walkie-talkies," Jackie explained to me. "They're illegal here, unless you're police. That's why they're checking us out—all the roadies have walkie-talkies." I, for one, was uninterested in Jackie's civics lesson. I was lost in a British fanzine, trying to catch up on the latest happenings back in the good old USA.

A tall man with a malformed, red drinker's nose and a sour, twisted mouth approached the car. He was wearing a battered-looking trench coat and was flanked by two British bobbies in full uniform. He knocked on the window of our car, and Scott rolled it down. There was a brief, murmured conversation, and then Scott turned back to us.

"I'll be right back, ladies!" he said with a weak smile.

When Scott walked off to go talk to the police we started making jokes.

"Maybe they think Scott is running a white-slavery ring . . ."

"Maybe they'll strip-search him!"

"Nah, he normally has to pay for that kind of treatment . . ."

After a few moments, a slightly worried-looking Scott returned to the car. The ugly guy with the red nose and the two policemen were with him. He opened the door and said, "Would you mind stepping out, girls?"

"Aw, what the fuck, man?" Joan sighed. She was trying to sleep in the back, using her battered leather jacket as a blanket. I continued to read, basically unaware of the command. That is, until a badge was flashed before my eyes, breaking the spell.

"Scotland Yard, get out of the car! Now!"

That got my attention, and we reluctantly got out of the car. It was freezing, and we stood there shivering in the misty, gray morning.

"Inspector Hadley, Scotland Yard," the ugly man said curtly, by way of introduction. He looked us over, with visible disgust. Five teenage girls wearing leather jackets and low-cut tops with their arms folded and insolent looks on their faces stared back at him. I was sure that he thought we were dressed too outrageously. He seemed the type. Probably thought we should have been in school, dressed like proper young ladies. Ugh, what a creep. Everybody was smirking and trying to look cool. "Will you empty your bags please?"

He went to Sandy first. We thought nothing of it until he triumphantly produced one of those cheap, barely functional hair dryers that they provide in hotel rooms. We didn't know Sandy had taken it. None of us realized that they had a different power system in England, which left our hair dryers useless. Joan and I'd bought an adapter but Sandy must have thought it would be easier to just take the dryer. Nobody thought it was a big deal; after all, they leave those things just sitting there in the hotel room . . . and how exactly was a girl supposed to tour Europe without a functioning hair dryer?

Inspector Hadley gave Sandy a dirty look as he produced a single room key, held it up for us all to see. "What are you planning to do with this?" He sneered at Sandy. "Return to the hotel and rob innocent people using your room key?"

Sandy stammered something about how she must have forgotten to return the key.

At this, I started to get nervous. I knew what he would find when he looked through the rest of our bags. Hadley moved on to Joan. Silently, he dumped the contents of her bag on the hood of the car. She folded her arms and scowled at the intrusion.

"What's all this, then?" he said to no one in particular as more keys clattered across the hood.

Joan shrugged. "Uh . . . they're *keys*?" she offered, nervously.

He continued rummaging around. He found hotel key after hotel key after hotel key. Sixteen in all.

The hotel-key thing had started when we met Robert Plant back at that first show at the Starwood. He'd told us that he'd collected the room keys for every hotel he stayed at on tour. He'd display them in shadow boxes—a record of every place he had been on tour. We all thought that this was a cool idea and started collecting our own room keys. Very innocent, really.

Hadley gestured to another officer, and Joan was taken aside with Sandy. "I told you guys that was a stupid idea," Jackie said, in her Little Miss Know-It-All manner. Joan gave her the dirtiest look she could muster. Lita stayed quiet, for once. She had told us it was a dumb idea at the time, too.

Now Hadley came to me. He sifted through all of my personal belongings. Man, this bastard was thorough. I started to think that maybe we'd dodged a bullet here. After all, how upset could they possibly get over some stupid hotel keys?

Thirty-two keys later and Inspector Hadley had seen enough. He straightened up, and looked at all of us with an evil smile on his thin lips. We grinned back at him, and suddenly the smile disappeared from his face. "I don't know what the laws are like where *you* come from," he said, "but in England this sort of thing is illegal."

Scott was about to say something, but Inspector Hadley cut him off with a wave of his hand.

"But they're just keys!" Joan blurted. "What's the big deal?"

"Hmm," Hadley said, "just keys. No big deal. No big deal until the time that you return to the hotel and use them to sneak into rooms and steal!"

"Oh, get real, man!" Sandy laughed. "You gotta be kidding us!"

Hadley looked real serious then. "I don't *kid*," he said solemnly—and I believed him.

"But—but we have a ferry to catch! We have a show in Paris tonight . . ."

"Not anymore. We're going to have to talk about this at the station," he said. Then, looking to the uniformed officers gathered all around us: "Arrest them!"

"I can't fucking believe this," Sandy said for the third time in ten minutes. "We're locked up in Scotland fucking Yard! Over some hotel keys and a fucking hair dryer!"

Joan and I were the only ones who'd been collecting the hotel keys. Sandy really had forgotten to leave that single key behind. And the hair dryer? That was just ridiculous! But no matter how silly it seemed, the fact was that the three of us were now locked up. Lita and Jackie were sent off with Scott and Kent to try to figure out a way to get us out. Sandy and I were in a stark, cold holding room with a set of dirty-looking bunk beds and concrete floors. There were no windows. When they first booked us, we had to sign a bunch of papers, get photographed, fingerprinted, the works. One of the female officers tried to do a strip search of us but I screamed, cried, and made such a fuss that they decided to forget it. Finally we were allowed to call our families. I stood there, holding the plastic receiver up to my ear, muttering "Please pick up . . . Please pick up . . ." to myself. On the sixth ring, Marie answered.

"Marie! It's Cherie!"

"OH MY GOD!" Marie screamed. "We were just watching the TV, and they're showing this movie called *Dawn: Portrait of a Teenage Runaway* and, like, CAN YOU HEAR THAT? They're playing 'Cherry Bomb'! No shit! Man, this is so cool . . . DAD! DAD! Cherie's on the phone! She's calling from England!"

"Please! Marie! Listen to me! I'm in jail!"

". . . DADDY! YES! IT'S CHERIE! OH MY GOD!" She was so excited to have me on the phone that she wasn't listening to a word.

"Listen!" I repeated. "I'm in jail! I'm in jail! I'M IN JAIL!"

"WHAT?! What was that you said?"

"I'M IN JAIL, MARIE!!! Put Dad on the line!"

"You're in WHERE?"

"PUT DAD ON THE LINE!"

Marie went silent.

When Dad finally got on the phone, I told him that I'd been arrested then started babbling about the hotel-room keys, but he cut me off.

"Let me make some phone calls, Kitten. Just calm down. Are they treating you okay?"

"Yeah," I said weakly.

"Let me make some calls. Hold tight, Kitten. It'll be all right!"

Because Joan had recently turned eighteen, she was being treated even worse than us. She had been put into a real cell, the kind with bars. We could hear her screaming and crying and freaking the fuck out. They locked her in there first, and as they led Sandy and me to our room, Joan literally leaped up on the bars like one of those crazed chimpanzees at the zoo and started rattling them frantically, screaming to be let out. The noise had been going on for forty minutes now, and my heart was aching for her. Her screams were primal, from the pit of her gut. She sounded tortured and scared. I knew that Joan could get claustrophobic, and being locked up in a tiny cell away from the rest of us must have been unbearable for her.

"Man," I said to Sandy, "this is fucked up!"

We listened to Joan's sobs and screams echoing down the corridors. We decided to start banging on the door and yelling until someone, anyone, would help her. Suddenly the noise stopped. Sandy and I looked at each other. We heard footsteps approaching. Then a heavy *clunk* as the lock slid back and the steel door swung open. There, with tears on her cheeks and a look of triumph on her face, was Joan, flanked by two pissed-off-looking guards.

"Get in there!" one of them ordered her. She ran inside, and hugged Sandy and me.

"Now, will you *please* keep the bloody noise down?" another guard growled, before he slammed the door shut again.

Hours passed. "You think they're gonna keep us here overnight?"

"No! Don't say that!"

Sandy frowned. "This really sucks." That had been her running commentary on the whole European tour so far.

The guard brought us some food after a while. We each got a cup of watery tea, a single fried egg floating in a sea of yellow grease, a slice of white bread, and some wrinkly-looking grapes. The food was disgusting, so we used the grapes to play hopscotch to pass the time. When a guard returned with another guard in tow to collect the trays, I asked if I could have another cup of tea and Sandy asked for another slice of bread.

"No!" the first guard snapped. "This ain't the bleeding Ritz, you know!"

The other guard, an older man with a mop of gray hair, looked at his partner with disgust. "Oh, come on now! They're only kids, fer Christ's sake!"

At that point, they produced papers for us to sign. The papers stated that we took full responsibility for what was found in our luggage. "If it has your name on it, you're responsible for it," the officer muttered. We signed the paperwork and they closed the metal door behind them.

"Bread, please?" Sandy pleaded in her most pathetic voice. Joan and I giggled.

The first guard reluctantly returned with a teapot, poured me another cup, then threw a slice of bread wrapped in a napkin to Sandy. He didn't volunteer sugar, and I didn't ask. When he left, Sandy mimicked him in her best Dick Van Dyke accent: "'This ain't the bleedin' Ritz, you know!'" and we got a rare laugh out of our situation.

This lighthearted atmosphere was brief. It lasted right up until I remembered something that turned my blood to ice. I clamped my hand to my mouth and steadied myself against the wall. Suddenly my knees had turned to jelly.

Joan and Sandy looked over to me curiously.

"What the hell's wrong?" Sandy asked.

"The coke!" I whispered. "The fucking *coke!*"

Joan came over to me and put her hands on my shoulders. "What are you talking about? What about the coke?"

I glanced nervously at the door again, and I hissed, "The *coke* is in my fucking *makeup case*!"

At this, we all fell silent. Sandy ran a shaking hand through her hair. Joan started pacing the room. "We have to tell Scott," Sandy said. "He'll have to get it out of your case before they find it."

"And how in the hell is he going to do that?" I wailed, curling up in a ball on the floor. I imagined spending the rest of my life in a crappy little English jail cell like this one. A drug smuggler! They can lock you up for life for that!

It wasn't five minutes before the door scraped open again. It was that old bastard Inspector Hadley, the one who started this whole mess. Behind him was Scott Anderson, still carrying that stupid brief-case of his and looking like a whipped dog. They both stepped inside the room and Hadley took a look at us. He fixed me with a nasty stare. "Zip your top up!" he scolded me. Then he muttered, "Bloody shameful!"

I crawled into the bottom bunk and pressed my body to the wall, away from the gaze of the detective. I made frantic hand gestures to Scott like I was raising a spoon to my nose. He just smiled at me dumbly. I finally knew that he understood me when I saw the blood drain from his face. He looked totally shaken. Hadley had noticed the look on Scott's face. When Scott felt Hadley's eyes on him, he cleared his throat and stammered, "A-a-apparently the luggage has been sent on to Calais already . . ."

For a moment I thought that everything would be okay, but then Scott continued.

"Inspector Hadley tells me that it needs to be confiscated by Scot-land Yard and searched. So that means—"

"That means," interrupted Hadley, "that you *ladies* will be stay-ing with us tonight, until the luggage is returned to Dover tomorrow morning. Once we have a look, we will decide how to proceed."

I started frantically signaling to Scott again. Suddenly Hadley swooped down to the bottom bunk and put his face close to mine.

"Secrets, eh? We'll have none of that in here, young lady!" He turned, and sent Scott out of the room like a naughty schoolboy.

When Scott returned later that evening, it was with the nice guard

with gray hair. The guard left us alone. Scott let us know that the luggage was now in Scotland Yard and would be searched in the morning. If I'd thought for a second that he would be coming with good news, I was sorely mistaken. Instead he and Kent had concocted some harebrained scheme to break into the fenced area where the luggage was being held so they could steal the coke.

"It's your coke, Scott!" I whispered urgently. "I can't go to jail for *your coke*!" My stomach was in knots.

Scott whined, "If we can't get into the hold, there's nothing I can do! You just got to hope that they . . . they don't *find* it!"

"*We* have to hope, Scott! Because I'm telling the truth if they do!"

"How are they *not* going to find it, Scott?" Joan asked. "All they have to do is open up her makeup case and there it is. They'd have to be blind!"

Scott went quiet for a moment, and looked sheepish.

"Seriously, Scott—they're gonna lock me up *forever* if they find it!"

"What do you want me to do, Cherie? It's out of my hands! If I could do anything, I would."

"Then tell them it's yours! You gave it to me! You need to tell them that!"

Scott gave me a look, and in that instant I knew that he had no intention of doing that. "It's too late," he said. "You signed that piece of paper saying that you take responsibility for what's in your luggage. That's just the way it is. We gotta hope for the best, that's all."

Before I could say another word, he went over to the door and knocked loudly, three times. "Guard!"

The door opened, and the gray-haired guard let Scott out. I sat on the bunk and burst into tears. That bastard! That weak motherfucker! He was going to let me take the fall for him! The guard gave me a concerned look before closing the door. Once Scott had left the building, the guard returned with cups of tea for all of us. He sat beside me, and watched me crying and sniveling for a while.

"What's wrong, luv?" he asked.

I shook my head and cried. I couldn't tell him.

"Come on," he said, "it can't be *all* bad. . . ."

I started blubbering to him about how homesick I was, and how badly I missed my family. About how I'd rather be just about anywhere else in the world than stuck in this stupid cell. About how mean the inspector and the other guards were. By the time I was finished, I was sobbing, on the verge of hysterics.

"It's going to be okay," he said to me. He put a hand on my shoulder. "You'll see." I just sobbed and shook my head.

Not when they find Scott's cocaine, I thought.

Sometime in the early morning hours, I was lying in the bunk listening to Joan and Sandy softly breathing. The cops had left the lights on, so Joan and Sandy had to sleep with their jackets over their faces. God, I wished I could sleep. Instead, I felt more drained, more fearful, as each second ticked by. I thought I could hear mice in the walls, scrit-scratching against the exposed brick. Every time I started to fall asleep, some cry, or bang, or clang would echo throughout the building and I'd jerk awake, paralyzed by fear and paranoia.

I had no idea how long we had been in there. There were no windows, just the bright fluorescent bars of light beaming down from the cracked ceiling. It was only when they brought in breakfast that I knew it had to be morning. The nice guard made sure that we had extra food. I couldn't eat. I was just staring at my cold toast when the door to the cell burst open, and in came Detective Hadley, Kent Smythe, Scott Anderson, and the nice guard. I looked over to Scott for a clue, but he shook his head. He was still in the dark. I looked over to the nice guard, who shot me a friendly smile, as if to say, "Don't worry." I looked to Detective Hadley, and felt my blood run cold. He had a mean smile on his thin-lipped mouth, and he positioned himself right in the middle of the cell. I felt beads of cold sweat forming on my forehead and upper lip. Oh God!

I looked over to the nice guard again, and he was staring at me with a concerned look on his face. He could see that I was about to faint, vomit, or both. He knew that I was scared. He knew that I was

worrying that I would be stuck here for the next twenty or so years. But his face radiated a calm cool, and that sweet smile was never far from his lips. His eyes stayed on me as Inspector Hadley began his speech.

"Well," he said, sounding slightly disappointed, "I personally feel that you girls are on the wrong path. I also feel that you're hiding something. Especially *you* . . ." He pointed right at me. "However, as much as I would have liked to have you stay with us for a while longer . . . it seems that we didn't find anything in your luggage to warrant keeping you here. Personally I think you were damn lucky, but I will give you fair warning: I'm going to keep an eye on you. All of you. And I swear that next time any of you pull a stunt like this in England . . . we'll have you. Now gather your belongings, and get out of here. You're free to go."

We all sat there, dumbstruck. I looked over to the nice guard again, and he gave me a smile and a nod. I didn't understand it, but I didn't want to hang around too long to find out that it was a mistake and that they wanted to arrest me again. I grabbed my meager belongings, and on the way out the nice guard whispered, "Take care of yourself, sweetheart."

It was then that it hit me. This guard must have been the one who did the search. He must have found the drugs, and then chose to ignore them.

"I will," I told him. "And thank you. Thanks for everything . . ."

When we got back to the car, Sandy let out a sigh of relief and said in a mock English accent, "Fucking hell! That was CLOSE!" I burst into nervous laughter. I had never felt so relieved in my life.

Lita was waiting in the backseat with her arms folded and a pissed-off expression on her face. The first thing she said to us was "Yeah, well done. We missed the fucking Paris show because of you three and your fucking room keys!"

"Oh, shut the fuck up, Lita!" Joan laughed as we piled in.

Scott jumped into the front seat next to the driver and turned back to us. "Say good-bye to Scotland Yard, ladies!"

And with a screech of rubber we took off as everybody in the car laughed. Everybody except me, that is. I stared at the back of Scott's head, and it suddenly became clear just what kind of a man he really was: a wimp. Weak and scared. I started to think that maybe my dad was right about him after all.

17

Postcards from Nowhere

After the scare with the hotel keys, the rest of the tour limped on under a black cloud—both literal and metaphorical—hanging over it. The European tour felt like the longest month and a half of my life. I became so homesick that I wanted to die. I had never felt anything like it. Before joining the Runaways, I had never been outside of California. I'd only been on an airplane once before. Suddenly I found myself in strange, foreign countries with a steady rain falling all day and night, and alien food that turned my stomach. Everything looked different. Everything felt different. And it wasn't like we could go sightseeing and try to get to know the countries that we were in; we rushed from venue to venue, hotel room to hotel room, the whole time. It didn't matter that we were in France; it might as well have been in Paris, Texas. It all looked the same when you saw it through the window of a speeding car or bus.

The fear was the hardest thing to live with. The fear that something terrible would happen. The fans were aggressive and angry, and I actually started to believe that eventually some psycho in the audience was going to open fire on us just like in Joan's dream. That never happened, but the bottles, coins, spit, and other projectiles that rained down upon us were relentless.

To top it off, as soon as we'd hit mainland Europe, I started to get sick—really sick, not just homesick. I would wake up in the morning feeling nauseous, and it would get worse and worse throughout the

day. I figured it was the food—something in the mutton or reindeer or whatever other kind of crap they were feeding us over there. I started to worry that some kind of mutant bacteria were eating me up from the inside. It didn't matter where we were, or what I was eating, I constantly felt like I was on the verge of vomiting. As the tour rolled on I was nauseous all of the time. All it would take would be the faint smell of cologne or food, and I would have to race off to the nearest bathroom to hold on to the porcelain for dear life. With all the nausea and unappetizing food, I started losing more and more weight. My clothes started feeling looser. There were dark rings under my eyes, and hidden beneath the makeup my skin started taking on a corpse-like quality.

I didn't get much sympathy from the people around me. Kent Smythe's solution was to put a bucket at the side of the stage in case I had to puke while performing. It was definitely a strange sensation to be strutting around in a corset in front of thousands of screaming European fans while all I could think was "where's the bucket?" The audiences didn't notice. They didn't care. All they knew about the Runaways was the press image that Kim Fowley had created—the tough, don't-give-a-shit feral teenagers. They didn't know how much I was hurting inside, and I couldn't let them know. This was my job; I was the Cherry Bomb. Suddenly, being a sixteen-year-old rock star was turning into a big fucking drag.

If I'd thought I could get any sympathy from Scott Anderson, I was totally mistaken. My worst suspicions about his character after the Scotland Yard incident were confirmed in spades as the tour rolled on. The man who I had lived with before this tour, the man who had held me in his arms, and told me that he really cared for me, treated me like I was an unstable hypochondriac.

"You're just homesick!" he barked when I told him that I felt too ill to perform one night. "And you're making yourself physically sick because of it. Jeez, Cherie, it's all in your head! Can't you just calm the fuck down and try to enjoy yourself?"

It was hard to believe that I'd once thought that I really loved this man. He'd told me that he loved me. But now he was treating me like I was his annoying kid sister. As I watched him flirting with the other

girls, I continued to suspect that he was fucking them, too. Maybe I was the idiot for believing his bullshit, and not listening to my dad's warnings. Whenever this thought occurred to me, it would bring tears to my eyes. Daddy tried to tell me! And I was so infatuated with Scott that I ignored him. Dad had never been so relieved as he was the day I told him that I was moving back home, a week prior to the European tour. As soon as I said it, he jumped right into the car and drove me over to the place I was sharing with Scott. Within minutes, it seemed, he had packed up my things. The way my father talked about Scott and Kim, I think he would have liked to have them both thrown in jail.

"I trust 'em about as far as I can throw 'em, Kitten," he'd say to me, his blue eyes gleaming with anger. "They're not okay cats. I've dealt with a lot like them in my time. Goddammit, they need shooting is what they need!"

I mean, my father didn't even know half of the things that went on when I was on the road with the band. I guess he was hoping that some responsible adult was looking out for us. . . . No, if Daddy had known about the drugs, the alcohol, the late nights, and the verbal and mental abuse that I had to put up with at the hands of Kim and his cronies, I would have been out of the band in a heartbeat. Dad would have *freaked*. Kim would have already been auditioning new singers. Up until this point, it seemed very important for me to keep all of this stuff under wraps so that I could continue to front the band. But as this long, miserable tour ground on, I was starting to wonder if my heart was even in it anymore.

My sickness was proving to be a huge downer for the rest of the band. I was tired and irritable and I often didn't want to go out, or do anything. Hell, I really didn't want to be around people. Even Joan was getting sick of me. I knew that Scott was whispering about me, telling the others that I was faking my illness. I felt genuine animosity from the others in the band, but I was too sick, tired, and depressed to try to fix it. Deep down I didn't blame them. I knew how it felt with Jackie complaining about being sick. That was a drag. I was becoming a drag.

I remember back before the European tour started, when I was still

living with him, Scott got a cold. You'd think that he'd been struck down with malaria from the way he complained. He was lying in bed, moaning and groaning, and I was bringing him bowls of chicken soup and hot tea with lemon. Even back then it kind of turned me off. He was supposed to be the man, and seeing him act like such a pathetic wimp really made me lose respect for him. I thought of that again when Scott pulled me aside to hiss, "God*damn* it, Cherie! Can't you knock this shit off! You're ruining the whole fucking tour for everyone with your whining! Seriously—whatever it is that's bothering you, you need to GET OVER it!"

"But, Scott—I can't get over it! I'm sick! I'm really sick!"

Scott grunted and shook his head. "You're sick in the fucking HEAD!" he spat, before storming off.

"But, Scott—" I said, but it was too late. Scott was gone, and there was nothing else I could do.

When we finally made it back from Europe, I was sick, tired, weak, and utterly demoralized. My family was so happy to see me that they didn't seem to notice how thin I was. One day I stood on the scale in the bathroom and realized that I was down to ninety-five pounds. That was too thin, even for me.

A few days after getting home, I was helping Grandma sweep the floor when I broke down crying for no reason at all. I started to think that I was losing my mind. I had returned from the European tour a physical and emotional mess.

I'd noticed something else, too. It was my boobs. Despite my dramatic weight loss . . . they were getting *bigger*. I thought I was imagining it at first, but there was no denying it. That made me feel a little better, at least. Maybe I was taking after my mom. She was pretty well endowed, so I guessed that could be the reason. The thought amused me. It would send Lita through the roof. She already hated the fact that I was thinner than her, and got more attention than her in the press. Still, she was very proud of her boobs. If I got boobs, too, it would drive her *crazy*. I felt shitty, but the thought of the look on

Lita's face if I showed up to rehearsal one day with big breasts almost made up for it.

I looked away from the mirror. I could smell something floating into the bathroom . . . Grandma was in the kitchen cooking. As soon as the smell hit me, my stomach lurched and I felt the color drain out of my face. Oh God.

Marie started banging on the door. "Come ON, Cherie! We gotta start getting ready!"

Tonight Marie, Vickie, and I were supposed to be going to a club called the Odyssey, an infamous gay dance club on Beverly and Gower. Like the Starwood, the place was run by Eddie Nash, and had already attracted a lot of familiar faces from the old English Disco scene. Tonight, none other than Chuck E Starr was supposedly DJing. I followed Marie into the bedroom, feeling listless and tired. Vickie was listening to records, lounging on the bed. I said hi. Sensing that I didn't feel well, Marie decided to help me pick out something to wear. She started rummaging through the closet, tossing out potential outfits. "Hey! Cherie—why don't you wear your black jumpsuit tonight? It looks really great on you . . ."

She pulled it out from the closet and handed it to me. I looked at myself in the mirror, and shuddered. I looked like crap. "Man," I muttered, "no matter how much makeup I wear, I just can't get rid of these black circles under my eyes."

Marie and Vickie came over and peered at my face. "You look fine, Cherie," Vickie reassured me. Marie didn't say anything; instead she went back to her closet and went on pulling more clothes out. I slipped into the jumpsuit and buttoned it up. The waist and the butt felt loose because of all of the weight I had lost. But as I continued to button it up, suddenly things got very tight around the chest area.

"Jesus!" I laughed. "Look at this, Marie! I can hardly button this over these things!"

Vickie's eyes looked like they were just about to pop out of her head. She took a closer look.

"Holy SHIT, Cherie! I'm jealous! You look like a Playboy Bunny!"

She was right. It was getting so that I didn't even recognize my own body anymore. I'd never seen myself like this. It looked alien.

Strange. I turned to the side and checked out my profile. Big boobs would take some getting used to; this looked like somebody else's body. I couldn't button the jumpsuit all the way up, so I left it low-cut. I turned back to the front. I had to admit my body looked good. It was my tired, haggard face that didn't fit the picture.

"Girls?"

Grandma was calling from the kitchen, pulling me out of my thoughts.

"What is it, Grandma?"

"Are any of you hungry? There's some franks and sauerkraut out here if you're interested. We have plenty . . . Any takers?"

As soon as I heard this, the sickness hit me. I turned cold, like a bucket of ice water had been dumped over my head. My stomach turned, and I felt the bile rising in my throat. "Oh shit!" I ran over to the bed and lay on it with my eyes closed tight, taking deep breaths. Slowly, I started to get the nausea under control.

"Hey . . . Cherie. You okay?" Marie asked.

All I could do was lie there and shake my head. Any sudden movement, any talking, and I knew I was going to puke. I felt my mouth filling with saliva and my guts fluttering unsteadily. Marie came over and knelt next to me.

"You're as white as a sheet," she whispered.

I just kept breathing. After a few moments I managed to croak, "I can't go out tonight. I'm too sick. Sorry."

"Shhh." Marie gently placed a hand on my clammy forehead. "It's okay. I'll hang back here with you. It's cool."

Hearing this, Vickie grabbed her purse. "You're not coming out *either*?"

"No. I think I'd better stay home, too. Cherie's feeing really crappy. You go on. It's cool . . ."

With an exasperated sigh, Vickie said her good-byes. I managed to groan at her as she left.

When the nausea passed, I got changed again and managed to make it to the living room. Grandma, Dad, Aunt Evie, and Marie were in the den. The family was all sitting around with TV trays, watching *Three's Company*. I smiled faintly at them before lying down on the

couch. I covered my nose with my hand because the smell of the food was sending queasy shock waves through my body. I closed my eyes, and the static roar of faraway applause filled the room.

"Cherie?"

I opened one eye, and looked over. My aunt Evie had turned away from the television and said, "Are you *sure* you don't want any franks? They're delicious! And the sauerkraut—that's what makes them so *good*!"

Seconds later and I was in the bathroom, vomiting. I barely made it before it erupted from me, a tidal wave of liquid heat. The puking was violent, and lasted for a long time. My whole body convulsed and shook with the strain. Tears ran down my cheeks. When it finally stopped, I just lay with my head next to the toilet bowl trying to catch my breath. Marie came in, and placed a cool, damp cloth on the back of my neck.

"Cherie . . . man, what's *wrong* with you?" she asked, with real fear in her voice.

I looked up, the tears still on my cheeks. I was trembling. "I don't know, Marie . . ." I said. "I really don't know!"

I was about to start crying. But before I could, the vomiting started again.

18

The Queens of Noise

My illness was not allowed to interfere with the Runaways' schedule. No sooner were we home from the European tour than it seemed that we were sent back into the studio to record our second album. Kim didn't believe in giving the general public time to get bored with you, I guess. This time we had a real producer, a long-haired guy called Earle Mankey who played guitar for Sparks and supposedly had produced a lot of cool records, including stuff for the Beach Boys. We were actually recording the album at Brothers Studio—the Beach Boys' recording studio out in Santa Monica. Still, the fact that there was another producer present didn't mean that Kim wasn't still ranting and raving from the sidelines, and making everybody's life a living hell.

This album was a lot more work than the first. In a way, I almost preferred Kim's approach. There was something to be said for just getting everybody to run through the songs live in the studio and wrapping up the album in record time. This time around, we were spending days on each song, perfecting the drum sound, getting the bass lines just so, overdubbing the guitars. This might have been the way that it was done professionally, but the whole process became as boring as hell.

On top of this, the atmosphere was very different. Things were quickly turning sour within the group. The tensions and rivalries that we'd put aside during the first album and tour were now simmering,

ready to explode. Every day there was a new fight, mostly about the arrangements: who would play what, who would sing what. Every time I cut a vocal, Lita was ready to rip my performance apart, just like a mini Kim Fowley.

Now that we had a "real" producer, the process had become painful, laborious. There was a lot of time to sit around reading magazines. On this particular day, that's exactly what I was doing— reading the latest issue of *Crawdaddy,* which happened to have a nice big cover feature on the Runaways. The cover was cool and iconic: we were all on there, with me in the center wearing a gold glitter vest. We looked tough, playful, and cool. Lita, Joan, and Sandy were aiming water guns at the camera. Jackie shot a slingshot right out of the picture. Images like this were helping to make the Runaways a household name in America—at least in every household with a teenager in it.

But the *content* of the article was another matter. As I read it, I felt the hairs on the back of my neck stand up, a sick feeling coming over me. This journalist had been on the road with us for a while, hanging out with us backstage, even coming back to my home with me on one occasion. It had really seemed like he dug us, and after a while we kind of forgot that he was even there. Maybe we had let our guards down a little *too* much. We had expected a good piece, or at least a positive one. Instead, as soon as he left our tour, he went back and wrote an article that absolutely creamed us. Creamed us! He called us whiny, stupid; he basically made us seem like a bunch of clueless kids.

Joan was furious. "How could that bastard say those things about us?" she fumed. I remember her telling me that she would never trust another journalist again. But even worse than the journalist's betrayal of our trust was the betrayal by my own manager.

There was a section of the piece where the journalist had asked Kim what it was like working with me. Kim's response?

"Handling Cherie Currie's ego is like having a dog urinate in your face." A lump forming in my throat, I read on. "The best thing that could happen to this band," said Kim, "would be if Cherie hung herself from a shower rod and put herself in the tradition of Marilyn Monroe."

We had been recording a track called "Midnight Music" all day

long. It was one of my favorite new songs—a little more melodic than the usual Runaways stuff. Still, hearing the same guitar parts over, and over, and over again was driving us crazy. But all of a sudden I couldn't hear the music anymore. All I could hear was my voice screaming in my head. I looked at the magazine, dumbstruck by the viciousness of what Kim had said. My hands started shaking, and I found myself staring hard at that ugly picture of Kim grinning out at me from the pages of the magazine.

"Cherie!" the engineer called out. "We're ready to lay down a vocal!" I looked over to him, sitting in front of the vast mixing board like the captain of some science fiction spacecraft. I looked back at the magazine in my cold, shaking hands. The rest of the girls were sitting around, tired and pissed off. Everybody's nerves were on edge by the painstaking process of getting every single track on this song just right. Tempers were flaring.

Joan came over to me and put a hand on my shoulder. She could see that I was really upset, and she knew why. "Come on, Cherie. It's just Kim. You know he's full of shit!"

Tears started to well up in my eyes as I continued reading the piece. All of a sudden something was very clear to me: I needed a quaalude. I needed one right away. But I knew that I was out, and I didn't even have the money to get more. But I needed one; otherwise I was going to lose it in a big way. There was a half-drunk bottle of Jack Daniel's in the studio, and I considered grabbing it and chugging it down. I needed something, anything, to take the edge off how I felt right then.

"That son of a bitch . . . how could he *say* such a horrible thing? He said he wants me *dead*!" I managed to stammer that much and then like a goddamn baby, I began to cry. I tried to cover my eyes, but of course everybody saw it. I could feel my cheeks flush with embarrassment, but I couldn't help it.

Lita threw her hands up in exasperation. "Motherfucker!" she screamed. "I can't take this! Are you gonna sing, or are you gonna sit there crying like a fucking baby?"

That was Lita. I could always rely on her in a time of crisis.

"DID YOU SEE THIS?" I bellowed, holding up the magazine and waving it in her face.

"Yeah?" She shrugged. "What about it?"

"Did you read what Kim said about me?"

Lita flung her hair back and laughed. "Yeah. So what, Cherie? It's only a stupid fucking magazine article!"

Lita was in an even worse mood than usual. She *hated* the direction that the new album was taking. If she had her way, we'd have been playing hard rock. But this album was getting a much poppier and polished sound than the first, and that drove Lita nuts. Plus, Earle Mankey was doing guitar overdubs on some of the tracks, something that Lita took personally. Her latest bone of contention was with the song that I cowrote, "Midnight Music." She thought it was "pansy-ass crap," as she so nicely put it. In an attempt to pull the album into a "harder" direction, Lita fought tooth and nail to get a terrible blues-rock song called "Johnny Guitar" onto the album. It was, in my opinion, one of the worst songs the Runaways ever recorded.

Now that she saw that I was in tears, Lita was on her feet yelling, pushing home her advantage. Sandy got between us, ready to intercede and calm things down. Whenever Lita started up like this, I'd get real nervous. On the last tour she had flipped out and physically assaulted Jackie. They were sharing a room, and Jackie had been speaking too loudly on the phone while Lita was trying to sleep. Lita's solution was to rip the phone out of the wall and try to strangle Jackie with the cord.

The producer looked on, used to this kind of drama. The sessions had been painful, and the band as a whole was extremely fragile. Poor old Earle Mankey just stared into space with this just-another-day-at-the-office expression on his face.

Lita grabbed the magazine from me and glanced at it. Then she tossed it to the floor. "He's right about your ego!" she spat. "Always in the center of every damn photo session! Always getting the biggest interview in every damn article!"

"That's not my fault! I don't ask for that!"

Sandy pushed her way in between us. "Will you two just shut up and get goin'? We've been here all day doing this fucking song! I want to get it done already so we can go home!"

My throat was burning from all the yelling. I tried to get my breathing under control, but the rage, frustration, and pain wouldn't stop. Sandy opened the door to the sound booth and said gently, "C'mon, Cherie. Forget the article! Let's just get this over with . . ." She stood there expectantly, waiting for me to walk in and record my vocal. I shook my head.

"I *can't* sing now!" I sobbed. "How can you expect me to sing?"

"See!" Lita yelled triumphantly. "What did I tell you? We all have to go by Cherie's fucking schedule!"

Even Jackie had put down whatever book she was reading and picked up the discarded *Crawdaddy* from the floor. She was flipping through it while all of this was going on. She looked up from it now, shook her head, and whistled. "Whoa! Pretty nasty stuff in there! I didn't even know you and Kim were fighting, Cherie." She tossed the magazine back to me.

"Neither did I . . ." I sniffled.

"We're not!" boomed a familiar voice from the doorway.

Kim was standing there, watching all of this go down with an amused expression on his face. I started shaking when I saw him. I stormed over and shoved the magazine right in his goddamn face. "Explain *this* shit!" I screamed at him.

Kim held the magazine between two fingers, as if it were covered in dog shit or something. He looked at me, grinning that crooked grin of his. Then, in that oh-so-patronizing voice of his, he said, "This, Cherie, is what we call *controversy*. This is publicity. What was it that Andy Warhol said? 'I don't pay attention to what they write about me . . . I just measure it in inches.' This is a juicy story for your fans to drool over, nothing more, nothing less." With that, he dropped the magazine into a trash basket.

"But . . . but *why*?"

"Why? Why *not*? It was there! This idiot wanted to hear some inside gossip on the Runaways, so I manufactured some for him. You should be glad, Cherie. Because of that little quote, we got an article twice as long, and most of it is focused on you! Its called selling records, dear."

Kim leaned in, and placed a crooked hand on my shoulder. "It's just *business*," he said with a nasty smile. "We're just selling records here."

"Good!" spat Lita. "They've kissed and made up! Maybe now she can get her ass back in that booth and finish this fucking song!"

"Of *course* she'll sing!" Kim cooed, still with that shit-eating grin on his face.

"I don't want to," I said, unable to even make eye contact with him.

Suddenly the smile drained from Kim's face. I sensed him straighten up, and I glanced up to see his eyebrows furl as he stared at me with a look of death. "You don't have to *like* it," he growled. "You just have to sing into the fucking microphone."

"Kim!" Sandy interrupted. "Why don't you leave her alone? She's had enough for today. All right?"

Kim turned on Sandy. "No, *dog*!" he snapped. "It's *not* all right. But . . . I'll let her take five, then she'll sing like a goddess, won't you, Cherie?"

"You don't own me!" I blurted.

Kim laughed at that. "To all intents and purposes, I do. You're on lease to me, and so long as I am renting your puerile sixteen-year-old brain, you will do what I say. This group is MY group! This group is MY creation, and I don't want to hear any more of these dog-puke complaints!"

"Then treat me like a human being!" I whispered. "I'm not a fucking dog."

"If you're going to learn anything," Kim went on, already up on his goddamned soapbox, "then you had better stop being so rebellious! If you want to rebel, go back to your high school math class and curse out your teacher. Go back and join the other hordes of brain-dead, no-hope teenagers around the country. If that's the life you want, then you're fucking welcome to it. But if you want to be a superstar, you'd better learn to shut your fucking mouth and absorb everything I have to teach you!"

I pointed an accusatory finger at him. A horrible image flashed in my brain, something I had been trying to shut out for a long time.

It was the image of Kim, naked on the bed with Marcie, telling us that he was going to teach us all how to fuck. *"YOU—CAN'T—TEACH—ME—ANYTHING!"* I screamed at him.

A silence fell over the room. Everybody was watching to see how this scene played out, even Lita. Kim nodded slowly and looked around the room. I was pretty sure that he wouldn't hit me—he had never hit any of us. But sometimes, I think what he did to our minds was far worse than hitting.

"Fine," he said. "Fine. All of you go. Get the fuck out." He reached over and punched a button on the twenty-four-track tape machine. The lights went out on the console. "Today's session is over. You can go do whatever shit it is that dogs do. You'd all better remember that without me you're nothing, you ungrateful dug cunts! I'd like to see how far you'd get without Kim Fowley in the picture . . ."

With that, Kim turned and stormed out of the studio. I looked around the room, and all eyes were on me. "I'm sorry," I told them. "I just don't know how much more of that bastard I can take."

Nobody said anything, but I knew how they felt. We'd been through this so many times already.

Sandy told me that I was too sensitive and needed a thicker skin. But at the same time she assured me that she would always protect me. God, I loved that girl. Lita told me that I was being a pain in the ass. Joan . . . Joan was my best friend in the group, but even she thought that by standing up to Kim, I was just making things harder on everyone. Jackie didn't even see the problem, and thought that maybe I just needed to take a break.

I looked around, and grabbed my purse before walking out.

19

The Procedure

The next day I was sicker than ever. I woke up early and knew what was coming. I had to run to the bathroom. After I was finished puking, I hobbled back to my bed to lie down. After a few moments, there was a light knock on the door, and my dad came in. He knelt beside me.

"How you feeling, Kitten?"

"Crappy. I don't know what's wrong with me." Dad kissed me lightly on the forehead. "I think it's time we found out. Something's obviously wrong. I'm taking you to see the doctor, and we'll get this all taken care of, okay?"

"Yes, Dad . . ." He placed a gentle finger against my cheek. "It's going to be okay, Kitten. I promise."

Later that morning, I found myself in the clean, sterile office of Dr. Frank. Dr. Frank was a nice old guy with a neatly trimmed gray beard and thick bifocal glasses. He smiled a lot, and made me feel at ease. The nurse took some blood; they weighed me, took my blood pressure, and did a bunch of other tests. Then we left, with the promise that they would be in touch as soon as the results were in. I was expecting this to happen in a day or two, but when Dad and I walked back into the house, Aunt Evie was at the kitchen table talking to the doctor on the phone.

She took a long drag of her cigarette, and I heard her say, "They

just walked in. Yes, I'll tell them now. Thank you, Dr. Frank . . . for everything."

She hung up. Grandma was standing at the kitchen sink. Aunt Evie raised the cigarette to her mouth again, and I noticed that her hand was trembling slightly. I started to feel breathless. Dad stood there, jangling his keys, waiting for her to speak. "Well?" he said.

Aunt Evie shot my dad a long, pensive look. Then she looked at me. "Honey," she said, "the doctor says you're pregnant."

The silence that followed was thunderous. I stood there, with my mouth open. I felt an icy heat on the nape of my neck.

Pregnant? Oh God, I'm PREGNANT?

The first sound that anybody made came from Grandma. She sat at the kitchen table next to Aunt Evie and started crying softly. I watched her, my whole body numb with shock, as her shoulders shook and she dabbed at her eyes with a tissue. I felt my father place a reassuring hand on my shoulder, and all at once I wished that I were somewhere else—anywhere else. My father cleared his throat.

"Okay, Evie, what do we do now?" Dad's voice was surprisingly calm. I could hear it quaver a little as he tried to keep it under control. In a daze, I walked away from them and sat down on the couch.

There was a baby inside of me. Suddenly everything made sense. My sickness. The crying. My breasts getting large and tender. How on earth could this not have occurred to me before? I didn't even notice that I had missed my period! It had never really been regular, so with the tour and all of the stress . . . I just assumed . . . oh *God*.

I let my eyes fall to my stomach. I placed a hand against my belly, tenderly. There was a baby in there. Holy shit. The tears fell from my eyes and landed on my shirt, making little dark patches. "Hello, baby," I whispered.

My mind scrambled to make sense of it all. A sense of relief flooded me. So I wasn't sick—I was a mom! I started to imagine how it would feel to hold a child of my own. Somehow, despite the circumstances, the idea was comforting to me. I will love this baby, I thought. I will nurture it.

After a whispered conversation in the kitchen, Aunt Evie and Dad

came and sat beside me on the couch. I closed my eyes as Aunt Evie said, "Honey . . . we need to talk."

"About what?" I sniffled.

"About . . . *your situation*. Dr. Frank says that he can't take care of this sort of thing . . . he's a pediatrician . . . so he suggested we call an ob-gyn as soon as possible. You know, Sandie has a good one, I should call her right now . . ."

I looked over to Dad. He didn't take his eyes off me. He gazed at me tenderly. I could tell he was saddened by what he and Aunt Evie were about to say. A cold panic started to set in. "Daddy? Daddy? What does that MEAN—*take care* of it?"

Dad reached out for my hand and held it. He held my hand firmly as Aunt Evie said, "Well, honey—you don't plan to *have* this baby, do you?"

I opened my mouth to answer, but it was bone dry, and no words would come out. "I—uh—I . . ." What I wanted to say was "Yes—I want this baby!" but I couldn't. Suddenly I felt very confused.

Daddy put his arm around me. "Let's be realistic, Kitten," he said. "You're a baby yourself. You don't want to do this now. Everything changes when you have a child. You have to take care of it . . . you have to support it. It's a serious business, Kitten. I don't think you're ready for it."

Suddenly the rest of the world fell away, and I realized what was about to happen. I felt sick all over again. Only this time it was a different kind of sick; it was a sick feeling that was deep down inside of me, inside of the core of me. I started to mutter, "No . . . no . . . no . . ." to myself, shaking my head.

"You can't have a career with the band if you have this baby," Aunt Evie was saying from some faraway place. "Everything is happening for you now . . . this . . . now. It's just not right. Maybe in a few years when you are with the right man, in a better place—but now? It would be the biggest mistake of your life. You have to talk to Scott. He *is* the father, isn't he?"

When Aunt Evie said this, I felt my cheeks burning. I put my hands up to my face and groaned. I couldn't believe I was having

this conversation with my dad right next to me. Instead of answering, I just nodded.

"And look how sick you've been, sweetie puss," Aunt Evie went on. "Some women . . . they're like that for the whole nine months! You don't want that! Come on, honey, you know what we have to do. We have to be smart here. We have to do what's right for *you*."

When the time came to call Scott, I couldn't do it. I was so ashamed, so humiliated. All I could think about was how lousily Scott had treated me on tour. I felt like a fool, that I had been used. In the end, my father had to call him. I sat there, cringing, listening to their tense conversation. When my father hung up, there was a look on his face that scared me. God, no father wants this to happen to his teenage daughter, I thought. "What did he say, Dad?" I asked in a quiet voice.

Dad shrugged. "He said he'd take care of it. Told me to let him know how much it all will cost and he'll pay us back." Then he muttered under his breath, "The little bastard!" He walked to the liquor cabinet and poured himself a bourbon and ice, and spent the rest of the day drinking and quietly brooding.

Sandie's doctor was curt and businesslike. After the examination, he informed my father and me that I was three months pregnant, and that I would have to stay overnight in the hospital to undergo the procedure. When he said that, I squeezed my father's hand a little tighter. The night before I was due in the hospital, I sat up in my bedroom most of the evening. I held my belly, running my palm over it to see if I could feel any signs of the life that was growing inside of me. I was crushed. An indescribable, desolate feeling came over me. Most of all, I was scared. Scared out of my wits.

When it was over, I was lying alone in the clean, white hospital linens staring out of the window. The sky seemed unreal, like the painted backdrop for some awful theater production. The sadness inside of me was unfathomably deep. I can't say what it was that I felt anymore. I couldn't cry anymore; it was as if I had somehow run out of tears.

When the doctor came in to check on me, I asked him if it was a boy or a girl.

He shook his head without really meeting my gaze and said, "I don't know. I didn't look."

Maybe he was trying to be kind. Maybe he didn't want me to know. I knew for certain that a part of me was gone along with my unborn child. I'd lost some vital part of myself in that hospital, and I felt instinctively that I would never get it back.

My father and Marie visited. Grandma and Aunt Evie, too. But Scott didn't. He didn't even call the house to see how it went.

When I made it back home, I stayed in bed for a few days, thinking it all over. I started to suspect that Scott wouldn't keep his word about paying for the abortion, and it turned out that I was right.

20

Too Many Creeps

was standing alone in Aunt Evie's backyard later that evening. I was still unable to get the day's events in the recording studio out of my mind. I'd missed a few days recording because I was recovering from my abortion. When I returned that morning, I discovered that Joan had recorded lead vocals on a number of tracks that I was supposed to sing. The one that hurt the most was the album's title track, "Queens of Noise." Billy Bizeau of the Quick had written that song specifically for me. Now I would only be singing on five songs out of the twelve on the album. What would I do onstage while these songs were being performed? I was scared that the others were using this opportunity to push me out of the band altogether. Of course, they denied it, but following my first day back at work, it sure felt that way.

It was chilly out there, with the crisp February air all around me. For once, it was quiet. Ever since we all moved into Aunt Evie's tiny house, privacy had become a rare commodity. In the gloom I rummaged around in my purse, trying to find something. If this had been the old house, I could have flicked a switch, and the backyard would have been bathed in the effervescent glow of at least a dozen lights: the underwater lights would have made the swimming pool glow and shimmer. But all of that was gone now. It belonged to someone else, some other family, some other life. I thought about my mother. Far, far away, she was living in some mansion with Wolfgang. I was sure they had a pool, maybe a dozen pools. Hell, maybe they had their

own private stretch of the ocean. She was over there in Indonesia with Wolfgang and my brother, doing whatever it is that people in Indonesia do. I wondered if she thought about Marie and me.

I stood there in the dark, rummaging through my purse, my sense of frustration growing. I wondered what my brother looked like now. Amazingly, it had been almost a year since he'd left. He'd be taller, maybe even taller than me. I wondered how old he'd be the next time I saw him. Probably as old as I was now. The thought made my head swim. I looked up, but there were no stars tonight. No shimmering pool. Nothing—just plain, bare concrete and the chirp of crickets.

"I thought I heard you come in . . ."

"Jesus!" I spun around to see Marie standing behind me, almost totally shrouded in darkness. "You scared the crap out of me!"

"Sorry . . ."

Marie came closer, and we just stood there for a few moments taking in the unimpressive panorama. After a while Marie asked, "How did it go? Did you have a good recording session?"

I shrugged. "They all hate me," I told her quietly.

"That bad, huh?" Marie laughed a sad, little laugh and then we lapsed into silence again. There was no rush for words. Sometimes Marie and I could communicate without saying a word. I knew that my twin could sense that I was hurting inside.

"Your friends . . . they've been asking for you at the Sugar Shack. They wanted to know if you've gotten too famous to talk to them anymore."

I laughed. "No, I'm just busy, you know that. I'll stop by next week, I guess. How is everybody?"

"Fine. Everyone's good. I, uh . . . well, I don't think that I'll be going to the Sugar Shack much anymore."

"Oh yeah? Why not?"

Marie shrugged sadly. "Too many creeps."

"Creeps? At the Shack?"

I was surprised to hear that. Of course the Shack had its fair share of bozos and losers . . . what place didn't? But Moose and Ken, the guys who ran the place, did a pretty good job of keeping the *real* creeps out.

"Well . . . you know how it is," she said hesitantly. "Everybody knows who you are. They know I'm your twin. Every asshole and his brother in the Valley seem to be in there these days, all wanting to hit on the Cherry Bomb's sister. Some of them . . . well, they're really scary, Cherie. I mean it—you gotta be careful the next time you're over there."

Marie lapsed into silence. I didn't say a word. I waited for her to continue, and when she did, it was in a wistful, sad voice. "They see you up there onstage. Acting like . . . well, acting the way you do. They think you're *really* like that. They even think *I'm* like that. This one creep . . . he . . . he even attacked me."

"What?"

"It was nothing. I mean—he was drunk. The bouncers threw him out. It was okay."

I turned and looked at Marie. With everything that had been going on with me, I hadn't had the time to really consider what my notoriety with the Runaways was doing to my sister. Once upon a time I was the wallflower; I grew up feeling that I couldn't hold a candle to Marie's personality. I was always hovering nervously in the background, looking on jealously as Marie went on dates and hung out with the popular kids. But these days Marie obviously felt the same way I once felt. I knew that she had to quit school when I joined the Runaways. Too much attention, too much jealousy. Since then, she'd gained some weight. There was a sadness in her eyes that I'd never seen before. She was working at a fast-food place called the Pup 'n' Taco over on Vanowen Boulevard to help the family with grocery money, which would be an okay job for any other sixteen-year-old . . . but not when your twin sister is one of the Runaways

Marie had never mentioned it, but Paul once told me that one bunch of guys drove for miles just so they could jeer at her through the drive-in window. He told me that she was totally humiliated, and that she was sobbing when she told him about it. She made him swear not to tell me.

"There was this one guy at the Shack," Marie told me. "He seemed really cool. He was just hanging out with me, and he seemed totally normal. He didn't talk about you at all. Honestly, I didn't even think

he knew who you were. But then all of a sudden he's asking me all kinds of stuff . . . all about *you*. He wanted to know your shoe size, and your bra size, and your fucking hat size. Turns out he's another damn lunatic. He told me he has pictures of you, and articles about you, all over his bedroom wall. Isn't that *sick*, Cherie?"

I shuddered, and for a moment I thought about my bedroom in the old house. All of the pictures of Bowie on the walls. I was about to say something, when Marie dropped a bombshell.

"Anyway, he told me that he's in love with you, but since he'd never get the chance to be with you, he figured that I would do just fine."

"Oh my God. What did you do?"

"What do you think I did? I told him to go fuck himself."

I could hear her anger, her resentment. It was directed at me, as if somehow I were responsible for every crazy who bought one of my records and then decided to go stalk my sister. I didn't know what to say anymore. I felt helpless.

"After that, I stopped going to the Shack for a while. Like I said: too many creeps."

There was a long silence. An uncomfortable one. It was at moments like these when I guess neither of us really wanted to be attuned to what the other was thinking. I started rummaging around in my purse again, mumbling "Goddammit!" when I still couldn't find what I was looking for.

"You looking for these?"

I looked at Marie's outstretched hand, and in the semidarkness I could see that she was holding my vial of quaaludes. It was a strange feeling, a vague embarrassment, like somebody had just walked in on me while I was using the bathroom. I shrugged, and nonchalantly said thanks. I reached for the pills, but Marie didn't hand them over. She was peering at the label, as if she had never seen a bottle of quaaludes before. I started to get mad.

"I found them on the floor," Marie said. "Lucky for you! If Grandma had found them, she would have had a conniption!"

"Yeah, well," I said, "Grandma's so old-fashioned. Can you give them back, please?"

Marie held the bottle to her chest. "Are you doing a lot of these?"

Something in the way she asked it really bothered me. All of a sudden she was acting like my mother.

"They're *ludes,* Marie, for Chrissakes. You're acting like you found some heroin or something. Calm down! They're just tranquilizers."

"I know what they are."

"Yeah, you *do* know. You've done plenty of them yourself, remember?"

She couldn't deny that. She did them; her friends did them . . . she had no right to get judgmental about this. I stretched out my hand for the pills. "Give me a break, Marie," I said, slow and deliberately. "I have a handle on it. Now hand them over."

"How many do you do?"

"Jesus Christ! A couple a day, at the most. You're acting like I'm a coke fiend or something! I just need something to help me wind down at the end of the day, okay?"

"Just like Dad, huh?"

That comment hit like a slap to the face. "No," I said coldly, "not in the slightest."

Marie looked at me with that superior I-know-what's-best expression that made me want to strangle her. I knew that she was worried, but I still didn't think she had any right to be giving me this speech. "I guess that explains it," she said, with a little smirk on her lips.

"What?"

"Why our room is always a mess. Why you haven't done any of your chores."

"Marie! I'm getting really, really pissed off right now. I'm in the middle of recording an album. I'm busy—you have no idea of what's going on in my day-to-day life, okay? So don't even—"

"You weren't this irresponsible when you were recording the first album!"

"Come on!" I snapped. "What the *fuck,* Marie? How can you stand there and give me this speech?" I'd thought that my sister was way hipper than this. I thought that she understood!

"You were never this irritable either!" she added.

We stared at each other. I didn't look away; I put my eyes right on hers and held her gaze. She was the first to look away. "I'm just worried

about you, is all," she said finally. "Look, I'm sorry . . . I guess I *don't* understand everything that's going on with you. But I do know that you're my sister, and I love you and I worry about you. That's all."

I could see tears welling in her eyes now, and I felt them forming in my own eyes as well. We'd always been connected like that. "You're so pale," she said, "and you're starting to get dark circles under your eyes. You're my sister, and I love you, okay? It's my job to worry!"

She hugged me tightly, and I hugged her back. We stood there in the darkness, holding on to each other for dear life. My mother and my brother were gone. Sometimes it felt like my father was slipping away from between my fingers, so it was good to hold on to Marie. To know that she was still there. All of the anger was forgotten. A part of me never wanted to loosen my grip on her.

"I love you, too, Marie," I told her, feeling my tears squishing against her cheek. We stayed like that for a moment. "Now," I whispered after a while, "can I *please* have the pills back?"

A few days later. It was midnight, and I was sitting with Joan outside of Brothers Studio smoking a cigarette. It had been a rough day. We spent an entire evening trying to get the bass line for "I Love Playin' with Fire" down. The fun was totally gone; it was just hack, hack, hack. Mostly we spent our time getting drunk and making fun of each other. A strange kind of cabin fever had taken hold of us. All of the excitement had drained from the songs as we played them again, again, again until Kim and Earle decided that we'd nailed it. All of the inspiration and the energy of the first album had gone. *Queens of Noise* was beginning to feel like the Runaways on autopilot.

"Joan," I said as I stubbed out my cigarette, "what would you say if I told you I thought we should all take a break for a while?"

Joan gave me a funny look. "I'd say you were nuts. Why?"

"Man . . . I dunno. I just don't think I can handle the pace."

"The pace?" Joan shook her head. "The pace is part of the fun, Cherie! You know that."

"But I'm not *having* fun! I miss my family. I really miss spending

time with them. With everything that's going on . . . I just feel like they need me. Like I need them. Didn't you miss *your* home when we were out on tour?"

There was a long silence as Joan considered that one.

"Look, Cherie, I guess we come from different worlds. I never had a fancy house in Encino like you did. We had to scrape for everything, all our lives. I mean, yeah, I guess I missed my mom, my brother and sister sometimes. But *home*? There's not that much about it worth missing."

I pulled out another cigarette, looked at it for a long time, and then put it back. I had to record vocals later. I needed to pace myself. "I really think that it would be good for all of us to take a break. Everybody's on edge. I just think we all need to take some time to cool off before the next album comes out."

"Don't be stupid," Joan said. I could hear anger creeping into her voice. "We're on the way *up,* Cherie! You can't just take a *break* when you're a new band, just on the rise. That's insane! It's instant death. We've worked so hard—if we did that, we'd be *over.* Finished!"

I knew that what Joan said made perfect sense. I just really wished that it *didn't.*

When I looked into Joan's eyes, I saw someone who was getting severely pissed off. I saw something else in there, too—a glimmer of fear. When it came right down to it, Joan was the backbone of the group. Sure, there were others who could shout louder, who could stomp their feet harder, but Joan had that certain something that set her apart from the rest of us. I guess she had that elusive "rock-and-roll authority" that Kim was always carrying on about.

"What about . . . what about if *I* took a break? You can sing my songs for a couple of shows. I'm just so . . . so—"

"Don't give me that crap!" she said. "Whether you like it or not—whether *we* like it or not—the Runaways is all five of us, okay? Even with just one of us missing, we don't have a band anymore. Don't you understand?"

The bottom line was that I was beginning to think I couldn't handle the responsibility anymore.

"You can yell and scream and deny it all you want," Joan said

coolly, "but if you flake on the Runaways, you know that you're going to fuck it up for all of us. You'll kill the band. It'll be over."

"What about my family?" I pleaded. "I have to think about them! I've barely seen them in the past year . . ."

"And what about us?" Joan countered. "The Runaways are a family, too. Who sat by your side in the hospital when you were sick, Cherie? I didn't see your fucking *family* doing that! Your parents weren't there. Your sister wasn't there. It was me."

That silenced me. I remembered the feeling I had when I woke up from the anesthesia and saw that Joan was sitting by my bedside, softly holding my hand. I knew that by far Joan was the closest friend I have ever had. After all, she was one of only five people in the world who could truly understand some of the crazy stuff I was going through right then. I thought of all of the good times, of all of the laughter we had on the first tour. I knew that I couldn't do this to her. I couldn't let her down. It simply was not an option. I started to nod my head, and I said, "I'm sorry. Man, I'm just tired. I'm stressed. I'm not going to flake."

"I know." Joan put her arm around me, and held me close. "We're making history here," she said. "Nobody said this was going to be easy. Just remember you can talk to me anytime. Okay?"

"Okay."

Joan stood, and stretched. She looked at her watch. "Fuck. It's almost twelve-thirty. Let's go see if Jackie has figured out her bass line yet."

"Sure . . ."

I got up and Joan opened the door to the building. I smiled at her, and we walked back inside. I could hear the music echoing down the corridor already. I wanted to feel good, I wanted to feel okay, but it was getting harder and harder. I was tired and worried. Once the album was done, we would be back on the road. Then, if Kim got his way, we'd be right back in the studio cutting our next record. I didn't know when it was going to stop. All I could do was keep showing up, and hope for the best. Who knew, maybe things would change once the second album was done. At the moment it felt as if things couldn't get any worse, at least . . .

21

Live in Japan

Once the *Queens of Noise* had been completed, we were put back out on the road immediately to do our second U.S. tour. This time around the venues were bigger, and we flew everywhere. We did huge sold-out shows, and had the likes of Cheap Trick and Tom Petty as our opening acts. When we'd pull into town, we'd hear our songs blasting from the local stations: Mercury was really pushing the album. As well as the glamour of flying around the country and playing big shows, there was also the other side of it all: the quiet moments after the shows, like the time we'd spend washing our stage clothes with Woolite in hotel bathrooms. It was Lita who'd taught us how to do that. Until she intervened, we had been wearing the same sweaty jumpsuits and stage clothes for the entire tour.

No sooner had we wrapped up the second U.S. tour than it seemed we were about to leave on our first Japanese tour.

The Runaways embarking upon their first Japanese tour was the highlight of my time in the band. Unlike in America, where the press and a large section of the general public could never get over our ages, or shake off the suspicion that somehow the Runaways were some kind of Monkees-type band overseen by Kim Fowley, people really *got* us in Japan.

"Cherry Bomb" was a huge hit, topping the Japanese pop charts. Kim had told us that the reception in Japan was going to be much bigger than it had been in the U.S., but I had to admit that going into

it, I was quite nervous. Although the second U.S. tour had passed pretty much without incident, after my experiences in Europe, I feared that another long foreign tour might prove to be the band's undoing.

Before the tour, Kim arranged for a photo shoot for Japanese pre-publicity and the glossy tour book, which would be sold at our shows. When he told me that the photographer would be coming to Aunt Evie's house to do the session, I immediately cross-examined him about the pictures.

"Will the other girls be coming over to my house, too?"

"No. He's taking some solo shots."

"But what about the other girls?"

"Don't worry about them. Everybody is having a solo shoot. That's the way the photographer wants to do it."

I thought that this was strange, but let it go. On the day of the shoot, the photographer had me dressed up in a pretty revealing outfit. It was a much more risqué shoot than anything that an American photographer had attempted with me before, and I remember that it made me feel uncomfortable. I figured that the photographer must know what he was doing. He kept instructing me, in broken English, how to pose.

"Move legs . . . like this!" and he would illustrate by moving his hands apart. "Open!"

The shoot had been going on for quite some time when my Grandma peeked in on us; she nearly fainted when she saw what I was wearing and how I was posing. Seeing her teenage granddaughter posing like that for some random Japanese photographer really upset her. She came charging in, screaming at the photographer and attacking him with her cane. The guy nearly dropped his camera in surprise, and ended up grabbing his equipment and fleeing the house, with my grandmother in hot pursuit.

I laughed it off at the time, but those pictures would definitely come back to haunt me.

I knew that the tour had to go well. Tensions in the band were pretty high, and one of the main issues was with Jackie. Her relationship with the others was at an all-time low. Her weakness as a bass player was becoming far too apparent, and there were many

discussions about how her playing skills were holding back the band live and on record. Also her attitude drove us all nuts. She would have nothing to do with the rest of us when it came to letting loose and having fun. If she didn't have her nose stuck in a book, she was indulging in her next favorite pastime: whining.

Normally, I consider myself quite a tolerant person. But when you're in a band that is constantly on tour, other people's bad habits can quickly become totally unbearable. There was something about Jackie's voice that really *got* to me. Listening to it was like having a nail driven into my brain. When she started complaining—which was often—it took on a really gut-wrenching quality.

Jackie whined about everything. About our schedule. About the songs. About money. About Kim. About our bad habits. About our drinking. About our drug taking. Sometimes being in the Runaways was a little like taking the wildest school trip ever with some of the baddest girls in high school. Unfortunately, Jackie's presence was like having the world's most uptight teacher along for the ride.

Also, the tensions between Lita and me were going nowhere. In order to defuse them, we tried to limit our interaction, but of course this was next to impossible on tour. All it took was the slightest thing, and Lita would be shouting and screaming at me, and I had had just about enough of her.

On the upside, Scott Anderson was suddenly, and unceremoniously, booted from the Runaways crew. Kim never gave us a reason, and I wasn't egotistical enough to assume that it was because of how he'd treated me after he'd got me pregnant. We assumed that he'd wanted more money or more control, and we figured that Kim would never have agreed to that. No doubt Scott thought he was irreplaceable. I would have loved to see the look on his face when Kim booted his sorry ass to the curb. I just wish I could have buried my foot up there on his way out. It was a relief to know that I wouldn't have to deal with him anymore.

The Japanese tour lasted for a couple of months. Coming to Japan was our first experience of being treated like real superstars. It was like Beatlemania—Runawaymania, really! We were huge on the radio over there, and had already attracted a devoted and fanatical

fan base. Everywhere we went, people stopped to give us beautiful gifts, ask for autographs, and pose for pictures. Our Japanese label spared no expense, and we stayed in only the grandest and most luxurious hotels. It was the only tour we had ever done in which we didn't have to share rooms: not only that, but the rooms that we had were incredibly extravagant.

We were on an immediate high upon arriving in Japan and realizing just what a big deal the Runaways were over there. That high became very short-lived when we got a look at some of the prepublicity that had been going on. The first problem was an article in a prominent music magazine that featured some of the pictures taken at Aunt Evie's house.

By now I felt strongly that Kim played fast and loose with the truth and was a troublemaker, but I still remember being surprised to see that I was the only member of the Runaways whose image was used for the piece. Lita's eyes just about popped out of her head when she saw the pictures of me posing, partially undressed, on the cover of the magazine. Not only had there been no separate photo shoot for the other girls, but they hadn't even been aware that I was having a solo shoot. Immediately a black cloud settled over the band, which darkened further when we saw the beautiful, glossy tour booklet that contained—almost exclusively—photographs of me. And, of course, the tour T-shirts, which contained an image of my corset with the cherry logo on the shoulder.

Lita went ballistic. She accused me of everything she could think of: lying about the photo sessions, deliberately keeping the others away from them, and somehow trying to subvert the Runaways so I could turn it into the Cherie Currie band. No matter how much I tried to explain, or protest my innocence, Lita was adamant that this was all my doing, and that I was a devious egomaniac who was hellbent on shutting the other girls out of their own band.

It seemed natural that the press would focus on the lead singer of any band. But the logic of this was lost on the others; they began shutting me out. Lita was the most vocal, of course, but the others expressed their resentment in more passive-aggressive ways. There was always the occasional comment about my "publicity hound"

tendencies, or the odd bit of eye rolling and snickering whenever my picture was taken. I decided that the way to deal with it was to try to ignore it.

While we played to sold-out stadiums, we started working on a new album—a live album meant to capture the energy and buzz of those Japanese shows. We recorded quite a few shows, and during our downtime, we were put into a recording studio to do overdubs. The *Live in Japan* album would go on to be one of our most successful, and also the source of one of my strongest memories of my time in the band. It was when we were doing overdubs on the track "Come On." After we had listened to the playback, Lita turned to me and said, "Good job, Cherie. Your vocals were really good on that. I liked it."

This might not seem like much, but the fact that Lita Ford had paid me any kind of compliment was kind of mind-blowing. Usually she just growled at me in the studio, like some kind of dangerous animal thinking about attacking. Other times she'd put on a Heart album, and when Ann Wilson started singing she'd scream, "Now why in the hell can't you sing like *that*?"

Funny, isn't it? After all of the things that went on in the band, one of my strongest memories was such a small, quiet moment.

We got over the shaky start to the tour, mostly because it was hard to be in a bad mood in Japan. When I say that the promoters and fans showered us with gifts, I'm not kidding. Pearls, silk kimonos, beautiful flowers waiting for us in our hotel rooms . . . To be frank, after a few weeks in Japan I really, really didn't want to go home. It truly renewed us. Finally being treated like the serious musicians that we were was a long overdue validation. Over there, our ages, and our sex, didn't count against us. Just the opposite, in fact. The Japanese really understood us, they *got* us, and our American teenage rebelliousness was exotic and alien to the Japanese youth who came to our shows and literally screamed and cried all the way through our set.

The shows themselves were incredible. Stepping out onstage, I would see a mass of screaming, devoted faces looking back at me every night. We fed off the energy of the fans, and probably played some of our best shows ever. As a document of all the real strengths

of the Runaways, I'm not sure that *Live in Japan* can be beat. At the time, it really felt like a new beginning for the band.

I fell in love on that tour.

He was a certain Latin singer, who had just had a major hit in the States with a ballad that had taken over the airwaves. I loved his song. The other girls' tastes tended toward the harder-edged stuff—metal and blues-rock for Lita and Sandy, punk and hard rock for Joan, I really had a thing for the soft stuff. I guess that's just the sunny California girl in me. That's why I didn't like punk when we toured the UK: I couldn't relate to it. It's all very well sticking safety pins through your ears, and screaming about the weather, and the dole, and how you're vacant, pissed off, and you want to smash it up. But I couldn't relate to that at all. I had traumas in my life, for sure, everybody does. But I didn't want my record collection to add to it! Music for me was an escape, a way out, I wanted it to make me feel *good* not depressed.

So I already knew who this singer was when we played the Tokyo Music Festival with him. He was very handsome, maybe a little overweight, but he had these deep, soulful eyes and long, dark wavy hair. And that voice! I remember watching him sing at his sound check, and I was just blown away by his whole persona onstage. He was dressed all in white. That was his thing. He was always in these crisp, clean white suits. When he was done with his sound check, I walked right up to him and said, "I'm sixteen years old, and I'm in love with you."

Then I walked away, leaving him standing there speechless. He actually sent one of his entourage over to find out where I was staying. When I arrived at my room later that day, there was a beautiful bouquet of flowers waiting for me. The note read "When can I see you?" That's how our love affair began.

We got to spend a few days together before he had to continue his tour. Of course the others got wind of our relationship, and their first reaction was something along the lines of "You gotta be fucking kidding me!" They thought that this guy's music was totally square, and they teased me relentlessly about it. Any chance they'd get, they'd burst into a mocking rendition of his hit song. To them, the fact that not only was I in love with him, but I actually *liked* his music was totally insane. I guess they thought that his style was

old-fashioned, or cheesy, but I was never one to be put off by what other people thought.

The relationship would carry on after I returned to the States. The first day I arrived home he bombarded me with white roses—four dozen on the first day. We were going to get married at one point, and my dad even gave his permission. He flew me out to San Francisco to meet his friends. Then suddenly, without warning, he dropped me like a hot rock. He wouldn't return my calls, and I was devastated! It was the first time I was ever genuinely heartbroken in my life. I found out later that his family had pressured him into breaking it off, because they thought I was way too young for him. I was just seventeen and he was twenty-four, and that was too big a difference for his family. He eventually apologized, and told me that he felt terrible, but it took me a long, long time to get over that one.

This amazing, incredible Japanese tour took a dark turn almost overnight, and nobody saw it coming. The incident that finally did it to us revolved around Jackie's beautiful, white, one-of-a-kind Thunderbird bass.

Jackie loved that bass. It was her most prized possession. Despite the luxury that surrounded us in Japan, we were still—by and large—totally broke all of the time. The bass had been a huge financial investment for Jackie's family, and Jackie was always warning the road crew to take special care of it. She was totally paranoid about anything happening to it. She had right to be, because our road crew—headed up by the loathsome prick Kent Smythe—was hardly the most considerate bunch around. As is often the case in the music industry, the road crew did just about as many drugs as— if not more drugs than—the band. They usually started drinking and doing coke early in the day, and kept on until they passed out sometime the following morning. They drove us around loaded on coke and speed, and they drank like fishes.

In Japan, the situation was a little better than back at home, because we had hired an all-Japanese crew who were hardworking and relatively sane compared with the crew we'd have over in the States.

But we still had Kent Smythe in charge, and with drugs not readily available in Japan, he tended to be drunk most of the time.

It was at a sound check that it all happened. We had just finished when Jackie put her bass down on one of those flimsy guitar stands, and she obviously hadn't put it back on correctly. As she was walking offstage, I wandered over to the opposite side of the stage with Lita. Suddenly there was a crash: Jackie's bass had tipped over, hitting the stage. Everybody looked, and Jackie came running back with her face white. Not only did the bass fall, it just so happened to land badly, and the neck snapped off. Her bass was ruined. When she saw the condition of her beloved instrument, she immediately accused me of kicking it over on purpose. I have no idea why she'd have thought that, and I immediately protested my innocence. Although I found Jackie to be irritating as hell, there was no way on earth I could ever have done something so callous. I knew how she felt about that bass; we all did. Jackie flew into a rage and began shouting, screaming, and crying. Her mental state was not helped when she discovered that her bass hadn't been insured, and Kent Smythe seemed less than concerned about how upset she was. His attitude was basically "Get over it!"

A replacement bass was provided for the show that night, but Jackie was a mess. I had never seen her like that. She didn't speak to anyone; she immediately became totally withdrawn and depressed. She played the show with little enthusiasm, and then went straight back to her hotel room, refusing to speak to anyone.

The next day, I tried to call her room. There was no response. I would walk past her room and hear her crying on the phone. I'd lift my hand to knock but decide against it. She really did believe that I had deliberately knocked over her bass, and I didn't want to make the situation any worse. I felt deeply sad for her, accompanied by a sense of dread that I couldn't explain. I asked Kent about her, and he told me that she was fine and not to worry. But I did worry. By late afternoon, I decided to go to her room and see how she was.

Jackie was on the floor above me. I went up in the elevator, and was walking to her room when I saw Kent Smythe coming toward me, obviously on his way back. Kent was a big guy, tall and beefy,

and totally unattractive. He had long, greasy hair, and treated us all badly. He was abusive, and bullying, and obviously had no respect for us as people or musicians. I think he regarded his gig roadieing for us as a glorified baby-sitting job. When he saw me coming, he barked, "Where do you think you're going?"

"I'm going to see if Jackie's okay," I snapped, and went to breeze past him. Suddenly Kent grabbed my arm and pulled me back.

"No, you're not!" he said. "She just needs to be left alone. Come on, let's go."

I shook my arm free and stared at this big lummox. "I'm going to go see Jackie," I said again. "And don't put your hands on me, Kent."

"No, you're not!" he insisted. "Come on, let's go."

"Get your FUCKING hands off me, you ASS! You just TRY and stop me!" I wrenched my arm free and continued walking, never taking my eyes off Kent till I knew he was out of lunging distance.

"Fine!" he shouted, throwing his arms up in exasperation. "Suit yourself . . ."

"Screw you!" I yelled, flipping him the bird when I knew I was safely down the hall and out of his reach.

As I approached Jackie's room, it became apparent that something was wrong. I don't know what had gone on between her and Kent moments before, but through the door I could hear her screaming and crying. I heard her banging things and eventually glass shattering. I started pounding on the door, telling her to open up.

After a few moments, the door swung open, and I was horrified at what I saw.

Jackie was standing there with a chunk of broken glass in her hand. Her arm was covered in blood. As I pushed my way into the room she continued hacking at herself with the glass. I lunged at her and tried to wrestle it from her hand. In the struggle, I ended up with a few cuts of my own. Jackie was hysterical, and by the time I'd thrown the glass to the floor, she'd collapsed on the bed, sobbing uncontrollably. I had never seen anybody in such a state. As I tried to comfort her and stop the bleeding with a bath towel, I realized that this wasn't just about her bass anymore. The bass had been the last straw, but finally all of the bullshit that we all put up with in

the Runaways—Kim's abuse, the roadies' indifference, the internal pressures, the arguments, the mismanagement of the money—all of it had climaxed into this. Jackie just lay there, bloody and barely aware that I was even in the room. I called down to Kent's room, and when the road crew arrived, I was ordered out and told not to say anything to anyone.

The following morning at breakfast, after a sleepless night, we were all informed that Jackie Fox had already left Japan, and not only that, she had left the Runaways. When Kent told us, it was in his usual couldn't-give-a-shit way: "She's on a plane home. Oh, and yeah, she's out of the band."

I glared at him. Jackie had always hated Kent. I couldn't help but think that I saw a sly, satisfied smile on his lips when he made the announcement.

To be honest, we didn't talk much about what happened with Jackie. There was too much work to be done. We still had to finish tweaking the *Live in Japan* album (Kent would end up filling in some bass overdubs), and we still had a huge show coming up that we didn't want to pull out of—the Tokyo Music Festival. As bad as we felt for her, we were still majorly pissed that she had left us stranded in the middle of our most successful tour. We would have to play as a four-piece, and that meant that Joan would have to switch to bass guitar and learn all of Jackie's parts. It was a hell of a lot of work, but somehow we managed it.

After that show, the Japanese tour was over. It ended far too soon, as far as I was concerned. I thought that Japan was a wonderful country, and I loved the people. What was *not* to love? The national dish, sushi, was my favorite food, and we were treated like superstars. When we had to leave, I cried. It was the only time I have ever cried upon leaving a country. The silver lining was that given the level of success that we had already achieved, we would definitely be back to play again.

Little did I know that the final show we played in Japan would be my last as a member of the Runaways.

22

The Last Straw

After the dizzying highs and lows of the Japanese tour, I spent the next four weeks in a haze of drugs and exhaustion. As soon as we'd touched down on U.S. soil, a new girl had been found to replace Jackie. Vicki Blue was a better bass player, but immediately the chemistry in the band changed. Bands are not like washing machines; you can't just remove a part of it and replace it with a new one, and expect it to work the same as it did before. A band is a family—in the case of the Runaways, a highly dysfunctional family—but a family just the same. My own family managed to function after Mom and Donnie left, but it was never the same. Vicki may have been a decent player and a cool girl in her own right, but something changed when she joined the band. There was a new cynicism about the Runaways, a jaded don't-give-a-shit feeling that to me signaled the beginning of the end.

Two weeks earlier, Kim had called to say that *Rolling Stone* had wanted to put the Runaways on the cover of an upcoming issue. Of course, I was ecstatic, until I found out that they wanted to use a solo image of me on the cover. Relations in the band were so strained at the time that I became convinced that it would be the end of the Runaways if they used that image. There was no way Lita would stand for it. For months she had been railing against this perceived bias when it came to the media. Especially after the fiasco with the promo pictures in Japan, I felt that putting my picture on the cover of *Rolling Stone* would be the last straw. I was literally on the phone

with *Rolling Stone* begging them not to use my picture on the cover. They were pretty taken aback, but finally agreed. I guess in their line of work they weren't too used to having to deal with people begging *not* to be put on the cover. So they went with some other band, and that is one decision that I regret to this day.

Everything came to a head during a photo shoot with renowned photographer Barry Levine. Barry had made his name as the still photographer on the Woodstock movie, and was at that time the photographer of choice for the band Kiss and many other members of rock royalty. We had worked with Barry before on the cover of the *Queens of Noise*. As I walked into his vast, white studio, I felt tense, even though none of the girls were there yet. I had just gotten my driver's license, so I drove myself, arriving early. As I helped Barry set up for the shoot, I explained to him that I needed to leave on time. Marie had an acting class later on, and we shared the car.

"No problem, Cherie!" Barry said absently as he tinkered with his camera.

"Okay, good. Just so you know."

Marie had already paid for the class and had warned me about half a dozen times that morning not to be late.

We discussed his ideas for the shoot. I pretended to be interested, but I wasn't really. Barry asked my opinion of the backdrop, and the colors he wanted to use. We were taking some test shots when Joan arrived. She sat down in a corner by herself, barely acknowledging us. She looked different. Older. Hell, we all looked that way. When she looked up and said hi to me, she sounded tired, irritable.

In a little while Sandy walked in, but there was still no Lita or Vicki. An hour passed, and we all sat around, impatient and irritable. I was surprised that Vicki would be late for her first shoot. Jackie's absence was barely filled by Vicki, who at rehearsal was probably looking around at all of us as we bickered and argued and wondering just what in the hell she had signed up for. Vicki looked so much like Lita that they could have been sisters, and that really pissed Lita off. When we first met her, Kim had commented in his usual tactless way on their likeness. Lita looked her up and down, scowled at her, and said, "Why the hell don't you dye your hair or something?"

"Remember, Barry, I can only stay till six-thirty," I reminded him as the time dragged on. "I have to have the car back for my sister . . ."

Barry laughed. "You mean to tell me that Cherie Currie doesn't have a car of her own? Man, I thought you'd have a silver Vette or something!"

I shrugged and gave an embarrassed smile. The truth was that I barely had enough money to afford a motor scooter. I didn't tell Barry that when we got back from Japan, with the huge concerts, and the sold-out arenas, and the live album that we were putting together in the studio, Kim had handed everybody a check for a mere twelve hundred dollars apiece, after "expenses." When everybody started going crazy, he gave us the usual spiel about how we incurred a lot of costs, and how we still owed the label a lot of money. If you believed Kim's stories, you'd think that being a rock star was a worse-paying job than working in a fast-food joint. At least my sister used to get sick days and holidays. Jackie used to be the one who tried to get us a better deal from Kim, but every promise he'd make to "look into it" with the label came to nothing. With Jackie gone, it didn't feel like anybody in the band had the smarts or the motivation to push him on this any further. Even after the amazing success we'd had in Japan, the band was just too tired to keep on fighting.

"Sure." Barry smiled. "No problem. We should be done before that. That is, if the other girls ever show up! Does anybody know where Lita is?"

I shrugged. Joan shook her head. "No idea."

Joan, Sandy, and I sat around and waited. Nobody had very much to say. It seemed less like we were waiting to do a photo session, and more like we were all strangers stranded together in the dentist's waiting room from hell. We looked anywhere but at each other. I was studying a particularly fascinating spot on the blank wall when Sandy announced that the *Live in Japan* album that Kim had rushed to market had just gone gold in Japan. She was the only one who seemed excited about it.

"The next one is gonna be platinum!" Sandy announced, trying, I guess, to pull us all out of the funk we were in. The comment just hung dead in the air. I thought of Jackie, stumbling toward me with

the blood dripping from her arms and a look of total and utter *despair* in her eyes. The memory made me shudder. Then I thought of Vicki. The poor girl had no idea what she was in for.

Lita finally arrived two hours late and Vicki with her. She stormed into the studio, slamming the door behind her and complaining about traffic and her damned car. She didn't apologize, of course. Once she was ready, like the rest of us, Lita fell into an icy silence. For two hours we posed for a cold, uninspired photo shoot. Toward the end even Barry had given up on trying to drag us out from behind our self-erected stone walls.

"So, uh, you're the new bassist, huh?" he said at one point, trying to break the ice.

Vicki nodded, and smiled.

"Cute," he said. "Man, Lita, she looks just like a sweeter version of you."

Lita put on her sweetest face, and gave Barry the finger.

As the session dragged on, I kept looking at the clock. At five-thirty I started to panic. The shoot wasn't winding down yet; we still had three costume changes to get through. The mood in the room was so poisonous, that I was scared to remind Barry, who seemed to have completely forgotten about his promise, that I'd have to leave soon. With everything that had been going on at home, I knew that the very least I could do was keep the promise I made to my sister.

"Barry," I finally said, pointing to the clock, "it's almost six. *Remember?*"

Before he could answer, Lita snapped, "What is she talking about?"

Obviously exasperated by the photo shoot, Barry sighed and put down his camera. "Cherie has to leave at six-thirty," he said. "Apparently her sister's acting class is more important to her than this shoot."

"Oh, like *hell* it is!" Lita screamed, turning on me.

Suddenly all of the simmering tension in the room boiled over. I felt that Lita had been waiting for an excuse to blow up, and Barry had just handed it to her on a silver platter. She stormed over to me, almost knocking Vicki down in the process, and got right in my face.

"Who the *fuck* do you think you *are*? We're *professionals* here!"

she screamed. Then she sneered at me at and added, "At least *most* of us are!"

Suddenly all of the pent-up frustration and anger of the past few months could no longer be contained. Instead of turning and walking away from Lita as usual, I gave it right back to her. *"You're the one who was fucking late! If you had been here on time, this wouldn't be a problem! You know I share a car with my sister. I promised that I'd have it back for her by seven!"*

Joan and Sandy stormed off, throwing their hands up in exasperation. They were both sick of Lita, and they were both sick of me, too. The good times that we'd had on that first U.S. tour were long forgotten, and now the simple fact was that nobody could really stand each other. Joan and Sandy looked like they were done with all of the fighting. Vicki just stood there like a deer in the headlights as it all played out.

"I don't know about you, Lita, but I have a *family* that I *care* about!" I screamed. Then I turned to Barry, hurt by his betrayal. "How could you? You *knew* I had to leave!"

Suddenly Barry turned and smashed his camera to the ground with a yell of frustration. *Crunch!* The thing just broke into a hundred pieces.

"Oh, now THAT was professional!" I sneered at him.

I stood there in shock for a moment, looking at the ruined camera. Then I turned and headed for the dressing room. I wasn't taking any more bullshit from Lita, or any damn photographer who needed to break a camera for dramatic effect. What an idiot! I closed the door behind me and started changing my clothes. With the door closed, I could barely hear Lita's ranting and raving in the next room. Everything was calm for a moment.

Then . . . *BOOM!*

Out of nowhere there was a blast against the door, which made it buckle inward. Like somebody was trying to break it down with a sledgehammer. I screamed, and jumped away from it. Outside, I could hear Sandy yelling at Lita: "LEAVE IT ALONE, LITA! Leave her ALONE!"

BANG!

For a second time Lita's foot smashed against the door, causing it to burst open. The door crashed against the wall, almost taking it off its hinges. I saw Lita's silhouette filling the entire doorway, teeth bared, hands balled into fists. She stormed inside, stopping within inches of me. I was terrified. I had never seen her this pissed off. She raised her fist like she was about to give it to me full in the face, but she stopped herself as Sandy barreled through the door. Lita pointed a finger dead in my face.

"You listen to me, you little *bitch*!" she spat. "When we joined this band, we all made a commitment! We put the band first, and all of the other bullshit second! You're gonna make a fucking choice, RIGHT NOW! It's your fucking family or *US*!"

"Then it's my family . . ." I squeaked.

For a brief moment, I was back in the locker room with Big Red, staring down her pointed finger, paralyzed in terror. I closed my eyes and braced for the impact . . . but it never came. Instead, Lita stormed out of the dressing room, slamming her fist against the already mangled door. What a finale! Vicki stood there with her mouth open, clearly intimidated and shaken. Joan and Sandy were peering into the room with shell-shocked expressions on their faces, while I just stood there, stunned.

Without another word, I grabbed my stuff and fled the studio. I couldn't think straight. All I wanted to do was get the hell out of there. I needed to go home. Take something to calm myself down. I wanted to be anywhere except in this stupid fucking studio with the band.

I knew then, as I got into Marie's car and took off with a screech of brakes, that the Runaways for me were over.

Kim was already on the phone with my aunt Evie when I made it back to the house. "Honey, it's for you. It's . . . *Kim*." The way she said it, it was as if Satan himself had decided to call me up. I picked up the phone. "H-hello?"

"I just heard what happened. My, that Lita is a feisty one, isn't she?"

"It's over, Kim," I said. "I can't take it anymore. I'm leaving the band."

Instead of the avalanche of abuse I was expecting Kim to lay on me, he said, without missing a beat "No problem, Cherie. To be honest, I'm surprised the band lasted this long. I have another project lined up for you—a solo album. You'll do your album, and if they decide to stay on, they can do an album of their own. Then everybody's happy, yes?"

"So—so I still have a record deal?"

"Yes! We'll talk tomorrow."

Despite everything I had been through with Kim, I was so tired, so upset, and so confused that I just wanted it all to be okay. Even though I couldn't stand him, Kim was telling me that everything could just go on as normal. More than anything in the world, that was exactly what I wanted to hear. Despite myself, I actually felt kind of optimistic when I hung up the phone.

"Honey," Aunt Evie said when I was finished, "what on earth happened?"

I shook my head. "I quit the band," I said. "I can't take it anymore . . ."

"Oh," Aunt Evie said. "So . . . what now?"

"I'm going to cut a solo record. It's gonna be fine. Don't worry."

The words sounded so strange coming out of my mouth, but the past few years had been so strange that I barely even noticed it anymore. Without another word, I walked straight to my bedroom, took a quaalude, and collapsed onto the bed before falling into an exhausted, drugged sleep.

23

Beauty's Only Skin Deep

My first solo record, *Beauty's Only Skin Deep*, was recorded in a rush, only weeks after I had quit the Runaways. What I'd wanted was a chance to take some time off and actually decide what my next step would be. In the Runaways I constituted a fifth of a band that had a domineering manager who forced most of the big decisions on us while keeping us totally in the dark about everything. Any attempts at influencing Kim's "vision" were met with threats and insults. Despite being the lead singer of the band, I was expected to shut up and perform, just like everyone else in the Runaways. Having your own opinions or ideas was unacceptable Kim.

Kim had no respect for us as artists. He felt he knew what would sell, and felt that he had dominion over us because he had a proven track record. He would constantly go off on long tangents about all of the records he had made. One of his favorite lines was, "When you've made as many records as I have, *then* I'll listen!"

While the Runaways had never achieved the kind of wild success in America that we had in Japan, we still had name recognition. I knew that a solo Cherie Currie record was my best chance to define myself, and put my career on the kind of trajectory that I imagined it should be on. But I would need time—the right sound, the right songs, the right *feeling*. I didn't want to rush into anything.

It didn't work out like that.

There were contractual obligations, and Kim and I had to deliver a

new album for the label right away. That's what he told me. There was no time for me to go away and write songs, or "find myself," or any of the other stuff that I needed to do back then. I had to go straight into the studio and start cutting tracks. I can only liken the album to a shotgun marriage: I didn't want to work with Kim anymore, but in a way, his presence was a comfort. It was what I was used to. It was the mentality that keeps a wife with a violent husband; even though Kim mistreated and demeaned me, the very fact that I had his full attention now was gratifying. Looking back, I can only think that this was a symptom of just how damaged I had been by my experiences in the Runaways. Kim had no interest in managing me over the long term, but we had to pack and deliver one final album together so we could finally end our relationship. It's no surprise that the album turned out nothing like I had wanted it to.

If any phrase sums up most of *Beauty's Only Skin Deep* for me, it was the one that Lita tossed at me a lifetime ago when I'd tried out for the Runaways with Suzi Quatro's "Fever" as my audition song: "middle of the road."

When we went to work on the album, Kim's attitude of "father knows best" was unrelenting. He played on my love of "MOR" and all of the songs that he brought to me or was having written for the album were in that vein. From the very beginning, I was unhappy with the direction that the record was taking. If I didn't like the songs—which was the case with most of them—Kim would shut me down. There was no time to argue, he told me. "You'll have plenty of time to get it right on the *next* record!"

We cut the album at Larrabee Studios on Santa Monica, in West Hollywood. Kim showed up with a bunch of songs from the various songwriters he was managing (just to make sure that he squeezed every last potential cent from the royalties). He had hired an Englishman called David Carr, who was formerly in an English beat group called the Fortunes, to coproduce. He was a nice guy, and a talented keyboardist and singer. He had a nice vocal range, and sang with a slight lisp. Part of his job was to do layers and layers of harmonies. He was patient with me, which was something I wasn't used to. Some of the sessions were just David and me, and it was nice to be able to relax

a little away from all of the madness I associated with Kim. I added lyrics to a few of the tracks. It didn't matter whether I liked the songs or not: I was expected to just show up and sing.

The songs themselves were swamped with syrupy, seventies pop production. I imagined the reaction of those amped-up kids who had been slashing the seats and beating the crap out of each other in the aisles at Runaways shows when they'd get a load of *this*. At the very least I found something perversely amusing about imagining that.

The sessions were quick and uninspired. I had come down with a bug and at times I was recording vocal tracks with a temperature as high as 101. Even Kim seemed more subdued than usual. Any spark, any fire, would flare for a moment, then dissipate just as quickly. Only two songs really stand out on this album for me, each for very different reasons.

"Science Fiction Daze" was my favorite. It was the closest I ever came to recording something that really brought me back to my Bowie roots. We bathed the song in trippy Moog synthesizers, and I was really happy with my vocals on that one.

The other song was called "Love at First Sight." Back in Japan, where our fanatical fan base pored over every detail of our private lives, the story about me having a twin sister had proved endlessly fascinating. People just couldn't believe that Cherie Currie, the wild-child singer of the Runaways, could have an identical twin sister. Never one to miss an opportunity for hype, Kim Fowley started feeding the Japanese press stories that there was no twin, and that the whole thing was a rumor. Then he would send out a conflicting story that Marie was real, and we were going to play some shows in Japan together. By the time he was done, there was a hysterical anticipation for me to return to prove once and for all whether there really were *two* Currie sisters. "Love at First Sight" would be the song that we performed together.

At first I was resistant. Again, it felt like I was being led around by the nose. I loved my sister, and I knew that my success had been hard on her. I also knew that more than anything she longed for a similar success. Although Marie would never, *ever* admit this to me, I'd heard via Paul that sometimes she pretended to be me, and even

signed autographs as me. Marie wanted to sing, she wanted to act, and instead she was watching from the sidelines as I lived out her fantasies. It was easy to imagine how her long-ago decision to tell Kim Fowley to go get bent was eating away at her.

But if I recorded this song with her, what then? I sure as hell wasn't willing to jump from one compromised situation like the Runaways into another. But unless this one song somehow kick-started a solo career for Marie, what would happen? Either she'd have to go back to doing what she was doing, or we would have to become some kind of double act. Neither of these options seemed like the right thing. However, with the studio clock ticking, I agreed to cutting the track. I felt I owed my sister that much.

"This will go over *huge* in Japan!" Kim told me. "You said you wanted to go back, didn't you?"

"Of course. I loved it there."

"This is a good move. It will cause an instant scandal back there. It will mean huge press coverage, and big record sales. And all you have to do is sing a song with your sister. How hard can that be?"

The song was a fairly pedestrian midtempo rock number, which had a little bit of a "sixties" feel to it, with plenty of opportunity for vocal harmonizing. We cut it in a day. Once Marie showed up in the studio, I was glad I had agreed to sing with her: she seemed so happy, so at home in the studio, and she really made me proud. The song came out sounding pretty good and then Kim went to work booking the two of us on a publicity tour of Japan to perform it to an audience that was already hysterical with anticipation.

Once the album was cut, it was rushed to market. We briefly shot a single promotional video, and Mercury didn't even bother sending me out on the road. It was pushed out into record stores with zero promotion, and quickly sank without a trace. I suppose it's something of a cult record now. I still get contacted by fans once in a while who discover it, and really enjoy it. Looking back, I can see more positives about it these days, but at the time I considered *Beauty's Only Skin Deep* a failure. However, Kim was right about one thing: the promotional tour of Japan was a hit.

Marie and I were flown over there for two weeks to do interviews

and lip-synch to the song a few times. The atmosphere between Marie and me quickly turned sour. I was pissed off that I was having to do my first solo tour with my sister in tow, and after the first half-dozen interviews the main thrust of which was questions along the lines of "Will you be recording more records with your sister?" I started getting belligerent.

"No," I told interviewer after interviewer, "this is a onetime-only thing. I need to figure out where I want to go first."

Of course, this didn't make Marie feel good. She would be sitting on the couch next to me, an interviewer's microphone shoved into her face, having to listen to her twin sister saying that as soon as we got back to the United States, she would be dumped. As every answer was translated into Japanese, the implication of my words was not lost on Marie: as soon as we were back in the United States, she would return to her old life while I'd go on to record more albums. In short, the whole idea blew up in my face in the exact way that I feared it would at the start. Marie agreed to recording this song as a onetime-only thing, and then resented me because I'd insisted that it really *was* a onetime-only thing. I could see her point. If the roles had been reversed, I would have been hurt and disappointed, too.

But what else could I do? I wasn't about to give up my one shot at being a solo artist, and the Runaways still haunted me. I missed Joan and Sandy and wondered what they were doing. When their new album, *Waitin' for the Night,* came out, I couldn't even listen to it. It was too painful. Putting that part of my history behind me was incredibly hard. If they'd asked me to come back, I would have. I'd always felt that all the band really needed was a break, some time to assess where we were heading, and maybe a little time off to look after ourselves. But, it seemed they were doing just fine without me, and of course, that hurt a lot, too.

Despite the flurry of press interest, and the hysteria of the audiences when we'd do a public appearance together, *Beauty's Only Skin Deep* was only marginally more successful in Japan than it was here in the States. We broke that first Runaways album by touring relentlessly. With this record, the songs were lackluster, neither Kim nor I

really gave a shit, and Mercury barely promoted it. It was doomed from the start.

The best thing that *Beauty's Only Skin Deep* did for my career was to free me from my management contract with Kim Fowley. I was finally in control of my own destiny. At least, that's what I thought in the beginning. After Marie and I returned from Japan, I was ready to finally undergo that period of soul-searching and healing that I had longed for since quitting the Runaways. No more being told what to do by my management, by the record label, by anyone. I was ready to step out on my own.

That was the plan. Of course, it didn't work out that way.

24

One Hundred Ways to Fry a Brain

I was seventeen years old. I was out of the Runaways, and out of control. I had one solo album under my belt that had flown very much under the radar, but now at least I was a free agent. No more Runaways and no more Kim. It was only after quitting the band that I could look back on that period with any kind of perspective. In my head, I likened my time working with Kim to being sucked up in the vortex of a tornado: at fifteen years old, that chance meeting with Kim Fowley and Joan Jett had ripped me away from my regular, suburban childhood and deposited me, two years later, beaten, bruised, and confused, on the other side of fame. Sure, I was still well known, and I had three albums to show for it. Now I was Cherie Currie, ex–lead singer of the rock super-group the Runaways, and solo artist. Once *Beauty's Only Skin Deep* had come out, I finally felt that I could try to regroup and focus on what it was that I really wanted to do with myself. But first I wanted to have some fun. And my idea of having fun involved a lot of drugs.

My existence became a dizzying roller-coaster ride of uppers and downers. Tuinals, sleepers, or quaaludes when I needed to feel mellow. Cocaine when I needed a lift. I wasn't much of a drinker, though. I thought, why spend all that time drinking when all I had to do was pop a pill for the same effect? Except now, without road managers and "nurses" around me twenty-four seven doling out the drugs, I had to pay for all the substances I ingested. My use of coke and pills was getting heavy. As well as feeling worn out, I was bitter:

after three Runaways albums and one solo album for Mercury, people assumed that I was doing pretty well financially. Actually, nothing was further from the truth. The Runaways had been an adventure for sure, but it hadn't given me any kind of financial stability. If I thought about it too much, it would eat me alive. So instead of thinking, I got high. With no source of income, and a mere pittance earned from my time with the Runaways, I found myself doing things for money that the old Cherie would never have done in a million years.

I started forging my father's checks and raiding his tip jar for drug money.

Being high from the moment I staggered out of bed until the moment I collapsed back into it (if I even made it to my bed; sometimes I'd wake up on the floor of the bathroom or in the bedroom, face still smeared with last night's makeup, wondering how in the hell I got there) was a total necessity for me. I was not an addict, I'd tell myself, I just liked drugs a hell of a lot. They became a part of who I was—Cherie Currie, the neon blur in the fast lane, the Cherry Bomb. I needed to be that person to cope with the pressure, because the pressure was everywhere. There was the pressure from myself, to bounce back from the Runaways and not just become another rock-and-roll casualty. After all, wouldn't Lita have loved it if I just faded away quietly? There was no way I was going to give her the satisfaction! Sometimes the pressure came from places that even I didn't expect. Like my father.

When I told him that I was going to regroup, find new management, and start working on another record, his face clouded over.

"What about your sister?" he asked.

What about her? I wasn't even sure what he meant. Sensing my confusion, my father pressed on.

"You know, Kitten, this . . . this *fame,* this *success . . .* it's been very hard on her. Put yourself in her shoes. Imagine if you were working at the Pup 'n' Taco while your twin sister was on the front cover of every music magazine in the country. When she went to Japan with you . . . she really got a taste of what it's like to be in your shoes. You said it yourself, she was really good on that track you did together."

"Yeah, that's true. I *know* Marie can sing."

"But what does she do *now*? Do you just expect her to go back

to her old life? To give up on her dream? How would that make you feel?"

Ugh. Conversations like this were another reason I needed the drugs. Why would my father even say things like this to me? Why should I be made to feel guilty for the success I'd experienced? I *earned* it. I went through hell with the Runaways, and walked away from it all not with money, but with fame. If I used this fame wisely, I figured I could turn it into a career. But that would take a lot of work, and a lot of dedication. Sure, it was shitty luck that Marie was where she was right now, but why should I be made to feel responsible for that?

I started to feel angry about the way this conversation was going, the anger even cutting through the Tuinals and the cocaine in my system. "So?" I said. "What am I supposed to do? I said right at the beginning that doing the song with her was going to be a one-time thing. All I can do is try to make a go of it myself. Use the opportunities I have and then . . . maybe—"

"I think there's more you can do than just *that*, Kitten. I think there's a lot more that you can do. People really *reacted* to the song that you did with Marie. I think that's the direction you need to be heading in."

I laughed. "It was a novelty, Dad! What could we do together after that? There's nowhere else we can take this . . . Not now!"

"You could cut a whole album with her."

"An album? Dad . . ."

"You know that Marie can sing, Kitten. She wants to sing. She wants to act. I think you're in a position to help her. And I mean *really* help her."

"Come on, Dad! What can I do? I don't own a record label!"

"You could work as a duo. If you told the labels and your new management that this is what you wanted to do, they'd have to say yes. They'd *have* to."

I thought for a moment that he was kidding. But then the look on his face told me otherwise.

It all made a terrible, sick kind of sense. Full circle, right back to

those days at the Kiwanis Club singing Dean Martin songs with Dad. The idea was utterly ridiculous: I knew in my gut that no label was going to agree to anything except a solo Cherie Currie record. Plus, in the past two years, I felt that I had finally crawled out from under my twin sister's shadow. Now my father was asking me to share the spotlight with her again. I shook my head.

"It's a nice idea, Dad," I said gently, "and I could maybe make that happen down the road after I prove myself . . . but now? It's impossible! The record labels won't go for it. I need time to *breathe*. I can't just jump into something like that. Please be realistic . . . Kim only suggested it because it was a novelty and *yes,* I wanted her to feel proud of herself but now . . . I have to find out who *I* am. I deserve that much, don't I? Even Kim didn't expect me to do a whole *album* with her."

At the mention of Kim's name, Dad's face darkened. My father was not a man who showed anger often, but this time he shook a little and spat out, "Kim? What does that creep know? He's made his living exploiting you girls!"

Then my dad fell silent. He didn't look so good. His eyes were watery, bloodshot. Over the past few months, his face had been filling out, his skin getting puffy and red. The booze was eating him up from the inside. I couldn't say anything. I just stood there watching this once proud man trying desperately to pull his broken family together. I needed a pill, I decided. I needed to end this conversation now, and get some chemically induced peace into my brain. Some calm.

Dad looked up to me. "I'm not asking you, Kitten. I'm telling you. Family has to come first. If you can't put your family first this one time . . . then I'm sorry, I'll have to cut you loose. Do you understand me, Kitten?"

"Yes, Dad," I said quietly.

"Marie is your sister. I want you to help her. Otherwise, I'll have to wash my hands of you."

I stood there nodding, dumbstruck. I wondered if he knew what he was saying. Maybe he knew about the checks. If he did, he was too proud to say anything. Too proud to admit that his own daughter was

stealing his money to buy drugs. Maybe this was his way of making it right. Maybe he could forgive me so long as I helped Marie. Maybe then he could pretend that I wasn't a thief.

"Okay, Dad," I said again. I walked away, confused and disoriented.

"Kitten," my father said, "not a word of this. To Marie, I mean. Marie would never accept this if she felt that I . . . got involved. It has to come from you. She's too proud, too stubborn."

I nodded. Proud. Stubborn. I guess that was a Currie-family trait.

At three o'clock the next morning, I staggered out of Daddy's car. I had borrowed it for the evening to hit a party in Malibu that turned out to be really wild. I couldn't stop laughing. The world was spinning around me, and I felt just about as wasted as a human being could get. When I hit the fresh air, I noticed deep scrape marks along the side, which exposed the raw metal underneath. I guess I'd sideswiped some cars. Maybe. I couldn't remember much about the drive home. Some strange kind of autopilot must have kicked in, steering me over the freeway and back to the house somewhat intact. There were other deep holes in my recollection of the evening, and if I'd considered them too long, I might have fallen into one and never came out again. I remembered being in the bathroom, and people pounding on the door to be let in. I had fallen asleep on the toilet. That's when I'd staggered out to the car. Still, despite having totally trashed my father's car, I couldn't stop giggling. The whole situation felt so unreal, so completely absurd.

Inside the house, the living room was rotating. "Stop it," I slurred, grabbing hold of the couch to try and make everything stay still. "Don't move!"

Out of the corner of my eye, I saw someone standing there. She was very unsteady and she was rail thin. I jumped, and then realized that it was my own reflection staring back at me from the big ornate mirror. I straightened up and tried to take a good look at myself, but the floor suddenly shifted under me and I staggered off toward the kitchen instead. I made it to the sink, and grasped hold of it, unsure if I was going to vomit or not. I groaned, but the puke didn't come.

I heard a familiar voice floating up from the darkness. It sounded like Marie. Marie in her typical overbearing way saying, "What the hell is happening to you, Cherie?" I heard that voice a lot these days, lecturing me, judging me. The only way to shut it up was to drown it out with more pills. I turned, and nearly fell over when I realized that it really *was* Marie.

"Oh shit," I slurred. "I thought *you* were in my *head*." Then I burst into laughter again, and the laughter had a weird hysterical edge to it.

"What the hell is so funny?" Marie spat, looking completely disgusted. I couldn't answer. I kept right on laughing. Roaring, doubled over, the tears streaming down my cheeks.

"Stop it!" she hissed. "You're going to wake up the whole house!"

I put a hand over my mouth, and tried to stifle my laughter. Marie looked so funny standing there in her stupid, plain nightgown. The whole scene was so stupid, so suburban, so dull! This isn't what the Cherry Bomb should be doing! Standing around in a kitchen getting a lecture from her sister! Marie shook her head. "You're going to kill yourself, Cherie. You drove home like this? You're gonna kill someone else while you're at it!"

"Oh, stop it." I laughed. "You're so fucking *square* sometimes. You sound like Grandma!"

"Daddy knows about the checks, you know," Marie said, folding her arms. "You were using Daddy's money to buy your cocaine!"

I shook my head. I knew somewhere in the back of my mind that if I'd been sober, this revelation would have really upset me. I should have felt awful, like I was the lowest of the low, but all I could think about was how absurd it all seemed. Thank God for drugs, that's all I can say. I dismissed Marie's concerns with a wave of my unsteady hand.

"How could you not expect him to find out!" she demanded. "You spent almost a thousand dollars on coke! You cleaned him out! All of his money!"

"Oh, phooey," I slurred. "You do coke, too, Marie. So don't gimme the Mother fuckin' Teresa routine."

"I pay for my own drugs, Cherie. I'm not a thief!"

"Oh, blah, blah, blah!" I screamed. As I did this, I gave a drunken wave of my arm, and my purse slipped out of my hand and hit the floor. It yawned open, and my little blue-and-red Tuinal capsules spilled out all over the floor. This started me laughing again, especially when I saw the look on Marie's face. Oh God, my sister had become such a huge *downer* these days!

Marie's face darkened further. "Did you hear me?" she growled. "Daddy's broke! Because of YOU! Stop *laughing*!"

But I couldn't stop. I was about to get down on my knees to start retrieving my pills when suddenly I heard a loud *crack*. It came from nowhere and I suddenly found myself flying through the air, my face slamming into the refrigerator. I didn't feel any pain. I was on too many pills for that. Instead it was a purely disoriented sensation: the world had suddenly shifted around me without warning. It was only after I sank to the floor that I realized what had happened. Marie had slapped me! My face started feeling numb and puffy where it had collided with the refrigerator.

Suddenly, out of the fog of booze and Tuinals, I felt the anger rise in me. I leaped to my feet, ready to kill. Terrified, Marie grabbed a chair and actually held it up to fend me off like a fucking lion tamer. I wasn't laughing anymore. My face was contorted in rage, and suddenly I had a diamond-sharp clarity.

"YOU FUCKING BITCH!" I screamed. "HOW DARE YOU!" I lunged at her clumsily, and hit my face on the leg of the chair. I tasted copper, but tried to lunge again anyway. Marie's face had a look of total and utter horror on it.

"You're bleeding!" she screamed. "You're BLEEDING!"

Marie had never hit me before. When she saw the blood, she dropped the chair and burst into tears. Suddenly the tension was defused, and I staggered back holding on to the sink for dear life, trying to avoid falling flat on my face. The world was spinning faster, faster. I looked up, feeling the hot blood dripping down my chin. I saw my sister sobbing hysterically. I saw the lights on behind her. In the doorway was my father, Grandma, and Aunt Evie. They were standing there, watching this ugly scene play out with looks of disbelief on their faces.

"Aw, Cherie . . ." my dad muttered. Grandma looked like she was about to faint. I saw my aunt Evie turn her back, unable to even watch anymore.

Just looking at my father, I could see that he'd been drinking. It was in the way that he stood, in the way that he held himself. Hell, I couldn't remember the last time he didn't look like this. My father wasn't so good at holding his booze these days. Once upon a time he could hide it so well . . . nowadays he was beginning to look like an old man to me, shaky and unsteady. I closed my eyes, and felt the unsteady ground lurch underneath my feet. From somewhere I could hear Marie sobbing, "I'm sorry! I'm sorry!" Nobody else said a word. They just stood there, mortified, too ashamed of me, to say anything.

The next morning, nobody said a word about what had happened. They were too embarrassed. I started to avoid my family as much as I could, spending more and more time with my new boyfriend, Tommy.

I'd met Tommy at the Sugar Shack, where he worked as a bouncer. I thought he was the most beautiful boy I had ever seen. As well as possessing chiseled good looks, Tommy had a temper and could be as jealous as hell. I liked that about him. It showed he cared. Another thing I liked about Tommy was that he didn't judge me when I got high. In fact, Tommy took almost as many drugs as I did. But he could hold his drugs well, and that was good, because most of the time I needed someone to look after me.

I swung by his apartment in Daddy's scraped-up car to pick him up a few nights later. I remember Tommy warning me not to get too wasted before we'd even left his place. "I'm serious, Cherie," he'd insisted. "I don't want you making a fool of yourself like last time."

I kissed him and said, "Cross my heart." I had no intention of making a fool of myself. But then, I never did.

The Runaways' booking agent, David Lebert, was throwing the party over at his place in Sherman Oaks. The house was big, beautiful, and packed with people. There were drugs everywhere. Not out in the open, of course, in front of people. But there was a definite undercurrent, and if you had the nose for it, you could sniff it out with ease. In darkened corners, hidden rooms, bathrooms, and patios, people were getting high. If you were straight, you could have

shown up at that party and never known for a second that people were snorting coke and popping pills. You might have thought the people seemed extraordinarily *talkative,* or that they seemed to be extremely drunk, but as for *drugs* . . . never! But, if you were looking for them, you would find them in all of the expected places. On the drive over I opened my purse and popped a Tuinal. Tommy gave me a concerned look and I said, "What? I'll be okay! I'm just not going to drink when I get there."

Tommy nodded, and then put his hand out. I dropped one of the capsules into his palm and he swallowed it dry while doing sixty on the freeway. I kissed his neck, and made him shiver.

Ever since getting back from the Japanese tour, I had started developing a taste for booze. Once upon a time I hated it, I hated the way it tasted, I hated the way it made me feel. But in Japan, the drug laws were insanely strict, and nobody wanted to risk bringing anything into the country. Once in a while the road crew handed us strange-looking pills that they claimed were downers, and we would say a silent prayer and swallow them down without question. But they were never as good as the stuff we could get at home. To combat this situation I became something of a borderline alcoholic overnight. Once I got back, I started to crave the stuff.

Tommy always warned me that downers and booze didn't mix. The more you drank, the harder it was to remember how many pills you'd taken, so you'd end up taking more and more. It could be a lethal combination, and you'd hear of people all the time who ended their evening by choking to death on their own vomit. Even though I was only seventeen, I'd already known a few people who'd checked out in this sad, undignified manner. But it didn't worry me. After all, I was immortal. Nothing could happen to Cherie Currie.

Once we arrived at the party and I had downed a few cocktails, time started to speed up. The evening started to break down into a haze of booze, pills, and cocaine. I would be introduced to people, and then immediately forget their names. Faces passed by in a hallucinatory blur, and people's voices blended together into a woozy, senseless chatter. Once in a while, Tommy would pull me aside and get mad at me, screaming that I was getting too fucked up and to

knock it off. "You're acting crazy!" he told me at one point. "You're slurring! You nearly knocked that girl over!" He pointed at some girl who I didn't even remember seeing before. I didn't remember much of anything. Hazy memories of someone handing me a strange pill, and my swallowing it without even knowing what it was.

"God, you're a fucking *mess,* Cherie!" he said to me later in the night, after pulling me into the bathroom. "Do you have any more Tuinals?"

I handed some over, and he swallowed them angrily, staggering out into the party again . . .

The party swirled on. The music rising and falling, the dim lights twinkling like winter frost. Suddenly, all at once, I found myself on the floor. *Thud!* I just lay there with my cheek against the hardwood floor, laughing to myself. I tried to move, but my limbs would not work.

"God*damn* it, Cherie!" I heard Tommy yell from somewhere above me. Then strong arms grabbed me, picked me up. He carried me away, and I felt the cool air hit me in the face, bringing me around a little. I became aware that we were outside, at least. I felt him bundle me into the passenger seat of my father's car. I tried to say, "Where are we going? I want another drink!" but my words came out in a sense-less jumble. I couldn't sit up straight, and my eyelids felt like they were made of lead. I heard the engine start as the vehicle lurched into life. Tommy was muttering to himself angrily.

As we sailed through the night, I found myself drifting in and out of consciousness. I felt like I was floating in some vast black pool. Every so often I would break to the surface, and I could see the twin-kling streetlights sailing past me before I'd sink into numb blackness once more.

Suddenly a loud *clank* brought me around with a jerk. My body jerked forward, and my eyes fluttered open. What I saw didn't make any sense, at first. There was no road anymore. I was looking at a light pole, and the front of Daddy's car was up on the sidewalk, the hood bent out of shape. I could hear Tommy cursing. I looked around me. We were in front of a Denny's, on the corner of Coldwater Canyon and Ventura Boulevard. We'd jumped the sidewalk and hit

the light pole. People were rushing out of the restaurant to see what happened.

Someone was knocking on the window. I looked over and rolled the window down a little, still in a daze. In my haze, I thought that I recognized the guy. He was a guitar player I knew, Joey Brasler. A guy I had once worked with in the studio. He looked concerned. Tommy was desperately trying to get the engine started again.

"Dude!" Joey yelled. "Are you okay?"

I started nodding in slow motion as Tommy got the car started and the engine roared into life once more.

"You're wasted, man," Joey yelled. "You shouldn't be driving!"

Tommy turned and snarled, "Fuck you, asshole!" before he threw the car into reverse and took off again down Coldwater Canyon Boulevard, with a squeal of rubber on asphalt.

As we flew into the night again, my head felt like it weighed fifty pounds. I nodded rhythmically, fading in and out. It felt like a preview of death. Little moments of perfect oblivion. I wanted to curl up in this blackness, this dreamless, silent place, and never return. It was so comforting. So still.

Suddenly my whole world erupted.

Glass was exploding all around me.

The whole car was ripping apart.

Tommy went flying forward, his head going straight into the windshield. Then he bounced back in again, spraying the interior of the car in blood. I felt the engine slamming into my back as I was twisted around 180 degrees by the sudden, violent impact.

And then nothing.

That silent, peaceful darkness once more.

It wasn't until I woke up to the beam of flashlights, the rhythm of police lights flashing in the night sky, and the chattering of walkie-talkies that I started to become aware of what had happened. There was a tree, and the car was wrapped around it. Daddy's car was destroyed, crushed like a child's toy. I knew that Tommy was alive because I could hear him screaming and cursing. Then a cop shined a light in my face. It was very bright. I scrunched my eyes up.

"She's alive!" I heard the cop yell.

"*Wasshappening . . . wasshappening . . .*" I slurred.

"They're wasted!" the cop yelled to the others. "I can smell it from here!"

Suddenly I became aware of the pain. Not even the booze and the pills could mask it. My leg felt like it was on fire. I glanced down, and could see it was bloody and ripped open. The cops were lifting me out of the wreckage. All I remember is repeating "Take me to the hospital" over and over.

Amazingly, apart from a badly cut knee on my part, and some lacerations to the head on Tommy's, we somehow survived the impact intact. Everything was hazy. As the cops checked our injuries, I asked again to go to the hospital. They were about to agree when Tommy started ranting and raving that he wouldn't go to any motherfucking hospital. Faced with a drunk, stoned, and belligerent driver, the cops decided that instead of bringing us to the ER, they would book him and take us to the station.

We were left to sober up in the Van Nuys police station. The more sober I got, the more my knee hurt. The pain was unbearable. Some fat, stupid cop said to me, "You're lucky to be alive, little girl . . ." and I wanted to spit on him, I wanted to claw his face for calling me that.

It was all Tommy's fault, I decided.

It's my agent's fault for having a dumb party.

It was the city's fault for not lighting the street well enough.

It was God's fault for making a fucking tree grow in such a stupid place.

The cops seemed to think that it was our fault because we were driving while "doped up," as one of them put it. But what did they know? They were just stupid fucking cops.

When Daddy and Marie arrived to pick me up, they were both in tears. I guess they were just glad that I was alive. My knee had me in such agony that I cried aloud as I tried to walk. I don't remember much more about that night, except for the pain and my father saying something on the way home that hit me very hard.

"Kitten," he said, "I don't know what to do with you. I can't deal with this anymore. You're going to have to make a decision. It's the drugs . . . or it's us."

The disappointment in his voice cut me like a knife. I never meant to hurt my father, or anyone in my family. I never thought that I would make my own father cry, but tonight I did just that. I'd stolen from him. Tonight I could have died, just like that. The idea of dying terrified me.

I started crying, and begging my father for his forgiveness. Through my tears, I promised him that I would stop using drugs. I told him that I would change my ways. I told him whatever he wanted to hear, because the simple truth was that I just didn't want to hear him talk about it anymore.

And maybe, some naive part of me, deep down inside, actually believed that I would stop. Maybe.

25

The Terrible Green Limousine

Because of the accident, my knee was in pretty bad shape. It had swelled up like a balloon and I could barely move it without severe pain. I left the hospital wearing a leg brace and on crutches. I didn't see so much of Tommy following the accident. His jealousy—which had flattered me in the beginning—became worse and worse, until it actually frightened me. The last time I called his house, his mother begged me not to call him anymore. In the background I could hear him screaming bloody murder and smashing up the house in some kind of jealous rage.

While I was recuperating at home Marie helped me with the physical therapy. The worst part of it all was going back to the hospital to get the fluid drained: I was never a big fan of needles, and I had enough stuck in me during that whole period to last me a lifetime. As I continued with the physical therapy, the knee started to improve and the pain gradually lessened. Immediately after the accident, a doctor informed me that I would never dance again, but I had my own ideas about that.

It was during the physical therapy sessions that I started talking to Marie about doing the next album together. She was really happy about the whole idea. I could see in her eyes that more than anything in the world she wanted a career in music, and she felt that the best way to achieve this was to cut a record with me. I never told her that our father had basically forced me into this decision. I knew that this

had the power to hurt her terribly. As much as my sister could drive me crazy at times, I would have never wanted to hurt her like that. No, I decided that this part of the story would have to remain my secret. I prayed that I was making the right decision, and hated the feeling that yet again, outside forces were pulling me in directions that I was not comfortable with.

The accident also made me reevaluate where my life was heading. I decided that I would take this opportunity to sober up. I wasn't planning on quitting booze and drugs for good, but I figured that it was at least time to slow down. I read a bunch of self-help books while I was lying around recovering, and felt determined that I could learn to control my drug use.

Giving up partying was easy at first, but as the weeks dragged on, a terrible realization came to me. It suddenly struck me that I didn't *enjoy* being sober. I thought at first it was just the side effects of the accident; maybe I was depressed because of the pain, or maybe even in shock. But weeks after the accident, life still felt gray and miserable without the occasional "toot" or pill. Before I'd joined the Runaways, I could be happy just being me, just being alive. But now, without pills or cocaine, I felt ill and tired all of the time, and couldn't find the joy in anything. I found myself having vivid dreams about popping pills or snorting lines of blow. I would jerk awake, bathed in sweat and gasping for breath. I'd look around my room and realize that it was just a dream. The yearning to get high would be unbearable. Throughout each long, pointless day I would find my thoughts returning time and time again to drugs. I longed for that detached, numb feeling that the blow and the pills gave me. I wanted to feel blank again: I wanted to feel nothing at all.

The biggest test was going back to the Sugar Shack. In the days since I had been a regular at the club, the scene had changed. A lot of the innocence had gone. It had gotten much darker. Once upon a time the drug of choice at the Sugar Shack was pot, maybe quaaludes. Now it was cocaine. Coke was everywhere, and there was a new decadence in the air fueled by the regulars' rampant coke use: in the darkened corners there was stuff going on that shocked even me. Drug use and sex were going on everywhere you looked.

Keeping away from temptation was tough. On one of my first trips back to the Sugar Shack, a friend offered me a toot of what he said was cocaine. The temptation was too much, and I accepted. Immediately after snorting it, I knew that this stuff wasn't coke: I started hallucinating. In the dark of the club, the faces around me took on a sinister, frightening look. The music itself started to distort and come at me in waves, disorienting me and hurting my ears. I panicked, and ran out of the club and down the street. As I ran past a storm drain, I could hear haunting voices calling my name from the darkness below.

I ran into a liquor store, gasping for air, convinced that I was losing my mind. I could hear a weird noise rising up from my feet. Looking down, I could see the carpet rising and falling . . . It was breathing! The carpet was *breathing*!

From nowhere, a voice asked if they could help me find something. I spun around with a yell of surprise and found myself staring into the strange, distorted face of the clerk. He took one look into my eyes, which were gleaming with chemically induced madness, and he stammered, "Oh—oh no . . . I doubt I can help *you*!"

I discovered later that what I had snorted was not cocaine, but a drug called angel dust, or PCP, an animal tranquilizer that had come onto the scene. After that incident, I was very careful about accepting anything from that particular friend.

There were many different social circles at the Shack—some gay, some straight, and some mixed—but they all had their own drugs, and their taboo lifestyles were incomprehensible to an outsider. So to keep on the straight and narrow, I had to be careful to avoid certain groups. I stuck with my old friends, the other "old faces" who just wanted to dance and have a good time. I spent my time hanging out under the glittering lights of the dance floor, or out in the parking lot, where I could talk to my friends away from the ecstatic roar of the disco and new wave that had replaced glam rock as the music of choice for the Sugar Shack's regulars.

On this particular night, I was out there in the lot surrounded by ten or so friends and my favorite security guard, Jackson. We were talking about the old days, and it was hard to believe that it had been only four years since I had caused shock waves at my school by

cutting my hair into a shag and pretending to be Bowie. It was surreal to think of just how wild my life had become when compared to my old friends.

"The old days" of junior high, and life in the Valley, seemed like it happened in some other place, some other time. Everything had changed; the music, the drugs, the scene was different. Ziggy Stardust was long gone, and in his place was the David Bowie of *Heroes*— more funky than fantastic. Punk had lived up to its nihilistic promise when Sid Vicious had supposedly stabbed his girlfriend to death, and then OD'd on heroin. Disco had moved from the clubs onto the *Billboard* charts. Nobody knew what the eighties had in store for us, but there was no doubting the sense that this vast, unstoppable party was building toward some kind of messy end. My personal circumstances had changed. There was a painful twinge when I thought about it, a sense that things would never be the same. Things could never feel that innocent, so alive with possibilities again.

The conversation swept me up, and the time passed by easily. People drifted away, and soon there were only five of us. My friends were talking about their upcoming high school graduation, and I was silent. When I was a kid, I used to dream about my high school graduation. What my dress would be like, who my date would be. Now that I had dropped out of school, I knew that I would never have a graduation. Even with all of the incredible things I had experienced with the Runaways, the thought really left me lost. It made me realize just how different my life had turned out from what I had once expected.

As more people drifted away, the conversation and the laughter continued. Somebody asked me about Joan Jett, and I told them funny stories about life on the road.

"Man, you guys should have never broke up," one friend who had her own band in those days told me. "You were my favorite band. I dunno, you guys really made it feel like anything was possible, you know?"

I'd heard this a lot over the years. We may not have had number-one hits, but it really did feel like the Runaways inspired a hell of a lot of people to form their own bands, to make their own music.

Whenever I heard this, I didn't talk too much about the dark side of life in the band. I didn't want to shatter people's illusions.

I looked down at my watch. It was just before eleven. My friend Andy had joined us. We had become very close over the years. I'd even had a Japan tour jacket made for him with his name on it. Andy was one of those rare people in my life who I could always count on. He was always there for me if I needed a ride or even help detouring some crazed groupie. He was such a good guy, so sweet and honest.

"You need a ride home?" he asked.

I gave him a hug. "No thanks. Marie is picking me up. She'll be here any minute now."

"Okay, sweetie . . . Just grab me before you leave to say good-bye." Andy kissed me on the cheek and then headed back into the club.

The club was still rocking. There were still quite a few people hanging out around the parking lot, sitting on the hoods of their cars, talking, laughing, and making out. Jackson, the security guard, was telling a story about having to beat someone up for hitting a girl at another club. I could hear the heavy bass and drums of some disco track reverberating out of the club and fading into the night air. I checked my watch again. Suddenly, someone called my name.

I looked over and there was a green limousine pulled up behind me. A guy with long, wavy blond hair was sticking his head out with a huge smile on his face. "Hey, Cherie!" he called again.

I leaned forward, trying to get a better look at him. The face wasn't familiar, but I figured that I must know him from somewhere. He looked like an aging surfer; he was tall and decent-looking. I had probably been introduced to every regular at the Sugar Shack at one time or another, and had plenty of those weird awkward conversations where they remembered me but I couldn't recall their names. I'd been introduced to everybody at Runaways' shows, or any other of the zillion places I'd played or hung out in. This guy looked a little older than the usual Sugar Shack shackers—maybe in his late twenties. Although the Shack was an under-twenty-one club, there were ways to get in if you were determined enough. Just look at Kim Fowley or Rodney Bingenheimer.

"Long time no see!" The guy laughed. "You remember me, don't you? I'm James! James Lloyd White! How've you been?"

"Pretty good," I said, playing along. The limo suggested that maybe he was someone from Mercury Records, or someone who played in a band that the Runaways gigged with. He gestured for me to come over to his window. I shook my head and pointed to the ground in front of me, suggesting that he come to me. He smiled and shrugged and held his hands up as if to say, "I got a car here!" Then he gestured again for me to come to the window. I did, and as he drew the window down, I got a closer look at his face. His features were harder than they had seemed from a distance. Chiseled. But when he smiled, it was disarming, and canceled out some of the toughness I could detect in him.

"You dig my new car?" he asked, patting the driver's door affectionately. "Pretty neat, huh?"

"Yeah!" I said. "It's real nice. Where's your chauffeur?"

"Ah . . ." James said, affecting some false modesty. "I gave him the night off. I'm a pretty thoughtful boss, you know?"

I laughed at this. Standing right next to the limo, I still really couldn't recall how I knew this guy. Maybe he was one of Moose's friends. That would explain why I didn't remember him. Whenever I'd be hanging out with Moose and those guys upstairs, there'd be a lot of drugs around. That must have been it.

"Man," he said, shaking his head with disbelief, "it's been such a long time!"

The way he said it . . . he was so sincere, I couldn't help but believe him. My mind was whirring desperately, trying to pull his name out of some dusty corner of my memory. I nodded and smiled at him politely, and he said, "You want a ride somewhere?"

Although this guy didn't seem like a creep, I knew better than to accept. "No thanks."

When I said that, he pouted a little. "Too bad. I was looking forward to showing off all of these neat features to you. Man, this limo is something else, you have to check it out."

"Yeah, well," I said, glancing around, looking for Marie's car, "maybe next time."

"You still partying?" he asked me.

I was about to say no when I stopped myself. James noticed the hesitation and added, "It's just that, uh, I was on my way to a party some friends of mine are throwing. My friend, he's in the, uh . . . the *importation* business. He just got some really top-notch shit in. Peruvian flake, the best on the market."

I didn't answer him. The fact that he did drugs actually made me trust him a little more. It also confirmed my initial suspicion that he was one of Moose's friends, someone I had spent a night snorting blow with while we hung out in the upstairs office. If he was a friend of Moose's, then I knew he had to be on the level. This allowed me to lower my defenses a little. So yes, the idea of going to a party to do some high-quality cocaine was tempting, but . . . no. I had made a promise to myself. I was trying to get straightened out.

"I can't," I told him. "You know, my sister's on her way to pick me up. Thanks, though . . ."

James nodded over to Jackson. "Can't you leave a message for her with the bouncer? I can write the address down for you. She's totally welcome to come, it's gonna be a wild one . . . It's in the Hollywood Hills, a really nice pad."

"No. Thanks, James, but I really can't . . ."

"All right," he said with a shrug. I was about to say good-bye and head back to the club when he called over to me once more. "Hey, you want to jump in while I pull around to park? It's got all kinds of gadgets. This thing is like a spaceship or something. I got heated leather seats in here! Come on, I want to show you . . ."

I looked around. There were still enough people in the parking lot that I felt safe. Jackson was only feet away, still holding the other kids spellbound with his crazy stories, and there were plenty of people hanging around who I felt had my back. Anyway, this guy was almost certainly one of Moose's friends. I shrugged, and said, "Okay, why not?"

I walked over to the passenger side and slid into the seat, closing the door behind me.

"Lemme just pull in over here before someone rear-ends me," he said. Then James started roaming around for a parking space. As

the car began to move, he started showing off all of the controls on the dashboard. He sounded like a kid boasting about his new bike. "You gotta hear this cassette player," he was saying. "It sounds, like, *incredible!*"

"You missed a parking space," I said as he cruised right past a gap in the cars.

"That's too small!" He laughed. "This baby needs a *big* space."

James was looking at me now. He wasn't paying attention to finding a parking space at all. He was just staring at me, and I started to feel uncomfortable. He shook his head and said, "I really missed you, Cherie . . ."

"You missed another one," I said as a second space passed by.

"I'll catch the next one," he said in a monotone. But as he said this, I felt the car accelerating, not slowing down. I saw him reach down to the left, and with a heavy *clunk,* all of the doors locked simultaneously. He passed a whole row of parking spaces while I looked on in horror. Suddenly we had pulled out onto the street and I was gripped by fear, realizing just how dangerous a position I was in. James Lloyd White, whoever the hell he was, didn't say anything to me as he picked up speed. I tried to calm myself. I focused entirely on trying to make this guy pull over so I could get out of the car. Maybe this was all some kind of sick joke. Maybe he just really wanted a date for this party of his. Once I'd made it out of the car, I would rip him a new one. For now, though, I needed to concentrate on getting the hell out of there.

"Listen," I said. "I don't know what you want with me, but—" CRACK! The slap came out of nowhere. It caught me hard and knocked the words right out of my mouth. My head snapped around violently, and the sound was shockingly loud, but then replaced by a steady ringing in my ears.

"Shut up," he said quietly. His voice had changed. It had dropped down to something predatory and threatening. I felt the tears coming, but I made an effort to choke them back. My cheek stung where he had hit me, but I forced myself to keep it together. I felt my stomach knotting up, and I knew that more than anything I had to keep cool and find a way out of this.

"I think . . . I think that you'd better take me back now," I said meekly. I didn't make eye contact as I said it. I closed my eyes and prepared myself for another slap, but it never came.

"I'll fuckin' take you back when I'm good and ready," he growled. "You fuckin' got it? When I'm GOOD and READY. We're gonna have a little fun first. You and me. You like havin' fun, don't you?"

He looked at me when he said this, like he expected me to respond. I looked straight ahead, scared to answer either way. Oh God, oh God, oh God. He stared at me for a few moments, and then looked back to the road. He went on, half talking to himself. "Oh yeah, you like to have fun. I've seen you onstage. Strutting around. The fucking Cherry Bomb. Lookin' like a fucking whore. Crawlin' around half naked, panting and groaning for all the boys, like some kind of bitch in heat. That's the kind of fun you like, isn't it?"

I felt him staring at me again. My bottom lip was trembling. The fear was all-encompassing, a great, cold wave of terror. Don't cry, don't cry, don't cry, I thought to myself. James laughed drily to himself and looked away again.

"I think it's *disgusting*!" he spat.

"Please . . ." I said, trembling. "Please take m-m-me back. If you duh-duh-don't, you're going to be in a lot of trouble . . ."

Without taking his eyes off the road, he reached over to me with his right hand and grabbed a fistful of my hair. He gave my hair a vicious twist, yanking me toward him, bringing tears to my eyes. I could feel the hair ripping out of my head in clumps. He slammed my head against the window brutally, and then pulled my face over toward him. He turned, and I found myself inches from his face, staring into the voids of his eyes. They were glittery with rage. His mouth was twisted and small.

"Don't you ever—EVER—threaten me again or I'll hurt you! I'll hurt you *bad*, you fucking bitch!" he growled. "We're going to a party. Then I'll take you back, okay? But I'm warning you—if you say another word, I'll fucking kill you. Do you understand?"

Then he shoved my head away again. I put my hands to my face and wept in fear and confusion. I pressed my body against the door, trying to be as far away from this crazy bastard as possible. He turned

onto the northbound Hollywood Freeway, away from the Hollywood Hills, where he said the party was. I looked around for a way out.

My father was always very protective of us girls, and he had offered advice for getting away from a kidnapper. I could hear his voice in my head now: *"Remember, Kitten, if a man ever gets you in his car, grab the wheel and pull it off the road. Grab any part of his face that you can get a good grip on, and just tear it off."*

But I was terrified. Paralyzed by fear. We were going so fast now—I felt for sure that if I grabbed the wheel and tried to force the car off the road, we would both be killed. I knew that if I tore at his face, he would kill me, if the resulting crash didn't do us both in first. If he slowed up at a light, what then? The doors were locked. He was controlling it all from some central, automatic lock. The utter helplessness of my situation terrified me.

Marie had warned me about stuff like this. *"There's a lot of creeps at the Shack these days."* Those were her exact words. She'd told me to watch myself. I cursed myself for not being more careful, for not listening to the advice that everybody had been giving me. What on earth had possessed me to get into a car with a complete stranger? He'd just seemed so safe, so normal. A different person altogether from the raging beast that had just hit me, and threatened to kill me. Oh, my dear God, oh God, oh God! I wondered where Marie was right then? Probably just arriving at the Shack. Looking around for me. Checking the bathrooms. She was probably not even worried yet.

Sometimes Marie and I had this telepathic connection. I started praying that this time it would come through for me. In my head I started screaming: *MARIE! MARIE! HELP ME! I'M IN DANGER!* I imagined Marie talking to Sid, the cloakroom guy. She'd find my purse in there. She'd know that I wouldn't just leave without my purse. She'd have to know that something was wrong.

Suddenly the car was turning again. He took the Osborne exit off the 5 Freeway. We were far, far north. I'd never been to this area before. It felt like we had been driving forever. We were heading down some dark street with just a few lonely-looking houses on it and no sidewalk. Old houses, out in the middle of nowhere.

It's a party, I started trying to rationalize to myself. He's just stoned

and crazy, and we're heading to a party and as soon as I get in there with all of the crowds of people I'll be able to sneak out. I'll run—I'll run and run until I find someone who'll help me . . .

But this thought was immediately shattered when we pulled up a long driveway to a house. It was on the top of a hill, shrouded in darkness. The place was as creepy, dark, and isolated as the motel from the movie *Psycho*. There was obviously no party there. I looked over to my captor, and he was staring off at the house with a faraway expression on his face.

"I—thought you said—"

"SHUT UP!" he screamed. He looked at me, and screamed "SHUT UP!" again, spraying me with spit. I cowered away from him, terrified that he was about to start hitting me. "I'm taking you to the party," he said in a low, dangerous voice. "But I gotta pick something up first."

The he got out of the car, slamming the door after him. He walked around and pulled my door open for me. Oh yeah, this bastard was a real gentleman. I peered up at him and said, "I can stay here until you come back. . . ."

It was a long shot, but I figured it was worth a try. Unfortunately, he had no intention of letting me off that easy. Instead he told me, "You're coming with me," and reached into the car. He grabbed me by my arm, and dug his painfully strong fingers into it. He dragged me out into the driveway. It wasn't cold, but I was shivering all over, my entire body trembling with shock. He dug his fingers in harder, and I screamed "STOP IT!" as loud as I could. He started toward the house, dragging me by the arm, his grip getting harder till he threw me out in front of him. "Walk!" he commanded. There was no one around. I considered just screaming at the top of my lungs, but he could have beat me to death right there before anyone would be able to save me. More than anything in the world, I didn't want him to hurt me. He shoved me up to the dark front porch, and pulled me onto it. With his free hand, he fumbled with his keys in the dark.

The front door opened. He pushed it in, then continued to shove me through his huge black house. Inside, I noticed the smell first. A rank odor of fermenting garbage, dampness, and mildew. The lighting was dim, but a quick glimpse around provided all of the evidence

I needed that this guy was totally unhinged. Black garbage bags, full and spilling, propped up in one corner in the living room. The wall-paper was peeling off the walls, exposing rotting lumber. Every sur-face was full of crap of all descriptions, and the carpet looked stained and dirty. Food was ground into it, and I couldn't tell what color it had been originally, but it was now an array of dark, bleeding smears. He pulled me past all of this and into a small, shabby kitchen. When he turned the flickering fluorescent light on, I saw that the sink was piled with dirty dishes. Cockroaches scattered when they were ex-posed to the light, scurrying away into the cracks in the tile, hiding away in shadowy corners. The countertops were smeared with dis-carded food. There was an open jar of peanut butter with a butter knife sticking out of it. He brought me over to a drawer, which he wrenched open. He fished around in there for a while before he pulled out a pill. I had never seen this particular kind before; it was huge, like something you'd give to a fucking horse. Then he turned and gave me an I'm-not-fucking-around look.

"Open your fuckin' mouth," he demanded.

I shook my head, tightening my lips. He grabbed my face and squeezed till the pain was unbearable. He jerked at my jaw. My vision blurred, and the world turned gray. The pain was so intense that I automatically opened my mouth, crying out. He shoved his fingers in my mouth, forcing the pill down my throat. "Swallow!" he com-manded, twisting my face till my eyes pooled with tears. "Fucking swallow it!"

I gagged, and the pill went down painfully. I started to cry. Nobody would know where to find me. There was no way out. I had been put into a position of total and complete helplessness. I had never felt fear like this.

"Good girl," he said as he shoved me up against the wall. I was wearing a jumpsuit, and he started unzipping it slowly. His brow fur-rowed in concentration and he looked for all the world like an artist drawing a fine line. I shook my hands free of him and managed to shove him away. With a *crack,* he smacked me across the face again. He smiled as he did it. He puffed his chest out. I could see that he was

loving every moment of this. I screamed because I knew that this man was insane.

"You wanna scream?" he said. "No one can hear you! Go ahead and SCREAM!" And I did. I screamed as loud as I could, as hard as I could. He joined in, with a scream so loud and so primal that my blood turned cold. I cowered away from him as he stood over me.

"You see, bitch? No motherfucker can hear you . . . so SHUT THE FUCK UP!" He raised his fist as if to hit me, then burst out laughing as I cowered away. "You shouldn't have left me," he said. "We were so happy back in Dallas. Why did you do it? Why did you have to join that band? You humiliated me! Can you imagine what it felt like to see you on TV, to see you onstage, parading around like that? You ripped my heart out!"

The whole time I was thinking, Dallas? I had never lived in Dallas. This guy had never even met me before. He was totally and utterly deranged. The realization shook me to my very core.

I needed to be at home. I wanted my dad. I wanted my sister. I started crying to myself. *Please, Marie, please help me . . . I'm in trouble, Marie. Very bad trouble! Please FIND ME . . . !*

In my terror, images started flashing through my mind. Suddenly I was seeing the face of Winnie the Wolf, as clearly as if he were standing right there. I saw every detail, right down to his shiny braces, as he smiled at me, his zit-filled face mocking my helplessness. *"Stay away from that goddamned kid!"* And another face. Derek. A face that still haunted my worst nightmares, now pressing down on me all over again. *"You look just like your sister!"*

What an idiot I was! What an imbecile! I should have learned my lesson when Daddy spanked me for playing with Winnie the Wolf. I should have learned when Derek raped me in my own bedroom back when I was fourteen years old. *I should have learned!* Now I was cowering in the house of a madman, miles away from anywhere, with no chance of escape. Compared to this monster, Winnie and Derek looked like the fucking Hardy Boys.

This can't be happening.

This can't be happening to me.

I'm Cherie Currie. I'm invincible.

How can this be happening?

This bastard was strong. When he grabbed me, he had hands like a vise. He dragged me over to his filthy couch and threw me on it. I managed to hit him across the face, but it didn't even faze him. He responded by backhanding me so hard that for a moment I wasn't even there. It was like he had knocked me clean out of this world. He grabbed the zipper of my jumpsuit and ripped it down hard, catching my skin, tearing it. He ripped my clothes away from my body, and I felt the cold, damp couch beneath me. He grabbed me by the ankles and started dragging me toward another room. The bedroom. I knew somewhere deep down it had to be the bedroom.

I screamed. I screamed louder than I had ever screamed in my life. My throat felt raw, torn open. I kicked, I screamed and screamed, praying that someone, somewhere would hear me. We were in the bedroom. The lights were dazzlingly bright. I was thrown onto the bed, still screaming for my life.

"SCREAM!" he yelled, standing over me. "SCREAM ALL YA WANT! NO ONE CAN HEAR YOU!"

I was naked, except for my panties. He climbed on top of me and put his face right up against mine. He grabbed my face in both of his hands to steady me. Then he screamed at the top of his lungs. He screamed for what felt like five whole minutes. The screams were loud, terrifying. His breath was like raw sewage as it blasted in my face. When he was done, he smiled at me and said, "How many times do I have to tell you? No one can fucking hear you, Cherie. You're wasting your fuckin' breath."

As I opened my mouth to scream again, he punched me in the stomach, knocking all of the wind out of me. He got up from the bed, and I lay there, gasping for air, sobbing and retching. I could see the bedroom door behind him, hanging open. I wondered if I could make a run for it, but realized it was impossible. Even if I made it out of the bedroom, where would I go? *Oh God, oh God no, oh God.* The whole world had caved in on me. The whole universe! There was nothing left for me to grab hold of. At that moment I realized that I was totally, utterly without hope. This was something beyond fear

now. A place where your darkest nightmares are born from. To call this terror would have been a total understatement.

Standing over me, James Lloyd White said something that chilled my blood even more. Something that left me no other option but to sob, to sob from the total horror of it all.

"I've killed before," he whispered. "Do you understand? *I've killed before*. Six in Dallas." He reached down, and pulled my panties off. As I lay there hyperventilating and crying, he climbed on me and put his mouth to my ear. Then in a hoarse whisper, he promised, *"And you're next."*

The spanking that Daddy gave me for playing with Winnie took less than five seconds. When Derek raped me and I fought him off, that lasted for around ten minutes.

This nightmare went on for six hours.

I can't even begin to explain what I went through. It's hard to tell another person some of the things that man did to me. What I will say is that the terror, the horror, and the humiliation that he inflicted upon me were even worse than what I imagine hell to be like. He hurt me with his fists, and with his body. He did it again, and again, and again. He thought nothing of hurting me. Every time I screamed, and I cried, and I begged for mercy, and I bled or I passed out, he seemed to grow stronger, more hateful, more crazed by the lust and the sadism that fueled him. As the night dragged on and my hellish ordeal continued into the breaking dawn, I came to the realization that this man was going to murder me as soon as he was finished torturing me. I did not doubt for a second his boast that he had killed six others. This subhuman creature did things to me that night that proved that he was incapable of pity.

There was blood everywhere, and the more he hurt me the more euphoric he became. Violence was *his* drug and he never seemed to get enough. A part of me prayed for it all to be over, but I knew that at the end of this I would die and there was so much I had to live for. When I wanted to give up, something far more powerful pulled me back to my reality, to think of other ways to end this. To end *him*. He

was destroying me, he was tearing me apart, but I kept telling myself that I could take it. It was my life and I had no intention of giving it up.

At one point, he heard me muttering, half insane with fear and pain, about Marie. I was still somehow hoping that my whispered prayers to her would be heard. He snapped, "Give it up. Your fuckin' sister is dead. I got to her before I got you," but I knew deep down that this was a lie. He kept talking about how we had lived together in Dallas, telling me that I had just up and left. He really believed this.

Sometime in the early hours of the morning he left me lying there while he lay next to me, exhausted and panting for breath. "I need to go to the bathroom," I said in a tiny, trembling voice.

He looked at me suspiciously, through slitted eyes. Then deciding that I was telling the truth, he grunted and pointed to a door. I hobbled over there, naked and bleeding, and closed it behind me. Desperately I looked around. There was a single, tiny window above the sink. There was no lock on the bathroom door, so I quickly clambered up onto the sink and tried to squeeze myself out of the window. My head and shoulder were outside when he burst in, screaming at me, and dragged me back inside by my legs. "You fucking cunt!" he screamed, smacking me in the face a couple of times. Then he dragged me back to the bedroom, and the torture continued.

In a moment of clarity, I remembered the knife. The butter knife by the jar of peanut butter on the counter. I knew I had to get to that knife. I asked to get a glass of water. He was very stoned by then. I don't know what he had taken, but the pill he had forced down my throat might as well have been an aspirin. It could have been a horse tranquilizer, but my adrenaline had pumped it clean out of my system. I was as sober as a judge, and his drooling mouth and heavy swollen eyes gave me an advantage. If I could get that knife, then maybe I could save myself. I'll bet he thought I had nowhere left to run to, so he allowed me to go to the kitchen by myself. I hurried over, figuring I only had moments before he arrived to check up on me. I went over to the jar of peanut butter and grabbed the knife, wiping the excess off the blade onto the countertop. Then I waited in the darkness for my chance. Seconds later, I heard him coming. I stood there beside the refrigerator as the moon cast an eerie, cold light through the kitchen.

I was trembling with the dirty kitchen knife in my hands. He came around the corner naked, the hellish silhouette I'd been waiting for. He called out to me. He saw me standing in the shadows and walked toward me, raising his arms as if to hug a long-lost friend, his eyes almost shut now. I thrust the knife upward into his gut with all of the strength I had left. My eyes were closed tight. I wanted to kill him; I wanted to gut him like an animal. I screamed as I thrust the blade into him, and he screamed as he felt it puncture his flesh. He staggered away from me, holding his hand to his belly. The knife was still in my hand, the tip slick with his blood. His eyes widened, his face contorted in incomprehension and rage.

"YOU FUCKING BITCH!" he screamed.

Everything began to move in slow motion as he looked down at his belly in pain and disbelief. I saw the wound. He touched it with his fingertips, removing the blood that started pooling in his navel. I realized that although I had cut him, the knife didn't go in deep enough to do any real damage. He reached out and grabbed the knife from my hand. I didn't even run. It was over. I dropped to the floor and covered my head with my arms, waiting for the knife blade to pierce my body. He screamed out, then I heard the knife smash against a far wall. And the blow to the back of my head turned my whole world black. It sent me sprawling to the filthy floor.

I lay there, dazed.

I knew that this was it, my final moments.

He grabbed the hair from the back of my head and, with one hand, dragged me, kicking and screaming, back to the bedroom.

I was going to die in this house, at the hands of this man, and nobody would know.

I would never see my family again.

He threw me on the bed, and straddled his legs on my arms so I couldn't block the blows. Then he began to beat me. He hit me again and again with his fists. With each blow my world spun. I felt my jaw go numb. Again. Again. His fists pounded against me until I couldn't feel my own face anymore. It was as if my pain threshold had been reached, and my body could no longer process the agony it was experiencing. I could hear him in some distant place screaming at me:

"You fucking STABBED me, you fucking CUNT! You're DEAD MEAT, you FUCK!"

I'm dead, I thought. I'm going to die now.

When I let go of any ideas of surviving this, of escaping, suddenly a strange calm descended on me. I almost felt at peace. My consciousness was fading. I was outside of my own body now, and although I could hear the brutal blows as they landed against my face, my shoulders, my head, somehow I didn't feel them anymore. I was outside of my body. I realized that this is what death must feel like.

I could hear a voice, a voice I didn't recognize at first.

The voice was pleading with him, telling him to stop.

From some foggy part of my brain, I realized that the voice was mine.

Stop, James, please!

Please, baby!

You never used to hit me like this!

For a second, everything slowed. He wasn't hitting me anymore. He was looking down at me, with a strange, confused look on his face. Then he started again, but with a little less vigor than before.

"You never used to hit me when we lived together back in Dallas," the voice was saying. *"I was only playing! We used to play like this all the time . . . I didn't mean to hurt you . . . Don't you remember, James? Don't you remember . . . back in Dallas?"*

As this strange, disembodied voice came from inside of me, the blows became less and less powerful. Finally, they stopped. There were a few seconds of silence in the room. I could hear him panting from the sheer exertion of beating me within an inch of my life. I opened my eyes, slowly. They were almost swollen shut. He was sitting over me. He brought his knees off my arms and grabbed my wrists. At first I was puzzled by the strange scene in front of me. My assailant was *crying*.

I didn't know who spoke those words, but I knew that they had come from some other distant place. They could only have been channeled *through* me. Looking back, I know it was some kind of guardian angel. Whoever it was, they saved my life.

"I'll go back with you," I said in a weak voice. "I'll go back with

you . . . back to Dallas. We can start over . . . Just *please*. Please don't hit me anymore . . ."

He smiled as he was sobbing. Bawling like a baby. "I'm sorry," he blubbered. "I'm so sorry. I didn't mean it. I really didn't. Would you really come back with me?"

Sensing a chance to make it out of there alive, I managed a slight smile. "Of course," I whispered through my busted lips. "Just take me . . . take me back to my apartment, I'll pack a bag, and we can leave tonight."

I hoped and prayed I was convincing enough. If I didn't convince this guy that I was for real, I was dead, no doubt about it.

He smiled, as if nothing had happened. As if we had just had a silly lovers' quarrel. "I knew you'd come back!" He was beaming. "I love you, baby!"

I smiled weakly through my swollen, bloody lips.

"Come on," he said. "Let's go . . ."

I stood up unsteadily and started to dress. James was pulling on his jeans, running his hands through his hair, whistling to himself. I dressed slowly, terrified of arousing his suspicions. As I dressed, I caught sight of myself in the mirror. I had to stifle the scream that threatened to tear out of me. I looked like I had just been dragged from the wreckage of a three-car pileup. I was covered in my own blood. My eyes were black and swollen. My lips were split. My hair was matted with congealed blood. Yet James seemed not to even see this. This crazy bastard seemed to think that everything was just A-OK.

On the drive home, he opened up his wallet and started showing me pictures of himself. He talked to me about the imaginary old times we shared back in Dallas. My mind was reeling. Wasn't he aware just from looking at me that he had beaten me almost to death? Wasn't he scared that a police car was going to pull alongside us, that a cop was going to peer in and arrest him on the spot? At a red light a car did pull up next to us. The driver was a young woman. I saw her look over to me, and then she threw her hand to her mouth in horror. She turned, and started telling her passenger to look at me. The light changed and we tore away. I fought the impulse to look at myself in

the side-view mirror. I knew I looked like a monster. But I didn't. I remained calm and silent. I prayed to God that we could get to where we were going as soon as possible.

I was taking him to Andy's apartment, the friend I was with the previous night just before the limousine showed up. It was almost daylight and I was afraid he would be out looking for me. With my purse left behind, they would all be looking. I needed Andy to be there. It was my only chance. When we got to Andy's apartment building, James pulled into the underground parking lot. "I'll be right back," I told him. He just smiled at me, and from his eyes I could tell that he was just . . . *lost*. He was so wrapped up in whatever fantasy world he was in that he really believed that I would come back in a few moments with my bag, and we would leave for Dallas.

I made it into the stairwell. Once I was out of James's sight, I collapsed. I managed to drag myself up to the second floor. I staggered to my feet and pounded on Andy's door. I wanted to scream for Andy, but thought James would hear and reappear so he could finish the job. As if in answer to my prayers, the door opened, and I saw Andy's face turn white. I fell into his arms. All I could say was *"He's downstairs. He's downstairs in the green limousine . . ."*

Andy brought me over to the couch, and then ran to his kitchen. He emerged with a large knife and a flashlight, ready to do battle with the monster waiting downstairs. "Stay here!" he yelled, before he ran out. The tears really came then, and I lay there sobbing in pain and humiliation until Andy returned a moment later.

"The bastard tore off as soon as he saw me! But I got the fucker's license-plate number . . ."

I have foggy memories of what came next. The ride to the hospital. Andy was crying, too. The nurses' horrified faces as Andy helped me through the doors of the emergency room. When I saw the way they looked at me, I knew I was in bad shape.

I felt one of them hold me in her arms, calling for a wheelchair. I collapsed against her, my mind drifting in and out of reality. I heard her say, "Dear God! What happened to you, girl?" but I couldn't respond. Then finally, mercifully, the blackness came. Perfect, peaceful blackness as I sank into unconsciousness . . .

26

Killers and Clowns

Y ou want me to do what?"

"Punch it. Kick it. Anything you want."

I looked at the clown again. They'd told me that his name was Bobo. His body was shaped like an egg and weighted at the bottom, so the idea was that no matter how hard you hit it, it would always pop up at you again. I had supposedly been sent to the Santa Monica Rape Clinic to help me deal with what I had suffered at the hands of James Lloyd White. Now I found myself staring at this stupid clown, feeling utterly ridiculous.

There were several women in the room, all of us victims of rape and sexual assault. The others listened intently to the instructions of the counselor. I stood there unable to move as everyone around me started beating the crap out of the clowns.

"I'm not hitting this clown," I said.

The therapist smiled indulgently. "You know . . . I think that it might help. It may *seem* silly, but if you just gave it a chance . . ."

"You know what would make me feel better?"

"I don't know, Cherie. Why don't you tell me."

"It would make me feel better to know that in one year's time, that bastard isn't going to be walking the streets. That would make me feel better. Or maybe you could just haul his ass in here and let me hit *him* instead. This fucking . . . *clown* didn't do anything to me."

With that, I stood up and grabbed my purse. "Thanks for the help," I said. "I really appreciate it."

The tears were coming again. It seemed that they were never far away back then. But these were tears of a different kind. As I watched the other women tearing the Bobos apart, a thought occurred to me. I had *made it*. I wasn't a victim. I was a survivor. And nobody could take that away from me.

I walked through the door and closed it behind me. As I walked the long corridor leading out to the street, I felt myself start to grow from that battered and broken girl that James Lloyd White had beaten within an inch of her life. With every stride, I grew taller and stronger. As I burst through the doors and left the Santa Monica Rape Clinic that day, I would emerge a new and different woman. I felt the sun on my face and I had hope in my heart. I had survived where others had not. And I would not feel ashamed. I swore that I would never feel sorry for myself again.

It was a powerful revelation. But getting there had been difficult.

They did catch the man who raped me. Andy provided the license plate number, and the knife wound on his stomach sealed the case. When I told the police about his boast about killing six girls in Dallas, the LAPD's Hillside Strangler task force interviewed me at my home to see if there could possibly be a connection. There wasn't, but I did hear through my dad that he had been linked to the murder of six girls back in Dallas just like he'd told me, but he was never charged. Lack of evidence, they said.

At the beginning it looked like he was going to be tried for what he did to me. But he had a good lawyer, some money-hungry soulless bastard who knew exactly how to work the system. They started plea-bargaining, and he ended up copping to "sodomy by force" instead of kidnapping, attempted murder, and rape. When the lawyers got done working the system, my rapist walked away with a year in the county jail.

On top of it all, my rapist had some powerful friends in the entertainment industry. He was an old pal of the actor Vic Morrow. Before his lawyers had wiggled him out of a jury trial, Vic had actually called T.Y.—whom he knew casually—and asked T.Y. to "talk to me."

"You know how *guys* are," Vic had explained to my brother-in-law. "Sometimes they get a little . . . carried away. Can't you talk to her? There's no use in going to trial with this."

The worst thing about it was that T.Y. actually *did* it. I guess that he must have been awed by the fact that Vic Morrow was asking him for a favor. T.Y. actually had the nerve to ask me if I'd consider dropping the charges for "his friend" Vic. I didn't speak to T.Y. for a long time after that.

If the pretrial hearings were anything to go by, the trial itself would have been a nightmare. Vic Morrow showed up to lend support to his pal James. On the stand, I kept breaking down as I described the horrors that I had experienced that night. The defense lawyer sensed my weakness and went in for the kill. He screamed at me, belittled me, and made it all seem like it was my fault. That I had somehow lured his poor innocent client into kidnapping me and beating me almost to death. That I had wanted it, that I had asked him to hurt me.

During all this, "he" was sitting there at his lawyer's table, totally unfazed by it all. I made eye contact with him at one point, and he smiled his evil smile, raised his fingers into a V, and flicked his tongue at me. I knew that given the chance he would do it all over again without a second's thought. I screamed at them all, "Don't you see what he's doing over there? Can't you SEE?" No one did, though.

It ended one day when I came apart on the stand. I just couldn't take it anymore. My body locked up into the fetal position with my fists to my eyes, and I screamed and sobbed. I don't remember much after that. I was totally unable to move, and it took two officers to carry me out of the courtroom.

After that, Vic did come and speak to me. After hearing my testimony on the stand, he apologized for asking me to drop the charges. This was the same day that I had to be carried out of the courtroom by the guards. He looked visibly shaken by what he had heard. I stared at him as he walked away. The next time I would hear about Vic Morrow was when he was killed while shooting a film we had both worked on—*Twilight Zone: The Movie.*

My family was devastated. My father wanted to literally kill him. When we were in my lawyer's office, my dad asked to use the

restroom. After a few minutes, my lawyer quietly asked one of his associates to go get him. Dad had left the building and had entered the courthouse knowing that the accused would be there. My father had a gun. Fortunately, some guards, accompanied by my lawyer's associate, stopped my father before he could get close enough. When they arrived back at the office, they claimed they had stopped my dad just yards from James Lloyd White.

So he got his year in county, and I was sent off for a round of useless rape counseling with the knowledge that this bastard would be out on the streets again within a matter of months. The only thing that kept me going was what you could call my "lightbulb" moment. When my inner voice told me that I had survived, and that nobody could take that away from me.

That really resonated, and it does to this day.

I had been attacked and almost killed, but I got out alive. I started to feel that this was something to be proud of. I could hold my head up high, knowing that I was a survivor. Not even that psychopath could make a victim out of me. Now it was up to me not to make a victim of myself.

I went home that day and ran a hot bath. Just after the rape, I spent many hours in the bathtub. It got to the point where it was bordering on obsession. I was trying to clean the stink of that piece of human garbage off me. I always felt dirty, no matter how hard I scrubbed. Over time, the feeling started to fade, but it was a slow process.

I remember at one point soon after this all happened reading a *People* magazine interview with the actress Kelly McGillis. Her picture was on the cover, looking real somber and sad. She was quoted saying something along the lines of "I was raped, and I'll never recover . . ." I felt furious when I read that. I couldn't understand why someone in the public eye would ever say that. I felt that if she really felt that way, she should keep her mouth shut. She had a responsibility to her fans to be strong. Strong for *them*! They looked up to her. If she said that she wasn't strong enough to recover, maybe they'd feel that they wouldn't be strong enough either.

I had done a lot of reading about rape and the law since the attack. I learned that in the United States a woman is beaten every nine

seconds and raped every minute. I also learned that my experience of having my attacker walk away basically scot-free was by no means unusual. I tossed the magazine away. The actress wasn't the only one who had gone through this, but I sure as hell would never say that I wouldn't recover. I was alive. I was luckier than most.

I threw myself into work. I did some solo shows around town, and after one particular show, I met a man named Dennis Brody from the William Morris Agency. He told me that I looked "really good up there" and had I ever considered acting. He gave me his card, and before I knew it, he was calling me out for auditions.

My first audition was for a movie featuring the Ramones, called *Rock 'n' Roll High School*. As I was awaiting word on whether I'd got the part, Dennis sent me to try out for a movie called *Twentieth Century Foxes*. It was a co-starring role, alongside Jodie Foster, Sally Kellerman, and Scott Baio. I guess 20th Century Fox didn't appreciate the reference—especially as the movie was being made by United Artists—so the title was eventually shortened to *Foxes*.

At the beginning I felt that there was no hope of me landing the role. When I walked into the offices of Casablanca Filmworks and looked around at the other girls, I nearly walked right back out of the door. They were all so beautiful, with gorgeous clothes and hair, and résumés that listed dozens of movie roles. I, on the other hand, had walked into the place wearing jeans, platform sneakers, and a small football shirt with my name across it. In a movie named *Twentieth Century Foxes*, I didn't think I stood a chance in hell! I already knew that I was up against established actresses like Kristy McNichol, who was very big in TV back then, and Rosanna Arquette, who had just starred in a hit movie, the sequel to *American Graffiti*. I felt ice cold and nauseous: it was an audition for the Runaways all over again.

I dropped my copy of the script on a table, turned around, and walked right out the door. I was thinking that maybe I could save myself some humiliation by just going home. Thankfully, that now-familiar inner voice told me to turn around and go back. I listened.

After the initial audition, I was called back half a dozen times. For a while it seemed like I spent most of my life driving back and

forth from the studio, my nerves on edge about the whole thing. First they had me read for the part of a girl named Deirdre. But, after the first reading, the executive producer Joel Blasberg handed me some new sides and sent me back to the waiting room to prepare to read for the role of Annie.

First I did the reading, and then a screen test. They were calling back so often that my sister Sandie started running the lines with me. She lived in the Sunset Towers, directly across from Casablanca Filmworks, where the production offices were. We worked furiously on the scenes one by one, and it seemed like I spent my every waking hour either at Sandie's apartment or at Casablanca films. As the callbacks kept coming, I started to feel there was a chance I could get this role, but I still doubted that I had enough experience. Plus I had at least one vocal opponent when it came to getting hired—Brandy Foster, who was Jodie Foster's mom. Although she didn't have any official role when it came to casting the film, Brandy was a powerful voice in all decisions. Although I never sensed that she disliked me personally, she obviously feared that I didn't have the experience and that I wouldn't be able to pull off an emotional and complex role like the hopelessly, strung-out, and doomed Annie. It was hard to be upset about Brandy's fears when I secretly shared them myself.

The casting director, Mae Williams—who was a great gal and a talented actress in her own right—called me one morning to do yet another reading, this time with Scott Baio. By the time I'd arrived back home, the phone was already ringing. It was Mae asking me to return to the office and read the scene again. I argued that I had just gotten back home, but she insisted, and left off with the hint that "this is a good thing."

When I arrived back at Casablanca, the room was filled with various producers, the writer Gerald Ayres, and the director Adrian Lyne. There were a few a nerve-racking moments before Scott Baio and I ran through the scene once again. When we were finished I looked over at Gerald Ayres and he was nodding at Adrian Lyne. I'm not sure why I did it, but I stood up to leave the room, and as I did, Adrian in his thick British accent yelled "Annie! Where you goin'! You got the part!" I screamed with joy and jumped right into his arms.

The first person I called was Sandie. I ran straight over to her apartment, running up the three flights of stairs to her door, so we could jump up and down together like excited children.

Two days later, Dennis Brody called to say that I had been offered the part in *Rock 'n' Roll High School,* but he thought *Foxes* was a better role. I agreed. I could hardly believe that I was going to be working with Jodie Foster. I had never been so happy. That moment made up for a lot of the horrible things that I had gone through recently.

In the time that had followed the car accident, I had made good on my promise to stay away from drugs. Not even the rape and the ugly aftermath of that night had pushed me into a relapse. I didn't drink, I didn't do coke, and I didn't even do quaaludes. I was clean.

Well, almost clean.

I *did* do Benzedrine. But Benzedrine was legal, so I felt that it really wasn't like a drug at all. I mean, if doctors could prescribe it, how bad could it be? Okay, you weren't supposed to snort it like I did, but that's just splitting hairs. Just because it was a white powder that pumped me up didn't mean that it was anything like coke. And it wasn't as if I did it every day.

Well . . .

I *did* do it every day, but I only did it in the mornings. In the same way that some people have a cup of strong coffee in the morning, I'd have a toot of speed. It helped me to focus, and I needed the extra energy with everything that was going on. Not only was I about to start shooting my first movie, it looked like I was finally going to get to record my next album, this time with none other than Capitol Records.

After the first couple of showcases for record labels, there were offers on the table, but everybody was balking at the idea of me cutting a record with my sister. Neil Bogart of Casablanca Records, who was doing albums by artists like Donna Summer, Kiss, and T. Rex, offered me a deal, but only if I agreed to cut a solo record. I turned him down with a heavy heart. I went back to my father and pleaded with him. I told him that the record labels were unwilling to sign Marie and me. They complained about her inexperience, and feared that the "novelty" could cause a backlash. But on this subject,

my father was stubborn. I was left with the same stark choice that he had put to me the year before—my solo career or my family. I knew that if Marie knew about this, she would put a stop to it, but Dad would never forgive me. So swallowing my pride, I held out, even when Rupert Perry, who was then the vice president of Capitol Records, called me personally to tell me that he wanted to sign me right away, with one big reservation.

"We don't want a sister act, Cherie. We feel it's a mistake. That's not why we approached you and we don't want it, period."

There was a long silence as I took this in on the other end of the phone line. I knew I was facing a repeat of the Neil Bogart situation, but there was nothing I could do about it. "Okay."

"Okay what?"

"Okay . . . well, thanks for the offer, but I'm going to have to decline. I need to do this record with my sister."

"Cherie, can I ask you a question?"

"Sure."

"How bad do you want this?"

"I want this more than anything in the world."

"Then why this stubborn thing with your sister? I have producers lined up who want to work with you. I have access to the best musicians, the best songwriters in the business. But you're leaving me hanging over this. Why?"

There was a long silence.

"Because I made a promise," I said. "And one thing that you'll learn about me is that my family means more then anything else."

"More than your career?"

I swallowed hard. "Yes," I said quietly. "More than my career."

With that, I assumed the Capitol Records deal was dead in the water. But a few days later I received another call from Rupert Perry. He had reconsidered. He was willing to sign me, with the stipulation that I understood that he didn't want a sister act, and that I would consider at the very least limiting her role. Maybe I could just have her do a guest vocal on a couple songs, he suggested. I agreed to consider it, and we signed the deal. The album that would eventually be known as *Messin' with the Boys* was born.

With the money I was making from *Foxes*, I finally was in a position to move out of Aunt Evie's place. I found a cool little one-bedroom apartment in Encino. This in and of itself was a huge step for me, and made me feel optimistic about the future. I felt that I was on the verge of something. All I could do was hope that this time it was something positive.

27

Foxes

Come on, Marie, it'll be fun!"

"I know, Cherie," Marie said. "I'll make it down to the set, soon. I promise. I've just been busy . . ."

"Can't you come today? You'd really like Jodie. She's supercool."

"Yeah . . ."

Marie sounded unsure, but she kept smiling at me, trying to reassure me. "I'll come down. Soon. I promise, okay? Look, Cherie, I know you're gonna do great." Then she turned away, and halfheartedly added, "I hope you become a big star."

I left it at that. For the past week I had been trying to get Marie to come and visit the set of *Foxes*. And for the past week she had been giving me excuses. Although she wouldn't say it to me directly, I was pretty sure what the problem was.

While I had been away touring with the Runaways, Marie had been attending acting classes. I knew that she harbored some pretty serious ambitions; after all, with my mom and Sandie, the acting bug ran pretty deep in our family. And then I came along and landed a big role in a major motion picture. Reading between the lines, I knew that Marie was furious that I had seemingly been handed this opportunity without really *working* for it. She had no idea of how hard it was behind the scenes to be a member of the Runaways. I told her, but I don't think she understood me. She seemed to think

that life had been all fun and games for me, and that these opportunities had just dropped out of the sky.

She had been the one studying acting while I had been singing for a rock-and-roll band. She had worked hard to have one thing that I couldn't. And now I was the one acting in movies. As disappointed as I was at my sister's reluctance to visit the set, at least I knew where it was coming from. It made me very sad that our relationship had become so damaged: there was this strange competitive edge to everything, all of it a direct result of my career as a Runaway. In a weird way, I almost wished that Marie had landed this role instead of me. It would have made things less complicated. I would have been happy for her. But that's not the way things were. It made me feel that once the movie was wrapped, I was going to have to put all of this right by recording our album.

With the Capitol deal inked, we had started working on the album every evening we could. We were going to cut the album at Cherokee Studios in Hollywood. At first the producer was supposed to be John Carter, who had arranged for the initial showcase with Capitol, but early on in the process, he was replaced by Jai Winding, a handsome and highly experienced session musician and producer. Although I didn't realize it at the time, John Carter was very upset over being replaced on the record. Looking back, I really wish that I'd worked with John rather than Jai.

I had been making the rounds of all of the top songwriters in Los Angeles, looking for the right songs for Marie and me. I knew that this album had to be a hit. I wasn't about to make the same mistake that I had with *Beauty's Only Skin Deep,* and put out an album that didn't feel exactly right. No, everything had to be perfect this time around. We were going to have the best songs, the best producers, the best musicians, and the full support of a powerful record label.

Through Marie, we brought her boyfriend (and future husband) Steve Lukather on board. Steve was one of the most sought-after session musicians in L.A.; he had worked with everyone from Boz Scaggs and Aretha Franklin to Michael Jackson. He was probably best known for being the guitarist for multiplatinum and Grammy-winning rock

group Toto. Bringing in Steve meant that we had access to the best of L.A.'s session musicians, all of whom had either worked with or knew Steve personally: Mike Baird, who had drummed for the likes of Hall & Oates and Journey; Mike Porcaro, who was the bass player from Toto; Trevor Veitch, who played for Donna Summer and Rush; Bobby Kimball, the lead vocalist for Toto; Bill Champlin, who had worked with Earth, Wind & Fire and REO Speedwagon; Michael Landau, who played guitar for Miles Davis and Pink Floyd . . . we managed to pull together a pretty amazing roster of talented musicians.

During this period, the Runaways had continued with a fluctuating lineup, recorded another album, and then split. I would hear about the latest happenings with the band through other people, but I didn't speak to any of the girls. If I started to seriously think about how the other girls were doing—especially Joan—it hurt too much. Leaving the Runaways was like giving up on a dysfunctional marriage. For my own sanity I had to start over, not continue wallowing in the past.

With the movie and the album, I was really burning the candle at both ends. There never seemed to be enough hours in the day: I would be on the set of *Foxes* first thing every morning, and then racing off to the rehearsal studio to prepare for the album in the evenings. I started needing more and more Benzedrine to keep up with this insane schedule, and even with the speed, I felt drained and tired most of the time.

Even though Marie wasn't likely to be coming to the set, I knew that my mom would be there. I wish I could tell some big dramatic story about how my mom and I got back together, but it really wasn't anything like that. There was no tear-filled reunion, with apologies or amends made. Three years after I had last seen her, Mom and Wolfgang moved to Washington, D.C., and Donnie came home to live at Aunt Evie's. This didn't mean that we reunited or anything like that. D.C. seemed just about as far away as Indonesia, and we never visited each other while she was there. It was only when I got the role in *Foxes* that Mom decided to visit the West Coast. She showed up just in time for the start of production: all of the years of us not speaking to each other were wiped away when I signed my contract

with Casablanca Filmworks. My mom had also landed the role of a lifetime: the stage mother. And she was damn good at it.

I pulled into the lot, took another tiny bump of Benzedrine to get me focused, and made my way to the set.

Later that day I sat watching the crew start setting up for the next shot. I looked at them all running around like ants, tweaking the set and setting up the cameras. That surreal feeling I had on my very first day of shooting never really left me. The movie world was just as strange, bizarre, and unreal as the music world. As I stood there watching it all in awe, my mom appeared out of nowhere. She placed a hand on my shoulder and said, "You're doing a wonderful job, Cherie." She smiled when she said this, and it's strange, but I think that this was the happiest that I had ever seen my mom. I had never seen her so approving of anything I had ever done. It's hard to stay angry with your own family. All of the resentment that I carried around about how she left three years ago fell away as my mom reassured me, telling me that she was proud.

It was as if the bad stuff had never happened. Sometimes I would get sad thinking about how things might have been different in the Runaways if I'd had my mom in my life back then.

"Thanks, Mom." I smiled.

This isn't to say that my mom's sudden presence on the set of *Foxes* was smooth sailing. Let's just say that she could be a little . . . forceful. I remember on one of her first visits, she had come down with my sister Sandie, and a photographer had been taking some publicity shots of me. My mom jumped right in and practically started directing the shoot.

"Okay, honey . . . now try posing with your hands on your hips . . . Yes, that's it! One foot forward, yes—yes, put it straight out, like you're marching. Yes! Just like the war-bond picture I was in when I was your age, the *famous* one . . ."

I looked at the photographer and smiled apologetically. He returned the smile without much humor and went on snapping. In the background I could see Sandie groaning and rolling her eyes. I had to see the funny side of it. I was okay with my mom getting to relive

her glory days through me. I found it endearing. Plus, my mom and Jodie's mom, Brandy, had been getting along great.

On the first day of shooting, Brandy's attitude toward me thawed considerably. Once the cameras were rolling and she saw me act, she decided that I was doing a great job. Coming from her, that meant a lot. Even Jodie seemed amazed that I was doing as well as I was: I was delivering like a real professional. As the shoot went on, she and I became very close. While the crew went on setting up the next scene, I walked over to Jodie's trailer. I thought she might be working with her tutor. Unlike the Runaways, to whom tutors were promised but never delivered (and let's be honest: nobody in the band was too heartbroken about it), Jodie was a dedicated student. I peeked into her trailer, not wanting to disturb her. But, instead of working, Jodie was having lunch.

"Hey, Jodie," I said, knocking lightly and letting myself in. "Whatcha eating?"

This was a joke, because Jodie was on this weird papaya-and-cottage-cheese diet, so I knew very well what she was eating. It sounded strange, and it looked gross, but it definitely worked. Jodie looked really great. She was becoming a gorgeous girl, shedding the tomboy image she was known for.

"Oh, you know, my usual gourmet stuff . . ." She smiled. "What are you doing?"

"Would you mind going over my next scene with me?"

"Sure thing . . ."

I sat next to her, and she put down her half-eaten papaya, peering at her dog-eared copy of the script.

"Um . . . Cherie," she said as her eyes darted over the pages. "You know you only have a couple of lines in this scene, right?"

"I know! I just wanted to rehearse it, anyway."

Jodie chuckled and shook her head. "You're too much, Cherie."

I blushed a little. "I just want to get it right. You've done this like a million times. This is my first movie!"

Jodie fixed me with those big blue eyes of hers and smiled warmly. "You'll do fine."

Hearing Jodie say that definitely made me feel better. I was in awe

of her talent as an actress, especially when coupled with her youth. "Thanks, Jodie," I said. "So . . . uh . . . does that mean you'll still go over the scene with me?"

I always had a wonderful time hanging out and rehearsing with Jodie. We both talked about our upcoming birthdays. She was about to turn sixteen and I was celebrating my eighteenth birthday in a week. We'd joke about our director, Adrian Lyne, who was so delightfully British. We both found his accent adorable, and cracked up whenever he'd pepper his conversation with weird, wonderful, and sometimes downright bizarre British expressions. Sometimes we'd wonder if he wasn't making them up to see how much he could sneak past his gullible teenage American stars. We'd also whisper about our producer, David Puttnam, who we both thought was simply gorgeous, despite the fact that he was nearly forty years old—which seemed super old to us both back then. We even found his salt-and-pepper hair sexy and endearing.

Those moments definitely reminded me of my time in the Runaways—of the hours spent sitting with Joan in a hotel or the mobile home, driving from city to city, talking about stuff like rock music, and guys, and all of the other things that made our glittery little world go around. But Jodie Foster, Marilyn Kagan, and Kandice Stroh were not the Runaways . . . they were actresses doing a job, not young girls with a dream, clawing for a hit song. Our shoot was scheduled to run for three months. I knew that we would all be together for that time, and then when it was over, we'd all go our separate ways. There would be no strings attached: no Kim Fowley, no binding record contracts, and no international tours. I knew that I would cry when the film was done because I'd miss everyone. I'd miss Jodie most of all. That fleeting, intense friendship with Jodie Foster reminded me of just how much I really lost when I left the Runaways. It wasn't the lifestyle that I missed, the crowds, or even the music. Not really. It was my friends. It took me a long time to realize this, but the friendships that you form when you're a teenager are among the most intense you will ever experience. What I felt for those girls in the band . . . well, it was love, pure and simple. A dysfunctional kind of love, but love nonetheless.

They called us out for our next scene. As we stepped out of Jodie's trailer, my mom was waiting for me with a concerned look on her face.

"There you are!" she said, sounding mightily relieved. "I was looking all over for you! Do you know your lines?"

"Yes, Mom." I sighed.

"Have they touched up your makeup? Did they check?"

"Yes, Mom they did . . ."

"Well then . . . go to it, sweetheart!"

I went to walk toward the set, but before I could, Mom grabbed me and gave me a big hug. She held me in her arms for a long time. It felt like she hadn't hugged me like that in ages . . . since before she and Dad got divorced, at least.

"I'm so proud of you, Cherie!" she said, her eyes looking wet.

I smiled. "Thanks, Mom . . ."

When I thought about it later, I realized that all I ever really wanted was for my mom to be proud of me.

The apartment that I was renting in Encino was a small one-bedroom. It was tiny, but I loved it. It was a strange feeling to finally have a place I could call my own. But I definitely missed Aunt Evie's a lot, and I visited often. Not having my family around me took some getting used to. There was something a little sad and lonely about coming home to an empty apartment.

On this particular day I was on the couch with my father, scratching my head and looking distractedly at my watch. I felt like I was late for something, although I didn't know what. It felt like there was always something I was late for, like there was always some other place I was supposed to be.

"Kitten," my father said, cutting into my thoughts, "I've been worried about you."

"Hmm?"

"Worried. About you. The last time I saw you, you were thin . . . I mean, I thought that you couldn't possibly get any thinner. But . . . you look even *worse* now. You need to start taking care of yourself!"

This was the first time I'd seen my dad in a few weeks. My schedule had been so grueling that I hadn't had the time to be anywhere but the set or the rehearsal studio. Even Adrian Lyne had noticed that I was looking a bit thin.

"You need to eat a few steak-and-kidney pies, luv!" he'd told me.

"Steak and . . . *kidney*?" I laughed. "Man, you Limeys eat some pretty crazy stuff."

"Ha! I'll have to tell you about toad in the hole sometime. Seriously, though—you're looking worn out, luv. What's going on? Are you getting decent rest? Do you have anything else going on besides the movie?"

"Well, there's the album. I'm working on that in the evening when I can . . . I guess I've just been spreading myself pretty thin recently."

"You want to know the best advice I can give you about that album?"

"Sure. What?"

"You need to stop working on it until we wrap this. I need you to be there one hundred percent for me, every day, Cherie. Three months is a tight schedule. No distractions, okay?"

"Okay."

So for the time being, the album was put on hold. Capitol understood, but Marie was pretty disappointed. Being able to focus entirely on *Foxes* helped a lot, but there was still pressure and stress, and even when I was alone, or with my family, I couldn't really relax. I couldn't seem to unwind. Also, a strange thing had recently happened: my heart started palpitating wildly, for no reason. It freaked me out the first time, and I promised myself that I would see a doctor, but I was determined to finish the shoot first. Putting in twelve-hour days on the set wasn't helping. Sometimes I was so preoccupied that I'd forget to eat. It's easy to forget to eat when you're taking Benzedrine. You don't notice the hunger, your stomach feels detached from the rest of you. With all of that going on, my weight had been dropping dramatically.

So now my father was looking at me with a concerned look on his face. I gave him my best smile. "I'm fine, Dad. Don't worry . . ."

"But I do worry, Kitten. I'm your father! How come you're so thin? Don't you keep food in your apartment?"

"Of course I have food! I'm eating fine, Dad . . ."

Looking at my father, I wondered if he shouldn't have been worrying about himself. He looked terrible. I was getting really concerned about his health. His skin had taken on this scary, yellowish tint; his eyes, too. Every time I saw him, he seemed to have deteriorated further. He looked older, frailer, and sicker. The booze was really eating him up from the inside.

Marie would keep me updated on his drinking. She told me that it was getting worse. That he couldn't go more than a few hours without a drink. That he was losing his balance, and that he seemed down and depressed. She was seriously considering putting him in the hospital.

When I was younger, I'd thought that my father's drinking was perfectly normal. I thought that my dad just needed a drink to relax, and I didn't see how this was a big deal. Some people just enjoy alcohol, but it doesn't necessarily mean that they're an "alcoholic." Because my father could always handle drinking so well, I felt sure that he didn't have a problem. That's what I'd thought for most of my life. Now I was beginning to realize just how wrong I had been.

Dad was drinking a glass of milk as he talked to me. I could tell that he hadn't had any booze for a while because his hand was trembling. We both did our best to ignore it, but I couldn't stop my eyes from drifting back to that telltale, trembling hand. He tried to casually place his other hand on top of it, to steady it, but it didn't work. A week before, Marie had told me that Dad tried to stop drinking completely, but he couldn't do it. He began to shake so violently that he couldn't function at all. In the end, she whispered, he *had* to have a drink. She told me that he was shaking so badly by then that he could barely raise the glass to his lips.

"How are *you* feeling, Dad?" I asked, eager to change the subject.

He smiled weakly. "Don't you worry about me, Kitten," he said, putting down that shaking glass of milk on an old water stain. "I feel like a tiger."

My father was not a good liar. I decided to let that one go. It was easier to ignore it than to have that painful discussion right then. I ignored the yellow skin, the yellow, watery eyes. I ignored the hand

that would not stay still. Maybe I honestly did believe that if I ignored these things, they would simply go away.

"Mom's been on the set," I said. I don't know why I said it; it was just the first thing that popped into my head in my rush to change the subject.

"How is she?" he asked. I couldn't tell whether he really cared, or he was just being polite. I suppose he was just as eager as I was to speak about something—anything—else.

"She's fine."

We continued talking about nothing in particular. An unspoken accord had been reached. No more words about my weight, and no more words about Daddy's drinking. Maybe if we just kept on in this state of denial for a while, everything would be fine.

It was a week or two later, on the set, that I really stopped and took a good look at myself in the dressing-room mirror. I looked tired. I hadn't been sleeping much. It was taking more and more Benzedrine to get me going. And the worst thing was that the more I used one morning, the more I would need the next just to get the same effect. And then that palpitating would begin again.

"Dad might be dying," I said to myself. There was no one else in the dressing room. I said it because the thought had been hovering around me for a while, an unfathomable darkness that lurked in the corner of every thought I'd have. This was the first time that I had ever spoken the words aloud. As soon as I said it, I felt that sick feeling in the pit of my stomach. "Shut up, Cherie," I added in a hoarse whisper.

I wanted a qualuude. I wanted to lose myself, to shed those toxic thoughts, and I dismissed the idea as soon as it surfaced. I couldn't do them anymore. It was bad enough that I'd started drinking again—nothing heavy, just a little wine now and then. Still, my racing mind tried to beat me up about this sometimes, but I dismissed those thoughts, too. But ludes? I knew that taking those again would be a disaster. Booze was different; booze didn't hurt anybody, right?

Wrong! my mind snapped. An image of Dad's yellowish skin flashed through my brain. "Shut up, Cherie!" I whispered again.

Looking in the mirror, I turned to the side, admiring my profile. I

was down to 103 pounds. Was I too thin, like my dad insisted I was? I smiled at the thought. *No, you can't be too thin, can you?*

"Anorexic" was how my father put it. He must have gotten that word from a magazine article. But I knew deep down that I wasn't anorexic; I just wasn't *hungry* anymore. Marie had recently accused me of being on drugs again. "That's why you're so thin! You're doing coke, aren't you?" She was wrong, of course, because the only thing I was taking regularly was the Benzedrine, and Benzedrine was legal, so it was practically not even a drug as far as I was concerned.

Of course it's a drug! my mind snapped.

Oh, shut up! I snapped back.

The back-and-forth in my head was getting pretty tiring. I wondered if I was going crazy from stress. No, I needed to calm down. I took a deep breath. I started thinking calm, rational thoughts.

Of course I'm not anorexic. I would know if I was anorexic. Jodie Foster loses weight by eating papaya and cottage cheese, and nobody is calling her anorexic. And Dad's not dying! The reason he looks older these days is because he is older! He's settling into his sixties, and I can't expect him to look the same as he did when I was a child. This is life. Everything is fine.

I approached the mirror in my dressing room to check my makeup. The bright bulb lights shone down upon my face. I starting toying and fluffing my hair . . . then froze. I thought for a moment that my eyes were playing tricks on me. I blinked hard and started parting my hair.

I gasped, and felt my blood turn cold in my veins. Oh God, what on earth was *that*? I moved closer to the mirror and put my fingers back into my hair. Looking closely, I saw something that terrified me. In the thickness of my blond hair there were barren patches—areas of thinness. Areas of baldness. There were raised welts under my hairline all through my scalp. I swallowed hard and stepped away from the mirror.

There could be only one explanation for this. I went to my purse and took out the vial of Benzedrine. It looked so innocent—just a silly little yellow vial. It had *tricked* me, I fumed. Tricked me into thinking it was a harmless medicine, into thinking that it was good for me. Now look what it was doing! I had to get off of this stuff!

I walked over to the dressing-room window and tossed the vial out into the bushes. As I did, there was a knock at the door. "We're ready for you, Cherie!" the assistant director called.

"Be right there!"

I was scared. Scared about what was going on in my body. What other side effects would this terrible powder have on me? I put a gentle hand up to my head and softly touched my damaged scalp again. This was *all* the Benzedrine's fault!

I started to panic, but I managed to catch myself. I forced myself to breathe slowly. I knew what I had to do. The solution to this problem was very clear to me. There was only one rational way to deal with it.

Before I returned to the set, I went to the nearest pay phone and dialed a number. On the second ring, she picked up.

"Hello, Stacy? It's Cherie." Stacy was a friend of mine. The one who'd introduced me to Benzedrine, and had been supplying me with it. "Listen . . . that Benzedrine stuff has been doing weird things to me. I don't think I should take it anymore. Could you do me a favor?"

"Sure. What is it?"

"Can you come to the set? I need you to bring me some blow," I said, gripping the receiver very tight. "I need you to bring it . . . as fast as you can."

I hung up, already feeling better. Coke had never made my damn hair fall out. No more of that stuff for me! No, this was a new Cherie Currie, a responsible Cherie, who would recognize when she had a problem and deal with it accordingly. Feeling highly responsible and totally in control, I strode over to the set, ready to act, ready to deal with my life. Because my life was good. It was better than good—it was *great*.

And I was in control. Right?

28

Battlefields

t was April. Although I was no longer on the set of a movie in progress, everything around me still had a vague hint of unreality. The clear California sky looked like a movie backdrop. Maybe that was just wishful thinking. There was certainly a part of me that hoped that I would wake up at any moment, and that all of the past few months would turn out to be some kind of terrible dream.

It had been three months since we'd wrapped up the shooting on *Foxes*. In those three months my life had undergone some pretty major upheavals.

"Should we tell him about Mom?" Marie asked as we drove toward Aunt Evie's house. My hands trembled as they gripped the steering wheel. I wondered if I should even have been driving. Although I wasn't high, I still felt that I was in no shape to be in control of a vehicle. I was sick with worry, and hurting inside. "Should we tell him?" Marie asked again.

"I don't KNOW, Marie!' I snapped. She turned away from me, and a frosty silence descended in the car. After a few awkward moments, I looked over to my sister. "I'm sorry," I said in a hoarse whisper. "I'm just . . . I'm feeling . . ."

"I know," Marie said. " I know how you feel."

I pulled up to the house slowly. Turned the engine off, and we just sat in silence for a moment. I wasn't sure if I even wanted to go in. I looked down at my cold, shaking hands. Was I ready to see my own father like this?

"How does he look?" I asked Marie, without looking at her. Daddy had been really sick recently; his legs had swollen up so badly that they looked like tree trunks, as gout racked his body. The alcoholism was really tearing him apart. I knew the answer already. Marie had been crying so hard when she called to tell me how sick he had gotten that I could barely understand her.

"He looks real bad," she said.

I opened my mouth, about to ask another pointless question, but then changed my mind. I didn't want to know any more. I thought about Mom again, and a shiver ran through my body. I didn't want to know how bad Mom was either. My mom was three thousand miles away, back in Washington. Even though they were thousands of miles apart, both my parents were gravely ill. Both my parents had something eating them up from the inside. For Dad, it was alcohol. For my mom, it was cancer.

I'd gotten the call the other day when I was in the control room doing the voice-overs on *Foxes*. That's how I found out. Although the shoot had wrapped, we still had "looping" to do. Looping is the process of rerecording lines that don't come out on the audio track. The first edit of the film, the rough cut, was done. This was all about the finishing touches. I was working in the control booth with Jodie and Adrian when the call from Wolfgang came. I had known that Mom was having some tests done, but that's all I knew.

Wolfgang wasn't the type of person to beat around the bush. The first thing he said was "Your mom has cancer, Cherie."

"What?" I whispered, running a shaking hand through my hair. "*What?*"

He didn't repeat himself. He knew that I'd heard. He cleared his throat and did his best to assume his typical, businesslike manner. "I know . . . I know it's terrible, Cherie. It's hard for all of us, but it's the way it is. We just got the diagnosis. They're doing the colostomy. They have to . . . remove her colon."

"Oh my God . . ."

I sat there in shock and listened to everything that Wolfgang had to say. He told me that Mom had a good chance of survival.

"How good is good?" I asked.

"Thirty percent."

I felt the tears welling in my eyes. "What's so good about *thirty percent*?" I demanded.

Wolfgang didn't answer. The rest of the call went by in a haze. I hung up the phone and turned to Jodie and her mother, Brandy. They were looking at me with concerned expressions.

"Are you okay?" Jodie asked.

I started crying. The only word I could sob was "No."

I snapped out of my thoughts. I looked over to Aunt Evie's front door. Behind it, my father was fighting another war. This time there would be no medals, and the only casualties were likely to be himself and his family. This time around, his body was the battlefield, and this conflict had been going on for so long that the scars of war were plainly evident. My dad—the tough, no-bullshit Marine who had survived despite terrible odds during the war—was now a casualty. I didn't know if he had another victory in him: the alcohol seemed to have the upper hand this time.

"I don't think we should tell him about Mom," I said. Marie nodded silently. Maybe Aunt Evie had already told him. But if he didn't already know, I felt that this was not the time to unload the information on him. "Come on," I said. "We'd better go in."

Dad was lying in Marie's bed instead of in his own room. His failing health had forced him to make one of his periodic attempts at detoxing, and he was currently undergoing a violent, cold-turkey withdrawal. I could smell it as I approached. A pungent, fermented smell that radiated from my father as he sweated the alcohol out of his body. Maybe he had soaked through the sheets on his own bed already, necessitating the move into our bedroom. Marie and I crept into the room. When I saw my father, I stifled a gasp. He was lying shivering in Marie's sheets, curled up in the fetal position. He looked like a baby. This wasn't my father I was looking at. This was *not* my dad! I closed my eyes tight for a moment. No father should ever look like this. I opened them again, but the painful scene was the same as before. Marie took my hand in hers and gave it a squeeze.

"We should have done something," I whispered. "We should have done something when we found him in his car . . . We should have

done something, forced him to dry out . . . before it came . . . it came to *this*!"

"Shhh," Marie said. I didn't want to look at her. I think she was crying, and I couldn't bear to see it. "Go see him," she whispered. "I'm going to speak to Aunt Evie, okay? I'll be right outside."

She left, and I was alone in my childhood room, looking at the frail, little man who was lying there in place of my dad. There was a half-finished glass of milk on the bedside cabinet. I tried to tell myself that once he went through the detox, everything would be okay. That he would smile at me and tell me that he was feeling "like a tiger." That he would come out of this, and never drink again, and that everything would go back to normal. He'd be a new man.

There was a time when I could have convinced myself of that, but not anymore. I was no longer naive enough to believe fairy tales. As sick as my father was because of the alcohol, and as painful as these periodic detoxes were, they never seemed to stick for any more than a few months. We'd know when my father was on the wagon because the kitchen pantry would suddenly be full of sweet stuff. He'd get an insatiable craving for sweets, and would eat stuff like Entenmann's cheese Danish or sugar donuts for breakfast, all washed down with a glass of milk. He'd look different, too. Twenty years would fall away from his face. His eyes would clear up. That yellow tinge would fade from his skin. Slowly but surely, though, he would slip back into drinking. That healthier, happier Dad would be nothing more than a happy memory. Then, like clockwork, there would be another painful detox on the horizon. Except that each time he detoxed, my father would be sicker, frailer, and weaker than before. We always feared that he wouldn't survive the next one.

I walked over and sat on the edge of the bed. *Daddy*. I felt responsible. He was my *father*! I should have taken care of him. I could feel fat, silent tears rolling down my cheeks. I reached out and touched him.

"Dad?" I said.

He stirred a little.

"Daddy?"

I shook him gently. He turned on his back, and his eyes opened,

slowly, painfully. The eyes looked yellow, sick. And they looked old—older than Grandma's. There was no light in them anymore. I watched him blink and try to focus on me. His hair was a mess, sticking up in places, flattened tight against the skull in others. I knew that if he were well, he'd be reaching for his comb right now. Instead he just stared at me, and managed to mumble a hello. I tried my best to smile at him reassuringly.

We remained like that, frozen, staring at each other. I sensed some unbreachable gulf in the inches between us. I don't know why I did it, but I reached into my purse and pulled out my wallet. I opened it and removed a hundred-dollar bill. I folded the bill up, and slipped it into his limp hand.

Through my tears I said, "I just want you to know . . . Dad . . . that you have money . . ."

Dad smiled weakly, and allowed his eyes to fall closed again. "Thanks, Kitten," he murmured. I watched him for a few more minutes, but he was asleep again. The bill slipped out of his hand and onto the bed. I wanted him to have it. I wanted it to be there for him when he woke up. Somehow I felt that this hundred-dollar bill would mean something. That it would magically chase away all of the problems, and heal all of the damage.

An anger rose in me, drowning out all other emotions. How could my dad let this happen to him? How could anybody willingly destroy their body like this?

I put the bill back into his hand. It slipped out. I put it back, but he couldn't hold on to it. I took the bill and placed it under his glass of milk. I had to get out. I didn't want my sobs to wake my father up. I felt like there was nothing I could do to help him anymore, so I quietly left him alone, breathing softly in Marie's tiny little single bed.

29

Annie and Me

I am in a Cadillac, gliding down the 5 Freeway with an older couple. I don't want to be there; I just want to get home to North Hollywood. These two are making me feel strange. They are man and wife, but the guy still puts his hand on my thigh. Right in front of her. She is laughing in the backseat. There is a sense of druggy madness in the air. I brush his hand away angrily. He laughs at me. "The beast with five fingers!" he mocks.

I don't find this funny. I've had a bad day. Hell, I've had a bad year. Too many drugs. Too many bad decisions. I just want it all to end. I just want to get home. If I can only get home, then maybe I could start over. Maybe I could give up drugs altogether, put my life back together.

The man pulls a bottle of Bacardi from between the seats. He takes his eyes off the road as he pulls the bottle free. He's already drunk; so is his wife. He takes his hand off the steering wheel and we begin to weave madly all over the road. Panicked, I reach over to try to steer for him. I curse my own stupidity. Hitchhiking was a terrible idea. Nothing good can come of this.

He puts his hand on my thigh again.

I scowl angrily.

Nobody is watching the road.

I look forward again. With a jolt I realize that there is a truck ahead of us, at a complete standstill. We are heading straight for it at a terrifying speed. I open my mouth to scream as the Cadillac plows into the rear of the truck at sixty miles per hour.

Cut to: The hospital, where they slice open my bloody jeans and take off

my shoes and socks. They stick a needle in my arm and put an oxygen mask on my face. I cough up blood, splattering it over the inside of the mask. My pulse drops lower. Lower. Then it disappears altogether.

The doctors stop their work.

It's over.

My friends watch in amazement and horror as the white sheet is pulled over my face.

It's all over.

Fade to: Some months later Jodie stops by to put flowers on my grave. She reminisces to herself and laughs sadly to herself about the good times we'd once had.

Freeze frame on Jodie's face.

Suddenly the dark theater erupted into applause. As the credits began to roll, the applause grew louder, people whooping and hollering. Relief flooded my body. I was sitting there with tears in my eyes. My father, sitting next to me, squeezed my hand. I look over at him. He looked better than he had looked in a long time. He was still drinking, but somehow tonight his pride in me seemed to have overcome all of the illness racking his body, and he looked years younger. Grandma was sitting there weeping. She had been doing this for most of the film. Daddy would always say that her kidneys were too close to her eyes.

I could barely believe it—I'd done it. I pulled off a heavy, dramatic role! I stood, side by side with Jodie Foster, and I didn't look like an idiot. All of the hard work had coalesced into this moment, the 1980 premier of *Foxes*. As the lights came up, I looked down the aisle. My entire family was there: Dad, Mom and Wolfgang, Aunt Evie and Grandma, Donnie, and Marie with her fiancé, Steve Lukather. Even Sandie and T.Y. Everyone I loved was in the same room, something that I honestly thought I would never see again.

Not to say that some relationships weren't strained. My relationship with T.Y. had never fully recovered from his asking me to drop the charges against the man who raped me. The sessions for *Messin' with the Boys* had proved to be torturous, and had put a huge strain on

my relationship with Marie. When Capitol realized that I was going ahead and recording a duet album with my sister, the pressure started building. The label's mantra became "We know what we signed up for, and it wasn't a sister act!" The most vocal critic was the man who had signed us in the first place, Rupert Perry, who was the vice president of A&R at Capitol.

On top of all of this pressure, when I started dating the album's producer, Jai Winding, Marie was *furious*. She felt that she couldn't get a fair deal in the studio if I was in a relationship with the producer. However, since we had brought her boyfriend—and soon-to-be husband—Steve Lukather in, I felt that all I had done was level the playing field a little. The power struggle for control of the album had left some scars. With Steve involved, and all of the people he had brought in from Toto, I started to feel sidelined on my own album.

The sessions had dragged on, and the songs started to take on the overpolished sheen of a Toto record. Of course, with so many members of Toto involved in the making of it, I guess I should have expected it. Since Steve had been winning a lot of Grammys his opinion carried a huge amount of clout in the studio. More than mine, it seemed. As the sessions dragged on, I started to get more and more depressed. One "highlight" occurred when Steve told me during a rehearsal to pull my performance back because I was "outshining" Marie.

"She hasn't been doing this for as long as you have," he told me. "I don't think it's fair that you project so much of yourself. Pull it back a little. Let her shine."

I remember thinking how insane it was that I was now being told to "pull it back" on my own project. Wasn't I meant to be giving every performance one hundred percent? To me, that summed up everything that was going wrong with the album. It all came to a head toward the end of the sessions when, during a heated argument, I finally told Marie that Rupert Perry didn't even want her on the record. She didn't believe me. The next morning I got a call from Rupert asking me to talk to my sister.

"She's in my office, crying and hysterical, and she won't leave!"

She had shown up demanding to know the truth. When Rupert

told her in no uncertain terms that he had thought it was a bad idea to have her on the album, she became hysterical. There was a sense of grim satisfaction in knowing my sister finally knew the truth about how the label felt about her inexperience, but deep down I knew that serious, irreparable damage had been done to our relationship. I knew this even as we were all smiles at the premier of *Foxes*. Still, I didn't have any clue about what was going to happen next; as far as *I* was concerned we were going to put a band together and take the album out on the road. Pretty soon I would discover how wrong I had been about that.

Looking at my family as the credits rolled, I turned to Grandma again. I saw that she was still crying. I smiled at her and she did her best to smile back and act as though everything was okay.

We all filed out of the theater, and I mingled with the cast and crew, hugging everyone and shaking hands. It had been well over a year since I'd last seen everyone, and it was a long-overdue reunion. My family was waiting for me outside the large screening room, so I tore myself away. When I made it over to them, Grandma was still crying.

I went over to her and gave her a hug. I knew very well why she was crying. "It's okay, Grandma," I whispered as I held this proud little woman in my arms. "It's okay. It was just a movie . . ."

"I know, sweetie," she said, but it didn't stop her from sobbing.

I looked up to the rest of my family and loved ones, and for a second it was as if I were looking at a photograph—a Polaroid shot, the colors faded and bleeding away with the ravages of the passing years. The sounds all around us receded for a moment, and it was as if I were seeing everyone truly for the first time.

This would be the last time that my family would ever be all together. Mom, Dad, Donnie, Marie, Grandma, Aunt Evie, and me. There wouldn't ever be another Christmas that would find us all in the same room. Although I didn't know this at the time, I sensed it. A cold shiver passed through my body, sucking all of the conversation out of the air.

Who would be missing the next time around? I didn't know. There were many black clouds hovering over my family at that moment,

despite all of the smiles and hugs. My dad could only mask his alcoholism so much. His eyes gave it all away. His drinking hadn't slowed, and the warnings of the doctors still echoed loud and clear in my head. And Mom? Her face was still radiant, but she was thin and pale. Following the operation, the doctors had informed her that she had maybe a year to live—if she was lucky. So far she had been doing much better than expected, but for how long? I knew that my mom was strong-willed and tough, but was that enough to beat the cancer that was eating away at her?

Even Grandma . . . you know, my dad told me that he'd found her in the kitchen one morning, crying. When he asked her what was wrong, she told him that she'd forgotten how to cook bacon. She talked more and more about Grandpa and her sister Martha, wistfully saying how she missed Martha's singing, as if in some strange way she were preparing to see them again. And Aunt Evie would talk about how she hated December. "Everyone dies in December," she'd complain sadly as she ticked off the names of our many lost loved ones. "I really can't *stand* December . . ."

I shook my head. It was dangerous to linger on thoughts like these. The sadness that they caused was too deep, too immediate. And what about me? A twenty-year-old girl, with her whole life ahead of her. But for a fleeting moment I was able to see my life from enough distance to catch a glimpse of the wider picture. A twenty-year-old girl who needed to keep cocaine in her purse and her medicine cabinet just so she could pretend to function like a normal human being. A twenty-year-old girl whose bathroom scale barely seemed to creep above a hundred, and whose heart palpitations never seemed to stop.

That's why Grandma cried so hard when the credits rolled. Because Annie's drug-ravaged life and violent death were more than just moments in a movie. I think that Grandma was crying because she, too, had realized that the next time the family would all be in the same room would be when we came together to say good-bye to one of our own.

And she was silently praying that it wouldn't be me.

30

Life in the White House

When it came time to put our dad into the hospital, I was about to turn twenty-one years old. Just months before, our beloved grandma Onie had complained to Aunt Evie of a headache. Aunt Evie took her to the hospital . . . where she died suddenly, and for no apparent reason. The family was in a state of shock and bewilderment. She was a wonderful, loving, and soft-hearted woman, who'd loved her only son more than anything on this earth. It wasn't until this day, sitting in a luxurious doctor's office next to Cedars-Sinai Medical Center, that I began to wonder if it hadn't been kinder that way. Grandma Onie would have been devastated by this tragic turn of events. The doctor spoke to all of us in dry, measured tones. I remember that I detested that doctor. I remember that very clearly. He was unsympathetic and blunt, and said things in front of my father that made my skin crawl.

"First of all," the doctor had said, "I want you all to hear this. Your father is very sick. He is in liver failure. He has heart disease, and lung disease. To be perfectly honest, he is sick enough to kill *three* people."

When he said that, I looked over at Dad. My father was trembling, unable to look at the doctor directly. He was staring at his hands, tapping his fingers nervously against his knees.

A few weeks before, Marie and I had been on *The Dinah Shore Show* to promote *Messin' with the Boys*. All we had to do was show

up, look good, and lip-synch. Dad's hero, Dean Martin, had been the cohost. Dean was drunk . . . well, that's putting it mildly. He was really *blitzed*. I remember that Dad just looked so happy to see us both performing and sharing a stage with Dean Martin. It was the happiest I could remember him being in a long while. To go so suddenly from that to this horrible scene in the doctor's office was beyond words.

I looked back at the doctor. He was a young man with a beard, full of vigor and life, and it was obvious to me that he had real contempt for alcoholics. He was sitting behind his desk, with his expensive-looking fountain pen on his mahogany desk and the look of superiority all over his face. Inside, I was screaming at this man. How dare he say such things in front of my daddy? In front of a war hero? In front of a gentle, good, and kind man who loved his children so totally and unconditionally?

As I sat there wishing I could claw this doctor's eyes out, Marie spoke up. "What are you trying to tell us, Doctor?"

"I'm just being honest with you. I don't believe that sugarcoating the situation is going to be beneficial for you, or your *father*."

Even the way he said "father" . . . there was a mocking tone to his voice. This man didn't know anything about the person our dad was. All he could see was an old alcoholic shaking in that chair, looking for all the world like the naughty schoolboy who had been hauled up in front of the principal. He barely hid his disgust behind that phony white coat and clipboard. Every word, every gesture insinuated that my father was weak, selfish, and that he had done this to himself.

I shook my head and looked away. For any other disease, people are sympathetic. If my father had been suffering from leukemia, the doctor's manner would have been totally different. He would have been caring, concerned. And yet they tell us that alcoholism is a disease just like any other, a chronic and incurable one at that. So why was this man treating my father as if he had some kind of moral problem?

"We'll have your dad stay in the hospital," he continued in that expressionless monotone, "but he may die. The evidence is plainly obvious—just by looking at him, you can see that he is in the final stages of alcoholism. The damage he has already sustained is very

severe. To be frank, if we can keep him alive through the delirium tremens . . . that is to say the shakes . . . then I would consider us fortunate."

We all looked at my father, this once proud man, sitting there, utterly broken.

"What are his chances . . . if we take him home?" Marie asked, in a quavering voice.

"Nil," the doctor replied.

I remember in the hospital a little later on, when he was in his pajamas and lying in the bed where he would later die, I asked my father why he couldn't give up drinking. We had tried—oh God, we had tried, we had begged, we had wept, we had done everything we could think of. We had read the books and we had brought him to meetings. After every meeting, my father would look more and more demoralized and deflated. "I'm sorry, Kitten," he told me on numerous occasions. "I just can't *relate* to those cats!" We had even resorted to hiding his liquor . . . We had done everything that was within our power. Yet on the morning of that final trip to the hospital, right before we checked him in, he'd asked to go to a bar so he could down his last two double vodkas.

"Why, Dad?" I asked him, my lips trembling, my hand holding on to his thin, frail arm. "Why didn't you stop? Why did it have to come to *this*?"

My father was silent for a long time. Then he looked at me. He stared at me with those sad yellow eyes, and his face became very serious. He looked as if he were about to impart some great cosmic truth, something that would help me to understand his pain, his helplessness in the face of his condition. He was shaking; I could feel his bones twitching and vibrating underneath my own hand. My father was terminally ill; I knew that. In my heart, I knew it. I could taste my own tears as they trickled down my face and touched my lips.

"Because . . . because I didn't *want* to stop drinking, Kitten," he said in a whisper. "And the truth is . . . *I still don't.*"

He closed his eyes, as if exhausted by the exertion of this revelation. He raised his hand and touched my wet cheek. "I love you, Dad," I said through my tears.

"I love you, too, Kitten. I love you both."

Marie and I held our father, hugged him and kissed him. We clung to him really, as if at any moment our father was going to be dragged under some vast inky expanse of water and we would never be able to hold him again. It reminded me of the time my father left for Texas, and we held on to him at the door, crying and begging him not to leave. How he had to call my mother, and she had to physically drag us off him, all of us hysterical and heartbroken. There was no one to drag us away this time. We clung to him for dear life. But still, we couldn't hold on to him forever.

I remember Marie reaching over to his dressing table and handing Dad his comb. His hair was a mess, and we knew he hated that. With shaking hands, he held his comb and brought it slowly and painfully across his head. He did this five times, until his hair was perfect. Drained by the exertion of this simple movement, he closed his eyes and breathed easy for a while.

Our father would survive the shakes. He made it through the entire detox, amazing even the doctor who had thought for sure that he wouldn't survive. The day before his scheduled release from the hospital, his doctor asked permission to perform a bronchoscopy. The procedure involved inserting a rigid metal tube into the lungs and collecting a tissue sample for testing. After all that my father had been through with his detox, we refused.

Later that day I got a frantic phone call from Aunt Evie. She told me that she had spoken to Dad, and that the doctors had gone ahead with the procedure. She told me that he sounded like he was in pretty bad shape, and that he'd told her that he felt he'd made a big mistake in giving permission for the bronchoscopy. I called Dad immediately. The voice on the other end of the phone sounded weak, hoarse, and unsteady.

"Dad!" I cried. "Why did you let them *do* it?" He didn't really have an answer. I told him to hold on, and I raced over to the hospital. By the time I arrived, Marie was already there. She was in tears. She told me that Dad was in a coma and on life support in the intensive-care unit.

Visiting Dad in the ICU was a harrowing experience. We just sat with him and cried. He was hooked up to every machine available,

including one that kept him breathing. He seemed to improve for just one day—our twenty-first birthday. Even though he was still on a ventilator, he looked so at peace and so young, just like he did in the pictures from his war days. We started to feel some cautious hope that he might improve. When we left the hospital that night, we really believed that Dad was going to pull through.

Daddy died clean and sober, three days later, at 4 A.M. They told us that he died peacefully, just as the sun was coming up. A male nurse told me he was with him, and that those quiet predawn hours were the nicest time to die. I don't know if there is such a thing as a nice time to die. But I did feel that our father died with dignity.

When I got the news, the memories came back—some painful, some sweet. I had lost the man who had meant the most to me in my life. I was a daddy's girl, and now my daddy was gone and I was totally lost. My father's death added to what was becoming a great black void inside of my soul that became impossible to fill. I missed, and continue to miss, my dad so much.

My mom was luckier than my dad. She beat her cancer, as if it were no contest at all. It was a miracle, they say. Mom had always been very religious, a devout Catholic. My mom is a tough lady, I had known that all along, but she took no personal credit for her incredible—or should I say miraculous?—recovery. My mom told us that when she lived in Jakarta, Indonesia, she'd fly to Singapore for her chemotherapy. Her doctors had told Wolfgang that she had maybe four to eight months to live. He said that the cancer had spread throughout her body and that all we could do was pray.

A friend drove my mom to her treatments. On the way they stopped at a small chapel in Singapore so Mom could say a prayer for a friend who was having surgery that day. Mom was praying to the Blessed Mother for her friend when she said the miracle occurred. She felt a tingling in her feet and then the sensation rose steadily up through her body. The feeling crept up to her throat, and my mom remembered raising her eyes to the statue of Mary in utter and complete amazement. She realized that she was hungry for the first time in months, and asked her friend to take her for lunch before the appointment.

At the clinic, after drawing blood, the doctors were about to

administer the chemo when a nurse rushed in to say that my mom's blood sample had shown something incredible. The cancer was gone; our mom had been cured. Her doctor later wrote and said that it was only God—with maybe a little help from Mom—who could have made that happen.

Although we were all beyond grateful for this news, it made me sad to think that miracles must only happen in Singapore. With my father passing, the last vestige of my old family life in California was lost forever.

Although *Foxes* was not the box-office smash I'd hoped it would be, the critical reception was very positive and other roles followed: I played Sara in *Twilight Zone: The Movie*. My character ended up with no mouth, the victim of an evil kid brother with paranormal powers. The director of my segment, Joe Dante, had called my agent because he'd seen a publicity picture of me and he liked my eyes. I had managed to get Marie a job on that movie, working as a body double for me. When I picked her up to take her to the set for my one day of shooting, she had been up all night doing coke and was a mess. She swore to me that she wasn't high, but just one look at her saucerlike eyes gave her clean away. I scolded her all the way to the set, embarrassed that everyone would know by simply looking at her. She had always given me a hard time about my drug use, so I guess this was my turn to feel what she had felt. By the time we made it over there, she had passed out completely. It was mortifying: I had done a small toot before the shoot as well, but I at least had been professional and had a good night's sleep. When the makeup guy, Rob Bottin, saw Marie, he rolled his eyes and gave me a look that made me feel about two feet tall. I felt terrible for her, but I was angry nonetheless. I cursed myself for not making her stay home the minute I saw the condition she was in. Despite the rocky start, Rob and I ended up becoming friends. Rob was a very talented artist, and had recently completed work on the remake of *The Thing* with Kurt Russell, which even now—over a quarter of a century after it was released—still looks amazing.

The *Twilight Zone* became infamous because of the terrible accident on the set of John Landis's segment, which killed Vic Morrow and two child actors. I remember the stunned mix of emotions I felt

when I'd heard that Vic Morrow was dead. The main emotion that the very mention of the name Vic Morrow had made me feel for years following his attempt to convince me not to testify against my rapist was fury. However, Vic did apologize to me after he saw me testify in court, and his death—along with the deaths of the two innocent children—was a terrible shock to everyone everywhere.

I also played Dana in the cult horror movie *Parasite,* which was the responsibility of director named Charles Band. To his credit, he did spin out a long career churning out cheapie B movies like the *Puppet Master* series and other "classics" like *Ghoulies* and *Mansion of the Doomed.* But even as we were shooting, I had the feeling that this director didn't really know what he was doing and that the movie was probably going to stink. That movie introduced the world to a young, up-and-coming actress named Demi Moore, and we became very close on set.

One of my strongest memories making *Parasite* was the late-night shoot where everybody got so drunk on Crown Royal that the lead actor could literally not say his lines. And then there was the accident on set that left me with three pinched nerves and reverse curvature of the spine, all because of the director's recklessness and incompetence. I ended up getting six thousand dollars' compensation after paying the lawyers' fees, and probably would have gotten more if I hadn't been dabbling so much in the coke that I blew off most of the physical therapy. I wouldn't even have sued if my mom hadn't insisted upon it.

I played Iris Longacre in the sci-fi movie *Wavelength,* which featured a soundtrack by Tangerine Dream. That movie is still considered something of a lost favorite among science-fiction fans. I fell in love on the set with my costar Robert Carradine, and we started having a passionate affair right under the nose of my live-in boyfriend, Jai Winding. I was doing so much coke during that shoot that it was kind of amazing that I got away with it all. I remember during one kissing scene in the movie, Bobby leaned in and licked my nose. Afterward he confessed that his entire mouth had gone numb after he did it. But the electricity between us was incredible. The first time we got together we were driving in his truck, following a long shoot. He was taking me back to the house I shared with Jai. I just told him, "Pull over!"

"Huh?"

"Come on! Pull over! You know this is going to happen . . . let's just make it happen. Right now!"

And he did. We pulled up to the deserted tip of the Hollywood Hills and did it right there on the hood of his truck. I was deeply unhappy in my relationship with Jai and I suppose I was subconsciously sowing the seeds for the destruction of that relationship. I've always regretted letting my relationship with Bobby end. We were so close. However, the last straw came when he found out that I had also been seeing Glenn Hughes of Deep Purple. I truly loved Bobby, but in the end my promiscuity and my drug use broke his heart.

Following the completion of *Messin' with the Boys*, Marie and I did a string of television appearances in the United States, Japan, and Europe. All lip synching. It was fun at first, but soon the familiar tension between Marie and me reared its ugly head. When it came time to put a live band together and get on the road to start really promoting the album, Marie bailed. "I'm sorry, Cherie," she told me. "I just can't do it."

I was at Jai's place when she called me. At first I had no idea what she was talking about. "You can't do what?"

"The tour. The rehearsals. It's just too much. My heart . . . my heart's not in this anymore."

And that was that. Marie was in love with Steve Lukather, and suddenly she had no desire to be on the road promoting *Messin' with the Boys* anymore. She wanted to be at home, and be a wife, maybe even a mother. And if I didn't like it? Well, there really wasn't much that I could do. After all, the sessions themselves had been hard on all of us. I had ended up putting my name to an album that sounded nothing like the way I wanted it to sound. But to keep my relationship with Capitol alive, I had to make the best of it. With Marie bailing on me, I knew deep down that it was only a matter of time before the label decided to cut their losses and drop me.

I immediately went back into the studio with Jai to record another album. We had completed just six rough tracks when the ax fell. Jai got the word from the higher-ups at Capitol Records that they were pulling the plug. He broke it to me over dinner. I was heartbroken, but

it would have been a lie to say that it was a total shock. Some locked-away, ignored part of myself had been predicting this since the day I agreed to cut an album with my sister at our father's behest.

But by the time I was twenty-four years old, there was only one thing I really did with any regularity, and it wasn't acting, or music, or anything close. Instead, I filled the emptiness in my soul with cocaine. I did cocaine when I woke up, and I continued doing cocaine until the moment I passed out. Then I would wake up and start all over again.

After the demise of my contract with Capitol, my relationship with Jai quickly fell apart. I originally met Bruce through an old friend of mine who I had helped to get a job doing makeup on *Wavelength*. He and the friend broke up around the time that my relationship with Jai was crumbling. I started hanging out with Bruce, up in his house in the Hollywood Hills. This was the early eighties, and a new drug craze was sweeping Hollywood: freebase. It was my brother-in-law T. Y. who introduced me to smoking cocaine, but on that occasion I didn't really "get it." The next time I did it, with Bruce, it was all over. I started romancing that pipe like a long-lost lover.

When I smoked cocaine, I knew that I had finally discovered the high that my years of drug use had been leading up to. Smoking cocaine was the most powerful, intense, thrilling, and addicting high that I had ever experienced. I erupted out of my own body, my ears ringing as the blood rushed around my ears, while a tidal wave of pleasure roared through every fiber of my being. It was better than an orgasm: it was the *ultimate* orgasm, because it felt like every single part of my body was climaxing at once. Have you ever wondered what it would be like for your *brain* to experience an orgasm? For me, that was what freebase was all about.

I knew that a rush this intense had to be dangerous, so I made a vow never to freebase with anyone but Bruce. That way I wouldn't end up doing it to excess. Within a few months, though, I was living with him, and I was freebasing as much as my body could physically stand. In a very short period, my entire existence became sidelined by my insatiable hunger for The High.

I grew to believe that I loved Bruce very much, despite his not

really being my type. He was a big guy, not very handsome, and he was such a cokehead that he always had dark circles under his eyes from lack of sleep. He always wore sunglasses, even inside the house. The house we shared was tucked away in the Hollywood Hills. We had high beamed ceilings, and huge windows that looked out over the glittering lights of Hollywood below. The house itself was suspended in the sky on forty-foot stilts, and it only touched the mountain at the place where the front door met the street.

Bruce loved me, totally. He worshipped me. No man had ever treated me like that before. He took me out to dinner whenever I wanted, and bought me whatever I asked for. His "real" job was as a jeweler, and when he felt it was time to ask me to marry him, he let me pick three of the biggest diamonds he had for my engagement ring. He made the ring himself. And of course, cocaine was everywhere: it flowed like air through our home. There was so much of it around that we jokingly referred to the place as "the White House." Ounces of the stuff were everywhere, and it was all for me. Well, mostly. Bruce was a drug dealer, a very successful one at that, and he made his living by buying directly from the smugglers and selling it to certain . . . *people* who had the ability to distribute it. He didn't really have to get his hands dirty, and he was not at all like you'd imagine a drug dealer to be. He was more like a regular businessman than anything else. Of course, having that much cocaine around could be a dangerous business, so there were some guns in the house. There was at least one gun in every room: shotguns, pistols, revolvers, and rifles. There were enough guns and cocaine in the White House to topple the government of a South American country. But Bruce kept the firearms well hidden, and the veneer of normalcy was perfectly maintained. If I didn't dwell on it, it was almost as if they weren't really there.

No, I felt that I was a lucky girl. I was lucky because Bruce had dedicated his life to making me happy. He gave me everything I'd ever wanted. So in a way, it was a good thing that he was a cocaine dealer. Because all I seemed to want in those days was cocaine. It had taken a long time for a purpose to rise up from the chaos of my life. I was being pulled in so many different directions by so many outside

forces for so long that I no longer knew what I wanted. Bruce suddenly changed all of that. I realized that there was only one thing in this world worth living for: coke, coke, and more coke.

Quaaludes were child's play. Benzedrine was for fools. And stardom—well, stardom was the most addicting thrill of all, but as time went on, I realized that it was no longer as important to me as it had been. Stardom, like eating or even breathing, took a distant second place to cocaine. I could admit this to myself in those days and not feel bad. And if I did feel bad, all it took was one more hit on the pipe to blast those negative thoughts right out of my skull. And after all, I didn't have to worry about what my Daddy would think anymore. No, Cherie Currie was all grown up, and for the first time in my life, I could be really honest with myself about what made me truly happy.

When I was child, I used to believe in God. It made me smile, back in the days when my life revolved around cocaine, to think that I'd once truly believed all those silly ideas about sin and retribution. Faith is all very well, until the real world comes along and snatches away everything that you hold dear. Then suddenly everything is thrown into sharp focus. No, cocaine was the only god I needed anymore. A god I could rely on to always make me feel good whenever I wanted. It was all I thought about, all I felt, and all I loved. In a strange way, cocaine became my salvation.

31

Marie Says Good-bye

There is a scientific principle that says that every action has an equal and opposite reaction. This principle holds true for cocaine. The greater the high, the more severe the crash. Back in the days when I snorted coke, I could count on feeling pretty crappy the next day. A coke hangover was something like a booze hangover, except that in addition to just feeling beat-up and nauseous, you feel depressed as well. You'd spend the night indulging in hours of intense coke-fueled conversation, telling anyone who would listen about how you were going to change the world . . . maybe sharing information that was so personal that you'd want to hang yourself from embarrassment the next day when you remembered it all . . . When you came around the next morning, all of that artificial goodwill was transformed into a deep-seated sense of misery, which you couldn't quite shake.

So, just as smoking cocaine increases the effect of the drug by a huge amount, so the comedown from smoking coke is also magnified: instead of the next-day blues, what you experience is a great void of misery and paranoia that seems to settle on you like an ominous black cloud. And as you smoke more and more, the time delay between smoking the coke and the crash gets smaller and smaller. And so, ten minutes after my last hit, the terror would begin. All of the problems in my life would come flooding back, bigger and badder than ever, twisted to hideous proportions by the chemical deficiency in my brain. This wasn't just depression: this was pure

fear. This was every terrible thing that had ever happened to me being relived in full color, wide screen, and 3-D. And there was only one cure for it: more coke.

And if there was no more coke, then I'd better find something else quick to knock myself out with before my brain suffered a meltdown from the horror of it all.

That's what had happened on this particular day. I don't remember how I got over there, but I was at the supermarket. I was blind drunk. There was no more coke in the house, and I couldn't get hold of Bruce. I had drunk a bottle of champagne and whatever else I had found lying around in the fridge. There was a time when I couldn't stand the taste of booze. Now I could barely taste it as it slid down my throat and raced through my stomach and into my blood. I didn't enjoy being drunk, but it was a means to an end. It meant that I felt less bad than before, and that was good enough for me. My life had degenerated into a series of ecstatic peaks and terrifying troughs, and the booze was just a way to help take the sharp edges off.

In the supermarket I was pushing a shopping cart. My brain was not communicating with my body effectively. My head felt like a helium balloon that was floating somewhere far above the rest of me, attached only by a flimsy string. I tried to make a turn, and accidentally demolished a display stand of some kind of dumb cleaning product that they were promoting. The display clattered all over the floor.

I wondered if I looked as crazy as I felt. I backed up, and continued going around the supermarket, staggering and almost losing my footing. I passed by the food aisles. The last time I weighed myself I was down to ninety-six pounds. I was still losing weight. The smaller clothes that Bruce had bought for me were already loose fitting. I didn't like to look at myself in the mirror anymore.

I finally made it to the cash register with my prize, a half-gallon bottle of Jack Daniel's and a can of Coke. I didn't think I could make it back to the house if my nerves were not fully coated with alcohol. The woman behind the counter looked at me and wrinkled her nose. She was butt ugly, with red hair all frizzed up by a ridiculous perm. Her face was covered with angry-looking zits. I smiled at her despite the fact that her face scared me. I wanted this bottle. I needed it.

"I can't sell this to you," the woman said with a voice like ice.

I started rummaging around in my purse. On the counter I started spreading all of the junk I found. Crumpled-up fifty-dollar bills. A battered pack of Carlton Lights. Lipstick. Keys. Four lighters. Finally I found my ID and handed it to her with a triumphant grin. She didn't even look at it, the bitch. She just shook her head and repeated, "I'm sorry, I can't sell this to you."

I started trembling. The crash from the coke was so fucking intense. If I didn't get the booze to make up for the lack of cocaine, I might die. That's the truth; I felt I might drop dead on the spot. I knew that if I didn't get this booze RIGHT FUCKING NOW, I might have had to hurt this bitch. "I am a paying customer, and I want this goddamn bottle!" I hissed. She started calling for a manager, some officious-looking little twerp in a button-down shirt with a name tag that read ELMER. Elmer looked like the result of some kind of experiment in inbreeding.

"What seems to be the problem?" Elmer smiled.

"I wanna make a complaint!" I slurred. "This . . . *lady* is being rude to me, and she will not allow me to buy this bottle."

"I'm sorry," Elmer said, sounding anything but, "but we can't sell this to you. If you'd like to make another purchase—food, groceries perhaps—that would be fine. But not this, not in your condition."

"Lemme tell you something, *Elmer*," I hissed. "You're on some pretty thin fucking ice right now. I'll call your goddamn boss, and I will have you *fired*!"

"I'll take my chances," Elmer said, and before I knew what was happening, he had me by the shoulders and I was being bundled out through the electronic doors. I was standing out in the parking lot, feeling disoriented. A light drizzle was falling. I thought at first that somebody was spitting on me.

I needed booze. Or cocaine. Coke would be better. I had some change, so I tried to call Bruce again. I staggered over to the pay phone and dialed the number. I got our answering machine. On the other end of the line, my voice sounded so fucking *cheery* and *happy* telling me that Bruce and I weren't home that it made me want to puke. I slammed the receiver down. I had one quarter left. There was

only one phone number that I could still remember. What choice did I have? I dialed it almost on instinct.

Half an hour later I was leaning against the cold car window. Outside, the rain pattered gently against the car. Every fiber of my body felt raw, exposed. I tried to shift position, and felt my bones grinding painfully against one another. Marie was in the driver's seat, her eight months' pregnant belly barely fitting behind the steering wheel. She and Steve had been married for a while now. Once Marie was sitting here, the reasons why I'd tried to avoid speaking to her these days were all flooding back to me.

"You smell awful, Cherie," Marie was telling me, with that nagging anger in her voice again. "You smell like stale cigarettes and booze. Ugh." When Marie talked to me those days, there was an anger in her voice, an anger even worse than the night she slapped me when I was stoned in Aunt Evie's house. There was so much that I *wanted* to say to Marie. There was so much unresolved anger between us regarding the collapse of our album. When Marie walked away from *Messin' with the Boys,* she went straight into her comfortable married life with Steve. No problems, no consequences. I was forced into recording that album with her; instead of putting my foot down and fighting for what was right for my career, I put my family first and did something that I felt had a good chance of coming back to haunt me. All of my fears proved correct. The end result was a glorified Toto album, which Capitol basically buried because Marie walked away from it before we could even go on tour. The label knew that without a promotional tour, the album didn't stand a chance. Marie waited until I had turned down better solo deals, made multiple enemies at Capitol Records, and recorded an album that was a far cry from what I wanted to do before she decided that singing professionally wasn't something that she wanted to do. I was left to deal with the aftermath. My career was ruined, my name was mud in the industry, and I knew that as a solo artist I was basically finished.

Marie had never apologized to me for that. Even my father, on his deathbed, had apologized for forcing me to cut that album. That was the final step in our making peace before he passed. I'd never had such a resolution with my sister. Marie never considered the fact

that this final, terrible spiral into drug abuse had been in part fueled by what had happened during the recording of that album. Instead of being sympathetic, she was now treating me the same way that Daddy's doctors had treated him. She acted like this was a symptom of my weakness, of my selfishness.

I wanted to say all of this to Marie, but I didn't. Despite all of the stuff that had gone down between us, I still didn't want to hurt her like that. And I was too tired. Too defeated. What did it matter? My music career was over; my life was what it was. It was too late to have that conversation. All I wanted from Marie right then was for her to take me back to Bruce. I could barely keep my eyes focused. I had to go home.

"Steve and I are tired of giving you our time and money if you're not going to change, Cherie."

God, that self-righteous tone of voice grated on my nerves. I wanted to tell Marie that she was a goddamn hypocrite. That she had done as much cocaine as I had over the years. I wanted to bring up the time that I'd gotten her a job on the *Twilight Zone* movie and she'd shown up to set ripped on coke on the tail end of a twenty-four-hour partying spree. Just because she's stopped getting high while she was pregnant, she suddenly thought that gave her the right to act like she was Saint-fucking-Marie. I knew that as soon as the baby was born, my sister would be back to using coke. Instead of saying any of this, I said in a small, defeated voice, "I'm sorry. I'll change."

Of course, I had no intention of changing anything. I had no power to change anything. The only thing that it was within my power to change was how I felt, and the only way for that to happen was for Marie to take me home, and once she had scurried off to her sub-urban existence, I could smoke some more coke. That was the only change on my horizon.

"Will you really change?" Marie asked.

"Sure," I said with a shrug. Fuck, they were only words, right? How could Marie expect me to think about the future when I could barely see beyond this windshield? My concept of time had become elastic. Time didn't seem to work anymore. Clocks tried to tell me it was noon, when I knew for a fact that I passed out in pitch blackness

only moments before. They told me that only an hour had passed when I'd lived through what felt like several days of horror.

Marie shook her head, not believing me. I felt indignant, even though I was lying through my teeth. She should have believed me! Marie owed that to me at least!

No, there were a lot of unresolved issues that were poisoning my relationship with my sister. She was always telling me how good she had been to me. Reminding me about how she had opened a bank account in my name, and she and Steve had poured money into it for me to use in an emergency, an account I had promptly emptied. What she didn't understand was that I *had* used it for emergencies only. When Bruce wasn't around to provide the coke, it *was* an emergency. Before I had moved in with Bruce, they had even covered the rent on my apartment in Studio City. What Marie saw as an act of charity for her struggling sister, I saw as rightful restitution for the way that she and Steve abandoned me with a quarter-of-a-million-dollar debt after the *Messin' with the Boys* album. Anyway, Steve was loaded. He was in Toto, for God's sake. It wasn't as if they were starving.

There was so much to say. But while Marie was driving me home I couldn't say any of it. I was too miserable, too weak, too preoccupied with my own sickness. Right then, forming a coherent sentence was well beyond me. Without cocaine to make my brain function, I was utterly tongue-tied.

"I want you to know, Cherie, that Steve and I are washing our hands of you. From now on, you're on your own."

"I understand."

We went back to the Hollywood Hills. I could feel the hatred radiating from my sister. That was okay. Hate was something I could deal with. I hated myself. It felt perfectly natural that other people would hate me, too. We sat there in the car, each waiting for the other to speak. The silence was endless, painful. Finally my sister said, "I don't want you around the baby. Not like this. You shouldn't be around a baby."

I nodded, and sat in silence for a while longer. Then I turned to my sister. "Is that it?" was all I could say.

Marie was crying silently. That made me cringe. How pathetic. I hated it when she cried. I looked away again. "When did you give up, Cherie?" she demanded.

Give up? When *did* I give up? I wanted to tell her that I didn't give up. It wasn't like that at all. I wanted to tell her that it wasn't a matter of *giving up*. It was a matter of losing my footing. My life over the past few years felt like a slow slide down into the pitch darkness. A black, velvet-lined path that seemed comfortable enough until I found myself at the bottom, in a black, velvet-lined tomb. It was a comfortable enough tomb, if dying was all you had in mind.

But I couldn't tell her any of that. Instead I said, "I don't know what you mean."

"Good-bye, Cherie."

I opened the door and stumbled out onto the muddy ground. It was raining harder now, and I was instantly drenched. I could hardly stand up. I lost my footing in the mud and staggered around a few times. Finally I slipped, and took a tumble into the ooze. I looked up, feeling bedraggled and pathetic, and I could see Marie crying harder and staring at me.

"I can't stand this anymore!" she screamed, and then she floored the accelerator.

Mud spattered out from her wheels and the car zoomed off down the mountain with the passenger door still swinging open. I watched it take a right, and the door swing shut by itself. The car was gone. Marie was gone. I put a hand to my face. Was I crying, or was it just the rain? I couldn't tell the difference.

The front door of the house opened behind me. I staggered over to it, and Bruce helped me in. He took me in his strong, dry arms and helped me stand.

"Where *were* you?" I cried. "I *needed* you!"

Bruce was what I needed. Not my sister. I had everything I needed right here in Bruce's house. I wondered if I would ever see my sister again. Right now none of that mattered as much as getting some coke immediately.

Lying in bed, wearing clean clothes after a hot shower, I had Bruce

draw the curtains because the sunlight was making me feel ill. Maybe it was still raining, I didn't know. As I lay there, a terrible, desolate feeling came over me. I felt horrible. Truly, truly horrible.

Bruce came over to the bed and knelt down next to me. "It's okay," he said. "Shhhh." He started rubbing my back. It reminded me of when I was a little girl, and Daddy used to do it to me when I had a fever. "I got something for you. Something to make you feel better . . ."

He opened up the nightstand and pulled out a big glass pipe. Then he produced a rock of coke. Not just a rock—this was a fucking *boulder*. A monstrous rock, a hundred-dollar rock at least. He loaded the pipe and put it to my lips. He held the flame against the rock as I lay in bed, inhaling the numbing white smoke.

"I love you, Cherie," he said.

I sucked more and more of the smoke up. My body went numb. The ringing in my ears drowned out Bruce's voice. That feeling—that indescribable, heart-stopping rush—filled me. It would never feel as good as that first hit had felt, never again. But it did make me feel less bad. And less bad was all I wanted out of life in those days.

Wonderful Bruce, I thought to myself, he's doing all of this for me. Not like that ungrateful sister of mine! No, Bruce had come through for me yet again. There was no way I could have funded an out-of-control cocaine habit like mine by any pleasant means. No—my wonderful, kind, considerate Bruce was giving it to me for free.

"I love you, Cherie," Bruce said again, putting the pipe away. He climbed into bed next to me and started kissing my neck. Moments before, this would have repulsed me. There is nothing worse than physical contact when you're in such a terrible place of drug need. But now all of that was gone. My body felt wonderful again. I wanted the contact. My body didn't belong to me anymore. It belonged to Bruce. He could do whatever he wanted to me. Anything at all, so long as he kept giving me the coke . . .

32

The Twilight Zone

The insistent ringing dragged me out of a dark, dreamless sleep. I blinked awake and looked at the clock next to the bed. I groaned—it was two-thirty. Why on earth was my alarm going off at two-thirty in the morning?

Confused, I looked around the bedroom. Afternoon sunlight was creeping guiltily from behind the heavy curtains. I looked back at the clock. Two-thirty in the afternoon didn't make any more sense than two-thirty in the morning. Why was the alarm set for such a ridiculous time? I reached out and hit the snooze button, knocking the clock off the nightstand. The ringing continued.

Ring-ring.

Ring-ring.

I had to deal with this noise, this stupid noise that was burrowing into my muddled brain and turning all of my thoughts to mush. I finally figured out that it must have been the telephone. I peered down at the chaos on the bedroom floor. I couldn't see the rugs anymore. They were buried under a thick layer of debris—abandoned clothes, magazines. There was a time when a scene like this would have filled me with horror, but not anymore. Instead I just shoved my hand into the mess, and struck gold first time around. I pulled the telephone out from under the mess.

"Hello?" I croaked. My voice sounded terrible. Like Elmer Fudd's. Raspy, weak, comical.

"Yes . . . hello. Is this . . . is this *Cherie Currie*?" said a voice.

"Yes. Who is this?"

A note of anger had crept into my voice. I had no patience for dis-embodied voices on the other end of telephone lines. They were inter-fering with my ability to get high or to sleep. Everything else that went on was a distraction from these two favorite activities.

"This is Michael Finnell. The producer of *Explorers*."

There was a long silence. I wasn't really processing the information. For a moment I zoned out until the voice talked again, sounding a little hesitant. "You do—uh—you do *remember* me, don't you?"

The information came at me through the fog. *Explorers* was a new movie, directed by Joe Dante. Didn't I have a role in it? I was sure I re-membered *that* much at least.

"Hello, Cherie—are you still there?"

I snapped out of it, and tried to assume a veneer of professionalism. "Oh, yes . . . I'm here. I'm sorry. Are we rehearsing already?"

"Oh no. Not yet. I just wanted to meet with you so we could talk over a few details . . ."

I yawned. I wondered if I could get away with putting Michael on hold for a moment so I could sniff a little coke. It felt like I needed it to continue with this conversation. Either that, or get off the phone as quickly as possible.

"How does today at five sound?" Michael said, after another awk-ward silence.

"Fine. That sounds . . . *great*." I sighed, without much enthusiasm.

"Good. Let me give you the directions . . ."

The voice on the other end of the phone started talking about left turns and right turns, and stop signs and street numbers. I tried to listen, but all of the words started blending together into a senseless babble that was receding farther, farther into darkness. I looked over to my jewelry box with heavy-lidded eyes. It seemed so far away. I would have to sit up so I could reach over to get it. And I was so warm . . . and comfortable . . . and happy in my bed. The voice went on and on. My eyes felt heavy. No . . . it was too far away. I would have to wait until Bruce got home.

From somewhere, far, far away, the voice was saying "Cherie . . . did you get that?" But I was no longer there. I was back in the numb

cocoon of a dreamless, deathlike sleep. The phone silently slipped from my hand. These little moments of death were beginning to feel more and more like home.

I was sitting in a chair, in front of the television, when the phone rang again. It was around six in the evening. I wasn't watching the television; it was on, but I couldn't concentrate on it. The house was a mess, but I didn't have the energy to clean it. I'd have eaten, but I didn't feel hungry. I would have gone back to sleep, if I hadn't just woken up. If I wasn't getting high or sleeping, then I was usually sitting around waiting until it was time to start doing one of those two things again.

Ring-ring.

Ring-ring.

I thought that maybe if I ignored the ringing, it would go away. But the answering machine was turned off, and the ringing just went on remorselessly. Eventually I forced myself to walk over to pick up.

"Hello?"

"Cherie—is that you?"

It was Scott, my agent. I was about to say, "Of course it's me, Scott," but he beat me to the punch.

"Did you get a call from Michael Finnell this afternoon?" he asked, sounding agitated. "He says he called you!"

I took a deep breath. I did remember something like that. I'd woken up with the telephone off the hook and lying on my chest. As I thought about this, something else came to me. Some vague, half-remembered conversation about a meeting. "I I think so," I answered.

Sounding more and more pissed off, Scott went on: "He said that you fell asleep while you were on the phone with him. Did that happen?"

"I—I don't remember."

I heard him give a long, exasperated sigh. "Cherie—how on earth could you possibly *do* that? Do you have any idea how hard it was to get you that role?"

I rubbed the sleep away from my eyes. "I'm sorry," I murmured.

"Tell him to call me again. Tell him to make sure it's later in the day next time, though."

Scott laughed, without any humor. "It was two-thirty in the afternoon, Cherie. How much later do you need? Who the hell sleeps to two-thirty in the afternoon, for Chrissakes?"

It was only then that I realized just how mad Scott was. The silence that followed was extremely uncomfortable. This wasn't the first time that my drug use had impacted my ability to work. I had been guest-starring in an episode of *Murder She Wrote* not so long ago when I'd decided to go home on my lunch break to smoke a little coke. I lost track of time, and when my sister Sandie knocked on my door, I was half naked, coked out of my mind, and vacuuming the floor. When I didn't show up after lunch, she'd received a frantic phone call from the set. Apparently Angela Lansbury was throwing a fit because I had held up shooting for the whole day. She was vowing that I would be eighty-sixed from CBS over it, and she stuck to her word. *Explorers* had been my big chance to prove that I could be reliable. I started to realize just what a big deal that stupid phone call this afternoon had really been.

"I might as well tell you," Scott said, "that they're dropping you from the film and they're giving your part to someone else."

Scott waited to hear what I had to say. This probably would have been a good time for me to come up with some brilliant excuse, or some eloquent speech about how I was going to snap out of my funk and pull myself up by my bootstraps. Instead, I couldn't think of a single thing to say. My silence sealed my fate.

"I'm pulling out," Scott said.

"Pulling out?" I parroted. "Pulling out of *what*?"

"I'm pulling out of *this*, Cherie. As of now, our contract is terminated. I am no longer your agent. Somebody else can go out there and bust their ass trying to get you a job. Frankly, I feel sorry for them. You don't deserve any work the way you've been conducting yourself."

I realized then that I suddenly stood to lose everything. An actress without an agent is really not an actress at all. She's no better than the millions of other people in Los Angeles who call themselves actors,

but are really waiters, video-store clerks, or bartenders. I was once a musician, but I no longer had a band or a record contract. If I lost my agent, then really . . . I was nothing at all. Not anymore.

"Please, Scott," I said, with genuine humility and fear in my voice. "Please give me one more chance."

Scott didn't even respond. The line went dead, and I replaced the receiver in shock. Suddenly an image flashed before my eyes. The scene in *Foxes* where Annie sees the truck speeding toward her at sixty miles an hour. Not even enough time to scream. I had finally done it. I'd finally reached the point of impact. Now everybody was leaving me. Marie was gone. My bandmates were gone. Daddy was gone. And now my agent was gone.

I began to shake. I felt cold, weak. I needed a drink. No, I needed coke. No, a drink. I didn't know what I needed anymore. Bruce! I needed Bruce. Bruce would tell me what I needed. And I would listen to him, because he loved me and he knew what was best for me. Mom and Wolfgang *hated* Bruce. They blamed him for the way I was. The last time I'd spoken to my mom she was crying and telling me that she wanted the "old" Cherie back. I didn't even know what that meant. Which Cherie did she want? I didn't even remember who this "old Cherie" was.

Ten minutes later, another call. My manager this time. A manager is even closer to you than an agent: an agent may sell you, but it's a manager who protects you and keeps you out of harm's way. After all, Hollywood is a violent, dangerous, dog-eat-dog town.

In a twenty-second phone conversation, punctuated by loud bursts of static, my manager dropped me as well.

When I hung up the phone, I suppose I should have cried. But I didn't. I was too dehydrated, and the tears wouldn't come. I sat and waited for Bruce to return. He was out working. Scoring some big deal. That was his job. I didn't have a job anymore, but God bless him, Bruce did.

I was standing in the living room. It was dark; all of the curtains were drawn. That's the way I liked it back then. I didn't like the sun to expose the mess that my life was in. I preferred to hide away in the darkness.

For the first time in weeks, I opened the curtains. The light poured in, and I had to close my eyes. Even with my eyes shut tight, the

brightness hurt. It burned through my thin, translucent eyelids. I suddenly felt light-headed. I knew that if I didn't sit down, I might faint. But I didn't sit down. I refused to sit down, or lie down. I breathed instead, feeling the irregular pounding of my heart. My heart had been twitching and skipping inside my emaciated rib cage for what felt like forever. It felt as though it was going to crank one last time and then die, just like an old automobile.

With the light flooding the room, I turned to look in the full-length mirror. I had always been able to gaze in the mirror and see whatever I wanted to see. After all, mirrors are only as truthful as the eyes that are looking into them. Today, for the first time in as long as I could remember, I demanded that the mirror show me the truth.

I looked at myself.

If I'd had the strength to scream, I would have. The scream would have been so loud that the mirror would have shattered into a million pieces, and I wouldn't have to look at the monster reflected in it for a moment longer.

That monster could not be me. That skull, with a mop of stringy hair on it, was not *me*! The thing in the mirror had eyes so dead, so lifeless, that they made me shudder if I looked into them for too long. The thing in the mirror had skin that was haggard and gray. The grayness was not *on* the thing in the mirror, it was *in* it. It permeated every aspect of my reflection, especially the eyes. The grayness was even inside, choking the life out of that struggling, irregular heart.

Cocaine had destroyed me; it had taken Cherie Currie far, far away and left in her place this hideous zombie. At that moment I craved coke more than I craved life. The problem was that right then there was no coke to be had. Until Bruce returned, I was without. Maybe that was a good thing. It occurred to me that I could get out, right then, before Bruce returned with more of the stuff. It occurred to me that this could be my last chance, because if I was still waiting to hit rock bottom, I was a fool. I was already down there, and had been for a long, long time.

My car was in the driveway. It didn't hold very much, but it held enough. I grabbed a handful of clothes. I grabbed some records, but then I dropped them again. On top of the pile I had dropped was

Hunky Dory by David Bowie. One of my favorite albums. But I didn't need it, not anymore. Instead I grabbed pictures—pictures of Mom, Dad, Marie, Sandie, and Donnie. I grabbed whatever I could carry before stumbling out to the car. I didn't even bother to go back and close the front door. I wasn't just leaving: I was fleeing, scared for my life.

I didn't look back. Some hysterical part of me thought that if I did, I would see Bruce standing in the doorway, with that big glass pipe in his hand. He'd be holding it out to me.

Just one more hit. One more for the road.

I knew that if he really was standing there with the pipe, I would do it. And then I would never be able to leave. I had to get out right now.

I started my car, stuck it into drive, and peeled out. With a screech of rubber I careened down the hill, nearly wiping out altogether in my rush. There was never any question about where I would go: I was heading to the Valley, out toward my aunt Evie's house. It seemed like it was a long, long way away but I knew I would make it. I had to. Right then, right there, I knew that making it to Aunt Evie's house was the only chance I had.

In a weird repeat of the scene I had been through with my dad, I found myself in a sterile hospital room while a doctor said things that scared me. Only this time the doctor was talking about me.

"I want you to know before we admit you," he was saying, "that you are in the terminal phase of your addiction. You weigh ninety-seven pounds. Your heart is in danger of failing, and so are the rest of your organs. If you hadn't come in, I honestly feel that you would have been dead within weeks."

I nodded weakly. The withdrawal had already begun. I was sweating, but I was cold. My body was screaming for cocaine. I was in the detox unit of a hospital in San Pedro, and I was set to be there for thirty days. Once the worst of my withdrawal was over, they would move on to rehabilitating me. If I could be rehabilitated.

Marie was sitting beside me, watching me as the doctor spoke. I

was trying to unwrap a candy bar, but my hands were too weak. She reached over and took it from me, unwrapped it, and then handed it back. I put it in my mouth, but I didn't have the strength to chew.

They put me in a wheelchair and rolled me away. Marie vanished behind me as the nurse pushed me through some double doors into a long, bare corridor. The medication they had pumped into me was already taking effect . . . I felt awful, but the worst was yet to come. It seemed hard to believe, but that's what they were all telling me.

When Marie caught up to me to say good-bye, I was already asleep, with the candy bar hanging out of my mouth. It would be the image she took with her as she started back on the long drive to the Valley.

33

A New Life

I wish I could tell you that it was as easy as staying in the hospital for a month and then simply emerging cured. But of course, nothing is that easy. I learned many things during my time in the hospital. One of the things that people kept telling me was an Alcoholics Anonymous mantra that went: "The definition of insanity is doing the same thing over and over, and expecting different results."

It didn't take me long to figure out exactly what this meant.

I wasn't sure about how well Alcoholics Anonymous would work for me. I didn't know how well anything would work for me. When I entered treatment in San Pedro, I felt that perhaps I was beyond saving. I remember very clearly that first time I stood in front of a room full of people and actually said, "My name is Cherie Currie. I am twenty-four years old. I am a cocaine addict and an alcoholic." It was definitely a hard thing to admit.

It was a hard thing to admit because some desperate part of my brain simply did not want to *believe* it. I did not want to believe that something that had been such a big part of my life for so long was no longer in my control. I had been doing drugs since my early adolescence. The idea that they would no longer be there for me was terrifying. "I've been an addict for almost a decade . . . and I need your help to make me well again."

I was just a few weeks into my treatment when I stood in that meeting and said this. I was still feeling weak and shaky, and my emotions

were intense and confused. Then, something very profound happened that day. I started crying, and I had to leave the podium without saying any more. As I walked back to my seat, I felt the hands of the people around me touching me gently. I felt hands on my shoulders, hands on my back. That touch, that connection with other people who had shared experiences similar to mine, seemed to lift me up and hold me away from the pain. I looked at them, people of all ages, from different walks of life, all of them drawn together by a shared problem and a shared desire for change. In their eyes there was something that I'd long felt I could never have again. There was *hope*.

I wanted to be like them. I wanted to feel hope again. That was the first moment that the thought occurred to me that if I really stuck with it, if I followed instructions and I attended meetings, then maybe— just maybe—I could claw my way out of the hole I had dug for myself. But only if I did it—as everybody was quick to remind me—"one day at a time."

But back to that other phrase, the one about insanity and doing the same thing over and over and expecting different results. I don't suppose that I was very different from the countless others who have left drug rehab full of determination to stay clean and then fallen at the first hurdle. Once I was out of the hospital, once I was no longer surrounded by my peers, by drug counselors, by the institutional safety of the treatment facility, I promptly relapsed.

I called Bruce, and told him I wanted to get high.

Of course, it was just meant to be a one-shot deal. A reward for sticking to it through thirty days of treatment. I felt healthier, and more determined than I had felt in a long time. This time, I thought, I would be able to handle it.

I guess I don't have to go into too much detail about what went on in those three days. I learned that all the warnings the drug counselors had given me about what would happen if I used again were true. They told me that I would never be able to go back to "normal" drug use. They warned me that something had altered in my brain chemistry, and that any drug use would send me back to a place that was as bad—if not worse—than my most recent "bottoming out." I learned the hard way that these weren't mere words or scare tactics. They were the absolute

truth. The moment that I put that crack pipe to my mouth and took in a great lungful of that numbing, white chemical smoke, I became a different person. The thirty days of being clean that I had achieved melted away in an instant. There was no enjoyment in it anymore. There was no euphoria. In that instant I regressed to a place of such utter desperation and drug need that by the time I fled Bruce's house for my aunt Evie's place in a virtual replay of what had happened a month before, I knew that I would never, ever touch cocaine again.

When I stopped again, after just three days of being back on coke, my body went into a kind of shock. The first night in Aunt Evie's house, I slept with her in her bed while the drugs worked their way out of my system. Without medication to ease me through the process, I experienced vivid hallucinations that seemed totally real to me. I woke up in the wee hours of the morning convinced that the bedroom was on fire. As the orange and red flames licked at the mattress, I realized with mounting horror that huge, mutant crabs with clacking claws were swarming all over me. I was kicking at their vicious, snapping maws and pincers. I screamed and screamed and screamed, literally crying in terror with my aunt Evie rocking me like a child, trying to calm me down.

"There's nothing there, sweetie puss . . . It's all going to be okay . . . Shhhh . . ."

I would be back in the hospital again very soon. This time I wasn't a patient. I looked awful, but not as bad as I looked when I'd checked into treatment all those weeks ago. Since detoxing at Aunt Evie's house, I had been doing better. No cocaine, no booze, nothing. I'd gained some weight—twenty pounds—and I regularly felt hungry again. My heart had resumed its steady, rhythmic beating and I didn't shake the way I used to. But most of the time I still felt weak and depressed— like I had been robbed of my emotions.

The doctors had warned me about this side effect. They told me that cocaine rapes your mind of its natural endorphins—the chemicals that enable you to feel good. My brain had spent so long pumping them out at an artificially high rate because of the cocaine that its

supplies were totally depleted. Feeling good, or even feeling normal, was a distant memory. The one thing that I clung to was that they'd promised that in time this feeling would go away, and my brain's natural chemistry would realign itself.

But here in the hospital, that was still a long way off. I slowly climbed the stairs to the third floor. I avoided elevators because even climbing stairs felt like a victory to me. When I reached the ward, I walked toward the huge glass panel. I could hear soft sounds in the room on the other side. What I saw made me feel light-headed: I placed my head gently against the glass as I took in the scene. A thought occurred to me: my father died in this hospital. I felt tears coming, but they were not tears of sadness; they were tears of joy. I realized that maybe my long-frozen emotions might finally be thawing.

On the other side of the glass, in the nursery, were six newborn babies. It took me only a moment to realize which one was my niece. She had Marie's nose and mouth and Steve's eyes. She was the most beautiful thing I had ever seen. I put my hand gently to the glass and mouthed "hello" to this tiny miracle.

Her name was going to be Cristina. Cristina Marie Lukather. She was born yesterday, but I wasn't there. I didn't think that the family wanted me there. I knew Marie didn't. She had said so. It was too soon, too many bad associations. I was carrying too much baggage, and that kind of darkness had no place in a maternity ward.

I was sober, though. And so long as I held onto that, I knew that everything else would be okay. It was Marie, Steve, and even Bruce who'd put up the money for my stay in the treatment facility. Today, illuminated by the good, clean sunlight that poured into the maternity ward, I could look at the people in my life with a new understanding. Even Bruce, poor Bruce, who was still so tied up in his own addiction, had tried to help me. Marie, who probably didn't believe it would work, still put up the money to help me get clean. Marie had heard me deny my addiction for so long that I'm sure she felt I was beyond saving. Despite all of the hurt that we had piled upon each other in the past ten, tumultuous years, my sister had come through for me. Now it was my turn. Now it was my chance to prove that I was worthy of her trust.

A nurse stepped into the nursery and gently picked up Tina. I followed her to Marie's room and stood at the doorway watching the two of them, watching Marie hold her daughter as if they were the only two people in the world. As the nurse left, Marie looked up and saw me. A troubled look flickered across her face, and then she looked quickly down at her baby again. I felt like I was violating a precious moment. The urge to hide my face and run out of the hospital came over me. Instead, in a quiet voice, I said, "Hello, Marie."

"Hi, Cherie."

"She's beautiful."

Marie smiled at that. "Isn't she?" she said, her voice dripping with wonder. Marie, the new mother, looked tired. She looked up to me again and asked, "How are you?"

"Fine."

We remained in silence for a moment, the only sound the tiny, almost musical cooing of Tina. There was a wall between Marie and me. Her guard was up, and although she was only feet away from me, the gulf between us seemed unbridgeable. I thought briefly of that rainy day when she drove off, leaving me covered in mud, drunk and high, because she couldn't bear to watch her twin sister debasing herself any more. She couldn't watch her twin sister kill herself in this most humiliating of ways for one more day. I suppose that she was even allowing me in the room after all of that was a tiny miracle of its own.

"I'm sober," I said.

"That's nice."

"I mean I'm *really* sober. For good this time."

"I'm glad for you," Marie said icily.

Of course, she didn't believe me. How could she? Nothing could really make her believe except the evidence of her own eyes. How long would be long enough? Thirty days? Sixty? When do you realize that something is forever? All I knew was that I had to stay true to my promise, and live my life without drugs or alcohol. Then, maybe one day . . .

I looked at Tina. She was smiling and gurgling, and seemed more content than any human being in the world. She was so beautiful, so

innocent and pure. All I knew was that I wanted her to remain this way forever. Of course, I wanted to ask Marie if I could hold her, but I didn't dare. If she had said no, I didn't think I would be able to take it.

"I really am through with drugs, Marie. And alcohol, too. I mean it. I even quit smoking."

"That's nice, Cherie," she said again.

I felt stupid for even saying it. There was no use trying to convince her with words. Words are cheap. Maybe Marie knew me better than I know myself. Or maybe she just knew the old me. This new me, who was emerging blinking into the light after ten years of being scared, in pain, numb, and consumed by sadness was new to *me,* too. We'd have to get to know each other all over again. That would take time, though. But I held on to the hope that someday, some way, my sister would be able to forgive me. That I'd be able to forgive her. That maybe I'd even be able to forgive myself.

I wanted that more than anything else in the world.

34

The End of the Ride

t was June and the days were getting longer. The sun rose in the mornings and fell at night with a reassuring regularity. The passage of time no longer seemed daunting to me. Without cocaine, pills, and alcohol ruling my existence, the clocks actually started to make sense again. I had been clean for three months, and I was no longer a neon blur in the fast lane. I was no longer the Cherry Bomb. I was plain old Cherie Currie again, and I liked it.

For the past three months, I had been attending twelve-step meetings twice a day. I felt healthier and happier than I could remember feeling in a long, long time. My old friends, the friends who knew me from the days when I was the ultimate party girl, would sometimes laugh and tell me that I didn't need those meetings anymore. "You're clean!" they would tell me. "So why do you keep going?" I'd just smile, because they didn't understand. Not really. I was smart enough to realize that if I didn't keep going to those meetings, at least for now, there was a very good chance that I would use again. It might just have been a glass of wine or a line of coke that somebody offered me at a party, but I knew how easily I could convince myself that one line, or one drink, was okay.

It was amazing to me how all of the alcoholics and the drug addicts that I met in those rooms seemed to have stories similar to my own. They might have been mailmen, nurses, doctors, or musicians, but their addictive behavior almost always followed an identical pattern. When I

heard them speak about their experiences, it confirmed for me that one drink or pill or line would take me right back to where I started. With every day of hard-won sobriety, the stakes got bigger. With each passing day, I stood to lose more and more if I decided to use again. No—I did not want to start over. I did not want to ever feel that horrible sickness, that utter and incomprehensible demoralization, again. The meetings were my way of ensuring that this didn't happen.

I took a job at a place called Designer Linen in the Topanga Canyon Plaza Mall. The first-ever "real" job of my life. When the man asked me what I wanted an hour, I didn't have a clue how much to ask for. Unsure, I mumbled, "Two fifty?" He smiled and was more than happy to oblige. It wasn't until a few weeks later that I found out that the legal minimum wage was $3.25. I was making less than Marie used to make at the Pup 'n' Taco. At times, that was difficult. Never in my life did I have to work so hard for so little. It felt slightly embarrassing to have a job in a mall after everything I had achieved in the past ten years . . . but I *wanted* it. I wanted to feel normal for once in my young adult life, and it made me proud to stand on my own two feet. That was what was most important to me, not what anybody else thought about it. To me, it was an adventure. An adventure in reality and humility. I was able to take home eighty dollars a week, and all of that money went to help Aunt Evie with the groceries. After everything that she had done for me, this small form of restitution made the petty annoyances of working at the linen store feel worthwhile.

I was the only person working at the store except the owner, and often the work was backbreaking. My boss was an olive-skinned man with a heavy Arabic accent. One day I confronted him about my salary, angry that he hadn't informed me about the minimum wage when I'd applied. He laughed, and said it had shocked him that I'd asked for so little, and gave me a raise on the spot. "I was just giving you what you asked for!" He smiled. He was awful, really. But there was nothing else in the world I *needed* to be doing more than working there. Working at the mall gave my life structure. The sun rose at six, and I was up by seven. I was at work by nine and home at six. It might seem strange, but this kind of routine was completely alien to me.

I was "paying my dues," plain and simple. I needed to. I wanted

to touch the face of reality; I wanted to look with pure crystal clarity at how close I had come to dying. To candy-coat it in any way would be a travesty, and I knew that it could possibly lead me on the road to destruction once again.

When I was fifteen years old, I imagined that I could just jump into being a rock star, and never have to struggle for it. It was like one of those rides at the carnival where the bottom drops away and you're stuck against the wall, spinning wildly, feeling sick and disoriented, unable to get off or even move until the ride stops. When you finally get off a ride like that, you have to grab onto a wall or a pole, just to get your balance back. I thought of the job at Designer Linen as my pole.

One day I was folding and stacking linens when a familiar face came into the store. I looked at her, and then froze. She didn't recognize me at first. Of course, she wouldn't have; she would never have expected to see me in these circumstances, working at a linen store in the To-panga Plaza Mall. She noticed me staring, but I guess she was well used to people staring at her. Everybody recognized her in those days. It was strange to think that I'd beat her out for the role in *Foxes*.

She stopped, looked again, and then her eyes opened wide in recognition. "Cherie? Is that . . . you?"

"Hi, Rosanna," I said quietly. I had become friends with Rosanna Arquette because of my brother-in-law Steve Lukather and Toto (the song "Rosanna" was written about her).

There was a mix of emotions when Rosanna came over to me. Shame? Maybe just a little, but it wasn't shame for what I was doing there—working like other normal, everyday people do every day. It was what got me there that made me ashamed. The urge to run away came over me for a moment, but I told myself that there was nothing to be ashamed of. I was much more proud of myself in those days than I had been in a long, long time. I may have thought of myself as the glitter queen in the distant past, but in those days I was the unhappiest I had ever been. Today my happiness did not depend on what other people thought of me. It did not come from a pipe, vial, or a bottle of booze.

"Cherie . . ." Rosanna was looking at me with this bemused amazement on her face. "Cherie! What on earth are you doing *here*?"

"Working," I said, giving her my proudest smile.

"But . . . but what about your music? What about your acting?"

I shrugged calmly. "There'll be time for that again," I said. "Just not right now."

"Well . . ." I could see that she was totally caught off guard by this, and she was struggling to find the right thing to say. "Well . . . you look great. You look really *great*, Cherie."

"Thanks!"

That was a compliment that I really needed. Since getting clean, I had put on twenty-five pounds, and looked healthier and more alive than I had in years. It was nice to get the reassurance.

"I feel great," I told her. "You know, I've been off drugs for six months now." I didn't mind telling her that. It was no great secret that I used drugs, and to be honest, it seemed that everyone in Hollywood had a drug problem of one kind or another. Hollywood people would admit to being drug addicts long before they'd admit to having plastic surgery. "I'm in the twelve-step program," I added.

She reached across the counter and took my hand. She smiled warmly and said, "Good for you." Then she laughed slightly. "I know plenty of people who *should* be doing what you're doing."

"I saw your last movie. You were great."

Actually, I'd seen all of the movies she'd been in. *Desperately Seeking Susan, Silverado* . . . Rosanna was a fantastic actress. In the early days of my sobriety, it was hard to watch movies, especially any movies that starred contemporaries of mine. It reminded me too much of what I had lost. It made me realize that I could have had roles like that if I hadn't let drugs tear my career apart. But I made myself get over it. That was ego, pure and simple, and those kinds of thoughts always led nowhere.

"So, how's Marie?"

"She's fine."

It still wasn't easy to think about Marie. There was a lot of unresolved hurt there. Something had profoundly altered between us. Sometimes I wondered if we would ever be able to get back to just

being sisters, without any of the bullshit that went on between us, poisoning the air.

"Have you seen the baby yet?" I asked.

"Not yet. Soon, though."

"Excuse me, Cherie! I need you!"

That was my boss. He hustled over, ranting and raving as usual. Whenever this happened, the urge to tell him to stick his lousy job would come over me, but I always resisted. The old Cherie would have done that and not thought twice about it. But I didn't want to be the old Cherie anymore.

"Come on! Ring her up! No time for conversation!"

I smiled at Rosanna, and she handed me her linens. I could see that the fact that I was waiting on her made her feel uncomfortable. It didn't bother me, though. Not even my pain-in-the-ass boss, standing over me and glowering at us, could ruin my mood.

Before she left, I made eye contact with Rosanna for a moment that seemed to last a lot longer than it really did. I handed her the bag.

"You know what, Cherie?" Rosanna said to me. "You have a lot of guts."

I smiled my thanks at her and watched her walk out toward the entrance, back to a life that—for now—I was no longer a part of.

35

This Side of Forever

Ventura Boulevard never changes. Not really. New buildings go up, old ones come down, but the landmarks remain pretty much the same. Everybody who lives in the Valley has their own landmarks along Ventura Boulevard, and I'd guess that no two people have the same ones. I was pondering this as I took a trip down that boulevard on my way from Aunt Evie's place to Studio City. The warm morning air felt good against my face as it blew through the open windows of my car.

Two years sober. This was quite an achievement. The idea that I could abstain from drugs and alcohol for two whole years would have seemed impossible to me once upon a time. But today, I was there.

I was nervous as I made the drive. A niggling anxiety. It reminded me of that time, ten years ago, when I was auditioning for the Runaways. My hands were cold again; clammy, too. Back then, I was a scared little girl with sweaty hands and sweaty armpits, who thought that the whole world rested on a mean guitar riff and the beat of a bass drum. Today I was nervous for a different reason. This wasn't an audition. It was much more important than that.

As I cruised down the boulevard, I crossed Hayvenhurst Avenue, the street that led to our old house. There on the corner was Gleason's Wine Store, where Marie and I used to hang out in the days before we'd discovered places like Rodney Bingenheimer's and the Sugar Shack. Then, two blocks up the road, there was the old house. No doubt that forty-two-thousand-dollar piece of property was now

worth close to a million at least. The pool would still be there. Maybe new kids were teaching themselves to do flips off the board. Different families would be starting out there, maybe breaking up and getting divorced, too. Then houses would be sold again, and new lives would start all over again within those walls. I wondered absently if houses had some kind of sentient memory of the pain of all those failing families who'd once lived inside of them.

I wondered who was in my old bedroom. What posters would be covering the walls today. Maybe Def Leppard, or Bon Jovi. Or had those posters already come down, to be replaced by next season's stars? Hell, maybe Bowie was still up there. Through the years, Bowie had always seemed to stay in style. David Bowie, Elton John . . . all of those sounds that had once pumped from the PA of the English Disco were still resonating in this new era.

I met a lot of stars during my time in the Runaways. More than I can probably remember. While all of it was going on, I was so loaded on pills, and booze, and coke that I'm sure I have forgotten as many of them as I can remember. But one that I'll never forget is David Bowie.

He came backstage after one of our shows. I remember that my heart just about jumped out of my chest when I heard he was there with Iggy Pop. They were touring together at the time, to promote Iggy's album, *The Idiot*. Then I turned and saw him. It was one of the most surreal encounters of my life. He came over to me and shook my hand. Wearing a scarf, sunglasses, and an English cap, he told me that he'd enjoyed the show, in that inimitable British accent of his.

I can't remember a word of what I said to him. I was totally and utterly starstruck. I do remember that he seemed smaller than I'd imagined. Quieter, too. He was shy and distant, as if there were a million important things he was quietly pondering. He looked . . . well, he looked like a *man*. A musical genius perhaps, but just a man nonetheless. Not the god that I had once believed him to be. After my initial dazed reaction faded away, I remember looking back at him and thinking, There's David Bowie. *Okay . . .*

I think that this is every rock star's secret fear. That someone will cut through the wild, bigger-than-life image that the Kim Fowleys of this world paint and just look them right in their face and say, "So

what? You're just a human being. Just like me." It took me a long time to realize how ridiculous it was to think that a rock star could be anything more than that. That *I* could be anything more than that.

The Runaways had all taken different roads now. Joan Jett, of course, had become the star that we all knew she would be. Lita, too, had gone on to achieve solo success. Sandy was still drumming, although her life would be tragically cut short by lung cancer in 2006. Jackie left the music industry altogether. She was back east in law school, and I'd heard that she wanted to be the mayor of Los Angeles one day. It was a scary thought, because a part of me believed that she might actually *do* it.

Up ahead was the Fireside Inn. Daddy's favorite restaurant. One of my earliest memories is of being there with Dad, Mom, Donnie, Sandie, and Marie. Marie and I must have only been around three, fighting and squirming around in a booth. I have an image of Donnie sitting in his high chair, trying to figure out how to use a spoon. Now the sign on the restaurant says TWAINS. Farther along again, at the Coldwater Canyon intersection, was the Denny's where Tommy crashed Daddy's car while I was unconscious in the passenger seat. The light post we rammed was still there, as solid and sturdy as ever.

Up in the hills around Coldwater Canyon were the houses that hung from the mountainside on poles, balancing dangerously on the cliff, like the spinning-plate act in a sideshow. Houses just like Bruce's. Dangerous homes, where dangerous parties took place every night. Parties where nobody really knew or liked anyone else, but we all pretended like we did. Parties where we talked a lot, but said very little. The years have gone on, and music and fashion have changed, but the spinning-plate homes still do their balancing act up there, and the spinning-plate people still throw parties full of strangers. One thing I knew for certain was that I was glad I wasn't one of them anymore. There was a time when I used to think you're either living or dying. Living was doing whatever you wanted. Dying was everything else. I believe that's true for the practicing alcoholic or addict. Now I live to *live*, and in these last two years I'd squeezed as much as I could out of life.

. . . .

I could see Marie in the garage and Tina in there with her. I stopped at the bottom of the driveway and watched Tina—who had just turned two—hopping around madly on one foot. She had just learned how to do it, and was obviously very excited about it. Marie, who was eight months pregnant with her second child, was sculpting. Marie had been sculpting ever since we were children, and she was amazingly good at it. Even though she did it throughout most of our childhood, I had never really taken much notice until recently. In these past two years, I felt like I had really been *seeing* for the first time.

I took a moment to think. *Was I really ready for this? Was it too soon?* I looked at myself in the mirror and told myself not to worry. I continued up the driveway.

As I stepped out of the car, Tina came running toward me, flashing those beautiful blue eyes in excitement. *"Aunticherie!"* she cried. *"Aunticherie!"* That's how she said it, as if it were all one word. She jumped into my arms and hugged me. A happy thought occurred to me just then: Tina had never seen me on drugs. She had never known the old Cherie. I was very grateful for that.

"Hey, Cherie!"

Marie gave me a hug. The hug was strong and warm. The kind of hug that felt like it had been a long time coming. Two years ago our hugs were as cool and reserved as they could be. But with each passing day of sobriety, they had thawed. Today that gulf between us that I had felt in the hospital was just a painful memory.

"Wow, what are you working on?"

"My latest creation . . ."

In the garage I looked at the sculpture admiringly. It was a statue of an alien, and it was a magnificent, graceful, and whimsical creation. Then Marie took my hand and placed it on her belly. I could feel the soft rippling of her tummy as the baby kicked.

"Oh my God." I laughed. "Any day now!"

"Maybe he'll be born on Tina's birthday," Marie mused. "Wouldn't *that* be a trip?"

Tina was hopping around us on one foot, impatiently.

Marie glanced at the name tag on my jacket. I had come straight over from work, and hadn't had time to get changed. "Wow, Cherie . . . look at you!" She laughed. "You're a full-fledged drug counselor now. How does it feel working with those kids?"

"I like it." I smiled. "I like it a lot."

I had been working at Coldwater Canyon Hospital for over a year. I began as a tech, and then took a course to qualify as a counselor for drug-addicted adolescents. The work was intense, and could be emotionally draining, but ultimately it was very rewarding. It amazed me how in the end our stories almost all seemed the same, no matter what the background, the drug of choice, or other mitigating circumstances.

Unable to take it any longer, Tina blurted out, "Aunticherie! What about the pony rides?"

I knelt down and picked her up. I nuzzled the soft skin of her neck. "That's right!" I laughed. "We can't keep the ponies waiting!"

I turned back to Marie, with Tina in my arms. I could see the mild lines of worry forming on her forehead, but they quickly vanished in a smile. Today was the first day that Marie was letting me take Tina out unaccompanied. The first day that she would trust me to take her daughter for the whole day. For me, it was the most wonderful occasion I could imagine. It meant that finally my sister trusted me again. She trusted me enough to leave her daughter in my hands. I felt that today, the ghost of the old Cherie had finally been laid to rest.

After I carefully strapped my giggling niece into the child seat, Marie leaned in through the open window and kissed me. "I hope you guys have a great time," she said. "Enjoy your day together."

Thanks, Marie. We will . . ."

"I know Tina is safe with you," Marie whispered, looking at me with eyes that radiated pride. I started to cry a little at that.

Tina noticed my tears in the rearview mirror and quietly asked, "Are you sad, Aunticherie?"

I shook my head and smiled at her. "No, baby," I said. "I'm the happiest I have ever been."

Marie stepped back as I pulled out of the driveway and headed slowly, carefully, down the hill. I kept glancing in the rearview mirror

at the smiling, giggling, beautiful little girl in the backseat. I had to blink back the tears. I knew that whether or not I ever got another recording contract, whether or not I ever acted in another movie, whether or not I ever performed again . . . none of it mattered. Not really. Everything that mattered was right here in this car. All that mattered was Tina, and all of the unconditional love that I felt for her.

I knew that with this one step I could finally lock all of that pain from the past away in its own velvet tomb. Lock it up and throw away the key. All this because of the giggling, smiling child in my car. A child who is more important to me than all of the money, fame, and records in the world.

Because Tina loves her auntie Cherie.

And if she loves me, then it must mean that I am worth loving.

AFTERWORD

Looking back on my life since that fateful day with my niece Cristina, I really see how truly blessed I am. Many years have passed, we have orbited the sun more then 7,500 times and I have seen such extraordinary things, and had so many profound experiences that I could easily fill the pages of another book. In the years since the Runaways I have lost some of my dearest friends, and I have reinvented myself time and time again. But through it all, the wonderment and personal triumph that emerges from the emotional depths I have experienced leave me knowing I wouldn't have changed a thing.

Sandie and T.Y. split in 1982, and both went on to meaningful, long-term relationships, though sadly Tony Young passed away from lung cancer in February of 2002. In 1989 Sandie married director/producer Alan J. Levi. Sandie has continued with a successful acting career, and recently appeared in the blockbuster summer hit *The Hangover*, the highest grossing R-rated comedy of all time.

Shortly after the release of my original book, *Neon Angel: The Cherie Currie Story*, in 1989, I left my job as a drug counselor after two years, and became a personal fitness trainer. I loved it. Talk about a 180, from hopeless drug addict to a focused, fitness guru! I was also working weekly with a voice-over group called the Studio City Carvers, looping everything from TV shows like *Colombo* and *Quantum Leap*, to major motion pictures like *The Sandlot* and various Adam Sandler productions.

When I wasn't doing voice-over work, most of my time was spent in the gym, and it was there, on a sunny November afternoon in 1989 that Marie introduced me to the actor Robert Hays. Of course, I already knew who Robert was via his work, which I had loved. One of his most famous roles was in one of the largest-money-making comedies of all time, *Airplane!* Robert had also starred in the ABC television series *Starman* and *Angie*. I was later surprised to learn that he had started out in the theater, doing a wide variety of dramatic roles, including Shakespeare.

Bob was interesting, down-to-earth, handsome, witty, and just as wonderful as he was depicted on the screen. Hell, I thought he was the sexiest, funniest actor out there. We were married just seven months later, on May 12, 1990. It was the first marriage for us both. On our two-day honeymoon in Montecito, California, we decided to throw condoms to the wind, and I discovered I was pregnant that July. Bob continued to star in some classic family films like the Walt Disney hit *Homeward Bound: The Incredible Journey,* and he also lent his voice to many television commercials and did countless voice-overs for animated films and TV. But Bob says his favorite production by far is the one he and I made together—our son, Jake Robert Hays, born February 8, 1991.

Jake, who turned nineteen in February, was an artist from the start, drawing in two dimensions at the age of four. His teachers claimed they had never seen a student like him. He picked up the guitar at age twelve, and has been writing, singing, producing, and recording music ever since. His appreciation for Japanese art set in motion a love for the art of tattoo. He has been a praised tattoo artist for more than a year and even Martha Davis of the Motels is adorned with a tattoo, her one and only, courtesy of Jake. But mostly Jake is a wonderful person to the core, and Bob and I really can't take credit for who he has become. We can only sit in awe and utter disbelief at this pure and wonderful human being that we have had the honor of bringing into the world.

Though our marriage ended after seven years, Bob has remained my best friend and Jake has benefited greatly from the loving relationship we have to this day. In recent years Bob has helped to create

an annual golf tournament to raise money for the SAG Foundation, which provides help to actors in need. He is just that kind of guy, and I'm so happy that I still have him in my life today. I call him "the Best Ex-Husband in the World," and he has earned that title, believe me. I love you, babe!

Marie and Steve stayed together for thirteen years. They separated shortly before Bob and I were married, and then divorced after nearly ten years. Their son, Trevor, now twenty-three, has followed in his dad's footsteps in fronting his own band, and has also toured as a guitar player for Lindsay Lohan. He continues to write and record, and I have no doubt he will make his mark on the industry just like his father has. Steve Lukather has been on the road nonstop with several side projects since the end of his first band Toto after thirty-plus years. In 2009 he was inducted into the Musicians Hall of Fame in Nashville.

Steve is now enjoying a new life with his wife Shawn and their two-year-old daughter, Lily Rose. Cristina Lukather, now twenty-five, was born with one of the best voices in the family and continues to strive and thrive.

In 1997 Marie began answering phones for a mortgage company that our brother, Don, was working for, and she soon worked her way up the ladder. She became an accomplished account executive. She is now a sales and branch development manager for HighTechLending, Inc., a mortgage bank created and owned by our brother Don Currie based in Irvine, California.

Speaking of our brother, Don, he went on to travel the world. Sometimes with just a backpack and that ever-present yearning for adventure. He graduated with a triple B.S. degree from Cal State University Northridge in business, finance, and real estate. He has served as a mortgage professional for twenty-eight years, and is also a national speaker and published author. HighTechLending, Inc., currently has forty-five branches and two hundred employees. He lives in San Juan Capistrano, California, with his wife of eleven years, Vena, who happened to be Jake's first preschool teacher. I thought Vena would be the perfect match for my country-hopping, daredevil brother, and I was right. They now have a beautiful daughter, Grace, who just turned nine.

Mom and Wolfgang are still married after thirty-four years and

live in Westlake Village, California. Mom just turned eighty-six, and dad, ninety-five. Mom recently fought and won yet another battle with colon cancer and she is considered a true miracle. She's a wonderful mom and we have made up for our lost years in spades. Our family is blessed each and every day that we have her and dad in our lives.

Aunt Evie passed away in December of 1999, the very month that she dreaded, and we miss her. She was responsible for the strong foundation our family was built on.

During my marriage, I continued doing TV guest appearances, and continued performing onstage here and there. I wrote songs, and recorded and starred in another film in 1991 called *Rich Girl* that I thought was terrible. I moved to Chatsworth, California, in 1997 after Bob and I divorced, and it was there that I became good friends with a man who would have a profound influence on the rest of my life, Kenny Laguna. Kenny had contacted me to be involved in the lawsuit to regain the lost and stolen royalties for the Runaways. Kenny and Joan Jett believed in the legacy of the band and in what it stood for. Together they found Chuck Ruben, an artists' rights activist in New York, who fought to regain the name and the lost and future royalties of the Runaways. Lita Ford and Sandy West joined in the fight, and through Kenny's persistence, we were finally awarded the rights to what had been stolen from us twenty-five years before. Kenny and Joan have done more for the legacy of the Runaways and its members than anyone else could have. Since then, Kenny and I have remained close, and Joan and I were able to rekindle a friendship that had been dormant for twenty-two years.

I bought my first home in 1999 and found that the only thing that felt fulfilling to me was art. I started painting, but felt I needed to take it a step further. Two-dimensional relief carving was the next step in my desire toward a more three-dimensional art form. In early 2002, when I was driving to Malibu Beach, I passed two guys chain-saw carving by the side of the road. I was immediately fascinated by this dramatic way of creating art. I walked into the Malibu Mountain Gallery and was amazed by the beautiful mermaids, tikis, bears, and sea life all created with such a brutal and dangerous machine. I heard that voice in my head saying, "You can do this, Cherie!" and I did. I

talked to the owner, Rio, who is a jolly guy with a constant smile on his face, and has a skilled command of the killing machine in his hands. He looked at my artwork and agreed to teach me how to carve. But you can't really "teach" someone to chain-saw carve. If you can't see the three-dimensional piece in your head first, you won't know where to start. Rio taught me how to not kill myself with the saw, and helped point out some of the finer techniques that are so hard for the untrained eye to see. For that, I will be forever grateful to him.

I started my own business in 2002 at the Log Cabin Mercantile in Lake Manor, with the help of owner Suzy O'Dea. In 2005 I opened a larger business in Chatsworth and started competing in chain-saw competitions in the Pacific Northwest, placing in two of the three competitions I participated in.

It was during this time that I decided to rewrite my original book *Neon Angel* and tell the stories that I couldn't tell in my young-adult book. I also brought it up to the present. Kenny Laguna took interest in the book in 2005 and started shopping it to heavyweight publishers. Although he was initially hit with resistance, Kenny continued to believe the book was worthy of a new publication and remained persistent even after I had long given up the dream.

I was a full-time mom and carver while Jake was in elementary and middle school. Bob had Jake on the weekends, which gave me the time to concentrate on the more complex orders that I had. Bob has been so supportive and we were always there for each other if one of us needed to leave town. This was happening more and more as I was starting to get television work and jobs doing demos as a professional carver. ECHO, a chain-saw company, gave me an endorsement deal, and I would travel to represent them at sporting events. All the while, Kenny Laguna kept shopping the book. He had told me that he thought it could be a major motion picture. Of course, I wanted to believe that, but to be honest, I had learned not to get my hopes up. It felt like anything "in the biz," to me, was a long-lost pipe dream and I had become comfortable in my artistic and creative life as a carver.

When Jake was fourteen years old he decided to attend Agoura High School, which was one of the best public schools in Los Angeles County, so he moved to Bob's home on Malibou Lake. Bob continued

to pay support as if Jake lived with me full time, to ensure that I would be fine on a carver's income. That's the kind of love and support one wouldn't expect from an ex-husband, but again, very few men are like Robert Hays and, in turn, like our son, Jake.

I received the call from Kenny that there was interest in the book not by a publisher but by producers who wanted to adapt it into a film. It took years for Kenny's vision to come to fruition, but it did, and in a big way. Art and John Linson opted to do the film. They had produced films like *Fight Club* with Brad Pitt, and Art Linson was a pioneer in the business who had produced films that included *Fast Times at Ridgemont High, The Untouchables,* and countless others. It was a fantastic dream, and none of us could believe it.

And then suddenly, it all came crashing down.

Sandy West called me with the most terrible news. Her doctors had diagnosed her with type C, small-cell lung cancer. How could this be happening now? All Sandy had ever wanted was to play with the Runaways again, and to see all our hard work, blood, sweat, and tears be worth something. It looked like it was all happening now, but Sandy, our dear and wonderful Sandy, might not live long enough to see it, and she knew it. Her attitude was nothing short of incredible. Sandy had always been so loving and selfless, and it was at this time that I saw Sandy give more than she could have ever received. She was extraordinarily brave, and with the heaviest of hearts, Joan and I looked on as Sandy West Pesavento died after her bravely fought battle with lung cancer. The Runaways, in all its glory, would forever be missing the true heart of the band. Sandy West was one of the greatest drummers of all time. The loss of Sandy was indescribable and heart-wrenching, and there was nothing we could do about it.

William Pohlad of River Roads came onboard. He had produced the Academy Award–winning movie *Brokeback Mountain*. Kenny Laguna and Joan Jett took their seats as executive producers and the movie went into full swing with Floria Sigismondi at the helm as director and scriptwriter. Though I truly wanted to believe in all that Kenny had accomplished, it wasn't until the news that Kristen Stewart and Dakota Fanning were set to portray Joan and me that everything came together in my mind. It was all so incredibly surreal.

Dakota has been, truly, my favorite actress since I first saw her in *I Am Sam* in 2001, and my knees literally buckled when I heard she was in negotiations for the role. The greatest gift that could ever have happened in my life, besides the birth of my son, Jake, was her. But the experience was very bittersweet, without our Sandy.

She was put to rest in a small private ceremony with so many people there who loved her. Now we had to believe that she could see from a higher place, that her dreams were coming true. I think that was the only way Joan or I could accept it . . . the only way we could live with it. It was just unbearable otherwise.

Kenny found a great literary agent named Paul Bresnick and the book went to auction for five days. To my excitement, HarperCollins bought the book. I should have felt that I was standing on top of the highest mountain. I never could have dreamed that my life would have taken such a turn. But the darkness of losing Sandy West made it so hard to enjoy the miracle of the whole experience. I felt guilty and sad. It was a nightmare to not be able to call and talk to her about this larger-than-life experience that Joan and I knew was Sandy's greatest hope and dream. I didn't know how to cope with Sandy not being a part of it.

Then I received an email from a man named Kenny Williams. He owned a place called Kenny's Music Store in Dana Point, just a couple of miles from my brother Don's home. He had been so touched at the loss of Sandy that he wanted to commission a special piece for her. A life-size mermaid in her memory. The very thought of putting my energy and love into something to honor Sandy filled me with hope. This would be my way of thanking her, of letting her know how much I loved her, and my way of showing her that she would never be forgotten.

We decided that the mermaid would be playing an electric guitar. I wanted sea life all around her, and optimism on her face. Jake designed the piece on paper for the city to okay the project. It took me two months to finish and I swear, Sandy was there with me. Growing up in Huntington Beach, Sandy loved the sea, probably as much as she loved the drums. She loved life. I inlaid the guitar with shells and stones, added a friendly seal and sea turtle by her side. Then, with the

plaque dedicated to her in loving memory, I made a monument inlaid like the guitar and added her drumsticks, which her family had donated. The same sticks that had rested in her hands as her energy had coursed through them. I know that Sandy was there throughout the toughest parts of the carving process, and she guided me and gave me courage to attempt the most difficult details with ease. As the movie began its first day of shooting, I was in Dana Point at the ceremony to unveil Sandy's sculpture and monument. Her family was there and the turnout was incredible. That morning, Joan wept because she couldn't attend as she sat in her hotel room thousands of miles away on tour. So I said a few words on her behalf.

It was on that day that I finally felt at peace with it all. I knew that Sandy was smiling down on me, and all who loved her. She was with us and would remain with Joan and me throughout this journey, this new adventure of our lives. We have her blessing. She is here.

And now the adventure begins . . . again.

DELETED SCENES

Meeting My Ex-Husband Robert Hays

Staying clean and sober for the last six years has opened many doors for me, emotionally, spiritually, and physically. After my first A.A. birthday, I started going to the gym and fell in love with weight training. For five years now this has been my addiction—five days a week for two to three hours a day. After the first year, I had achieved the hard body that I had only dreamed of and, with the help of other trainers, I made myself knowledgeable in all areas of fitness training. I started training my friends at first but after a few months I found myself training up to seven clients a day. What started out as a favor to a couple of friends had turned into a comfortable living for me and I enjoyed it.

My brother, Don, owns an apartment building in Studio City. I had been living with Aunt Evie for three years but I was, again, ready for a change, so when Don called to say he had an apartment open for rent I was thrilled. The apartment was a darling one bedroom with vaulted ceilings and a view of the San Fernando Valley. The rent was seven hundred dollars a month and I was so proud to say to my brother, "I can afford that!" I took much pride in decorating it, picking each piece of furniture out carefully. This was MY place, my space and I'd worked hard for it, with my blood, sweat, and tears.

My day begins at 4:30 am and I work until 10 pm. My life is so busy there hasn't been time for a relationship. Sometimes it's been lonely and I find myself thinking about how nice it would be to have that special someone to hang out with. My last relationship ended a

few months ago, it was with a younger man, a model named Lance Strader. I met him at the gym and I have to say that he is truly one of the most beautiful people I've ever known, inside and out. He had to move back to Seattle to pursue his modeling career. It was hard because we had grown so close and been through so much together. I cried the day he left and I still miss him even though we occasionally keep in contact by phone. Now I fill my spare time with close friends.

The other night before I went to bed I got on my knees and had a little talk with God. First, I thanked him for all that he had given to me, my life, my strength, my hope for the future, and the love that I have for my family and friends. I thanked him for making me a person that they can love back, someone worth loving. I told him that if I was never to find that special 'someone' in my life, I was OK with that. . . . I was OK, all by myself, because for the first time in my life, I had found a truly loving relationship . . . with me.

I'd seen him at the gym a few times, working out in the weight room downstairs where I spend MOST of my time. I recognized him right away and so did everyone else. He had starred in a film that had come out in 1980, the same year they had released *Foxes*, yet his film had become known as one of the funniest movies of all time. That movie was *Airplane*, and HE was Robert Hays.

I found myself glancing over at him while I trained my clients. I guess I couldn't help being 'starstruck' and I wasn't the only one. I loved that movie; I remember seeing it in the theater and then watching it over and over again when it was on cable. I'd also seen him in a series called *Angie*.

He's CUTE! I thought as I caught myself staring, so I turned away. When I thought it was safe, I peeked over at him again and thought, *He looks like he's in his mid-to-late thirties, handsome, successful . . . he's got to be married! He looks too old not to be married! Everyone's married at his age! Married with KIDS!! He isn't wearing a wedding band . . . but who wears rings when they're working out?*

A couple of days later, I'm at the gym talking with Marie while she rides the Lifecycle. Robert walks by, and Marie yells, "BOBBY!"

He looks in our direction then looks behind him as if he's confused as to who she is calling for.

"BOBBY!" she yells again.

"You KNOW him?" I say astonished, "You don't know him, DO YOU?"

He looks in our direction again. He taps his chest and mouths, 'Me?' Marie starts waving frantically for him to come over. Robert looks at her for a moment then firmly points his finger to the ground as if to say 'You COME HERE'.

Marie throws her arms in the air and says, "But I'm on the bike!" He shrugs his shoulders and still looks confused. "It's me, Marie, Steve's wife."

That look melts away as a light bulb goes off in his head. "HEY! MARIE! How are you doin'?" He moves through the rows of Life-cycles towards us.

She DOES know him! I think to myself as he heads in our direction.

"We met at The Baja celebrity car race last year," Marie says, "He was teamed up with Kent McCord and Steve was with Fee Waybil, Bobby's a living doll."

Robert finally works his way to us, "Hey, Marie.

What've you been up to? How's Steve?" He grabs her, lifting her off the bike's seat and gives her a warm hug. I stand there trying not to stare as they embrace.

"Oh, Steve's great, it's so good to see you."

Then he turns to me, "You know the reason why I was ignoring her? It's because NO ONE calls me BOBBY and gets away with it!" *He says with the grin that made him famous.* "Only my MOTHER can call me Bobby," He laughs.

"Your Mommy and ME," laughs Marie. There's an awkward silence until Marie says, "Oh Bobby, this is my sister, Cherie."

He looks at me warmly, "Well, hey, It's nice to meet you Cherie."

Marie and Robert engage in conversation but I can't hear them, I'm transfixed with this mans face, his mannerisms; I mean, shit . . . this is THE Robert Hays! I've never been one to get starstruck but there is something about this man that I like . . . a lot. He seems so down to earth, not the stuck up star type that can't seem to get enough of themselves . . . I've met enough of those. This guy seems so genuine.

I feel the urge to jump into the conversation, "So . . . Robert, what

DO you like to be called . . . Robert? Bob?"

He answers quickly, "Definitely NOT Bobby."

At that moment, Robert's trainer walks up and asks to talk to him. "Excuse me girls, I'll be right back." I watch him as he walks his trainer through the crowd to the front door.

"Oh my god, Marie! Is he single?" I ask with anticipation but fearing the answer.

"Bobby just got out of a serious relationship, she broke his heart, devastated him . . . why?"

"What do you mean WHY Marie-zzee . . . HE'S CUTE!!"

Marie's eyes grow wide as she puts two and two together. "You're interested in him? Cherie-zzee?"

"Well, what's there not to like, he seems sweet, he's handsome. Why wouldn't I want to get to know him? Do you think you could ask him if that's something he'd be interested in?"

I see Marie's eyes light up as she assumes the role of Cupid. "That's a GREAT idea!" I start feeling that anticipation in my stomach, you know, when you finally see someone who interests you. I'd almost forgotten what that felt like. I start to get nervous as we see Robert working his way though the crowd towards us.

"Leave it to me," Marie says with a 'sure of herself' look on her face. As he approaches she says, "Bobby, you know Steve would love to see you. We always say we'll get together and we never do. So why don't we just plan it right now? The four of us should go out to dinner; we'll have a great time!"

Bob hesitates for a moment at the suggestion but gives an enthusiastic "Sure, Why not. Have Steve call my assistant Connie, she knows my schedule better than I do and we'll do it."

After his hesitation, I can't help but think it isn't gonna happen, but I don't let my disappointment show. "It was so nice to meet you Robert . . . hopefully we can get together soon. I'd really like that."

"Me too," he says as he leans in to give Marie another hug, then he turns back to me. "Oh and by the way . . . most people call me Robert but YOU can call me Bob . . . O.K?"

I feel a blush coming on, "Thanks Bob. See you soon."

. . . .

A couple weeks go by and I've seen Bob at the gym a few times. We exchange some casual hellos and talk about how we still all plan to get together when Steve gets off the road. Twice we had set up dinner dates and at the last minute Steve and Marie had to cancel. I knew that could mean at least a month or more before we could reschedule.

I called Marie on the phone, "Marie, are we ever going to make this happen? I don't really want to wait until Steve gets home. I'd really like to see Bob before then."

"Well," Marie replied, "maybe the three of us can go out. If things don't gel between the two of you I'll be there as a buffer."

I liked that idea. I thought we would get along fine but there was nothing wrong with having a backup. I decided the next time I saw Bob I was going to ask him out myself.

It was a week later when I saw him downstairs in the weight room. I slid into the chest press machine at the other end of the room and adjusted the weight. Bob was dressed in white Adidas sweat pants and a tattered white T-shirt with the sleeves torn off which really accented his muscular and toned body. He wore his tan leather weight belt cinched tightly around his waist. I couldn't take my eyes off his face. Everything seemed to be moving in slow motion. He was laughing, telling jokes and I saw his friends around him laughing. He always had everyone in stitches. I thought about what it would be like to be with him. I pictured us laughing together, sitting in a restaurant, walking on the beach, driving over Malibu canyon on a hot summer day at sunset . . .

Suddenly I was jolted from my daydream by the voice of a friend yelling out, "See you later, Robert!"

I turned to notice Bob grabbing his work out bag and heading toward the stairs saying his good-byes to people one by one. He glanced over at me and waved good-bye. This is my chance, if I am going to make this happen it has to be now. I slide out from behind the chest machine, grab my things and follow him upstairs. I continue to follow him around corners and down hallways nervously planning my approach. He rounds the final corner that heads to the exit. It's now or never...

"Bob?" I say, running up to catch him.

He stops and turns around, "Hey, Cherie!"

God I'm nervous, "Bob, I've been thinking, Steve and Marie have canceled twice on us now. If we're ever going to have dinner together I think we're going to have to do it without them."

Bob just stands there, his blue eyes study my face and his happy expression turns serious. "Ah, Cherie . . . I have to be honest with you, I think you're a sweetheart and I like you, but I just got out of a serious relationship. It's been a few months but she really broke my heart." There's a long pause and then, "I mean, she ripped it out and stomped it into the ground. I got really hurt . . . in fact, she destroyed me. I just don't think I'm ready to date anyone just yet."

The news is a shock to me. Marie had mentioned something to that effect but I didn't take it seriously. Someone broke HIS heart? Was this woman crazy?! I opened my mouth and it all came rushing out, "I totally understand, I just got out of a fairly serious relationship myself and that can be hard . . . ah . . . it doesn't have to be a *date* date, we can just go out and . . . talk." I see his face start to soften as I continue, "I like you Bob, I'd just really like to . . . be your friend. We would have fun, really."

He stares at me for a moment, looks down at the ground and smiles. I can't help but smile myself, he's so damn cute. He gives me that 'ah shucks' look then he shrugs his shoulders and says, "Okay, fine."

I wasn't going to let him get away this time. "Okay, Bob . . . when?"

"Well," he says with a smile, "I'll call ya."

More playful than shy I ask, "You promise?"

He just stares at me seeming to enjoy this, "Yup."

I hand him my card, "That's my home number there."

He looks at the card, "Okay . . . fine."

We stand there staring at each other for a while, I start to walk to the door but turn one last time, "Promise, promise?"

He nods slowly with my card in his hand and an equally playful grin. I smile and walk out the door on cloud nine.

. . . .

I'd been home nearly an hour when the phone rings. "Cherie? Hi it's Bob."

I can hardly contain myself, "Bob? How are you?!" My voice is so giddy that I can hear him laugh.

"Oh I'm fine . . . so . . . do you want to do this, you know, have our little date?"

I'm in shock, I didn't expect him to call so soon. "Yes Bob, I would LOVE that!"

He laughs, "How's Thursday, that's the day after tomorrow . . . too soon?"

"No . . . no! That would be great!"

"Okay then, my assistant Connie will call with the details . . . I'm looking forward to it."

"Me too Bob. We'll have a good time."

"I'll see you Thursday, Bye."

"Bye." I fall on my bed and let out a little scream, "Whooo Hoo!!" I lie there feeling dreamy . . . the whole thing seems surreal to me.

About five minutes later the phone rings again. "Is this Cherie? I'm Connie, Robert Hays' assistant, how are you? Robert has asked me to phone you to see if you would be available for dinner this Thursday night at 8 o'clock?"

I feel the streak of excitement rush through me again. "Yes . . . YES! I would love too."

The Birth of My Son, Jake

Over the months that Bob was away I read every book on natural childbirth that I could get my hands on—Amish, hippie, anything. I read about how Amish women will work in the fields all day, laboring on their feet, and only come into the house to deliver. I read countless stories of hippie births and came to the conclusion that I would have my baby naturally, with no medication. I swore that I wouldn't miss a thing.

I read about how fear is the enemy when it comes to childbearing, and that lying on your back can prolong labor. Laboring on your feet lets gravity help you along. I was told by Bob's sister, Lynn, that with every contraction I should relax with my arms draped around Bob's neck and envision my cervix opening like the shutter of a camera. I wanted my child's birth to be perfect, and anytime someone tried to tell me different I shut them out. I didn't want to hear horror stories.

We had hired a labor coach, a nurse to come to our home to help prepare us for the natural birth. I told her that I didn't believe in the 'Lamaze' method because I had been a coach myself for three other births and, to me, it seemed to interrupt the natural birthing process. The 'Hee hee, Ho ho' thing wasn't my bag so I was going to relax and let my body do what it naturally did best. My body was going to deliver this baby no matter what I did and I was not going to fight the process. I trusted my body entirely.

After our conversation, she believed that we didn't need her but because she was a nurse at Cedars-Sinai Hospital she would probably be there. I was glad because I liked her a lot. Bob wanted to deliver

Jake himself so Dr. William To (the greatest doctor in the world) said that Bob would be Catcher #1 and he would be Catcher #2.

Bob went to Rome and returned without incident. Five days after my due date, Dr. To decided that there was no reason to wait. We were to induce labor on the eighth of February. I wasn't thrilled about it; I wanted everything to be natural, but Dr. To explained that we didn't want the baby to be any bigger, or the delivery any harder and more painful. I wasn't about to argue that point. We set the date.

On the 7th of February, I was in the gym getting in my last work-out before the delivery. I was ready, DEFINITELY ready, to have this child. Bob's parents, Evelyn and John, drove in to be there for the event while Bob's sister, Lynn, and her daughter, Tessa, were flying in the next morning. It was an exciting evening knowing that the very next day Jake would be here. We retired early considering that we were to be at the hospital at 5:30 a.m.

As Bob and I lay in bed I shared with him that I had read sex is an excellent way to bring on labor.

He turned to me and said, "Well, lets bring this baby on!"

After the delightful deed was done and Bob was asleep I could feel the contractions begin. YEAH!! All through the night they continued. They weren't painful, just a 'tightening' every ten minutes or so. When the alarm went off at four a.m. I hadn't slept much and told Bob that I thought I had been in labor since he had gone to sleep. I put his hand on my stomach, and he could feel the contractions. I was sure it was labor that I was feeling.

When we got to the hospital, the nurse said that I was definitely in labor. I was so happy! I really didn't want the baby to come before he was ready, the timing was perfect.

When Dr. To arrived at 8:30 a.m., he still felt that Patosin, a drug that intensifies contractions should be administered, he didn't see any reason for me to labor longer than necessary, he said in his calm and loving voice, "Let's bring this baby on as soon as possible, no need to wait." I agreed.

Bob jumped in, "But will it be more painful with the Patosin?"

Dr. To replied, "The contractions will be stronger but it's nothing

that Cherie can't handle." He smiled and walked out of the room as they hooked up the Patosin to my I.V.

By 11:30, I was just cruisin' along. No real painful contractions, very livable actually. Bob came in to say that Evelyn, John, Mom, Wolfgang, and Aunt Evie were getting hungry and they had asked Dr. To if it would be safe to leave for an hour for lunch. Dr. To said for them to go ahead, that there was plenty of time before the baby would be born.

Bob said that he was thinking about going along with them and I said, "Sure, go ahead." Marie insisted on staying with me so Bob felt safe to go. It wasn't ten minutes after they left that Dr. To came in and thought it was time to break my water. He said it would bring the baby on faster. I looked out the window and saw Bob and the gang crossing the street to the restaurant. Marie tried Bob's cell phone but he didn't answer. I really wanted Bob to be there but I told the doctor to go ahead and break my water anyway. Almost immediately, the contractions became harder, this time with quite a bit of pain mixed in.

The African-American nurse with the great sense of humor came in and asked if I would like some pain medication. "Come on, honey," she said in a strong southern draw, "it will make it all a lot easier, baby."

I shook my head no and then jokingly said, "I don't want any pain medication and don't give it to me even if I beg for it."

The nurse laughed. The contractions got so hard, so fast, that Marie was trying to get Bob on the phone while helping to hold me up during some of them. We didn't know the restaurant they had gone to, all we knew was they had gone to The Beverly Center. I wasn't going to lie down, I was using gravity to my advantage.

Finally, at 1:45 Bob comes through the door. As he was walking down the hall the nurses were waving for him to hurry up. His phone had accidentally been turned off when he put it in his pocket, that's why he couldn't get our calls. By now I'm in full swing. My nurse checks me at eight centimeters and asks me again if I had changed my mind about the medication. I told her that I hadn't and could manage without it.

"OK, honey child, but this may be your last chance."

"No thanks," I say under my breath.

I continued to envision my 'camera shutter' opening with every contraction as I hung all my weight around Bob's neck. It was intense, but still 'livable'. I was tired and crawled up on the bed on my hands and knees when the next contraction came. I relaxed and breathed deeply when all of a sudden I felt this POP! It was the baby's head that had past through my cervix and the pain was excruciating!! I yelled that the baby was coming and to get the nurse.

She came running in as I was saying, "It's coming! It's COMING!!"

She said, "It can't be girl! I just checked you!"

I turned to her and with a little 'Linda Blair' action thrown in, threw my legs apart and yelled, "CHECK ME!!"

In a moment her gloves were on and her eyes widened as she could feel the baby's head. "Dear Lord, child! You're having this baby!!"

The pain was beyond explanation, more than I could bear and I said, "I'll take that pain medication now PLEASE!!"

She shook her head, "NO honey! Too late now!"

I grabbed her hand almost begging, "BUT THIS IS TOO MUCH!! I CAN'T TAKE IT!!"

She looked me in the eyes, "All you have to do now is push!! Push and the pain will subside!"

I bear down and push as hard as I can. To my relief, she's right! The pushing relieves the awful pain. I try to get back on my hands and knees but she takes me by the shoulders and tells me that I need to be on my back for delivery.

"I've got to get the doctor now honey! I'll be right back!" She motions to Bob who comes to my side and he takes my hand.

"God Bob! That really hurt!"

The calmness on his face is comforting as he strokes my hair, "Just do what she says babe, just push and it's all going to be all right."

But I'm afraid of the next contraction, terrified of that PAIN!! But I know it's coming, the next contraction. It's like taking a breath when you see that huge wave coming and you drive under it. It's as scary as hell but you KNOW you have to do it . . . and you do. The contraction came fast and furious. Bob pulls me forward and supports my back as I push as hard as I can. Dr. To comes running in along with Marie.

She has been running back and forth keeping people filled in on the progress. She stands there in amazement as Dr. To says that the baby is almost here. I could tell that even he was surprised at how fast the baby was coming. There were things crashing and banging as they scurried around in preparation for the birth. The bed I was on was transformed into a birthing table with stirrups and all. They couldn't seem to get everything fast enough. After four pushes Marie ran back into the room. I hadn't wanted anyone there but Bob for the birth, I thought it was something special that should be shared between just the two of us and of course, the Doctor.

Hey! It was the two of us alone that made this baby! I thought it should be just the two of us there at the birth, yet I was so glad to see Marie's smiling face at the door when the next contraction came. She continued to stand in the doorway with her hand over her mouth.

As I pushed, I could hear her screaming, "OH MY GOD, Cherie!! I can see the HEAD!!"

The doctor called to Bob, "OK Bob, come here."

He leaves my side and joins Dr. To for the delivery. I can hear them mumble something to each other then Dr. To says, "Cherie, It looks like you might tear so I need to give you an episiotomy."

I'm dead set against it. "NO! Doctor! I don't want that!" His voice was calm and comforting but that was not the way I had planned it.

"Cherie, you need to trust me. I'm going to give you a numbing injection, you'll only feel a little stick."

I had done enough reading to know that most episiotomies are not needed. I know that Dr. To is THE BEST doctor, but that's still surgery and it takes longer to heal from that than the child birth itself! I don't want it!! I decide that I'm going to push that baby out before he would have a chance to cut me. He had the needle in hand when the next contraction came and I bore down as hard as I could! My eyes were closed but what I could hear was the scuffle as both Bob and Dr. To jumped in to catch the baby!

Marie runs in and grabs the Polaroid camera and starts snapping away as they lay little Jake on my stomach. He starts to wail while Bob cuts the cord, and that was when I got a chance to look at that glorious little face. He was absolutely beautiful! Blue eyes and blond,

almost white hair. The nurse puts a little blue knit cap on his head and wraps him up tight in a blanket, then she takes him over to the scale to be weighed.

Marie holds a Polaroid picture up in front of me that has just developed. It's the picture she had taken just when they had laid Jake on my stomach.

"Cherie! The look on your face! It's a look of such LOVE!!"

I take the picture and study it for a moment then I say, "That's not a look of love Marie-zzee. That's a look of, "GOD my FUCKING crotch is KILLING ME!!"

She breaks out laughing. I'm still in the stirrups when people start piling in. Kent and Cynthia; Mom and Wolfgang; Evelyn and John; Aunt Evie; Don; Sam and her husband, Alan; my trainer Elizabeth and her husband, Morgan, everyone is there. I'm exposed to the world so Bob quickly throws a surgical sheet over me and I watch as everyone hovers over Jake.

Six pounds, 8.3 ounces! The nurse brings him over to me and lays him in my arms. Bob snuggles in next to me as we take in the wonderment of our child. I look at this perfect little creature and I fall in love, it's a different kind of love though, something so deep, magical, and penetrating that it takes my breath away. It's a love I know that I have never felt before. It's a gift from God.

We check out of the hospital the next morning and take our new baby home. Lynn had flown in with Tessa. Everyone was there to help, which I appreciated since caring for a newborn is not really something that you can learn about in books. It's hands-on all the way and Evelyn and Lynn were pros at it. I had gotten the 'nursing thing' (breast feeding) down which was a relief, but Jake was so tiny you could almost fit him in a shoe box!

Jake, like so many other babies, was jaundiced for his first few days. We had to take him every day for a blood test where the doctor pricks his heel to draw blood. Every time they did and he cried, I would start crying. After the second day I couldn't even be in the room when they did it. As Bob stayed with him I would stand in the hallway and cry. I could not believe how much I loved that little child, I did not know how I ever lived without him. My only thought was

to care for him the best I could because I knew there would be no life for me without him.

Five days later, everyone left, including Bob, who had another celebrity event to attend, and I was left alone. Jake had a touch of colic and that first evening I couldn't get him to stop crying no matter what I did. Finally, after an hour, I lay down with him on the bed and we both cried. If he hurt, I hurt. It's a bond, all powerful, all consuming. My life would never be the same because of him and I was glad for that. This baby boy would always have an abundance of love, and no matter what ever happened we would always have each other.